Collecting
as Modernist
Practice

Hopkins Studies in Modernism
Douglas Mao, *Series Editor*

Collecting as Modernist Practice

Jeremy Braddock

The Johns Hopkins University Press
Baltimore

The Johns Hopkins University Press
2715 North Charles Street
Baltimore, Maryland 21218-4363
www.press.jhu.edu

Library of Congress Cataloging-in-Publication Data

Braddock, Jeremy.
 Collecting as modernist practice / Jeremy Braddock.
 p. cm. — (Hopkins studies in modernism)
 Includes bibliographical references and index.
 ISBN-13: 978-1-4214-0364-9 (hardcover : acid-free paper)
 ISBN-10: 1-4214-0364-1 (hardcover : acid-free paper)
 1. Modernism (Literature) 2. Collectors and collecting.
3. Anthologies—History and criticism. I. Title.
 PN56.M54B746 2012
 069'.409—dc23 2011019906

A catalog record for this book is available from the British Library.

*Special discounts are available for bulk purchases of this book. For more
information, please contact Special Sales at 410-516-6936 or specialsales
@press.jhu.edu.*

The Johns Hopkins University Press uses environmentally friendly
book materials, including recycled text paper that is composed of at
least 30 percent post-consumer waste, whenever possible.

For Rayna

Contents

Acknowledgments ix

Introduction: Collections Mediation Modernism 1

1 **After *Imagisme*** 29
 The Lyric Year and the Crisis in Cultural Valuation 29
 The Anthology as Weapon 39
 The *Others* Formation 50
 Reprisal Anthologies 64

2 **The Domestication of Modernism: The Phillips
 Memorial Gallery in the 1920s** 71
 Pictorial Publicity 71
 Subconscious Stimulation, a Professional Public
 Sphere 77
 Problems in Collecting Pictures 87
 Akhenaten, Patron of Modernism 93

3 **The Barnes Foundation, Institution of the New
 Psychologies** 106
 Against Dilettantism 106
 A System for the New Spirit 111
 Collection and Institution 125
 The Art of Memory in the Age of the
 Unconscious 137

4 *The New Negro* in the Field of Collections 156
 Sage Homme Noir 156
 Precursor Anthologies 159
 Coterie, Movement, Race 173
 The Heritage of *The New Negro* 185
 Downstairs from the Harlem Museum 194

5 Modernism's Archives: Afterlives of the Modernist
 Collection 209
 Two Termini 209
 Two Consecrations 212
 Two Archives 214

 Notes 229
 Bibliography 279
 Index 301

Acknowledgments

The earliest thinking for this project began with the inspiration of two remarkable teachers, Phil Harper and Tim Morton. The work took shape under the brilliant guidance of Jean-Michel Rabaté, who first listened to my inchoate effusions about the Barnes Foundation and *The New Negro* (responding with "collecting!") and then spent many hours in conversation with me as the project evolved. I am equally indebted to Susan Stewart, who has been an assiduous respondent and inspiring mentor from almost the beginning; it is impossible to think of a better reader for these pages. Jim English encouraged me to pursue questions of institutionality more thoroughly, advice that proved to be decisive as I revised and rewrote the manuscript. Michael Awkward, too, was a smart, perceptive reader. Many other teachers, colleagues, and friends in Philadelphia contributed to the intellectual life of this book: Bob Perelman, Margreta de Grazia, Michèle Richman, Vicki Mahaffey, Craig Saper, Ilan Sandler, Ben Austen, Kathy Lou Schultz, Tyler Smith, Gabriela Zoller, Hester Blum, and Martha Schoolman.

My research was greatly aided by many archivists and librarians. I am happy to acknowledge the expertise of John Pollack and Dan Traister of the Rare Books and Manuscript Library at the University of Pennsylvania, Nancy Kuhl at the Beinecke Rare Book and Manuscript Library, James Maynard of the Poetry Collection at the University at Buffalo, Karen Schneider of the Phillips Collection, Katy Rawdon and Deborah Lenert of the Barnes Foundation, and Joellen El Bashir of the Moorland-Spingarn Research Center at Howard University. In a similar spirit I thank Bruce Kellner, who provided guidance concerning the collection of Carl Van Vechten, and Suzanne Churchill, who helpfully answered questions about Alfred Kreymborg and *Others*.

Since leaving Philadelphia, I have benefited from the challenging read-ings of new colleagues. I thank Evan Kindley, Crystal Bartolovich, Bill Solo-mon, Marlon Ross, Chris Raczkowski, Nick Jenkins, and Sean Shesgreen for their insights. I am grateful for conversations with Brent Edwards, Wanda Corn, Bill Maxwell, Janet Lyon, Pamela Smart, Hal Foster, Max Pensky, Jim Longenbach, Dan Blanton, and Guy Ortolano, among many others. Teach-ing for a year at Haverford College, I was lucky to have the collegial en-gagement of Gus Stadler, Tina Zwarg, Kim Benston, and Raji Mohan. And I am very thankful, too, for the support and advice of colleagues during my two years at Princeton, especially Daphne Brooks, Claudia Johnson, Valerie Smith, Diana Fuss, Ben Baer, Zahid Chaudhary, Meredith Martin, Oliver Ar-nold, and Jennifer Greeson.

Before arriving at Haverford, I received a postdoctoral fellowship from the Cornell University Society for the Humanities. Grants from the English department and from the Society for the Humanities at Cornell University later provided important support during the project's final stages, and the University's Hull Memorial Publication Fund provided a subvention of the book's production costs.

To support the revision and expansion of this book, I received a year's fellowship at the Stanford Humanities Center. Cornell University gave me additional support during my year of leave. My wonderful year at Stanford helped me to understand much more thoroughly what I had been working on all along, and I am enormously grateful to the staff of the center and to the other fellows, especially Ben Lazier, Jim Clifford, Paul Kiparsky, Liisa Malkki, Chris Rovee, and Gerry Bruns. During that year, I was fortunate also to participate in the Stanford Workshop in Poetics, organized by Roland Greene and Harris Feinsod. I thank them and the other participants of the seminar.

At Stanford, Eric Messinger and Aaron Quiggle were valued research as-sistants. And at Cornell, Corinna Lee and Bernadette Guthrie helped me pre-pare the manuscript for publication.

I have been very grateful for the support of my colleagues at Cornell. In particular, I wish to thank Dagmawi Woubshet, Sabine Haenni, Tim Mur-ray, Molly Hite, Dan Schwartz, Roger Gilbert, Andy Galloway, Nick Salvato, Mary Pat Brady, Eric Cheyfitz, Medina Lasansky, Judith Peraino, Margo Craw-ford, Shirley Samuels, Camille Robcis, Dan Magaziner, and Jenny Mann, all of whom helpfully answered questions. Many of them also generously read parts of the manuscript and provided suggestions for revision.

At the Johns Hopkins University Press, Matt McAdam has worked tirelessly on behalf of this book: I give him my sincere thanks. I wish also to thank Jesse Matz, John Xiros Cooper, and one anonymous reader of the manuscript; each of them made suggestions that have greatly improved this book.

Series editor Douglas Mao has been far more than that title conveys. He has been a brilliant reader of this project for many years, and he has my unending gratitude.

Damien Keane and Jon Eburne have long been invaluable intellectual companions; it is easy for me to see their influence throughout this book, and I look forward to continuing to repay my debts to them. Kevin Bell, Jessie Labov, Gabrielle Civil, and Jim Mutton have provided brilliant friendship for a still longer time. More recently, David Suisman has been a terrific reader, interlocutor, and friend. And I thank Joe Wessling, Jeff Goldman, Tim Albro, Matt Kelley, David Quintiliani, Dave Solomon, and the Big Mess Orchestra, friends whose work, on the lower frequencies, speaks for me.

Special thanks go to my brother, Nathaniel, and my parents, Robert and Sarah. It makes me happy to think that my book has in some way married my father's prescient academic study of Tudor bureaucracy with my mother's unsurpassed mind for provenance and patrimony.

This book was written twice, its first pages written just after I met Rayna Kalas, and written again in the company of our brilliant and beautiful daughter, Astrid. To Astrid I give my undying love and thanks; I am happy to be able finally to answer, yes, this book is in the library. And to Rayna, who has brought such intelligence and passion to these pages and to their writer, I dedicate this book with my love.

The author has made every effort to identify owners of copyrighted material. Any omissions will be rectified in future editions.

Permission to quote from the William Carlos Williams Papers has been granted by The Poetry Collection of the University Libraries, University at Buffalo, The State University of New York.

The letters of Amy Lowell are quoted by permission of the Trustees under the Will of Amy Lowell.

Permission to quote from the correspondence of Duncan Phillips and from The Phillips Collection Oral History Program has been granted by The Phillips Collection Archives, Washington, DC.

The Barnes Foundation has granted permission to quote from the correspondence of, and unpublished material written by, Albert C. Barnes.

Permission has been granted to quote from materials held in the archives of the Pennsylvania Academy of the Fine Arts.

Permission to quote from the papers of Alain L. Locke has been granted by the Moorland-Spingarn Research Center, Howard University.

Permission to quote Countee Cullen's poem "Heritage" has been granted. Copyrights held by Amistad Research Center, Tulane University, administered by Thompson and Thompson, Brooklyn, New York.

Permission to quote Helene Johnson's poem "Bottled" has been granted by the Helene Johnson and Dorothy West Foundation for Artists in Need.

The correspondence of Carl Van Vechten is printed by permission of the Carl Van Vechten Trust.

The correspondence of Anne Spencer is quoted with the permission of the Anne Spencer House and Historic Garden Museum.

Permission to quote the correspondence of Charles S. Johnson has been granted by his son, Jeh V. Johnson.

Permission to quote the Charles D. Abbott correspondence has been granted by Neil G. G. Abbott and by The Poetry Collection of the University Libraries, University at Buffalo, The State University of New York.

Previously unpublished correspondence of Ezra Pound, copyright © 2010 by Mary de Rachewiltz and Omar S. Pound, is reprinted by permission of New Directions Publishing Corp.

Permission to quote the correspondence of Nancy Cunard has been granted by her literary executor, Robert Bell.

Collecting
as Modernist
Practice

Introduction:
Collections Mediation Modernism

A study of the central role of the collection within modernism might simply start by observing how many modernist artworks themselves resemble collections. We could begin by pointing to the citations and quotations that mark Ezra Pound's *Cantos* and T. S. Eliot's *The Waste Land* and, following Marjorie Perloff, connect these strategies to the collage aesthetics of futurist painting, synthetic cubism, and Dada.[1] Alternatively, we might follow André Topia's suggestion that another kind of collection, the archive, is the principal referent for the writing of Eliot, Pound, James Joyce, and Gustave Flaubert.[2] The archetypes of the collage and the archive would each find a correspondence in Walter Benjamin's well-known claim that he wished to compose a manuscript entirely out of quotations, or in the passages that constitute his unfinished *Arcades Project* (a text whose resemblance to the *Cantos* J. M. Coetzee has proposed).[3] In a related vein, we could include the works produced under the banner of Soviet factography in the 1920s.[4]

Looking to the United States, and invoking still another important form of collecting, one could point to the early blues poetry of Langston Hughes, in *Fine Clothes to the Jew*, or Sterling Brown, in *Southern Road*, to underscore those poems' more than accidental resemblance to the transcriptions of folk songs that had been published in the collections of scholars such as Natalie Curtis Burlin (under the aegis of the Hampton Institute) or John Wesley Work (at Fisk University). This recognition may in turn remind us of the pointedly blurry line between Zora Neale Hurston's fiction and her anthropological work as a collector of folklore, as well as the evocations of a vanishing folk culture in the writing of William Butler Yeats and Jean Toomer.[5] Hurston's anthropological training under Franz Boas could then return us to Eliot and Pound, whose debts, respectively, to James George Frazer and Leo Frobenius are well known. And we could finally note the

thematic importance of collecting in novels of the period, from *Ulysses*, whose opening pages feature the English character Haines who has come to Dublin to collect Irish folk material, to Wallace Thurman's roman à clef *Infants of the Spring*, where variations on the word "collection" provide a leitmotif of the novel's assessment of New Negro institutions.[6]

As this heterogeneous list reveals, what might be broadly named a "collecting aesthetic" can be identified as a paradigmatic form of modernist art. And yet to isolate the collection as an available *form* for art obscures the constitutive role of the collecting *practices* that the works invoke: archiving, ethnography, museum display, anthologization. It is significant that nearly all of the works listed above were produced in the 1920s, not at the historical origin of what would later be called modernism, but rather at the high-water mark of "high modernist" productivity. The emergence of a collecting aesthetic at this secondary moment signals a more general concern with the art's institutional representation and future authority: just as Pound heralded *The Waste Land* as "the justification of the 'movement,' of our modern experiment, since 1900," Hughes would write, a few years later, "we build our temples for tomorrow, strong as we know how."[7] Such questions had special currency in the United States, where the works of modernism were received within a relatively fluid, or unformed, institutional field. At the beginning of the 1920s, it was not simply the case that no American museums were prepared to commit to the representation of modernism; nearly all of them remained unbuilt. This was also true for the American literary field, which would have no Poet Laureate until 1937, and where a history of canon-defining anthologies was far shorter and thinner than it was in Britain.[8] To consider the institutional reception of the new work of art was for this reason to consider the very nature of the institutions themselves. It was in this situation that *material* collections of art and literature were advanced as means not simply (or even primarily) of institutional consecration but of cultural and social intervention.

In this book, I do not aim to reveal and interpret a range of canonical works according to their secret affinity as collections but rather argue that if a collecting aesthetic describes a salient form of modernist art, it is because it bears witness to a larger set of crises and possibilities that the collection could both represent and address. Most critics have understood collecting as a mode of subject formation, what Jean Baudrillard termed "a discourse addressed to oneself."[9] An echo of this self-referential world of private consumption can be found in Lawrence Rainey's influential *Institu-*

tions of Modernism, which claims that "[m]odernism, poised at the cusp of th[e] transformation of the public sphere, responded with a tactical retreat into a divided world of patronage, collecting, speculation, and investment, a retreat that entailed the construction of an institutional counterspace, securing a momentary respite from a public realm increasingly degraded, even as it entailed a fatal compromise with precisely that degradation."[10] This powerful thesis, as we will see, accounts very well for certain key figures, such as the patron and collector John Quinn. More typically, however, the collection was not a form of retreat, but instead a means of addressing the work of art to the public, modeling and creating the conditions of modernism's reception. Presuming in advance the social potential of the new art, American collectors believed that the often radically innovative work of modernism promised a broad transformation of institutional culture and even social practice at this inaugural moment of reception. Rather than constructing a regressive "institutional counterspace," the modernist collection was figured as what I will call a *provisional institution*, a mode of public engagement modeling future—and often more democratic (although the meaning of this word would be contentious)—relationships between audience and artwork.

The two most prominent forms of modernist collecting were the privately assembled, but publicly exhibited, art collection and the interventionist literary anthology. Privileging the cultural authority of painting and poetry, these collective forms nevertheless stood in contrast to the grandly narrativizing institutions of the nineteenth century such as the civic museum or the historical anthology. Modernist collections aimed instead to determine the constituents of the movement, group, or field, in gestures that were by turns restrictive (because of the constitutive selectivity and exclusions of a given collection) and synthetic and enabling (where the collection's disparate pieces represent a new, hitherto unimagined form of sociability and set of affiliations). The aesthetic dimensions of the modernist collection also indicated a belief in the virtue of maintaining a connection to the idiosyncratic subjectivity of the collector who had assembled them. With this in mind, it is possible to see a series of instructive homologies between the art collection and anthology forms: the heterogeneity of objects in Albert Barnes's galleries and Alain Locke's *New Negro* anthology, the emphasis on the avant-garde formation that marks the practices of Katherine Dreier's Société Anonyme collective and Alfred Kreymborg's *Others* anthologies, the popularizing (and also patrician) affinities of the literary

impresario Amy Lowell and the art collector Duncan Phillips. Such collec-
tions, moreover, are related not only by formal resemblance but by the ac-
tual transactions among the collectors, artists, and authors.

The homologies are revealing, but collectors of art and of literature were
also keenly aware of the limitations, as well as the possibilities, of their
specific media. Within the general field of collections, the genres of the
anthology and the art collection were complementary, but also unequal and
competitive, modes of aesthetic and institutional expression. An anthology
could circulate among and recruit disparate audiences in a way that was
not possible for a gallery exhibition (even the few that toured), whereas
an art collection could index economic to cultural value in a way that was
more difficult for the commercial form of the anthology. Modernist anthol-
ogy prefaces repeatedly made anxious reference to the acknowledged cul-
tural prestige of modernist painting; collectors like Barnes and Phillips were
readers of modernist anthologies, and their own promotional texts at times
emulated that collective form.[11] As I will finally argue, the failure of the
anthology form to secure a patrimony for literary modernism (one compa-
rable to the works that would be enshrined at the Museum of Modern Art)
eventually led to the ascendancy of another form of institutional collecting:
the university archive.

Although canons have been more recently challenged, revised, and ex-
panded, the midcentury institutionalization of the works of modernist art
and literature in, respectively, the museum and the university continues to
obscure the practices that once associated them much more closely. Taken
together, the collective forms of the anthology and the art collection (and,
eventually, the archive) define a specific field of cultural activity, doing so
at the very moment that the collection itself began to become recognized
as a paradigmatic form of aesthetic modernism. At a time when the cul-
tural value of modernist art was acknowledged but the mode of its insti-
tutionalization, its canon, and its relationship to society were undecided,
the contest for modernism's social definition took place within this field of
collections.

To emphasize the centrality of the collection as both form and practice is
to engage two distinct senses of the term *mediation*. In the sense that corre-
sponds more directly to practice, collections of art and literature are mate-
rial forms that mediate between work and audience. This more sociological
sense of the term has been an implicit touchstone of all of the critical work
that has been advanced under the rubric of "material modernisms" and

theorized most influentially in the work of Pierre Bourdieu, which repeatedly emphasizes how "the entire structure of the [cultural] field interposes itself between the producers and their work."[12] Bourdieu's notion of the structured field involves an entire system of practices, positions, and institutions, of which collecting would only be one element. In this sociological register, the individual work of modernism is mediated by the collection's often polemical apparatus (such as prefaces or self-promotional criticism) and acquires further meaning and context in relationship to the other works in the collection (by organization, arrangement, and display). In addition, the economic and cultural authority of the collector may exert a determining influence not only on reception but on production itself, as in, for instance, Phillips's critical interactions with artists whom he supported financially, or in the way figures like Pound and Locke imposed changes on poems before admitting them into their anthologies. In such cases the practice of mediation can become a determinant of form, as Bourdieu recognizes: "Few works do not bear within them the imprint of the system of positions in relation to which their originality is defined."[13] The individual collector, expressing sensibilities both aesthetic and institutional, holds a particular form of agency within this system of positions.

This more practical conception of mediation corresponds most nearly to what Raymond Williams identifies as the term's typically "negative" articulation, where "certain social agencies [in this case collectors and collections] are seen as deliberately interposed between reality and social consciousness [here, the work of art and the public], to prevent an understanding of reality." In this view, the collection's apparatus hinders and obscures the "truth" of the individual work. But Williams also identifies another sense of mediation, "related, if controversially," to the constitutive agency of aesthetic form itself, and *immanent* to the work of art. What Williams intends by this (and as it was taken up by other critics, notably Fredric Jameson) is to provide a complex, rather than reductive, account of the way in which the objects of culture mediate the social. Unlike the obstructive activity of a collector (among other cultural intermediaries), this form of mediation is "positive and in a sense autonomous"; it is "a direct and necessary activity between different kinds of activity and consciousness." On one hand, the positive sense of mediation is specifically opposed to a pure or "empty" formalism, since it asserts the mutually constitutive processes of various levels of society (economic, political, cultural) and insists upon the material and social character of media and form. But equally importantly, it refuses

to insist upon an identity of expression among the levels of society: the work of art could be socially determined without being required to reflect social conditions directly: "All 'objects,' and in this context notably works of art, are mediated by specific social relations but cannot be reduced to an abstraction of that relationship."[14]

These critical traditions of mediation—sociological and formal—seem relatively independent. But their independence will be more difficult to sustain if we insist that a material collection is itself an aesthetic object, even, more pointedly, an *authored work*. In this view, the collection possesses the properties of an individual work even as it interposes between the artists' works and audience. Shaped by sensibilities that are aesthetic and epistemological, the anthology and the art collection exist not simply for the sake of their individual works; they are also systems with meaning in themselves.[15] As a form, the collection expresses something inherent within modernity—as, for instance, the "loss" of a grand narrative instigates a search for new social, aesthetic, or political affiliations in the present, or a wish to reinvigorate or rewrite historical traditions. It assimilates the "fragments" shored against Eliot's "ruins," or is a means of "creating a usable past," in the words of Van Wyck Brooks's 1918 essay. What may be emphasized is that Williams's second sense of mediation need not be restricted to the aesthetic forms licensed by convention: a mediated representation of the social totality may be found in a collection as well as in an object recognized as an autonomous work.

At the same time, if the collection is understood as a powerful determinant within a Bourdieuian "system of positions," or within the structure of the cultural field, we can begin not only to appreciate the collection as a powerful model for the originality of modernist art but also to see the way it could be fashioned as a provisional institution. As provisional institution, the modernist collection was a means of intervening in and reforming cultural practice, doing so on the basis of its form: the collection's aesthetic arrangement, as well as its inclusions and exclusions, was a representation of ideological position. This is evident, among other places, in the way American modernist collections mediated the broader social problematic of race, whether explicitly, as in the cases of Alain Locke and Albert Barnes, who each insisted on the interrelationship of modernism and black culture, or obliquely, as in the cases of the *Spectra* anthology and the collection of Duncan Phillips, where race appears as what Jameson would call an "absent cause." To recognize the collection as both an immanent (or formal) and a

practical form of mediation is therefore also to recognize the collection's centrality both to the "autonomous" work of modernism and to further-reaching questions of social practice.

The collectors themselves were deeply concerned about the degree to which the social significance they perceived as inherent to modernist art in its formal aspects could be made to correspond to transformations in cultural and social practice. Commenting specifically on the modernist period, Williams observed that "since the late nineteenth century, crises of technique—which can be isolated as problems of the 'medium' or of the 'form'—have been directly linked with a sense of crisis in the relationship of art to society, or in the very purposes of art which had previously been agreed or even taken for granted. A new technique has often been seen, realistically, as a new relationship, or depending on a new relationship. Thus what had been isolated as a medium . . . came to be seen, inevitably, as social practice."[16] Implicit in Williams's formulation is the special capability of the work of modern art to register the transformation of society in advance of its actual occurrence, something the poet and anthologist Pound also intuited in naming great artists "the antennae of the race."[17] David Simpson has pointed out, however, that the problem with this formulation is that it appears to depend on a necessarily retrospective judgment of modern art, since Williams "fails to make clear how we are to establish that [the social contradictions immanent within the work of art] are in fact 'pre-emergent,' indications of a social formation about to take form, rather than simply idiosyncratic or arbitrary."[18]

Modernist collectors were motivated by what Williams identified as the "sense" of a connection between radical aesthetic form and transformative social practice (mediation in the immanent sense), but they were impelled also by the fear that without the proper forms of *practical* mediation the works in question might simply remain, in Simpson's words, "idiosyncratic or arbitrary." The very tenuousness of this connection between the aesthetic and the social authorized the ambitious collecting projects of figures like Dreier and Barnes (or, later, Nancy Cunard) who wished to establish working-class, or interracial, audiences for modernism and its institutions. It also, in a more conservative register, informed Phillips's wish to banish avant-gardists such as Léger from his collection out of concern about the political implications of the artist's collectivism and antihumanism, and it prompted Alain Locke's purging of radical racial politics from the pages of *The New Negro*. In order to appreciate the way a range of modernist

collections obtained the agency of provisional institutions—and without uncritically lamenting the loss of modernism's true social potential—it will be helpful to examine two transitional events, one pertaining to art collecting and the other to anthologies, that involved the transmission of European modernism to a new cultural situation in the United States. It is in the wake of these events and the exchanges they elicited that the stakes of the cultural struggle would become clearer.

In February 1927, the American Art Association buildings in New York City hosted the auction of paintings and sculptures that had been owned by the New York lawyer and patron and advocate of literary modernism John Quinn. The auction of 819 pieces comprised five sessions held over the course of four days and marked the final dispersal of one of the first and greatest modern art collections in the United States, one that included sculptures by Constantin Brâncuşi, Henri Gaudier-Brzeska, Raymond Duchamp-Villon, and Jacob Epstein; canvases by Henri Matisse, Pablo Picasso, Georges Braque, Henri Rousseau, André Derain, Georges Seurat, Gino Severini, Wyndham Lewis, and Jules Pascin; and hundreds of African and Asian objects.[19] Several of these contemporary artists were represented in considerable depth in Quinn's collection, as suggested by the Paris dealer Paul Rosenberg's purchase, en bloc, of fifty-two Picassos in advance of the auction.[20] Notable among the many pioneering pieces Quinn had owned were Matisse's *Blue Nude* (1907) and the early version of Marcel Duchamp's *Nude Descending a Staircase* (1911), works now consecrated in the Baltimore and Philadelphia Museums of Art, respectively, but which had been the two most controversial pieces at the foundational International Exhibition of Modern Art of 1913 (the "Armory Show"), of which Quinn had been a major patron.[21]

Quinn had been dead for three years by the time of the 1927 auction. Although his will stipulated that the collection be sold in order to support his sister Julia Quinn Anderson, there was considerable debate among Quinn's friends and executors—and also within the American art world—about the manner in which the collection should be dissolved.[22] At issue was whether the enormous collection (more than 2,500 pieces in all) should be sold at one monumental auction or, for fear that such a massive event would flood the modern art market and draw down prices, it should instead be dissolved over the course of several years by private dealers. In the end, a compromise was reached according to whose terms the collection was liquidated

between 1926 and 1927 in a variety of forums: there were "authorized pri-
vate sales" held for the benefit of collectors and dealers like Rosenberg, a
separate "memorial exhibition" and sale at the New York Art Center, an auc-
tion at the Hôtel Drouot in Paris, and, finally, the 1927 American Art Asso-
ciation auction, which dispersed the remainder of the collection.[23] Quinn's
library and manuscript collection, which contained several artifacts that
would be crucial for the institutionalization of *literary* modernism (several
manuscripts by Joseph Conrad and a complete handwritten draft of Joyce's
Ulysses), had already been sold at auction shortly before his death.[24]

The publicity that surrounded the final public auction places it among
the most sensational United States art events to have followed the Armory
Show of 1913. Yet to appreciate its importance, historically and sociologi-
cally, it is worth a brief glance at a seminal auction from the previous de-
cade, the sale of the Peau de l'Ours collection in Paris in 1914. That collec-
tion of 145 fauvist and cubist pieces, specializing in the early work of Picasso
and Matisse, had been assembled by a coterie of thirteen collectors led by
the businessman André Level. La Peau de l'Ours was an experiment in art
investment (the name, "the skin of the bear," referred to a parable by Jean
de La Fontaine about speculation) whose telos had been the agreed-upon
sale of the entire collection after ten years of acquisitions. *Making Modern-
ism*, Michael FitzGerald's excellent study of Picasso and the development of
the modern art market, opens with the authoritative account of the Peau de
l'Ours sale, an event whose enormous economic success—it earned 116,545
francs, more than quadrupling the initial investment—marked a transforma-
tion in the economy of modernist art. In FitzGerald's words, critics sympa-
thetic to modernism "perceived the auction as a confirmation of the art's
importance that their own aesthetic evaluations could not confer."[25] Its fi-
nancial success and the great publicity it generated demonstrated the aes-
thetic and financial convergence of the avant-garde with the public sphere
that had become visible by the start of the First World War. If, over the
course of a decade, modernist art in Paris had significantly appreciated in
value, both cultural and economic, private collectors like Level and his col-
leagues were key agents of that "appreciation."

Despite its significant transformation in the wake of the war, an interna-
tional market for twentieth-century art was an acknowledged reality by the
time of Quinn's death a decade later. Quinn himself had been instrumental
in providing that market with a transatlantic dimension when in 1913 he
had successfully lobbied against a United States government tariff on the

importation of art less than twenty years old, an intervention that made the Armory Show possible.[26] The impressive performance of the market for modern art, however, was not guaranteed, as the considerable negotiations concerning the maximization of profit from the sale of Quinn's collection indicate. The problem of the market, moreover, concerned both Quinn's beneficiaries and the still-living artists whose work was represented. Indeed, FitzGerald has speculated that Rosenberg (who was himself Picasso's dealer) may have purchased the block of Quinn's Picassos in order to guard against the possibility of his artist's market value suffering as a result of relatively wide market availability, and Duchamp later admitted that he had performed a similar service at Brâncuşi's request.[27]

Uncertainty persists today about the relative market achievement of the Quinn sales. The Hôtel Drouot auction was the most unqualified success, with Rousseau's *Sleeping Gypsy* (1897, now at MoMA) selling for 520,000 francs or $102,900.[28] Yet total sales and profits have been a matter of more debate. In relation to Quinn's expenditures, over the course of his life, of about $500,000, Quinn's biographer, B. L. Reid, claims that Quinn lost around $100,000.[29] It is more likely that the sales turned a profit; Aline Saarinen has proposed $750,000 as an estimate; Judith Zilczer suggests they made $600,000.[30] What is certain, as well as telling about the status of the American market for modernism, is that many of the more radically modernist pieces in the February 1927 auction sold for less than Quinn had initially paid for them. The *New York Times* noted the lower prices commanded by the "radicals" represented at the auction,[31] but this observation did not, in turn, lead to a repudiation of Quinn's tastes or of modernism *tout court*. The perceived *cultural* value of the collection was not questioned in fine arts publications such as the *Dial*, the *Arts*, or *Art News*, and even in the mainstream press such challenges were uncommon.[32] The instructions in Quinn's will had, in fact, already indicated that he expected his more radical pieces to obtain lower prices when they were dispersed at auction among fellow private collectors such as A. Conger Goodyear, Samuel Lustgarten, and E. Weyhe and through off-market sales to other individual collectors, including Walter Arensberg (who bought the *Nude Descending a Staircase*) and Katherine Dreier.[33] He was also aware that the major American museums were not yet ready to commit to modernism, which ruled out the possibility of a major bequest the likes of which are now common. Although he left perhaps his greatest Seurat to the Louvre (*The Circus*, 1891, now at the Musée d'Orsay), the public reception of the Impressionist and Post-Impressionist Painting exhibition that he

had helped to stage at the Met in 1921 had not left him sanguine about a large donation in the United States.[34] Indeed, when Goodyear led the charge for Buffalo's Albright Gallery to make one of the few institutional purchases from among Quinn's modernist pieces (Picasso's *La Toilette*, 1906), it had the consequence of his not being reelected to the gallery's board of directors the following year.[35]

By 1927 the demonstrable interrelation of economic and aesthetic value, which it had been the acknowledged accomplishment of the Peau de l'Ours auction to reveal, had become a more complex proposition. That complexity obtained in the United States in a particular way; no clear correspondence could be drawn between the prices obtained at the Quinn auction and the critical importance of individual works or artists. This was true in part because of the desire to manage a market for modern art that was still in the process of development, but also because the question of public access to the works, in galleries or, eventually, in public museums, was now becoming a matter of interest and concern. Whereas the economic value of modern art was expected to prove itself in the long term, its value as cultural capital was in an important sense more immediate, even if—or especially because—public institutions were not yet alive to it, and it was on the basis of this cultural capital that the more significant conversations about Quinn's art turned.

In these conversations, the crucial object of consideration was arguably less the individual works Quinn had acquired than the collection itself *as a collection*. One argument that had been made in favor of dispersing Quinn's entire collection in a single monumental auction, by critics including the *Independent*'s Frederick James Gregg, was that it would operate, precisely, as a monument to Quinn's impressive achievement as a collector, while also permitting a fleeting grasp of the breadth of the collection in a relatively public situation.[36] This argument was homologous with the dismay privately expressed by other figures, among them the dealer Joseph Brummer and the collector Duncan Phillips, that the collection should be dissolved at all rather than being preserved in the form of a modern art museum.[37] Importantly, neither of these positions foregrounded the autonomy of the individual artist in the way that Rosenberg's and Duchamp's market interventions had done, even if they were still concerned with the relative valuation of individual artists. Nor did they, entirely, prioritize Quinn's autonomy. Whereas these reactions to the impending auction appeared ostensibly to be homilies to Quinn's capabilities of discernment, in an important way they

extended beyond the subjective dimension of the collector's taste. As the public aspect of the debate necessarily implied a question of the public as such, the cultural meaning of the subjectively assembled collection began to be transformed from a representation of the individual collector's excellent taste to a body of works that possessed an internal logic, which in turn suggested the parameters of a new field of art and a new set of institutional protocols. Thus, what could be called in the most vulgarly materialist terms the evidence of Quinn's aesthetic consumption now found as its legacy a larger question of aesthetic reception. What could be preserved by preventing the collection's dissolution was the fashioning of a representative body of modernism, as well as an ideological justification of its inclusions and exclusions, its method of organization, and its new orientation to the public. In the moment of its translation from the realm of private property and taste to the possibility of its social and public authorization, the private collection began to become imagined as a particular kind of institution—a provisional institution—representing and providing social meaning for the cultural capital that modernism could now claim. At the same time, the individual sensibility that marked the assembly of the personal collection presented itself as a sign that could be directed against the hegemony of official institutions such as the academy or the public museum.[38]

It would not require, by the 1920s, the intervention of Filippo Tommaso Marinetti to reveal the sense of crisis that surrounded the civic museum in the United States. Whereas Marinetti's "Futurist Manifesto" had in 1909 famously declared museums to be "cemeteries! [i]dentical, surely, in the sinister promiscuity of so many bodies unknown to each other," by the time of the Quinn auction, public discourse in the United States revolved around a similar problematic and availed itself of a comparable rhetoric.[39] As early as the mid-1910s, for example, Lee Simonson would complain in two *New Republic* articles about J. P. Morgan's relentless accumulation of objects for the Metropolitan Museum of Art in precisely this way:

> This practice of unending accumulation, which displays everything and reveals nothing, is the direct result of a policy of mere acquisition, seemingly the only policy our museums are able to conceive. . . . Private collecting, which is private hoarding, is a vagary. But public collections, which are only public hoarding, are a social blunder.[40]

> The few collectors who still insist on creating monuments to themselves in the form of miscellanies of art objects will erect wings to their private mausoleums

in which to expose them. Having failed to humanize art museums, they may suc-
ceed in humanizing the cemeteries.[41]

Situating the museum as a potentially necrophilic institution, Simonson of
course stopped short of Marinetti's call to "set fire to the library shelves!
Turn aside the canals and flood the museums!"[42] Instead, he left open the
possibility for a new kind of ownership that might reform, rather than
purge, the libraries and museums, and which might find its form in a new
mode of collecting.

Such a conclusion would be more difficult to draw if it were not the
case that the modernist collectors who were still active in 1927 actively
devised public institutional identities for their collections—and, with one
very qualified exception, pointedly avoided the term *museum* in doing so.[43]
A concern not only to represent modernist art publicly but also to use that
occasion to restructure the relationship of the work of art to its audience
was operative in all the significant American collections of the 1920s after
Quinn: Duncan Phillips's Memorial Gallery (founded 1918, opened 1921),
Katherine Dreier's Société Anonyme (1920), Albert Barnes's Barnes Foun-
dation (founded 1922, opened 1925), A. E. Gallatin's Living Gallery (1927).
This is something that could not have been said for Quinn, who did little
to make his collection visible even within the walls of his own apartment.[44]
Although in the early 1910s Quinn had expressed interest in establishing a
gallery for contemporary art, he grew increasingly reluctant to lend works
for exhibition and specifically opposed any notion of educating the public.
"Peripatetic exhibitions cheapen art," he wrote in 1924; "[a]rt, great art, the
great art of Matisse and Picasso is never for the mob, the herd, the great
PUBLIC."[45] In this sense, Quinn's practices affirm Rainey's thesis that mod-
ernism responded to the "transformation of the public sphere . . . with a
tactical retreat into a divided world of patronage, collecting, speculation,
and investment." Indeed, Quinn's predisposition toward private ownership
had been publicly evident at the 1923 sale of his library and manuscript col-
lection, where the auction catalog featured a quotation from Edmond de
Goncourt's will that declared, "these things of art which have been the joy
of my life . . . shall all be dispersed under the hammer of the Auctioneer,
so that the pleasure which the acquiring of each one of them has given me
shall be given again."[46]

The emergence of a newly socialized dimension of private collecting
can be discerned in the writing of the formerly working-class figure Albert

Barnes. In 1915, Barnes described the pleasure of buying art in terms that recall Quinn: "when the rabies or pursuit of quality in painting, and its enjoyment, gets into a man's system[, a]nd when he has surrounded himself with that quality, bought with his blood, he is a King."[47] Seven years later, however, the newly public identity of Barnes's collection, as well as his hopes for a radically democratized audience, was suggested in the Barnes Foundation's bylaws, which proclaimed "that it is the plain people, that is, men and women who gain their livelihood by daily toil in shops, factories, schools, stores and similar spaces, who shall have free access to the art gallery."[48] This new position does not mark a change in the *status* of ownership, but rather in its *orientation*, from a Baudrillardian "discourse addressed to oneself" to a form of ownership that is also a mode of communicative knowledge, endowing its works with collective social meaning and (appropriatively) summoning them to the purpose of cultural intervention.

From this perspective, we can perceive a homology between the public form of the modernist art collection and the modernist anthology, which each select a series of works to be included or excluded, create meaning out of their material association, and justify their collective meaning in prefatory apparatuses and critical writing. At the same time, the problematics of copyright and formal and material difference (anthologies may circulate, individual poems may be used to contradictory ends in different anthologies) also impose important and irreducible distinctions. We could observe generally that with the anthology the terms of ownership are inverted: it is the anthologist who expresses a form of symbolic ownership of the poems while the reader may be the owner of the collected work, participating in what Barbara Benedict has called "the private possession of culture."[49] And it is possible to see in the modern art collection a reciprocal desire to overcome its own material limitations. As Pamela Smart has observed in her excellent study of the Menil Collection, "Domenique de Menil . . . speaks of an alchemy by which we might all become collectors, albeit vicariously, rather than merely passive consumers."[50]

Whereas significant portions of Quinn's acquisitions are now significant portions of major American museums—the Philadelphia Museum of Art, the Albright-Knox Art Gallery, the Museum of Modern Art, the Metropolitan Museum of Art, the Cleveland Museum of Art, the Fogg Art Museum—Quinn's collection was initially dispersed among individual collectors largely because the relatively few American institutions that did exist in the mid-twenties were reluctant to invest in modernist work. Those private

collections that were still being assembled in 1927, however, would tend not to meet with the same fate as Quinn's. By midcentury, it would become customary for major American museums to acquire individual collections in their entirety.[51] This practice has had the effect of naturalizing the transition of a private collection, assembled according to the rubric of subjective choice, to its "final" residence in the public institution, which, as Walter Benjamin conceded, "may be less objectionable socially and more useful academically" than the hermetic form of private ownership exemplified by Quinn.[52] The extent to which such an institutional economy has come to determine the field of art consumption in America can be judged by the comparatively recent wooing of the Detroit art collector Lydia Kahn Winston Malbin, who insisted in 1986 that "[t]hey're going to have to wait until I'm dead to find out" who would gain control of her important collection of Italian futurist works.[53] When that event transpired, "they" discovered that Malbin had left the heart of her collection to the Metropolitan Museum of Art in New York, with 103 remaining pieces placed on auction at Sotheby's in May 1990.[54]

But as the debates around the Quinn auction demonstrate, the transmission of the private collection to its "final" residence in the public museum was not a destiny agreed upon in advance, even for some of the collectors (such as Dreier or Gallatin) whose pieces did end up in such institutions. What has often been taken to be a natural transition from private ownership to a public representation of modernist art obscures a field of struggle for cultural authority that must be understood as a signal dynamic of modernist culture in the United States. Indeed, at this point the meaning of the word "modernism" (itself not quite an anachronism in the literary field) was itself tellingly hazy. Its indeterminateness demonstrated its social availability, applying as it might to aesthetic objects or more broadly conceived ideologies, for appropriation within various institutional systems. Jean-Michel Rabaté has stressed that "[m]odernism remains a vaguer and more abstract notion that derives its impetus from the lumping together of all the 'isms' of a given period that [it] believes it discovers in the 'modern.' Like philosophy for Hegel, modernism as a concept always intervenes at the end of a process of creation or gestation; one could speak of the 'owl of modernism' along with the 'owl of Minerva' that takes its flight at dusk."[55] With this temporal view of field formation in mind, we might suggest that modernism's owl began its flight not at midcentury, as has been usually believed, but rather at this earlier moment of collecting. This is evident in

the different canons and ideologies that are proposed by the various col-
lections of art. But it is true in a related way of the anthology form, which
emerges in the 1910s as the genre *par excellence* of "all the isms" (futur-
ism, imagism, spectrism), composing a field that was received collectively
as modernist verse, as I show in chapter 1. And the anthology persisted
throughout the 1920s, as I show in chapter 4, as an instrument of future
reconfigurations and arguments about the aesthetic and social agency of
the modernist cultural project as such.

It is because of its increasing emphasis on social practice that the oc-
casional, coterie, or interventionist anthology endured, indeed flourished,
as a salient provisional institution. It had an agency distinct from, on the
one hand, that of the more expressly canon-defining modernist antholo-
gies such as those of Harriet Monroe and Alice Corbin Henderson (*The New
Poetry*, 1917) or Louis Untermeyer (beginning with *Modern American Poetry*,
1919), which augur the Norton and Longman institutions and make com-
paratively few claims upon the social.[56] And it differed, on the other hand,
from the institution of the little magazine, which played a decisive role in
the promotion of modernist art and literature, but which (like individual
exhibitions of art) played a comparatively weaker role in arguing for the
terms and meaning of its long-term reception. Whereas the distinctions
among these forms of literary collections are not absolute—the *Little Re-
view* would at times refer to itself as an anthology, and annual anthologies
such as Amy Lowell's *Some Imagist Poets* were subject to the rhythms of
serial publication—it was the unique capability of the interventionist an-
thology not merely to *identify* but perhaps more accurately to *interpellate*
collective formations in the service of the volume's social reason for being.
Such occasional anthologies, constructed under the appropriative curation
of an often controversial editor, are homologous, not identical, with the
art collections that competed for authority in the years leading up to and
following the Quinn auction. In order to demonstrate further this homol-
ogy and the primacy of the occasional anthology within this dynamic, we
will turn to an example apparently hostile to modernism: Edward Marsh's
Georgian Poetry.

In London in 1912 Edward Marsh, then private secretary to First Lord of
the Admiralty Winston Churchill, conceived of *Georgian Poetry* together
with his friend Rupert Brooke, who had been recently disappointed by the
poor sales of his first book of poems. For Marsh, the aim of the anthology

project was to redress a decline of public interest in contemporary poetry by employing the modern techniques of publicity that until that time had only been used in the promotion of novels.[57] The Georgian poets were primarily young and unknown English male writers whose work demonstrated an inclination toward bucolic themes, an apparently titillating sensibility, a somewhat relaxed approach to meter, and above all a valorization of ordinary speech.[58] While Brooke believed that the new volume should be the "herald of a revolutionary dawn" marking a break with the torpor of Victorianism, Marsh's preface made the more measured claim that these writings were gathered together "in the belief that English poetry is now once again putting on a new strength and beauty" and stressed that "we are at the beginning of another 'Georgian period' which may take rank in due time with the several great poetic ages of the past."[59] Marsh and Brooke were in agreement that their strategy should be to differentiate Marsh's selections from what Edmund Gosse would call the "exaggerated sonority" of Victorian poetics and from the still-popular historical anthologies of the Victorian period assembled by Francis Turner Palgrave and Arthur Quiller-Couch (whose *Oxford Book of Victorian Verse* was published simultaneously with Marsh's first anthology).[60] As Marsh's more careful language tacitly acknowledged, the Georgian intervention was at the same time very conservative in relation to the highly publicized activities of Marinetti, who in London that year had staged a sensational series of lectures on behalf of futurism, one of which Marsh had himself attended.[61] Whether or not Marsh was knowingly borrowing Marinetti's model of an interventionist anthology—the latter's *I poeti futuristi* also appeared in 1912—his gesture was one that clearly sought to reorient the established form of the traditional literary anthology to the perceived present crisis of readership.[62] The first words of Gosse's 1913 review nevertheless indicated the connection to the avantgarde: "This attractive volume is at once an anthology and a manifesto."[63]

When Marsh approached Harold Monro about the possibility of his Poetry Bookshop publishing the collection, Monro agreed only on the condition that Marsh would provide insurance against what he saw as the likely failure of the project. Any profits made would be split equally between Monro and Marsh, the latter dividing his portion among contributors as royalties. The Poetry Bookshop printed five hundred copies that were to be made available just before Christmas; priced cheaply at three shillings and six pence, they sold out before the holidays. *Georgian Poetry 1911-1912* went on to sell fifteen thousand copies, going through twelve printings in

just five years. The second *Georgian* volume sold nineteen thousand copies, leading to a run of five volumes in total, ending in 1922.[64] Marsh's success with the first edition allowed him quickly to distribute three pounds to each of the book's contributors; poets collected for the third volume received as much as eight guineas. Walter de la Mare guessed that the five poems he contributed to the first *Georgian Poetry* had brought him almost as much money as his first three single-authored volumes combined. The success of Marsh's collections, moreover, provided a model for publishers and editors that would significantly shape the field of poetry—from conventional verse to the avant-garde—for more than two decades. As Aaron Jaffe has critically observed, "[i]t was *Georgian Poetry* that first created the staging ground for replacing pretensions of comprehensiveness or completeness [i.e., the historical anthology] with pretensions of selectivity."[65] The year that the fifth and final Georgian volume appeared, by which time anthologization was seen as a liability by some poets, among the numerous poetry collections was Harcourt Brace's *American Poetry 1922*, a self-described "American companion" to *Georgian Poetry*.[66]

The very title "Georgian poetry" indicated both a connection between the poems and the political establishment and a desire to forge a historical continuity between the romanticism that flourished under George III and the present reign of George V ("another 'Georgian period'"). By 1917, Gosse could claim that *Georgian Poetry* had indeed been responsible for "a revival of public interest in the art of poetry," yet the series' unforeseen success soon prompted questions about poetic authority that Marsh could not have anticipated.[67] In a withering 1919 review of the fourth installment of *Georgian Poetry*, John Middleton Murry intimated the outlines of an obvious crisis for the poetic field, unintentionally produced by Marsh's success: "Before the 'boom' took place, the Poet Laureate was our single poetical institution, about which were grouped one or two Poets Laureate. After the 'boom' we observe a certain displacement in the heavens. 'Georgian Poetry' is a new fixed star . . . sufficient to outshine the old and familiar constellation."[68] Nor was Murry the first critic to have observed that *Georgian Poetry* had "displaced" the authority of the office of the Poet Laureate. The fact that the stratospheric success of the first Georgian volume had coincided with the death in 1913 of Alfred Austin, Tennyson's successor as Poet Laureate, had led a reviewer for the *Times Literary Supplement* to suggest that Marsh's project would establish a new form of authority in the place that

Tennyson's death had left vacant.[69] The *TLS* review registered the degree to which Austin's tenure was perceived to have been a failure, but Murry's revisiting of the connection in 1919, six years after the appointment of Austin's successor Robert Bridges, indicates how deeply the literary marketplace had become involved as an arbiter of literary value in the intervening years. Whereas Marsh's affiliation with political authority, as well as his conservative tastes, soon became all too reminiscent of an earlier model of aesthetic production and valuation, the example of his success as the editor of the Georgian volumes suggested a new range of possibilities for anthologists promoting more radical work. Just as the Peau de l'Ours collectors would in the very next year confirm the power of the marketplace to confer cultural value upon art beyond the systems of the Salon and the museum, the Georgian anthology appeared to promise a similar mode of cultural authorization for poetry, one based on its carefully managed commodification.[70] However unintentionally, *Georgian Poetry* had established the anthology form as a provisional institution that displaced older regimes of cultural valuation.

Very shortly after the publication of the first Georgian anthology, no less implicated a figure than Marsh's publisher Harold Monro issued the first installment of the journal *Poetry and Drama*, whose contents included a positive review of *Georgian Poetry*, an announcement for a forthcoming futurist number of the journal, and a notice about Ezra Pound's newly formed school of *imagisme*. Also in this first issue was an ambiguous obituary for Alfred Austin that Monro had written himself: "*We regret to have to record the death*, on June 2, of the Poet Laureate, Mr. Alfred Austin. The news having only reached us on the eve of going to press, we are unable in this number to attempt any estimate of his poetry. Born at Headingley, near Leeds, on May 30, 1835, Mr. Alfred Austin was appointed Laureate in 1896. With his death it is probable that the official post will be abolished" (my emphasis).[71] In a letter written to Brooke later that summer, Marsh described having to reprimand his publisher Monro for his willful outburst against the Laureateship, but he also portentously made note of the new literary development that Monro had briefly mentioned in the same issue of *Poetry and Drama*: "Wilfrid [Gibson] tells me there's a movement for a 'Post-Georgian' anthology, of the Pound-Flint-Hulme school, who don't like being out of G.P. but I don't think it will come off."[72] Although Marsh wished to deny it, these exchanges made manifest the new function of the anthology as a model for a new set of cultural hierarchies and relationships.

Hoping to participate in Marsh's success, the "Post-Georgian" anthology did "come off," in the form of Pound's *Des Imagistes,* which appeared in the following year, 1914. Monro himself would be the London publisher of the anthology, but the book also appeared in two forms that same year in the United States, first in the February 1914 issue of the *Glebe,* a New York magazine run by Alfred Kreymborg and Man Ray, and the following month in book form under the imprimatur of Albert and Charles Boni, who would be the publishers of Alain Locke's *New Negro* anthology a decade later. Although the anthology form would later become for Pound the almost typological sign of the conspiratorial dimensions of culture under capitalism, in 1912 (the year of the first *Georgian Poetry* volume) Pound expressed much more sanguinity about the market: "Did not the palaces of the Renaissance have an advertising value? . . . At any rate in these new [New York] buildings the mire of commerce has fostered the beautiful leaf. So commerce has, it would seem, its properties worthy of praise—apart from its utility."[73] Whereas Rainey has shown in Poundian imagism a rear-guard response to Marinetti's radical publicity experiments, one might make an equally strong case for Pound's wish, however fleeting, to use the example of Marsh's successful anthology as a means of confirming the value of modernist poetry in the marketplace.

While relatively widely reviewed, *Des Imagistes* proved to be a financial failure and a great disappointment to Pound. The commercial fortunes of his second foray into the field, 1915's *Catholic Anthology,* were even more disastrous. In the United States, however, the example of Pound's first anthology was galvanizing. As is well known, three subsequent anthologies compiled and promoted by the commercially savvy Amy Lowell brought imagism a financial success comparable to that which had been enjoyed by *Georgian Poetry.* That this success did not eclipse her anthologies' association with the public controversies of modernism can be judged by a disparaging comment made by the art collector Duncan Phillips—before his conversion to modernism—that connected Lowell's poetics with the paintings exhibited at the Armory Show: "[Matisse] is even more crude in his obviousness than is Miss Amy Lowell when she calls attention to her unrhymed cadences."[74] Lowell's anthologies helped produce a public consciousness of modernist poetry so great as to sustain an elaborate hoax perpetuated by the poets Arthur Davison Ficke and Witter Bynner, who in 1916 pseudonymously fabricated and promoted a rival anthology and school of "spectrist" verse that they notably offered as a literary equivalent to "Futurist Paint-

ing."[75] The Spectra hoax was so successful as to elicit subsequent publications of new work by the imaginary Emanuel Morgan and Anne Knish in Harriet Monroe's *Poetry* magazine and in the *Little Review*—not to mention an entire "spectrist" issue of Kreymborg's *Others*—before being exposed in 1918.[76] *Spectra* confirmed that the anthology form had quickly become the preeminent material expression and justification of a series of practices—including magazine publication, reviews, and public readings—that centered around the production, promotion, and self-definition of modern poetry, particularly as a collective formation (whether Georgian, imagist, futurist, or spectrist). Such practices, which had found their earliest articulation in Marsh's work on behalf of *Georgian Poetry*, had particular authority in a country that did not yet have a Poet Laureate.

But perhaps the most telling evidence of the new position of anthologies in the commercial and institutional field of modernism came a decade later in two texts jointly authored by Laura Riding and Robert Graves. The first of these, 1927's *Survey of Modernist Poetry*, is notable for having been the first attempt to associate the term *modernism* with a specific set of poetic principles, notably the proto-New Critical concepts of the commensurability of form with content and the self-sufficiency of the poetic object. Riding and Graves distinguished a properly ahistorical modernism from modernisms that made unwarranted reference to modern "civilization" or to history, and they also poured scorn on work whose claims of innovation were really merely those of a misguidedly faddish contemporaneity.[77] It was the latter tendency that they pointedly identified with what they called the "commercial advertising of poetry," of which imagism (a style by then fifteen years old) was for them the most notable avatar (RG 55). In this view, the wish to make poetry seem up-to-date was a betrayal of the larger imperative of the necessary ahistoricism of modernist poetry, and its imagist commodification served as the most damning sign of this historical capitulation.[78]

It was no coincidence, then, that the following year's companion volume should have been titled *A Pamphlet against Anthologies*. This was an even more combative text that decried the several forms of "trade anthologies"— or "commodit[ies] destined for instructional, narcotic, patriotic, religious, humorous and other household uses"—that they held to be exemplary of the ruinous commercialization of poetry and possessing a promiscuously collective form that violated the autonomy of the individual poem and poet (RG 165).[79] Here they strategically spared mention of the imagist and Georgian models until the very end, yet the force of their argument spoke

throughout to what had become the legacy of those anthology models. In Riding and Graves's view, the only truly legitimate anthology forms were the collection of fugitive verse and what they named the "non-professional, non-purposive collection." What they meant by the latter was something akin to a commonplace book, a self-made collection of personally chosen poems whose virtue "diminishes with the increase in the number of persons for whom it is made" (RG 163). As they went on to elaborate, "Even an honest private anthology loses most of its value when published as a public anthology. The poems included have become part of the anthologist and have lost their original context. This does not harm the anthologist, but it makes him a bar between the readers of the anthology and the poem, and thus prevents a direct introduction to the poem by the poet himself, who alone has the right to give it. [It is a] tyranny which no personality has a right to exercise over the reader" (RG 169). This judgment against such mediations has, not without reason, anticipated a number of recent studies of anthologies.[80] But Riding and Graves's valuing of the "honest private anthology" also reveals a meaningful affinity with the kind of private ownership and experience that had been exemplified by the art collector John Quinn (as, for example, in Quinn's citation of de Goncourt's will), but not by his more publicly oriented successors.

The authors' complaint about the transition from the "private anthology" to the "public anthology" obtained a more specific articulation in their contempt for editors who instrumentalized poetry toward any political or social end. They inveighed heavily against collections of patriotic poetry, a tradition to which *Georgian Poetry* had partly contributed (RG 211-12, 229).[81] But this was only the most obvious form of what they saw to be a far wider problem, and they offered as more pernicious examples Henry Harrison's recent *Sacco-Vanzetti Anthology* and Carl Sandburg's poem "Cool Tombs," the repeated anthologization of which they noted had helped launch an American movement to repatriate the corpse of Pocahontas. What the *Survey of Modernist Poetry* had attempted to preserve under the mantle of the "plain reader's rights" (RG 5-16) could in this context be saliently described as the individual poet's—or, better, the individual *poem's*—rights, rights that should not be subjected to any prior determination by a private-turned-public anthologist.

Yet such gatekeeping also tacitly confirmed that the true legacy of the imagist and Georgian experiments was to have made available a set of social

and institutional possibilities for literary collections that hewed paradoxically closely both to the models of the anthology "specializing in publics" (RG 167) and to the subjectively determined "private anthology"—collections that, in other words, served a particular set of social and aesthetic agendas while at the same time bearing the subjective mark of the anthologist. By the time Riding and Graves published their text, such anthologies were as likely to be collections of poetry by anarchist or socialist writers as they were to be patriotic collections. But in the United States, the most significant subfield of literary collections in this period was undoubtedly the African American anthology. Indeed, the anthology could reasonably be claimed as the preeminent black literary form of the twenties, enacting as it did a performance of collectivity and interpellation, political demand and representation, and also, in some cases, canon formation. As Brent Hayes Edwards has stressed, however, the decisive characteristic of these anthologies was their role "not in confirming the canon, not in a backward-looking survey of the high points in a trajectory, but instead in founding and enabling the very tradition [they document], 'at the beginning rather than the end of literary history making.'"[82] And in this, such texts must be seen as a necessary extension of the field of modernist-interventionist anthologies. Indeed, it was precisely this social potential of the anthology form, when translated into the field of black letters, that Ishmael Reed represented in his own Harlem Renaissance-themed novel *Mumbo Jumbo* (1972), where the revolutionary energies of "Jes Grew" assume their material form as an anthology circulating throughout New York City: "some sort of anthology that will upset the nation," as Woodrow Wilson Jefferson surmises.[83]

The most influential of these collections was Alain Locke's *New Negro* anthology of 1925. Riding and Graves notably fail to mention *The New Negro*— or any other black anthology—by name. Yet they do betray a knowledge of the field, and likely the anthology itself, in their outrageous designation of Countee Cullen, the poet to whom Locke had given pride of place in his anthology, as a "white man's negro, a burnt-cork minstrel." In concluding that "modern negro poetry so labelled [sic] is only inferior white poetry," they intimated that any specifically racial referent in a modern poem should be viewed as one more invocation of the contemporary "civilization" that disqualified it as true "modernist" poetry (RG 230). And because the anthology was such a central form for 1920s black literary production, Riding and Graves's argument extended logically from the poetry itself to the mode of

its collective representation and circulation. Thus, Edwards's assertion that "the anthology is a means more broadly to grapple with *modernity* itself" is confirmed by the negative example of Riding and Graves's attempt to claim, first, a modernism with no necessary relationship to modernity and, second, a world where there could be no legitimate social function for the anthology form.

The interrelation of these proscriptions grows still clearer when we recognize that the poets most valorized in the *Survey of Modernist Poetry*—E. E. Cummings, Gertrude Stein, and Riding herself—were modernists whose styles would be least assimilable within a concept of a "collecting aesthetic." While Riding and Graves acknowledged that the work of assembling an anthology closely "resembles creation," they did not recognize such work to be a salutary model of modernist intertextuality (RG 169). And while they suggested that the integrity of the anthology form implied the corresponding construction of a "composite author," the modernist intersubjectivity that such a form of authorship represented was construed to be a threat to the purity of an eternal and individualist modernism (RG 186). The forms of textual sociability, referentiality, and collectivity that they worked to exile, in other words, were themselves the language of the modernist collection, and this was exactly the modernism against which Riding and Graves directed their own collective labors.

In both practice and theory, Riding and Graves prefigured the protocols of close reading that became the cornerstone of literary study in later decades (and in this light *A Survey of Modernist Poetry* contains readings that still merit revisiting). Their work also marks an early stage in what became the dominant definition of modernist autonomy. This definition, ironically set forth in a joint-authored text, exiled collective expression as a legitimate category of aesthetic production or representation. As the argument extended into the *Pamphlet against Anthologies*, it categorically excluded African American writing according to the same terms that it had disqualified contemporary reference in poetic language, and thus negatively conjoined ethnic identity with modernity itself—a connection that was also central, as I will argue, to Bynner and Ficke's satirical *Spectra* anthology. The effort to delegitimate anthologization as a cultural practice, finally, proved to be a means of denigrating the collection as an aesthetic form. In this sense, the *Pamphlet* was much more than an idiosyncratic and particularized invective against the commodification of poesy. Its argument against anthologies was constitutive of a larger argument about modernism and thus participated,

albeit from a slightly different position, in the same contest for institutional authority that had been engaged by modernist anthologies themselves.

Riding and Graves's critical interventions had been in part impelled by the congruity between what I have been calling a collecting aesthetic and an emergent formation of modernism. As this suggests, the forms and practices broadly at issue extended beyond the Anglo-American poetic field that Riding and Graves had addressed. A decade later, the same congruity between modernist form and the collection would inform another well-known critique of modernism, that of György Lukács in the seminal essay "Realism in the Balance" (1938). Here Lukács made no distinction between Riding and Graves's dehistoricized "true" modernism and the "false" modernism that they had attacked; rather, he issued a categorical condemnation of aesthetic modernism as such, whose embrace of fragmentation and obscurity betrayed a credulous acceptance, in Lukács's view, of the alienation of modern life under capitalism. For Lukács, modernism could be negatively characterized by the way it willingly surrendered the obligation to represent "the overall objective social context and [flouted] the 'insistence on all-round knowledge' required to do it justice."[84] Because this is evidently such a different set of concerns from those that motivated Riding and Graves, it is all the more remarkable to discover that the conclusion of his essay caustically derides numerous apparently distinct forms of collecting, which are presented as so many modes of false consciousness—or as so many figures for modernism itself. These include "any swank who collects stained glass or negro sculpture," anyone who "collect[s] old folk products indiscriminately," the avatars of "an artiness which artificially collects and aestheticizes about the primitive," the modernists who "regard the history of the people as a great jumble sale . . . a heap of lifeless objects in which one can rummage around at will, picking out whatever one happens to need at the moment," and, finally, the intellectuals who would reduce the classics "to an anthology and then to reassemble whatever 'material is suitable.' "[85]

Lukács objects to the appropriative violence and bourgeois privilege that is implicit in these acts of collecting, but his deeper objection is epistemological. In Lukács's view, the collection is both emblem and instrument of modernism's cavalier refusal to attempt to envision society, or history, in its totality. Replacing this kind of comprehensive vision with a more metonymic one, modernism (here represented by the collecting aesthetic of

cinematic montage) "abandon[s] any attempt to mirror objective reality, [and] give[s] up the artistic struggle to shape the highly complex mediations in all their unity and diversity and to synthesize them as characters in a work of literature."[86] Whereas Riding and Graves struggle ferociously against the possibility that the collection might be a figure for "true" modernism, Lukács takes the identity of modernism with the collection (including, explicitly, the anthology) as a precondition of his argument in order to inveigh against the fragmentary knowledge that these forms produce.

It was precisely from the context of the Lukácsian concept of reification and its "complex mediations" that Fredric Jameson, in *The Political Unconscious*, worked to recuperate a heroic capability for literary modernism. Like Raymond Williams, Jameson argues against the necessity of "affirm[ing] the identity" of social relations and aesthetic form. "[O]ur aim," he stresses, "is rather to demonstrate the ways in which modernism—far from being a mere reflection of the reification of late nineteenth-century social life—is also a revolt against that reification and a symbolic act which involves a whole Utopian compensation for increasing dehumanization on the level of daily life."[87] As is true for Lukács, Jameson views the abstraction that defines modernist aesthetics as corresponding to the abstraction of social life under capitalism—"a historically new experience"—but as is untrue for his predecessor, the fragmentary character of those aesthetics also provides compensation for what has been lost in reality. And most notably for our purposes, Jameson also offers as a privileged example of that compensation the character of Stein in Conrad's *Lord Jim*, a revolutionary-turned-capitalist who "becomes a butterfly collector, that is to say, essentially a collector of images. [He gathers] fragments of a quantified world [now] libidinally transcoded and Utopianly transfigured."[88]

For Jameson, this act of aesthetic compensation, here figured both by Conrad's impressionistic style and (allegorically) by the very act of collecting, must necessarily remain in the realm of the imaginary. But his revision of the Lukácsian position is worth briefly remarking because of its affinities with the still more heroic role that Walter Benjamin would reserve for the collector in his later writings. Indeed, it is tempting to speculate whether Lukács had meant indirectly to attack Benjamin, whose essays "Unpacking My Library" (1931) and "Eduard Fuchs: Collector and Historian" (1937) had already appeared in Germany by the time "Realism in the Balance" was published. In the first of these essays, Benjamin had proposed that it is only in private collections that "the objects get their due," but in his drafts for the

Arcades Project, Benjamin was ready to make a larger and more categorical set of claims on behalf of the form of the collection: "What is decisive in collecting is that the object is detached from all its original functions in order to enter into the closest conceivable relation to things of the same kind. . . . It is a grand attempt to overcome the wholly irrational character of the object's mere presence at hand through its integration into a new, expressly devised historical system: the collection. . . . We construct here an alarm clock that rouses the kitsch of the previous century to 'assembly.' "[89] In this late formulation, the Benjaminian collection provides a form of "Utopian compensation" against the loss of real historical knowledge in an increasingly "irrational" world, but as is untrue of Jameson's allegorical example, it also expressly gestures toward the possibility of its one day becoming a mode of transformative practice.[90]

It is tempting to find in Benjamin's redemptive private ownership a master theory for the modernist collection as such. But for our purposes, it will be more useful to read his work as part of a more general structure of feeling that found a particular articulation, as well as a set of institutional possibilities probably unimagined by Benjamin, in the United States. If, as Paul Holdengräber has proposed, the collection constitutes "the master-trope of Benjamin's work" as a whole, that claim can be enriched as we understand the collection to be, more generally, one of the "master-tropes" of modernist culture.[91] Benjamin's account valorizes the role of the collector's subjectivity—a source of antipathy for Lukács as it is for Riding and Graves—and he also makes visible the importance of comprehending collecting as a mode of *practice* as well as an aesthetic (or historical) form. But what does not appear in Benjamin's writing is the possibility of the collection obtaining, as it did for the figures to be studied here, the instrumental agency of a provisional institution.

To figure the collection as a provisional institution is no doubt to sacrifice, in some measure, the revolutionary or Utopian character of which Benjamin dreamed. Yet as James Clifford has insisted, we must see in the phenomenon of collecting "both a form of Western subjectivity and a changing set of powerful institutional practices."[92] Following Clifford, we can claim that in the interwar period a particular sense of the social agency of art—a sense rooted in Clifford's collecting subjectivity—emerged to contest, in Benjamin's words, the "wholly irrational character of the object's mere presence at hand" within the dominant institutional structure and to propose new modes of the object's integration. The private collection offered itself

as a powerful instrument of cultural intervention, available to a wide variety of aesthetic and social interests, because of the momentarily indefinite institutional situation in the United States of the early twentieth century. It was because of this unusual situation that the Quinn auction could have elicited such impassioned and far-reaching responses, that *Des Imagistes* could have a much stronger influence and longer life than it had in England, and, more generally, that a heretofore hermetic form of acquisition and possession could be invested with such transformative potential. To study the conflicted field of collections that emerged in response to those opportunities is to grasp again the other destinations that once seemed possible for the modernist project.

1 After *Imagisme*

The Lyric Year and the Crisis in Cultural Valuation

By the time Ezra Pound's anthology *Des Imagistes* appeared in London, it had already circulated in New York in two forms. It was published as the February 1914 issue of Alfred Kreymborg and Man Ray's journal the *Glebe*, and in early March the same sheets were bound as a book appearing under the imprint of Albert and Charles Boni, the same publishers who would later publish Alain Locke's *New Negro* anthology. In April, it was released in London under the imprimatur of Harold Monro's Poetry Bookshop, which had published Edward Marsh's wildly successful *Georgian Poetry* anthology sixteen months earlier. Very unsuccessful in the country where Pound had mostly lived since 1908, *Des Imagistes* would be far more influential in the United States both in the example it set for free verse and for the cultural function that could subsequently be claimed for the anthology form. Despite its commercial failure, *Des Imagistes* established a standard for the circulation and the writing of modern American poetry. It also proved to be a salutary example for future anthologists to react against. For its part, Pound's collection had both emulated and implicitly attacked two recent anthologies that had been very successful in London: F. T. Marinetti and Paolo Buzzi's avant-garde *I poeti futuristi* and the conservative *Georgian Poetry*. But if these books were Pound's points of reference for assembling and promoting imagism, it was a different anthology—Ferdinand Earle's *The Lyric Year*—that conditioned its reception in the United States. The shortsightedness of *The Lyric Year*, as well as the controversy it elicited, revealed a new set of possibilities and desires for the social role of poetry in America, and it was to these desires that the more limited and tendentious example of *Des Imagistes* seemed to speak.

The Lyric Year was an early example of a "prize anthology." It comprised one hundred poems by American poets, ordered alphabetically by name and chosen from, Earle claimed, ten thousand submissions. One thousand dollars in prize money was divided among the authors of the three best poems, as chosen by a jury composed of Earle, Edward J. Wheeler, and William Stanley Braithwaite. Published at the end of 1912, the same year as the futurist and Georgian collections, Earle's *Lyric Year* was promoted as an innovative, forward-looking text. Its publisher, Mitchell Kennerley—who would soon publish D. H. Lawrence's *Sons and Lovers*—had already established himself as a publisher of socially and sexually progressive books.[1] A decade later Kreymborg would remember him as "the white hope among publishers [of poetry]."[2] In the year preceding its release, Kennerley vigorously promoted the project; it received three separate advance notices in the *Dial* alone, where it was called, without irony, "an extremely interesting experiment in poetical encouragement."[3]

Kennerley's belief in the project, as evidenced by his energetic promotional work, was rewarded in the very short term, as the book was widely reviewed and went through two printings in its first year.[4] Yet despite this apparent success, Kennerley soon abandoned his plans to make *The Lyric Year* an annual competition and anthology. This change of heart came in response to an unforeseen public outcry against the jury's award selections. While the first prize had gone to Orrick Johns for his social protest poem "Second Avenue," popular sentiment declaimed loudly in favor of "Renascence" by the nineteen-year-old Edna St. Vincent Millay, a poem chosen for *The Lyric Year* but accorded no special recognition. The controversy, which occupied the popular press for weeks, launched Millay's career and, some have claimed, the career of modern poetry in the United States. As early as 1925, Kreymborg could perceive that the "Renascence" scandal had publicly signaled the coming obsolescence of an older regime of cultural valuation. But although the episode would in retrospect resemble the later contests for legitimation characteristic of modernism's cultural economy (the phenomenon of the legitimating scandal), Millay's poem did not become a cultural fault line in the sense that Duchamp's *Nude Descending a Staircase* would the following year at the Armory Show, or as imagist poetry would, slightly less sensationally, shortly thereafter. The near-unanimous support for "Renascence" within the public sphere indicates that a different cultural economy was still operative at the moment of Earle's anthology.

Indeed, *both* of the poems at the center of the *Lyric Year* controversy will likely seem conventional in comparison with *Des Imagistes* and the explosion of free verse that followed after it (irrespective of the quality of the work). Both "Second Avenue" and "Renascence" were composed in rhymed iambic tetrameter, and the sexually emancipated themes for which Millay would be famous were barely yet in evidence.[5] The debate about Johns and Millay consisted in their respective relationships to traditional form, rather than more polemical questions of destroying convention. Against Johns's rigid prosody, Millay's meter was looser and more varied. Similarly, the sentiment of Johns's paean to the Lower East Side ghetto was understood as hackneyed and conventional in comparison to Millay's audacious visionary poem, which imagines its speaker's death, burial, and rebirth:

> I screamed, and—lo!—Infinity
> Came down and settled over me;
> Forced back my scream into my chest,
> Bent back my arm upon my breast,
>
>
>
> I saw and heard, and knew at last
> The How and Why of all things, past,
> And present, and forevermore.
>
>
>
> Deep in the earth I rested now;
> Cool its hand upon the brow
> And soft its breast beneath the head
> Of one who is so gladly dead.
> And all at once, and over all
> The pitying rain began to fall;
>
>
>
> O God, I cried, give me new birth
> And put me back upon the earth!
> Upset each cloud's gigantic gourd
> And let the heavy rain, down-poured
> In one big torrent, set me free,
> Washing my grave away from me!
>
>
>
> And as I looked a quickening gust
> Of wind blew up to me and thrust

Into my face a miracle
Of orchard-breath, and with the smell,—
I know not how such things can be!—
I breathed my soul back into me.[6]

Johns himself acknowledged the superiority of Millay's poem, which further suggests that the emergent controversy did not concern rival schools of poetry so much as it did the ability of cultural authorities to recognize and adjudicate literary quality across a national cultural field.[7] Writing in just the fourth issue of the journal *Poetry* (which had itself been founded in 1912), Harriet Monroe complained that the prizes "must have been measured by some academic foot-rule dug up from the eighteenth century." As opposed to "Second Avenue," which Monroe found to be "a *Gray's Elegy* essay of prosy moralizing, without a finely poetic line in it, or any originality of meaning or cadence," Millay's poem "outrank[ed] the rest and ennoble[d] the book." It was the "daring flight of a wide-winged imagination, and the art of it, though not faultless, is strong enough to carry us through keen emotions of joy and agony to a climax of spiritual serenity."[8]

What Kennerley and Earle had intended as an innovative use of the anthology form was all too easily construed as an avatar of the old guard. Even the sympathetic review in the then-staid *Dial* betrayed the project's belatedness. After praising the "experimental" quality of the project, the review tellingly went on to remark that "[a] particularly gratifying feature of th[e] exhibit is found in the fact that it includes so many of our best-known names."[9] What had seemed to the *Dial* editor a reassuring ratification of American masters, however, was more widely viewed as a sign of a crisis of national cultural institutions: even an experimental project such as *The Lyric Year* ended up reifying the tendencies of academic verse.

The sense of frustration with *The Lyric Year* was such that William Carlos Williams, who had been bitterly disappointed by his own exclusion from Earle's collection, would write a poem titled, after Keats, "On First Opening *The Lyric Year*." Monroe printed it among the letters in the June 1913 issue of *Poetry*:

It is a certain satisfaction to overlook a cemetery,
All the little two-yard-long mounds that vary
So negligibly after all. I mean it brings on a mood
Of clear proportions. I remember once how I stood
Thinking, one summer's day, how good it must be to spend

Some thousand years there from beginning to the end,
There on the cool hillside. But with that feeling grew the dread
That I too would have to be like all the other dead.
That unpleasant sense which one has when one smothers,
Unhappy to leave so much behind merely to resemble others.
It's good no doubt to lie socially well ordered when one has so long to lie,
But for myself somehow this does not satisfy.[10]

Williams's rhymed, loosely metered poem was an unusually (and perhaps unintentionally) rich commentary both on the prize controversy and on the larger problem of the anthology itself. Improvising on the burial device of Millay's "Renascence," Williams obliquely suggests the impossibility of a poem's (and poet's) transcending the anthology form. For Williams, the anthology is both a homogenizing medium—it prizes poems that "vary . . . negligibly" in the interests of being "socially well ordered"—and an ossifying one, a place to bury dead poems. In Williams's account there is no rebirth for poet or poem.

The governing metaphor of the anthology as cemetery also recalled the language of Marinetti's futurist manifesto of 1909: "Museums, cemeteries! Truly identical in their sinister juxtaposition of bodies that do not know each other."[11] Like Marinetti, and anticipating Lee Simonson's excoriation of the Met in the *New Republic*, Williams implicated official culture in the death of art. Yet Williams's invective does not concern the failure to reward Millay so much as it commemorates Earle's rejection of the poem Williams submitted to the contest: the graveyard in his poem is also a memorial of his desire for an older form of cultural legitimation. Although "On First Opening *The Lyric Year*" appeared to attack the anthology form as such, Williams was nevertheless happy to allow Pound to include his poem "Postlude" in *Des Imagistes* soon thereafter. Pound's was an anthology, moreover, that counted among its sources a poetic cemetery—the classical fragmentary epitaphs collected together as the *Greek Anthology*.[12] But in bringing its contents together under the interventionist rubric of *imagisme* (however dubiously, in the case of some poems), *Des Imagistes* also created a forum in which the poems might, to adapt Marinetti's phrase, "know each other." For what Earle had failed to do, and what Pound subsequently learned from both Marinetti and Marsh, was to make the anthology an occasion and means of summoning poets imaginatively to the purpose of intervention.[13]

Des Imagistes, moreover, would have cultural legitimacy because, not in spite, of the editor's involvement with the poems he collected. Harriet Monroe's critique of *The Lyric Year* had obtained a particularly incisive edge because of the article that had immediately preceded it in the January 1913 *Poetry*: Pound's "Status Rerum." Pound's London letter had the explicit function of advertising his—and, by extension, *Poetry's*—proximity to the London scene. And it was no coincidence that the piece culminated in Pound's second public reference to *imagisme*: "The youngest school here that has the nerve to call itself a school is that of the *Imagistes*. To belong to a school does not in the least mean that one writes poetry to a theory. One writes poetry when, where, because, and as one feels like writing it. A school exists when two or three young men agree, more or less, to call certain things good; when they prefer such of their verses as have certain qualities to such of their verses as do not have them."[14] This well-known passage has been read as an index of Pound's desire to distance himself from Marinetti's avant-gardism in London.[15] But in the country in which "Status Rerum" was published (fresh off the failure of Earle's competition and survey), *imagisme* circulated with the currency of an avant-garde movement. For Pound the culmination of the "school's" productivity would come in the form of an anthology, a text that could affirm (or appear to affirm) a set of shared principles, if not precisely a collective identity. That the anthology would be the ultimate destination and medium for *imagisme* was signaled by the fact that what in turn preceded "Status Rerum" in the January 1913 *Poetry* was the first appearance in print of H. D.'s poems, under the title "Verses, Translations, and Reflections from 'The Anthology.'" Acknowledging, and advertising, H. D.'s ancient sources in the *Greek Anthology*, the title also anticipated her poems' subsequent publication in *Des Imagistes*.

If the aim of that austere sixty-page anthology was to represent the *imagistes* collectively as a "school," it also clearly exhibited Pound's editorial control, as he divided pages unevenly among the poets, whom he also declined to order alphabetically. The volume seemed rather to stage simultaneously the orderly continuity of *imagisme* with its archaic sources as well as its decisive modernity as a metropolitan poetic school.[16] The volume begins by devoting roughly half of its total pages to the two poets most invested in the Greek material, H. D. and Richard Aldington. Five poems by F. S. Flint then extend the imagist aesthetic into the context of modern London. After single poems by Skipwith Cannéll and Amy Lowell, Williams's Greek-

inflected "Postlude" immediately precedes Pound's selections, the first two exploring classical themes, the remainder borrowing from Chinese sources. This second ancient context (itself made available via the ancient anthologies of Confucius and Qu Yuan) was an influence for not only Pound but also Allen Upward, whose "Scented Leaves from a Chinese Jar" followed Pound's poems in the anthology.[17] That Pound imagined this activity specifically as a form of *collecting* may be judged by the essay "Patria Mia" (published serially between 1912 and 1913), where Pound wrote, "when the fire of the old learning began to run subtly from one end of Italy to the other, certain rich collectors sent out their agents through Greece and through all the East to gather what fragments they might of the ancient beauty. I honor a similar habit in our American collectors."[18]

The balance of Greek and Chinese sources, for this very reason, also pointed to *imagisme*'s roots at the heart of the modern British Empire. It was this imperial context that permitted Pound also to forge a cosmopolitan identity for the movement. Unlike Marsh's or Marinetti's anthologies, *Des Imagistes* could claim an international group of writers, who furthermore were not segregated by nationality in the volume; the final piece in the anthology was the Polish modernist Kazimierz Przerwa-Tetmajer's "The Rose," a prose poem translated by the Russian-American Cournos. The way it echoed the last of Upward's "Leaves" in mode and subject both bespoke Pound's curatorial sensibility and provided a stronger continuity among the contributors than could have been claimed on the basis of their actual interaction.

Des Imagistes did more than claim a space in the literary field for free verse; it also established the semi-cooperative "school" or "movement," hitherto more strongly associated with French poetry, as the dominant cultural logic governing the circulation of new poetry in the United States. That it did so irrespective of the degree to which its contributors identified collectively pointed to the creative, and appropriative, labor of Pound as a collector.[19] The field of modernist anthologies that exploded in the United States in the decade following *Des Imagistes* subjected Pound's example to a complex set of identifications and disavowals. This was especially true for the two principal anthologists who followed in his wake: Amy Lowell and Alfred Kreymborg. For both Lowell and Kreymborg it would be vital to establish their anthologies as self-determined and self-determining, in precise opposition to the paternalism that had been advertised in Earle and Kennerley's scheme. But it would also be necessary to avoid the appearance of

manipulation and instrumentalization that would soon be associated with Pound's activities. Such efforts would eventually become complicated, or even contradicted, by the very nature of the anthology form. But, despite these complications, Lowell and Kreymborg each found in the *imagiste* anthology a new cultural strategy adaptable to their own collective free verse projects, one that succeeded in breaking from the older modes of legitimation that had been all too evident in *The Lyric Year*.

To understand more broadly the transformation of the anthology form in the wake of *Des Imagistes*, and its place in a wider cultural field of collections in the United States, it will be helpful to consider the complex trajectory of a telling and recurring metaphor. In his preface to *The Lyric Year*, Earle had proposed that his national project participated in a cultural economy that resembled the world of the fine arts: "If the usual volume of verse by a single author may be termed *a one man's show*, if poems appearing in the magazines may be compared to paintings *handled by dealers*, if time-honored anthologies may be called poetical *museums*, The Lyric Year aspires to the position of an *Annual Exhibition* or *Salon* of American poetry, for it presents a selection from one year's work of a hundred American poets" (Earle's emphasis).[20] Earle was here specifically referring to Pittsburgh's broadly inclusive annual Carnegie International exhibition, using the prestigious event as a rhetorical figure for his anthology. Comprehending the reference, Harriet Monroe's attack on *The Lyric Year* asserted that its judges had been insufficiently qualified and too distant from the center of the literary scene to evaluate submissions with authority. She stressed that the "jury of awards, are not, even though all have written verse, poets of recognized distinction in the sense that [the judges of the Carnegie International] are distinguished painters."[21] Written a year before the Armory Show, Monroe's complaint was untroubled by the Carnegie's unresponsiveness to postimpressionism, and it did not specifically indict Earle's unresponsiveness to free verse. But it did implicitly claim the authority of Monroe's collaborator Pound, a "distinguished" poet who was then compiling his own more limited, school-defining anthology.

A decade later—following the proliferation of often factional anthologies that were to come after *Des Imagistes*—a pointedly unsigned programmatic foreword to the serial anthology *American Poetry 1922* would refigure this same conceit of poems as paintings according to the by-then-established conventions of modernism:

The poets who appear here have come together by mutual accord and . . . each one stands (as all newcomers must stand) as the exponent of fresh and strikingly diverse qualities in our native poetry. It is as if a dozen unacademic painters, separated by temperament and distance, were to arrange to have an exhibition every two years of their latest work. . . . Their gallery would necessarily be limited; but it would be flexible enough to admit, with every fresh exhibit, three or four new members. . . . The newcomers . . . have taken their places with the same absence of judge or jury that marks any "society of independents." There is no hanging committee; no organizer of "position." Two years ago the alphabet determined the arrangement; this time seniority has been the sole arbiter of precedence. Furthermore—and this cannot be too often repeated—there has been no editor. To be painstakingly precise, each contributor has been his own editor. As such, he has chosen his own selections and determined the order in which they are to be printed, but he has had no authority over either the choice or grouping of his fellow exhibitors' contributions.[22]

Separated by a decade, the prefaces illustrate the cultural positions that were available, and desirable, both before and after the seminal events of the Armory Show (1913) and *Des Imagistes* (1914). Attesting as they do to the abiding concern of occasional anthologists to justify their work according to the culturally legitimated terms of art exhibition, the prefaces are as instructive for their continuities as they are for their differences.

As Monroe recognized, Earle had invoked the universalizing principles that governed Pittsburgh's annual Carnegie International. The preface of *American Poetry 1922*, by contrast, would refer unmistakably to the motto of the first Society of Independent Artists exhibition (1917): "No Jury—No Prizes."[23] Here the strategy appeared to advance the field of modern "unacademic" poetry as both democratic and autonomizing, free of the need for the authentication of Earle's prize committee. But although the 1922 anthology in one way advertised its modernist bona fides, in another way it represented a temporary retrenchment against the more interventionist mode of the form that Pound had introduced to the United States, and which we will soon examine in more detail. Despite its rhetoric, this anthology did not introduce "newcomers" so much as it brought together poets who had in many cases made their names in the context of the factional anthologies of the previous decade: Millay, H. D., Conrad Aiken, John Gould Fletcher—even Lowell and Kreymborg themselves. Its very title, moreover, indicated a desire to reassert the broad view of a national poetry, just as Earle had

wished to do a decade before. *American Poetry 1922* therefore belongs more
nearly to a group of texts that attempted to neutralize the interventionist
mode of the anthology and to recapture the form for official culture: these
are collections I will call "reprisal anthologies."

What is finally noteworthy about the gestures of both prefaces to the fine
arts world is how they figure the anthology not as a *collection*, but rather as
a *group exhibition*. While this metaphor tellingly construes the anthologies
as ephemeral, not permanent, documents, it is equally important to observe
the way they each deny the agency of the editor as *collector*—an agency as
yet unimagined at the moment of *The Lyric Year*, but stridently disavowed,
or repressed, for the occasion of *American Poetry 1922*. The intention of such
a disavowal in the latter case was to use the collective form of the anthology
paradoxically to autonomize the individual poets that the collection repre-
sented, and to overcome the mode Riding and Graves would denounce as
the "anthology specializing in publics." As a result of this strategy, the status
of the literary collection as an aesthetic object in its own right, as well as the
anthology as a form of cultural intervention, was strongly diminished. This
was in all likelihood a reaction against the strong hand that Pound had taken
in *Des Imagistes*, and against the example such a strategy had provided for the
promotion and circulation of modern poetry.

Despite their complicated relationships to Pound, the more factional ex-
amples that immediately followed *Des Imagistes* each embraced the social
and aesthetic potential inherent in the form as a collection. Kreymborg and
Lowell would find themselves engaged in difficult negotiations to define
their respective free verse projects while protecting the autonomy of their
respective authors. Yet during these same years, the notion of the anthol-
ogy as a communitarian text persisted more unambiguously elsewhere.
One of the greatest poetic successes of these years was Edgar Lee Masters's
Spoon River Anthology (1915), which was not a collection of disparate poets,
but rather a "novel in free verse" composed of a series of poetic "epitaphs"
that together described a semi-fictitious small town in Illinois. Originally
published in *Reedy's Mirror*, Masters's poems, like H. D.'s, explicitly bor-
rowed their form from the fragmentary epitaphs that had been collected
in the *Greek Anthology*.[24] This was no doubt one reason Pound responded
so strongly when he first discovered Masters's writing in 1914. The over-
whelming success of the volume helped drive the explosion of *vers libre* in
the United States for the rest of the decade. But the popularity of *Spoon
River* was not simply a matter of poetic form; it also derived from Masters's

conception of how the anthology form could be employed as a social, as well as poetic, mode of representation (Zora Neale Hurston would adopt the conceit for her "Eatonville Anthology," which appeared in the *Messenger* in 1926). Moreover, it situated the anthology literally as an *authored* text, something that had been implicit in *Des Imagistes* and would find fuller expression in the next decade, even as it required strategic disavowal in the short term.

The Anthology as Weapon

Among the anthologies that appeared to disavow the strategies and implications of *Des Imagistes* was Pound's own *Catholic Anthology 1914-1915*. Published in London by Elkin Mathews in November 1915, this collection of mostly American poets was issued without any of the notice Pound had directly and indirectly issued to prepare the public reception of his first anthology. Its periodizing date suggested a serial publication more akin to Marsh's *Georgian Poetry* volumes, and its title appeared to abjure any particular aesthetic affiliation. Writing to Harriet Monroe as he was beginning the project, Pound indicated his desire to position himself more as an arbiter than a participant in the field of the new poetry: "I should not call it an Imagist anthology, but should select from the newer schools,—stuff on modern subjects, mostly *vers libre*."[25] His deviations from the model of *Des Imagistes* were not entirely freely chosen, however; they were also positions that Pound believed necessary for containing the success of a new institution, Amy Lowell's *Some Imagist Poets*.

The story of the transition from the Poundian phase of imagism to its more expansive and commercially successful articulation under Amy Lowell has been told many times, issuing first from Hugh Kenner's phallocratic, canon-defining account and more recently receiving reappraisal in accounts that have worked to restore Lowell's place in the history of American modernism.[26] This story has many familiar touchstones: the commercial failure of *Des Imagistes* in London; Pound's break from the rest of the "*imagiste*" group and commitment to the more dynamic "vorticism"; the courting and galvanizing of alienated *imagistes* (H. D., Richard Aldington, F. S. Flint) by the aristocratic and well-connected Lowell; Lowell's successful popularization of the now Anglicized (or Americanized) "imagism," which between 1915 and 1917 circulated in a series of annual anthologies selected and arranged democratically by its contributors; Pound's subsequent denunciation of the ensuing work as "Amygism"; and T. S. Eliot's designation of Lowell as the

"demon saleswoman." Once knowingly proffered in modernist criticism as a sign of the commercial desecration of the sanctity of art, this story reads differently in light of more recent, and more reflexive, studies of the literary marketplace.[27]

Until now, however, only James Longenbach has recognized Pound's *Catholic Anthology* as something other than a compromised text half-heartedly composed by Pound amidst more serious commitments in London (such as Wyndham Lewis's new journal *Blast*). No doubt the accepted reading has been encouraged by Pound's self-deprecating comments about the project in his letters to Joyce, and by his assessment twenty years later that the anthology was commissioned "for the sake of printing sixteen pages of Eliot."[28] But there are many good reasons not to take these proclamations at face value. Longenbach correctly notes the "extravagant" rhetoric that increasingly marked Pound's correspondence with Monroe about the project, letters written as the first *Some Imagist Poets* anthology was poised to extend dramatically the cultural reach of free verse in the United States.[29] And he underscores the importance for Pound of including Yeats's "The Scholars" as the anthology's preface, a gesture of approbation from "the greatest living poet" that Pound could use as a weapon against Lowell. All of this seemed necessary because "Pound felt that [both] his own reputation and the future of the arts rode on the *Catholic Anthology*."[30] In another decade, Pound would extend these large claims—"the future of the arts"—to still more ambitious anthology projects.[31] It is all the more surprising, then, to recognize the incoherence of the *Catholic Anthology*, a failing derived less from Pound's disinvestment than from his uncertainty about how to respond to Lowell's success. A brief glance at the collection will help clarify the significance of Lowell's innovations.

The title chosen by Pound, indicating the volume's openness or "catholicity," made a show of renouncing the question of movements as such (preeminently but not only imagism), and it appeared to reserve for itself a higher set of principles of selection foregrounding modernist topoi in general. But the spectacle Pound makes of his idealism does not withstand much scrutiny. Harriet Monroe's biographer Ellen Williams has gone so far as to suggest that the book may be read as "an assemblage of the people who made the first three years of *Poetry* memorable."[32] If this were true, *Catholic Anthology* would more strongly resemble later anthologies that consolidated and distributed more widely and permanently the work of a little magazine; *Others*, the *Pagan*, *Contemporary Verse*, *Masses*, and the *Libera-*

tor all issued anthologies of this kind.[33] It is more accurate to understand *Catholic Anthology* as a more general means of shoring up allies, including but not limited to those affiliated with *Poetry*. Of the poets Pound selected, Allen Upward and William Carlos Williams were veterans of *Des Imagistes*; Harriet Monroe, Alfred Kreymborg, and Harold Monro had all been publishers of Pound's poetry; Edgar Lee Masters, Carl Sandburg, Alice Corbin Henderson, Maxwell Bodenheim, Douglas Goldring, and Orrick Johns had all appeared in Monroe's journal; Bodenheim, Johns, Goldring, and Williams would also publish in Kreymborg's Pound-friendly journal *Others*.[34] It was through Pound's intercession that *Poetry* had published T. S. Eliot's "The Love Song of J. Alfred Prufrock" and *Others* had published "Portrait of a Lady"; *Catholic Anthology* included both of these and three more of Eliot's poems.[35]

As was true for *Des Imagistes*, *Catholic Anthology* lacked any programmatic statement, although Yeats's prefatory poem—with its excoriation of the "Bald heads forgetful of their sins / [who] Edit and annotate the lines / That youug [sic] men [...] / Rhymed out in love's despair"—situated it as an anti-academic collection that could claim Yeats as a forebear. And whereas *Des Imagistes* had devoted several more pages to the core imagists (Aldington, H. D., and himself) than it did to contributors like Lowell, Upward, and Skipwith Cannéll, in the new anthology it was Eliot, Masters, and Williams who each received more than ten pages, the disparity among their approaches uncertainly indicating a set of possible new directions for free verse, rather than the tenets of a "school." These strategies were also points of *contrast* with Lowell's *Some Imagist Poets*, a book that included a programmatic preface and divided its pages equally among its six contributors.

Against the more curatorial method of organization that had characterized his first collection, *Catholic Anthology* apparently arranged its poems alphabetically by author; when soliciting contributions, Pound had been explicit about this arrangement. In this way the new anthology provided an air of neutrality that approximated the democratic principles that *Some Imagist Poets* was then advertising, while significantly mitigating the drive either to shape the volume as a whole or to orchestrate possible relationships among the poems. This seemingly egalitarian arrangement had come at the price of altering two of the contributors' names: Bodenheim's (whose name was suppressed and appeared between Harriet Monroe and Harold Monro as "M. B.") and Henderson's (whom Pound convinced to use her married name as opposed to her preferred Alice Corbin). This permit-

ted him to promote Eliot to the head of the volume, endowing the volume with a hierarchy, but also an alibi for that hierarchy.[36] Eliot was indeed grateful for the attention "Prufrock" received as a result of its inclusion in the collection, but as this brief survey suggests, Pound's second anthology was understood to have attempted to honor too many incompatible sets of obligations.[37] This was not simply or even primarily a question of aesthetic form—in *Des Imagistes* Ford Madox Hueffer's "In the Little Old Market-Place" had at best a genealogical relationship to imagism, and D. H. Lawrence's verse was undoubtedly an outlier in Lowell's imagist anthologies—but instead involved a more general question of the relationship among the poems and poets represented.

Though it disowned the politics of group affiliation, Pound's second anthology was an instrument for preserving institutional alliances; Harold Monro's "Milk for the Cat" might have been a poem too cloying even for *Georgian Poetry*, but it was all the more damning when it was perceived for the debt paying it was.[38] And although it borrowed some of the protocols of Lowell's "democratic" arrangement, it violated those protocols in order to promote Eliot. None of these strategies aided the aesthetic composition of the book as a whole. William Stanley Braithwaite, an ally and defender of Lowell's, was perhaps justified in naming it an insincere volume.[39] And even in the friendly pages of *Poetry*, Max Michelson's review protested too much, providing an extravagant encomium to Pound that can easily be read as a defense against the reputation that had already grown around him. Whereas Braithwaite had made the overstated claim that the *Catholic Anthology* included "only those poets who take their cue from Ezra Pound," Michelson's review presented an implausibly romanticized Pound: "whenever I read him I seem to forget for awhile what I am reading and think of the man—of his self-abnegation. He is to me the most interesting figure in the recent awakening of poetry. Like Cézanne he always seems to say, 'I am nothing—my work is everything.'"[40] While Michelson was ostensibly describing Pound the poet, he was also clearly eulogizing Pound's service to the arts and artists, in which his anthologies played a more public role. As the first *Some Imagist Poets* became one of the great successes of 1915, *Catholic Anthology* quickly proved an even greater failure than *Des Imagistes* had been. Despite the strong representation of American poets, Pound was unable to find a United States publisher for the volume, and numerous copies of Elkin Mathews's initial print run of five hundred remained unsold in London as late as 1936.[41]

By contrast, the first installment of *Some Imagist Poets*, which had appeared in April 1915, sold 481 copies of its original run of 750 in advance of the release date and would go on to sell more than 1,300 copies in its first year.[42] This was due in no small part to Lowell's superlative publicity skills, which involved giving public lectures, writing in to numerous magazines, and cajoling and soliciting positive reviews (one of which she and a fellow imagist had written pseudonymously).[43] Even negative reviews advanced the public profile of imagism; Conrad Aiken's "The Place of Imagism" and the responses it elicited made Lowell's anthology a topic of debate in the pages of the *New Republic* for more than a year.[44]

The successful negotiation of the critical sphere was just one element of a more systematic change worked out in advance of the anthology's appearance. Lowell's new imagist group preserved the English/American balance that had characterized *Des Imagistes*, while streamlining the membership to six poets: it included the refugees from the first volume (Aldington, H. D., F. S. Flint, and herself) and added D. H. Lawrence and the American John Gould Fletcher.[45] More importantly, Lowell had instituted a new politics of representation within the anthology and secured new conditions for the books' circulation. Her letter to Harriet Monroe of September 15, 1914, outlined the strategy: "I suggested [to Aldington and H. D.] that the last little book [*Des Imagistes*] was too monotonous and too undemocratic, in that certain poets were allowed much more space than others, and I suggested that in the 'New Anthology' we should allow approximately the same space to each poet, and that we should get a publisher of reputable standing, and I offered, in case we could not get any publisher to take the risk of the volume itself, to pay for its publication."[46] Pound's curation of *Des Imagistes* was thus construed as an authoritarianism to be redressed by democratic principles; each poet would choose which poems to print, and the unsigned preface, drafted by Aldington, would be approved by all six contributors.[47] These new principles were advertised in much the same way that Kennerley and Earle had promoted their prize campaign two years earlier, in the book's preface and in carefully placed magazine articles. What was at least as important for the success of *Some Imagist Poets* was the fact that Lowell had secured a "reputable" American publishing house to promote and distribute the book in the country that had already demonstrated its receptiveness to imagism and free verse in general. Of all small presses, Lowell specifically wished to avoid the Bonis, who had published *Des Imagistes*; after shopping the book first to her own publisher Macmillan, she arrived at an agreement

with the relatively conservative Houghton Mifflin.[48] This arrangement did oblige Lowell to pay for the printing costs, but it also guaranteed advertising and exposure and secured a commitment from Houghton Mifflin for a series of three annual imagist anthologies to be included in a broader New Poetry Series, over which Lowell had influence.[49]

Lowell's new group had in fact considered the idea of abandoning the term *imagist* altogether, but their editor at Houghton Mifflin, Ferris Greenslet, insisted it be retained for its "mercantile value."[50] Lowell thus embraced the group principle as an instrumental value, but not as a means of self-definition. When Lowell strenuously promoted the collaborative and democratic concept of the project (despite the far stronger hand she actually took in producing the text and promoting it), it served the purpose not only of preserving the autonomy of each of the anthology's six poets but also of guarding against suspicions that the book was merely a self-funded vanity project.[51]

When promoted as a part of the new imagist group identity, the democratic conceit also became a weapon that could be used against Pound. Exactly one week after Lowell had described the group principles to Pound's interlocutor Monroe, Lowell's second book of poems, *Sword Blades and Poppy Seed*, appeared from Macmillan. Her first volume to bear the influence of imagism, the book also contained "Astigmatism," a sixty-six-line free verse poem that bore the dedication

To Ezra Pound

WITH MUCH FRIENDSHIP AND ADMIRATION

AND SOME DIFFERENCES OF OPINION

The patronizing dedication raised the possibility of Lowell's assuming leadership over the movement, imagism, that was barely concealed in the poem's title. "Astigmatism" describes a Poundian "Poet's" progress past a series of flowerbeds that contain, successively, daisies, irises, dahlias, and gillyflowers. The Poet then employs his walking stick (one of Pound's signature accoutrements, lavishly described by Lowell in the poem) to decapitate each of the flowers:

The little heads flew off, and they lay
Dying, open-mouthed and wondering,
On the hard ground.
"They are useless. They are not roses," said the Poet.[52]

The overdetermined gendering of "Astigmatism's" devices—the cane and the flowers—indicates a critique of Pound's misogyny, as Andrew Thacker has recognized.[53] But the poem also alludes more inventively to the etymology of the word *anthology*: "a collection of the flowers of verse."[54] Viewed in this way, the poem reads less as an address from poet to poet, or from wronged poet to exploitative editor, as it does from impresario to rival impresario. It is this reading that best accommodates the poem's arch refrain: "Peace be with you, Brother. Go your ways."[55]

Lowell's poem anticipated, and very likely influenced, Braithwaite's complaint that the *Catholic Anthology* included "only those poets who take their cue from Ezra Pound." Lowell and Braithwaite alike portray a dictatorial Pound fundamentally opposed to "catholicity." The "Poet's" demand for "roses" indicated the tendency of his modernist polemics to produce an intolerant—and ironically standardized—form of modernism. This is precisely the criticism that the art collector Duncan Phillips would make of the avant-garde in painting and sculpture. For Phillips, cubism had established a formula, presided over by "King Pablo," that dictated in advance the work of younger artists; in Lowell's poem, Pound's elitism disqualifies broad categories of ostensibly legitimate verse, despite the libertarian or individualist claims of his rhetoric.[56]

Although it may have appeared to be the opening shot in a very public feud, "Astigmatism" proved nearly to be Lowell's final public acknowledgment of Pound. All subsequent attacks on Pound would be implicit. Whereas in their self-promoting pseudonymous review of *Some Imagist Poets* Lowell and Fletcher would not hesitate to signal the "jejune maledictions and assertions of [the *imagistes*'] chief spokesman, Mr. Pound," Pound would receive virtually no credit in Lowell's landmark study *Tendencies in Modern American Poetry* (1917), where imagism was nevertheless situated as the most fully realized form of modernist poetry.[57] Most crucially, Lowell succeeded in suppressing Pound's name from the programmatic preface that Aldington had drafted for the first *Some Imagist Poets*. In this she prevailed over the objections of the others—Fletcher had even lobbied for a manifesto titled "Against Poundism"—which was possible because of her closeness to Greenslet and Houghton Mifflin. As Lowell confided to her editor, she wished to make the volume "as dignified and little provocative as possible."[58] The published preface began with a measured acknowledgment of Pound's first anthology:

In March, 1914, a volume appeared entitled "Des Imagistes." It was a collection of the work of various young poets, presented together as a school. This school has been widely discussed by those interested in new movements in the arts, and has already become a household word. Differences of taste and judgment, however, have arisen among the contributors to that book; growing tendencies are forcing them along different paths. Those of us whose work appears in this volume have therefore decided to publish our collection under a new title, and we have been joined by two or three poets who did not contribute to the first volume, our wider scope making this possible.

In this new book we have followed a slightly different arrangement to that of the former Anthology. Instead of an arbitrary selection by an editor, each poet has been permitted to represent himself. . . . A sort of informal committee . . . have arranged the book and decided what should be printed and what omitted, but, as a general rule, the poets have been allowed absolute freedom.[59]

Acknowledging the volume that had preceded *Some Imagist Poets*, the preface nonetheless had the effect of discrediting Pound not only literally (by neglecting to mention him by name) but also on the level of his ethics or aesthetics (depending on one's reading of the word *arbitrary*). Yet the fact that he was unnamed was the fact most emblematic of Lowell's strategy; writing to solicit a review from Monroe at *Poetry*, she begged, "please don't lay stress on the schism with Ezra. I don't want to make the row important."[60]

The preface went on to recast, in more expansive and positive terms, Pound's and Flint's founding documents of imagism, which had appeared in the March 1913 *Poetry*.[61] In "Imagisme" and "A Few Don'ts by an Imagiste," documents aptly named "anti-manifestoes" by Janet Lyon, the Poundian articulation of imagism had been deliberately hermetic and exclusive.[62] Flint's essay famously identified a "certain 'Doctrine of the Image,'" which [the *imagistes*] had not committed to writing"; the preface to Lowell's anthology, on the contrary, aimed to clarify "much of the misunderstanding of the former volume [*Des Imagistes*]."[63] Against Pound's proscriptions ("Use no superfluous word," "Go in fear of abstractions," "Don't be 'viewy,'" "Don't chop your stuff into separate *iambs*"), the new anthology listed a series of "essentials" ("To use the language of common speech, but to employ always the *exact* word," "To create new rhythms," "To present an image," "To produce a poetry that is hard and clear, never blurred nor indefinite").[64] That these were presented in the infinitive was no accident. Although based on

the original imagist doctrine, imagism's values were now declared to be the domain of no particular school or epoch: "These principles are not new; they have fallen into desuetude. They are the essentials of all great poetry, indeed of all great literature."[65]

Whereas Poundian imagism had also stressed its sources (thus indicating the antipathy of both stages of imagism to the radical break insisted upon by futurism), a key distinction consisted in the way each anthology consciously constructed and mediated its literary past. Speaking for Pound, Flint's essay had declared that the imagists' "only endeavor was to write in accordance with the best tradition, as they found it in the best writers of all time,—in Sappho, Catullus, Villon."[66] The distinction between "best tradition" and "great literature" is subtle but decisive. Tradition for Pound was a deep and exclusive form of gnosis, embedded in texts like the *Greek Anthology* and in the work of Confucius; it is the object of the *artist's* study and aspiration. As Eliot would later put it, "[i]t cannot be inherited, and if you want it you must obtain it by great labour."[67] As the anthology form had materially preserved the ancient traditions of Greece and China, *Des Imagistes* represented an exclusive society committed to the practical extension of those ancient and threatened values. Alternatively, the "great poetry" and "great literature" that are continuous with Lowell's imagism were articulated as a more general matter of cultural knowledge and competence; it is not a property specific to artists, but common to audiences as well. In stressing that "[t]hese principles are not new," the preface to *Some Imagist Poets* thus had the structure of an appeal for public recognition as much as a manifesto. The "absolute freedom" it claimed on behalf of its artists, moreover, was the antithesis of the Eliotic "great labour" and instead self-consciously mediated the principles of the presumably American democracy that Pound famously denounced as a "beer-garden."[68]

In this respect Lowell's efforts again anticipated those of the collector Duncan Phillips. Like Lowell, Phillips would elaborate a transhistorical model of modernism in order to popularize modernist art among those members of the public that remained resistant to abstraction and experimentation. This recalled *Some Imagist Poets*, which, rather than claiming an exclusive and mercurial set of antecedents ("Sappho, Catullus, Villon"), stressed a heritage for imagism that could more easily be claimed as the bourgeois American's cultural patrimony; the 1916 preface (written by Lowell and Fletcher) claimed Dryden, Milton, Arnold, and Chaucer as pioneers and practitioners of *vers libre*.[69] And just as Phillips would resign in pro-

Amy Lowell's first anthology, *Some Imagist Poets* (1915). The dust jacket's Victorian figure of Pan and motto "tout bien ou rien," as well as the eminence of the book's publisher Houghton Mifflin, conspired to place free verse within a stable, continuous poetic tradition. *Some Imagist Poets: An Anthology*. Boston: Houghton Mifflin, 1915. Courtesy Department of Special Collections, Stanford University Libraries.

test from the conservative American Federation of the Arts, Lowell's most public battles transpired at lectures for traditionalist institutions such as the Poetry Society. Like Phillips, too, Lowell strenuously wished to dissociate modern art from the taint of political anarchism; she withheld, for example, financial support from the journal *Seven Arts* for its pacifist affiliations.[70] Irrespective of the questions of gender (and sexuality), the proximity of the two collectors' positions is produced to a significant degree by the patrician class position they shared. Indeed, Melissa Bradshaw's assessment of Lowell's position applies equally well to Phillips: "fostering a sense of

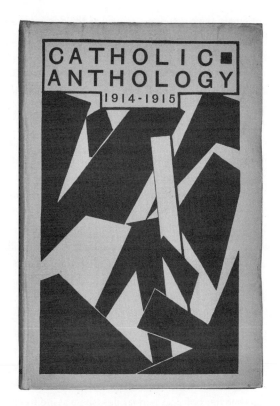

Ezra Pound's *Catholic Anthology* (1915). Dorothy Shakespear's vorticist cover image encouraged readers to read the anthologized poems in the context of contemporary avant-garde painting. This suggestion was imperfectly received by readers like Max Michelson, whose review compared Pound to Cézanne. [Ezra Pound, ed.] *Catholic Anthology 1914-1915*. London: Elkin Mathews, 1915. Courtesy of the Division of Rare and Manuscript Collections, Cornell University Library.

dialectic between the conservatism of the academy and the elitism of the avant-garde[, s]he positions her brand of poetry as the only logical response to these two extremes."[71] This position reveals itself, among other places, on the cover of *Some Imagist Poets*, whose Morrisesque illustration of Pan contrasts with the vorticist illustration (by Dorothy Shakespear) that appears on the cover of the *Catholic Anthology*. It was largely through Lowell's successes that free verse became the object, in Christine Stansell's words, of "tremendous middlebrow enthusiasm"; Phillips's activities, I will argue,

most nearly anticipate the procedures as well as the dominant and popular cultural position of the Museum of Modern Art.[72]

It does not weaken the argument to cite Phillips's public disparagement of Lowell's poetry, made before the collector's later conversion to modernist art: "[Matisse] is even more crude in his obviousness than is Miss Amy Lowell when she calls attention to her unrhymed cadences, stressing her accents by means of metrical arrangements until all the mysterious subtlety of the ancient music of rhythmic prose has been spoiled and sacrificed."[73] Like Michelson's comparison of Pound and Paul Cézanne, Phillips's attack points to the perceived continuity between modernist painting and modernist verse. But it also points out the social threat that both the art and the poems appeared to pose, particularly at the time of the Great War. Just as Phillips, prior to his conversion to modernist art, would claim in his review of the 1917 Society of Independent Artists exhibition that "war is a good cleanser" that would purify the world of the menace of anarchist modernism, a 1916 piece in the *New York Times* would bear the title "Free Verse Hampers Poets and Is Undemocratic: Josephine Preston Peabody Says That, Nevertheless, the War Is Making Poetry Less Exclusive and the Imagiste Cult Will Be Swept Away."[74] The vehemence of the latter's argument, for which the article's author Joyce Kilmer was responsible, would only have been possible as a consequence of free verse's popularity, something Lowell had labored to achieve. Lowell's poetics were perhaps no more radical than her political sympathies (she was indifferent to suffragism, opposed to verse of "social consciousness," and generally supportive of the war). But as the *Times* article demonstrates, the popular reception of modernism imparted to the art an importance as much sociological as aesthetic; group formations as such—even the conciliatory modernism of a patrician like Lowell—could be understood as oppositional, by definition, to the established social order (in Kilmer's terms, "cults"). Such a context informed Phillips's overdetermined critique of Lowell and also shaped the material conditions governing the reception of modernist groups of the prewar period more generally. Among them was a group that could have claimed a stronger affiliation to anarchism: Alfred Kreymborg's *Others*.

The *Others* Formation

Although they disagreed on much, Pound and Lowell had each traded on the idea of imagism as a "school," a limited group putatively defined by aesthetic principles. By contrast, the little magazine, anthologies, and affili-

ated projects that bore the name "Others" were defined by their association not with a single literary sensibility but with a more generalized form of avant-garde *practice*. Others had a more ambiguous, but also more organic, relationship to group identity, one best understood, I will argue, with reference to the term *formation*.

The ambiguity of the "Others" group identity was related to its designedly ambiguous relationship to anarchism. In 1913 Kreymborg had moved, along with the painters Man Ray and Samuel Halpert, across the Hudson River from New York to an artists' colony in the Pallisades town of Ridgefield, New Jersey (also known as Grantwood). Ray and Halpert had been affiliated with the Ferrer Center, an East Village cultural center that had strong ties to anarchism and could count among its founders Emma Goldman herself.[75] Grantwood would soon be populated by several Ferrer Center figures, including the anarchist artists Adolph Wolff and Manuel Komoroff, as well as by the socialist writer Floyd Dell, the poets Bob Brown and Orrick Johns (late of *The Lyric Year*), and several others.[76] Kreymborg and Man Ray began publishing the *Glebe* here in 1913 (it was to Ridgefield that Pound had sent the manuscript for *Des Imagistes*), and *Others* emerged after the *Glebe* collapsed.[77] *Others* was printed by the anarchist Sebastien Liberty, who had a print shop near the Ferrer Center on St. Marks Place. According to Kreymborg's autobiography, "Mr. Liberty . . . refused to earn a cent on what he called 'redicals' and submitted an estimate at the absurdly low figure of twenty-three dollars a month."[78] An article in the *New York Tribune*, written by Johns's wife Peggy and published the month of *Others*'s debut, placed the Grantwood scene within a wider milieu that included "the sculptor Adolph Wolff, author of revolutionary poems; Arturo Giovanniti, the I.W.W. poet and editor of 'Il Fuoco,' and Edmond McKenna, the author of 'The Likes o' Me,' many of whose poems appeared in 'The Masses.'"[79] Giovanniti's and McKenna's work would not appear in *Others*, but Wolff's poems did, and the anarchist Lola Ridge became one of the group's most important figures. But *Others* also featured the work of nonpartisans such as Wallace Stevens and even, in its second issue, Amy Lowell. The cover of the first *Others* anthology quoted a review that situated its verse as "revolutionary," but the word was indefinite in this context: "By the way, the new poetry is revolutionary. It is the expression of a democracy of feeling rebelling against an aristocracy of form." Perhaps most telling was the classification scheme proposed by Braithwaite: "At the beginning of the present year [1916] one could define four separate groups of poets. The fixed and

firm traditionalists, the social-revolutionists, the Imagists, and the Radicals of the *Others, A Magazine of the New Verse* group."[80] What may be stressed is the variability of the term "radical," which for Braithwaite names a formal quality that distinguishes *Others* from the "social-revolutionists," but which Sebastien Liberty uses to connect formal experimentation with political "redicalism." *Others* was not a journal committed to "converting the sheriff to anarchism and vers libre," as Jane Heap depicted the mission of the *Little Review*.[81] The great majority of its poems were not politically radical in an easily recognizable sense, and the "people most outraged," as the principal scholar of *Others*, Suzanne Churchill, has noted, were not the public at large, but "those with the biggest stakes in the new poetry field: Amy Lowell and Harriet Monroe."[82] Indeed, it was Lowell's promotional activities that were more likely to elicit public attacks like Kilmer's; by contrast, the conventional response to *Others* was bemusement or mockery.[83] If Lowell had already claimed the "middlebrow" position for imagism, the "radical" or "revolutionary" position of *Others* was advanced less as a sign of political radicalism than as a position within what Bourdieu has named the field of restricted production: "a system objectively producing [culture] for [cultural] producers" with the "power to define its own criteria for the production and evaluation of its products."[84] This was evident both in the journal itself, which had a very limited circulation that averaged about three hundred copies per issue, and in the more institutional form of the anthology, which circulated as a collector's item.[85] These documents reframed, without absolutely erasing, the project's more avowedly political origins at Grantwood.[86]

Others was conceived in collaboration with Walter Conrad Arensberg, a Harvard graduate of independent means who also financed the project. A poet himself, Arensberg is better known for assembling, with his wife Louise, one of the preeminent collections of modernist art in the post–Armory Show period.[87] By 1915, their 67th Street apartment was home to a salon that was a central location for New York Dada; two years later the Society of Independent Artists would be organized there.[88] The son of a poor German immigrant, Kreymborg had for his part been introduced to modernism through his visits to the 291 gallery, where Alfred Stieglitz's privileging of intimacy had provided a model for the "one-man shows" of the *Glebe*.[89] Arensberg, a devotee of Poundian imagism, was drawn to Kreymborg as the original publisher for *Des Imagistes*. As Kreymborg would recall a decade later, Arensberg "confided [that] what was needed in America was a poetry

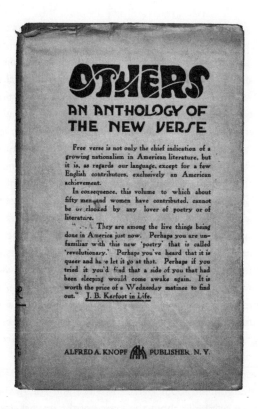

The cover of the first of Alfred Kreymborg's *Others* anthologies (1916). Kerfoot's review places "poetry" and "revolutionary" in scare quotes, at once affirming and disavowing the cultural connotations of each word. Stressing that free verse is (almost) "exclusively an American achievement," Kreymborg suppresses the London origins of the anthology that inspired the Others project, Pound's *Des Imagistes*. Alfred Kreymborg, ed. *Others: An Anthology of the New Verse*. New York: Alfred A. Knopf, 1916. The Poetry Collection of the University Libraries, University at Buffalo, The State University of New York.

magazine, not like Poetry in Chicago, which admitted too many compromises, but a paper dedicating its energies to experiment throughout. He wondered if such a venture was feasible and whether [Kreymborg] would join him in it."[90] According to Kreymborg's account, they immediately decided on a few key contributors—Stevens, Mina Loy, and themselves—as well as the journal's motto: "The old expressions are with us always, and there are always others."[91]

What Arensberg was specifically denouncing was *Poetry*'s well-known "open door" policy, its commitment to publishing poems written in traditional forms as well as *vers libre*.[92] By avoiding this "compromise," he and Kreymborg aimed to situate the journal at the experimental vanguard of modernism. Monroe made a point of recognizing the distinction in a letter to Kreymborg: *"Poetry* you know tries to publish the best we can get of ALL the different schools. We have published a good deal of rather radical experiments and shall no doubt continue to do so, but I assume that 'Others' stands exclusively for the radicals and for a rather more youthful effervescence than I am quite ready to endorse publicly."[93] Monroe was being high-handed, but she was also informally agreeing to minimize competition within the expanding but still very limited modernist literary field. From the perspective of *Others*, however, Monroe's aim to document inclusively all the contemporary "schools" resembled Lowell's wish to situate *vers libre* within the continuum of "all great literature." For what was ultimately signaled by Kreymborg's motto was not simply the enduring hegemony of the "old expressions" (partially endorsed by *Poetry*) but the necessary and equally enduring availability of "other" positions that could be assimilated neither to "great literature" nor to mainstream culture (the two fields united in Lowell's imagist strategy).

In this respect, the Others position was important less for its participation in an argument about Harriet Monroe and *Poetry* than for what it implied more pointedly about the legacy of the imagist intervention as such. The example of *Others* suggested that the importance of imagism to the United States had been misapprehended by most of the avatars of the free verse, even by Pound himself. Lowell's popularization of free verse had wrested imagism from the realm of a laboriously acquired "tradition" and placed it within the grasp of a much wider audience of readers and practitioners. Kreymborg, in contrast, cited imagism as an inspiration but discovered that its implications inevitably led away from both Lowell and Pound:

> The movement which crystallized one and all, which brought about a recognition of quasi kinship, was Imagism. Imagism only gave us forms with which we were unfamiliar, stimulated us to try them. The individual response to our environment was still of necessity our own. Most of us welcomed Imagism enthusiastically, but were puzzled by its foreign airs and graces. It was not enough. It depended too much on books we didn't know and too little on the life we knew. We accepted the forms, but could not accept the whole spirit. What was

all this about the Greeks, the Provençal, the Chinese? It was beautiful, alluring, intoxicating, but it did not stay with us. It was too remote from our lives among the lonely streets and byways of this mysterious land. The untutored among us, and most of us were untutored, felt as if we had neglected our education. Some of us could not afford education, not college education; others felt that college held the wrong education for them. We craved a more direct cultural expression, however crude, hard and blundering.[94]

From Kreymborg's perspective, imagism's importance consisted in its having been a modernist form that did not require its justification with reference to a cultural patrimony, whether esoteric ("tradition," Pound) or bourgeois ("great literature," Lowell).[95] As Kreymborg made this emancipatory gesture, he also tellingly declined to cite the importance of Pound's anthology for making imagism, in Lowell's phrase, a "household word." *Des Imagistes* was important, rather, for having facilitated "a recognition of quasi kinship" among a much more limited group ("us"). And the context of this observation had additional weight coming as it did in Kreymborg's history of American poetry, *Our Singing Strength*, rather than in his memoir. Imagism was important for Others, if this may be permitted, in precisely the way that the Ramones' London concert of July 1976 or the Cramps' February 1979 show in Washington, DC, was to the burgeoning punk scenes in those cities—as an event not to be *reproduced* but *translated* into a new form of "specialized practice."[96]

At Grantwood in 1915, prior to the formal arrangement with Arensberg, the "quasi kinship" took the form of weekly meetings attended by the residents of the colony and by visitors including Duchamp, Arensberg, Mary Carolyn Davies, Horace Holley, Skipwith and Kathleen Cannéll, and, especially, William Carlos Williams.[97] Kreymborg and Williams misremember Mina Loy and Marianne Moore as participating as well (neither had yet met Kreymborg), but as Churchill observes, the significance of the short-lived Grantwood colony is represented by "its tendency to expand in duration and number in the memories of participants."[98] In a letter to Monroe, Kreymborg described the Sunday meetings as serving "the purpose of working together and of condemning the world at large"; in the *New York Tribune* Peggy Johns reported that they were held "to exchange talk of the latest star that has appeared on the free verse horizon, or of the new rhythm one of their number may have invented since the last meeting, and to plot the destruction of the traditional school of poetry."[99] After the institution of

the little magazine, the Others formation appeared to extend outward to the rest of the country. As Williams recalled, "Good verse was coming in from San Francisco, from Louisville, Ky., from Chicago, from 63rd Street, from Staten Island, from Boston, from Oklahoma City. . . . New-comers to the city if they were alive to artistic interests in their own parts naturally drifted into the crowd."[100]

The transition from the salon-like formation at Grantwood to the provisional institutions of the *Others* journal and anthologies can be compared to the genesis and development of the New Negro movement a few years later. A key progenitor of that movement was the Washington, DC, salon—familiarly known as the "Saturday Nighters"—hosted by the poet Georgia Douglas Johnson at her S Street house in the early 1920s. Participants included Jean Toomer, Langston Hughes, Countee Cullen, Jessie Fauset, Wallace Thurman, William Stanley Braithwaite, Charles S. Johnson, Zora Neale Hurston, James Weldon Johnson, Angelina Weld Grimké, Richard Bruce Nugent, and Alain Locke.[101] It was in light of the success of Johnson's salon that Locke suggested to Hughes that there was "enough talent now to begin to have a movement—and express a school of thought."[102] Installing himself as the movement's impresario, Locke shifted its geographical center from Washington to New York, thereby effecting a transition away from the informal and collaborative sociability represented by the Saturday Nighters and toward cultural institutions that supported the arts more materially: publishing houses, magazines, and patrons. This transition culminated in the publication of *The New Negro* in 1925.

If Locke fundamentally obviated the foundational role of the Saturday Nighters, Kreymborg, by point of contrast, attempted to maintain for Others a relationship to the loosely collaborative, and more bohemian, formation that had engendered it. (Wallace Thurman and Richard Bruce Nugent hoped their avant-gardist Negro journal *Fire!!* would occupy a similar social position.) Over the course of its run, *Others* featured numerous special issues and guest editors (Williams, Loy, Helen Hoyt, William Saphier). These did not merely speak to the precarious state of the journal; they were also indices of the desire to preserve the less hierarchical ethos that many of its contributors associated with the project's origins. As Kreymborg claimed in a late and rare intervention, the editors "do not sit on judicial or pedantic pedestals; primarily, they ask that they be permitted to evolve their own individualism, if they possess any, and to permit other folk to evolve

theirs. They are editors in name only."[103] If this may be read as privileging a desire for radical individualism, such individualism would "evolve," to use Kreymborg's word, in the context of the collective medium of *Others*. It was an apparent contradiction that provided the project with its definitive structure.[104]

Despite its affinities with and roots in the culture of the bohemian salon, it is critical to realize the provisionally institutional dimension of Others. In this sense the project advanced by Kreymborg can best be understood in its relationship to another provisional institution: the Société Anonyme and its founder Katherine Dreier. I have already suggested that the cultural position that Lowell claimed for free verse resembled the one that would be prepared for modernist art at Duncan Phillips's Memorial Gallery. The proximity of Kreymborg and Dreier, however, is more than conceptual, as Others and the Société Anonyme were born from affiliated phases of the New York avant-garde and indeed had members in common. Marcel Duchamp, for example, was a frequent visitor at Grantwood, and it was here that he met Kreymborg's former collaborator, Man Ray. Dreier, Duchamp, and Man Ray would all be on the board of directors of the first Society of Independent Artists exhibition in 1917, and three years later they incorporated the Société Anonyme, an artist-run cooperative that would go on to stage more than eighty modernist exhibitions and produce thirty publications in the United States.[105] Kreymborg, along with fellow Others Mina Loy and William Carlos Williams, would be among the fourteen poets to give readings at the 1917 SIA exhibition.[106] And, to an unusual extent, the journal and anthologies published under the title *Others* featured poetry written by painters and sculptors: Man Ray, Halpert, Wolff, Charles Demuth, William and Marguerite Zorach, Marsden Hartley. Except for Wolff, all of these artists participated in the 1917 exhibition, as did Loy herself.

This proximity not only indicates the broader New York avant-garde scene that the groups helped determine; it also suggests the way Others and the Société Anonyme each operated as *formations*, in Raymond Williams's sense of the term. In Williams's thinking, formations may be "most recognizable as conscious movements and tendencies (literary, artistic, philosophical or scientific)," but they may also attain a looser, and not directly collaborative, character, as a "mode of specialized [intellectual or cultural] practice."[107] If collecting represents a particular mode of modernist cultural practice, a characteristic distinction for both Others and the

Société Anonyme lay in the resistance to imagining the primary function of
the formation as consisting in the production of the collection. Their col-
lections, rather, emerged later as attempts to solidify or provide a record
for more ephemeral, semi-cooperative projects.[108] Both groups were also
defined by a general commitment to the avant-garde as such. This entailed
outwardly refusing a divisive partisanship *within* the avant-garde, while
also rejecting the obligation to exhibit or justify work according to broader,
more inclusive historical or aesthetic principles. Thus, just as the Société
Anonyme could claim in their annual report that in their first year they had
exhibited postimpressionists, pre-cubists, cubists, expressionists, simulta-
neists, futurists, Dadaists, and "those belonging to no schools, but imbued
with the new spirit in art," the little magazine *Others* would devote special
issues to the choric and spectric schools of poetry, even as a late manifestic
policy statement from Kreymborg would assert that "collectively or sepa-
rately, [we] eschew everything which approximates ismism."[109] And while
Others would devote itself to post-imagist experimentation, the Société
Anonyme could claim in their first annual report that "[t]he works of men
representing the older schools will not be exhibited, as there are plenty
of museums, exhibitions and art galleries, that handle works representing
this period."[110]

It was from within this context that Kreymborg was performatively po-
sitioned as the reticent figurehead of a group that desired no figurehead.
Orrick Johns remembered Kreymborg as a "modest, spectacled fellow, who,
in an undramatic, even neutral way, by some magic, won the heart of ev-
erybody," but he then went on to say that Kreymborg also "had the gift . . .
of leading up to the point where *you* said the thing he wanted said."[111] The
cultivation of such a disposition is evident, too, in Kreymborg's own auto-
biography, where he tellingly refers to himself in the third person by the
nickname "Krimmie": "Without any affected modesty, each seemed posi-
tive that the other fellow was a better poet than himself, and this attitude
engendered a regard which expressed itself in silence or a quiet, ungainly
phrase. Nothing intrigued Krimmie more—himself eaten up with respect
and shyness—than the pastime of setting his friends vis-à-vis like so many
men on a chessboard."[112] These anecdotes depict an almost comically di-
minutive Krimmie. He is nevertheless a figure who possesses a unique, con-
cealed, creative agency that enables, shapes, and directs aesthetic produc-
tion and sociability alike. That this role was to a large degree choreographed

is also indicated in Kreymborg's programmatic refusal to respond to critical attacks on *Others*. The precise antithesis of the combative tendencies of Pound or Lowell, Kreymborg's attitude was synonymous with the journal's and the anthologies' eschewal of promotional or editorial apparatus. The "policy," as Kreymborg described it in a letter to Williams, "of ignoring [Lowell] & everybody else entirely" was itself part of a larger apparatus for the autonomization of the Others formation.[113]

The first issue of the little magazine *Others* appeared three months after the first *Some Imagist Poets* in July 1915: its first anthology appeared in March of the following year. There would be two more anthologies, in 1917 and 1919, the last one appearing the year the magazine ceased publication. Unlike Lowell's anthology, which was printed and promoted under the auspices of established publishing houses in the United States and Great Britain, *Others: An Anthology of the New Verse* emerged from a small American press comparable to the imprint of Albert and Charles Boni. Alfred A. Knopf, a former employee of Mitchell Kennerley, had started his publishing house the previous year with a modest list of ten books. In 1916, the list expanded to twenty-nine titles, including Kreymborg's anthology. Knopf's advertising circular did not position the *Others* anthology as a mass-market competitor of *Some Imagist Poets*, but rather as an elite object for collectors:

> Approximately fifty men and women have contributed to Others which will in all probability be the most important volume of American verse to appear in 1916. If you wish a copy of the first edition, which will be a small one and eagerly sought for by collectors, you are urged to use the order blank on page four.... The book will be a tall thin octavo of about one hundred and sixty pages, printed in eleven point Scotch type on featherweight paper appropriately and uniquely bound. Size about five and one quarter by eight and one quarter inches.[114]

Knopf's circular indicates how, in the space of a year, the "redicalism" that had been identified by Mr. Liberty had been neutralized as Others became an object in which collectors could invest, construing it as an object to be owned as much as it was to be read.[115] In this sense it resembled more familiar forms of modernist autonomization.

While the invitation from Knopf to anthologize *Others* was especially welcome to Kreymborg because of the dire financial straits of the journal, it also posed another kind of opportunity whose importance was not pri-

marily pecuniary. It allowed the possibility of consolidating the work of the journal as the product of a collective effort and of establishing *Others* as a project issuing from a larger and more organic collectivity than either phase of imagism could claim to have done. This, too, was communicated in the circular and on the cover of the volume itself, which proclaimed that "[a]pproximately fifty" (in reality, thirty-six) poets had contributed to the anthology, far more than Lowell's six imagists or the sixteen poets in Pound's *Catholic Anthology*. At more than 150 pages, the book was also half again as long as those anthologies, in whose company it would often be reviewed. Having already appeared together in the magazine, the selected poems could seem to possess a logic that was more than simply "catholic," yet the absence of a preface or other editorial apparatus (save the announcement on the cover) and the alphabetical organization of its contributors conveyed the sense of a collective expression without a hierarchy. The lack of apparatus was nevertheless itself an apparatus, entirely consistent with Kreymborg's performance of his own editorial absence. While that absence aimed to accentuate the individualism of the Others contributors, it did so by emphasizing a group identity, one defined loosely by a set of shared practices, rather than by a coherently defined aesthetic. Kreymborg's claim that the project was started "with no sense of the word [Others] as a group" was thus simultaneously justified and also a strategic overstatement of the radical autonomy of the collectively represented Others.[116]

Though it was not public, Kreymborg violated his policy of refusing to engage with criticism on at least one occasion, and that was to write to object to Alice Corbin Henderson's review of the first *Others* anthology in the May 1916 issue of *Poetry*. Henderson's review was exemplary of the bemused public reception that *Others* characteristically elicited, but it also testified to the ambiguously collective project of Others as such: "Replacing the outworn conventions of the I-am-bic school, we have now the I-am-it school of poetry. (NOTE: *Les I-am-its* are not to be confused with *Les I'm-a-gists*, who are already out-classed and *démodé*.)" She then went on to quote from a series of poems, all of which prominently featured the singular first person pronoun, before concluding, "We regret to say the printer announces that there are no more I's in the font."[117] In an immediate sense, the review openly refused to take the poems seriously, and in this way it resembled the general public reception of Others as a fundamentally comical project; such an attitude would also be evidenced in Clement Wood's appreciative, but hardly canonizing, article "The Charlie Chaplins of Po-

etry."[118] The art of Henderson's (hilarious) review, however, consisted in the way she allowed Kreymborg's individualist apology to become an ironically unifying formal feature of the poems themselves; the wish of Others to establish itself beyond the parameters of a "school" was no less programmatic, Henderson implied, than either phase of imagism. It also represented a failure to recognize Others as the name for a form of social practice rather than a particular aesthetic. It is significant that when Williams wrote Harriet Monroe in defense of Kreymborg, his letter did not defend the poems but instead stressed precisely the significance of Others as a formation: "Valueless as the Others anthology may or may not be it is a fine thrust out into the dark. It has at least been a free running sewer and for A.C.H. to ignore its positive qualities for the mere accident of its contents is too bad."[119] Pound had already betrayed a similar failure of appreciation when he wrote anxiously to Monroe in December 1915 that "Kreymborg gets too many new stars for them all to be real."[120] These denigrations of Kreymborg employed a standard of cultural valuation—permanent literary value—that was not the primary horizon of the Others project (the "accident of its contents"). And this insistence, indeed *agreement*, upon the badness of *Others* makes it all the more striking to observe that the *Others* anthologies contain far more poems that are regularly taught and anthologized today than do the imagist anthologies, and they contain still more work by poets ready for rediscovery (Bob Brown, Adelaide Crapsey, Helen Hoyt).[121]

Monroe made amends to Kreymborg by commissioning a second review of the anthology by Max Michelson, which appeared to acknowledge (although negatively) the qualitative difference of the Others concept—"I assume that Miss Monroe, whose editorial ideal evidently is for poems of more artistic permanence than many in this volume are, will agree with me"—before recognizing Kreymborg in a decidedly more muted, even patronizing register than he had used a month earlier in his review of Pound's *Catholic Anthology*: "When one tries to realize clearly all the drudgery, toil, and self-sacrifice involved in such pioneer editing, one must extend to Mr. Kreymborg hearty good wishes for success in his venture."[122] Michelson's semiconciliatory review also revealed the extent to which, for all his performed reticence, Kreymborg was nevertheless widely understood to be the governing figure of Others. This recognition could also take less patronizing forms. When Kreymborg arrived in Chicago in 1916, Carl Sandburg (whose poems had already appeared in *Others*) presented him with a poem titled "Others," written in the style he associated with the journal:

Ivory domes . . white wings beating
 in empty space . .
Nothing doing . . nuts . . bugs . . a regu-
 lar absolute humpty-dumpty busi-
 ness . . pos-i-tive-ly . . falling off
 walls and no use to call doctor,
 lawyer, priest . . no use, boy, no use.

O Pal of Mine, O Humpty Dumpty,
 shake hands with me.
O Ivory Domes, I am one of You:
 Let me in.
 For God's sake—let me in.[123]

What should be emphasized in Sandburg's poem is that Kreymborg, as the
honorific but also diminished "Humpty Dumpty" (read also: "Krimmie"), is
synonymous with the collective "You" of Others—over and against, per-
haps, Williams ("doctor") and Stevens ("lawyer").[124] Synonymous with the
Others collective, Humpty Dumpty is nevertheless also given the authority,
almost literally, of a gatekeeper: "I am one of You: / Let me in."

There were other, material factors that informed Kreymborg's ever-
increasing authority within the Others formation. Arensberg had aban-
doned the project by the time the first issue of *Others* appeared in July 1915
(though he funded the first year of the little magazine's production). By the
end of that year, Kreymborg had moved back to Greenwich Village, taking
the operations of *Others* with him. Whereas Knopf's agreement to publish
the first *Others* anthology in March 1916 led to the temporary securing of
a new financial backer, John Marshall, the Others project had already, in
Churchill's words, "entered a volatile phase that would continue until the
end of its run, characterized by shifting boundaries and aims, erratic appear-
ances, and changing editorial controls and alliances."[125] In response, Kreym-
borg's activity increasingly took the form of an investment in the long-term
viability of Others as such.

As the Others project entered into its "volatile phase," a disagreement
developed, primarily between Kreymborg and Williams, over the question
of the value of establishing Others as a provisional institution. In Kreym-
borg's view, the benefit of the anthology was to have allowed Others to be
established as what could anachronistically be called a franchise. By the end
of 1916, Kreymborg was proposing a series of additional Others projects: a

bookshop, a book series, a series of pamphlets, a lecture bureau, the Others Players, even a Spanish language edition to be titled *OTROS!* In a November 1916 letter to Williams, Kreymborg argues, "My letter from Bogie [Maxwell Bodenheim] argues that the name, Others, must go on as a weapon. . . . we might do things on the road, in Rutherford, etc., or in town, privately—to which end everything Others does in the way of occasional publications would contribute, and eventually a complete combination of forces, i.e., Others, Provincetown, musicians, etc. might be effected. Everything we have on record, or in prospect, as an independent body, would strengthen our position, would give us votes, in any collaborative effort."[126] Kreymborg, in other words, was now proposing that the term be used still more broadly as the marker of a provisionally institutionalized avant-garde of which he could claim a form of symbolic ownership. The dust jacket of the 1917 anthology now openly declared the book to represent "Mr. Kreymborg's interesting movement."

Whereas Williams had defended Others's value as a "free running sewer," he would soon take an antithetical position. Writing a premature obituary for the magazine in the *Egoist*, he publicly lamented what he saw as Kreymborg's crucial failure: "he insistently spoke, alas, not for the poems, but for Others."[127] Williams was nevertheless still attempting to revitalize the journal. The first innovation was the installation of a "competitive number" (July 1916), which included a single poem from twenty-two poets, thereby enhancing the individualist ideology of Others, although also perilously approximating the model of *The Lyric Year*. After a series of innovative but sporadic additional special issues (a Central and South American issue, Helen Hoyt's "Woman's Number," the notorious "Spectric School" issue, a "Chicago Number," a "Play Number," "A Number for the Mind's eye, Not to be read aloud"), Williams definitively finished its run in the summer of 1919 with a combative rant titled "Belly Music." As Williams defended himself thirty years later, "I know Kreymborg . . . thought I had sabotaged it at the end. But it was finished. It had published enough to put a few young men and women on their feet . . . but had really no critical standards and offered only the scantiest rallying point for a new movement."[128]

Williams's account is not to be taken as definitive. Johns's memoir is not unique in describing Kreymborg's "remarkably loyal following," and Williams himself acknowledged, in the *Egoist* piece, that "Kreymborg was the hero."[129] Indeed, perhaps the most decisive point of comparison between Dreier and Kreymborg may consist in the special solidarity expressed to

them by the artists they represented. When Dreier worked to consolidate the Société Anonyme collection, years after its peak activity, artists were eager to donate their work. John Storrs would write to Dreier, "you can imagine how happy I am to be represented in such a collection—the collection *avant le* [sic] *lettre* of collections in America."[130] Similarly, Robin Schulze has reported Marianne Moore's willingness to allow Kreymborg to print "her entire output of new poems for late 1916 and early 1917" in the 1917 *Others* anthology.[131] Writing in to the *New York Times* in 1950, Dreier could have been speaking for Kreymborg as well as herself when she asserted (in response to a critical review of her recently published Société Anonyme catalogue), "You have overlooked the point that it is 'the many' who create a movement—not the isolated leaders. It is this we have emphasized which makes the Collection of such historical value."[132] The attitude against which Dreier inveighed is one that has proven if anything more pernicious in literary scholarship; as Churchill points out, it was just a few years after *Others*'s collapse that four now-canonical poetic monographs appeared almost simultaneously from poets whose work had found an early voice in Kreymborg's magazine: Loy's *Lunar Baedeker*, Stevens's *Harmonium*, Moore's *Observations*, and Williams's *Spring and All*.[133] If Kreymborg was himself a minor poet, Dreier was a still more minor painter. But when Margaret Anderson told a colleague that she did not like Kreymborg's verse, the reply came, "Oh but you would if you knew him."[134] The value of his and Dreier's labor lay elsewhere, in the more ephemeral practices of collecting.

Reprisal Anthologies

Nineteen sixteen, the year of the first *Others* anthology, was also a high-water mark for the poetic anthology more generally. It saw numerous novelty collections such as J. Earl Clauson's *Dog's Book of Verse*, P. Anderson Graham's *The "Country Life" Anthology*, and Susan Tracy Rice and Robert Haven Schauffler's *"Mother" in Verse and Prose*; it also featured patriotic collections such as J. W. Cunliffe's *Poems of the Great War*. That same year another trend of political, ethnographic, and identitarian anthologies, whose strategies would be taken up more systematically in the next decade, also became visible: Padraic Colum and Edward J. O'Brien's *Poems of the Irish Revolutionary Brotherhood*, John A. Lomax's collection of *Cowboy Songs*, Joseph Friedlander's *Anthology of Jewish Poetry*. In England, Alfred Austin's successor as Poet Laureate issued an international anthology titled *The Spirit of Man*, and the first annual collection from Edith Sitwell's *Wheels* group

also appeared. All of these books could be viewed as the legacy of the wild success of Edward Marsh's *Georgian Poetry* series, but in the United States they were equally influenced by the modernist example set by Pound's first anthology and extended by Lowell and Kreymborg.

But there were four, not three, important modernist anthology projects that succeeded the introduction of *Des Imagistes* in the United States. Along with *Some Imagist Poets*, *Catholic Anthology*, and *Others*, we must also include the notorious *Spectra*, which appeared eight months after the first *Others* anthology in November 1916. Writing pseudonymously under the names Anne Knish and Emanuel Morgan, Arthur Davison Ficke and Witter Bynner together contrived the new school of "spectrism" to great critical and public attention, perpetrating a hoax so successful that it was not until 1918, with the United States then at war, that it was exposed. In his historical account of the hoax, William Jay Smith insists that the primary target of the hoax was Lowell; more recent considerations from Churchill and Cristanne Miller have situated it more closely to Kreymborg and *Others*. It is best understood, however, as a skillful manipulation of devices and procedures that had been developed by all three figures—Pound, Lowell, and Kreymborg—for the circulation and promotion of free verse, and it focused on the anthology as the primary medium of reception.

As had been true for *Catholic Anthology* and *Others*, the *Spectra* anthology appeared under the imprint of a small press. The publisher Mitchell Kennerley (erstwhile patron of *The Lyric Year*) may have been especially pleased for a volume that could compete with *Others*, which had been published by Kennerley's former protégé Knopf. Himself in on the hoax, Kennerley also suggested that "Knish" and "Morgan" write an article on "The Spectric School of Poetry" for his journal *Forum*, thus preparing a reception for the volume in a way that resembled the documents that had gradually disclosed the existence of *imagisme* in *Poetry*.[135] That the "school" should be the domain of just two poets (a third, Elijah Hay, the *nom de plume* of Marjorie Allen Seiffert, was added for the special "spectric" number of *Others*) represented a *reductio ad absurdum* of the notion of group formation and thus hewed more closely to Lowell's and Pound's strategies than it did to Kreymborg's. (Pound, we recall, had written that "[a] school exists when two or three young men agree, more or less, to call certain things good.")

The volume also included a manifestic preface, which only *Some Imagist Poets* could claim, but its psychologistic rhetoric—"the term spectric relates to the reflex vibrations of physical sight, and suggests the luminous appear-

ance which is seen after exposure of the eye to intense light, and, by analogy, the after-colors of the poet's initial vision"—more closely resembled Pound's "doctrine of the image": "that which presents an intellectual and emotional complex in an instant of time. . . . I use the term 'complex' rather in the technical sense employed by the newer psychologists, such as Hart."[136] On the other hand, the preface's valedictory disclaimer—"the members of our group would by no means attempt to establish a claim as actual inventors of the Spectric method"—more closely approximated the mode of Lowell's anthologies.[137] But in stating from the outset that the method was "not so wholly different from the methods of Futurist painting," Ficke (as Knish) both named the movement from which Lowell and Pound were so eager to distinguish themselves and laid bare the troubled aspiration of free verse to provide for itself the cultural legitimacy of modernist painting. Pointing to this very anxiety, Ficke's abstract design for the cover of the anthology, which superimposed a black triangle on top of a white triangle, was a clear reference to the cover of the *Catholic Anthology*.

Subsequent poems by Knish, Morgan, and Hay appeared in modernist journals such as the *Little Review*, a rush of exposure that culminated in the special issue of *Others* in January 1917. Because of the special attention that *Others* devoted to the spectrists (and here we could also point to the way this support belies Kreymborg's testimony against "ismism"), Kreymborg has sometimes been taken as the greatest victim of the hoax. But I am in agreement with Churchill's assessment that the affiliation of the spectrists with *Others*, by involving the participants "in a poetic discourse that was not 'purely technical,'" revealed the "ineluctably social" dimension of collective formal experiment.[138] The unique emphasis the Others formation placed on "specialized practice," over against the permanent value of its individual works, made it relatively immune to the logic of the spectrist attack. It is hardly inconsequential, as Churchill notes, that Bynner would continue to write under the Emanuel Morgan pseudonym as late as 1927, almost a decade after the hoax was exposed.

If the reception of *Spectra* eventually muted Bynner's hostility to the culture of free verse, with its dangerous "formal laxity, cultish behavior, and superficial fads," it is important to consider more deeply the specific form that hostility took.[139] Miller rightly points out the central role in the hoax of the figure of the female Jewish poet Anne Knish, which she ties to the three female poets most closely affiliated with *Others*: Mina Loy, Lola Ridge, and Marianne Moore. The work of these three poets, in this account,

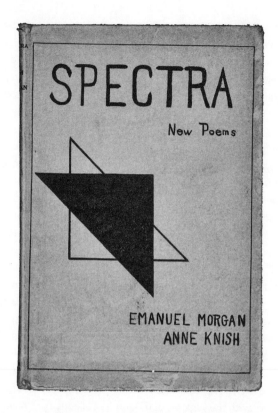

Emanuel Morgan and Anne Knish, *Spectra: A Book of Poetic Experiments* (1916). Arthur Davison Ficke's cover image conflates the Star of David with an abstract representation of interracial sex ("the most scandalous and indictable design known to the Western World"), thus lampooning what the spectrists saw as the miscegenating desires of the downtown avant-garde. Emanuel Morgan and Anne Knish [Witter Bynner and Arthur Davison Ficke]. *Spectra: A Book of Poetic Experiments*. New York: Mitchell Kennerley, 1916. Courtesy of the Division of Rare and Manuscript Collections, Cornell University Library.

exemplified a general commitment on the part of the journal to representing "the hybrid position of the immigrant and Jew as vitally associated with that of the new poet."[140] The attitude Miller has identified in *Others*, moreover, was not restricted to this journal but was even more clearly expressed in Joseph Kling's Greenwich Village little magazine the *Pagan* (founded in 1916), which soon issued an anthology of its own that included translations "from the Jewish" of the immigrant writers Moishe Nadir, Monnie Laib, and

Ovro'om Raisin, along with Maxwell Bodenheim, Mary Carolyn Davies, and work from a very young Hart Crane.[141]

Both Miller and Churchill imply that "Anne Knish" was offered as a figure that satirized the cosmopolite (and New Woman) affiliations represented by *Others* (and are still more evident in the *Pagan*). This was evident in the spectric verse itself, as they demonstrate, but it was nowhere more baldly—and shamefully—expressed than in Ficke's cover design, which was a clear pastiche of the Star of David.[142] Ficke never acknowledged this, but he made a more telling admission when he later recalled, "It is fortunate for Kennerley, Bynner, and myself that the guardians of morality in These United States never detected the obscene significance of the design I made—for, as any one can readily see, I dared to depict, twice over, the 'Loves of the Triangles,' in all their unashamed nakedness. It is probably the most scandalous and indictable design known to the Western World."[143] Working from this admission, it is impossible to avoid the implication that Ficke's superimposition of a black triangle over a white triangle was an abstract depiction not only of the figure of Judaism, but of interracial sex. *Spectra* thus lampooned the miscegenating aspirations of the downtown free verse project and thereby anticipated one of the key complaints of Laura Riding and Robert Graves's *Pamphlet against Anthologies*. The full force of Bynner and Ficke's satire, as would be true also of Riding and Graves's critique, consisted in its negative association of a collective ethnic identity with the vagaries of modernist collectivity.[144] A decade later, Alain Locke's *New Negro* anthology would make a similar set of associations with the aim of redeeming both racial and modernist collectivities; Locke consciously borrowed the language of international modernism—for example, citing his movement's "consciousness of acting as the advance-guard of the African peoples"—while also asserting that "[a]s with the Jew, persecution is making the Negro international."[145]

The ludic tactics of the Spectra hoax obtained a more official and institutional form in *The Masque of Poets*, a 1918 collection that marked the end of the first phase of modernist anthologies. The project had begun in February 1917 as a monthly feature, also titled the "Masque of Poets," curated by Edward J. O'Brien for the mainstream journal the *Bookman*. Each installment of the series in the *Bookman* printed a few poems without authorial attribution. The aim, in O'Brien's words, was "to define the quality of the best contemporary poetry as poetry, rather than as the literary production of writers whose work was sought by the public because of the personali-

ties which produced it."[146] Although it made a show of promoting its disinterested evaluation of individual poems, O'Brien's language was weighted against the tactics of modernist promotion, and his deeper aim was to erect a limit and telos for the free verse project as such: "the circle which begins with the Greek Anthology is completed in Imagism, as the circle which begins with Crabbe and Ebenezer Jones is completed in the social poetry of America to-day. . . . Five years from now it would be interesting to repeat this experiment, and I think that the results would prove that very little change had taken place in the substance of our poetry."[147]

At the end of a year, the poems were collected together in *The Masque of Poets* anthology. Here they were no longer presented anonymously, thus effecting the poets' inevitable "unmasking"; it was an obligation, O'Brien implied, necessitated by public demand. But O'Brien's project had never been as hostile to the question of poetic personality as he pretended. From the very first issue, the *Bookman* had provided a list of the poets who had agreed to participate, and this amounted to a veritable who's who (with the unsurprising exception of Pound) of figures who had contributed to the free verse movement, together with more conventional poets: Alfred Kreymborg and Maxwell Bodenheim from the core Others group; Amy Lowell and John Gould Fletcher from *Some Imagist Poets*; Carl Sandburg and Vachel Lindsay; Conrad Aiken, who had written the negative review of Lowell's first anthology; William Stanley Braithwaite, who had reviewed it positively; Witter Bynner and Arthur Davison Ficke, the perpetrators of *Spectra*; and Edward Arlington Robinson and George Sterling, both of whom had auditioned as potential third spectrists.[148] Two years earlier, O'Brien had coedited *Poems of the Irish Revolutionary Brotherhood*, an American anthology that featured the poetry of four executed leaders of the Easter Rising and a lengthy and tendentious introduction by Padraic Colum.[149] With *The Masque of Poets*, O'Brien repressed the social claims that had been specific to the form of the politically interventionist anthology, thus presenting under the banner of what he called "friendly rivalry" a new articulation of the national expression of *The Lyric Year*.

In its effacement of both aesthetic and political disagreements, *The Masque of Poets* paved the way for the still more official, nationally identified series of *American Poetry* miscellanies we considered near the beginning of this chapter. That the semiannual *American Poetry* project included so many established poets—including several who had contributed to O'Brien's "masque"—heavily ironized its claim to exhibit a "society of

independents."[150] It instead demonstrated how easily an "independent" an-
thology could be shorn of any pretension to an oppositional or vanguardist
function, and it also indicated a desire to neutralize the highly politicized
reception of the first Society of Independents exhibition (which will be
discussed further in the next chapter) by appropriating the logic of "No
Jury—No Prizes" to this end. It would require the negative example of the
Quinn sales (beginning in 1924) and the subsequent establishment of art
collections as modes of symbolic affiliation, intervention, and ownership
to demonstrate anew the social possibilities that could be embraced by the
collective form of the anthology.

After the crisis of cultural valuation of the early 1910s, and amidst the
growing public enthusiasm for modernist art and literature, the critical
activity engaged in by anthologists and art collectors alike turned on the
question of how modernism's popular reception might effect a broader
transformation of United States culture more generally. It was in this milieu
that new forms of collectivity would emerge as the object of modernist
collections; if the avant-garde could no longer present itself as a minority
culture, minority culture would in the following decade collect itself—or be
collected—as an avant-garde.

2 The Domestication of Modernism
The Phillips Memorial Gallery
in the 1920s

Pictorial Publicity

By the 1920s, and particularly after the Quinn auction, collectors of modern art in the United States were loosely cooperating in a general project of popularizing modernism, as well as competing for influence over the mode of its reception—competing, in other words, for the meaning of modernism itself. Of all of these collectors, it was Duncan Phillips who most successfully anticipated the dominant cultural position that modern art would occupy by the 1950s, even though his canon of artists would not be identical to the one that would be enshrined at the Museum of Modern Art. Among his signature practices were the now-customary procedures of borrowing and lending works and the organization of special modernist exhibitions (for his own galleries as well as for civic museums). This groundbreaking work, however, had in some crucial ways been preceded by the activities of Katherine Dreier and the Société Anonyme in the 1920s. The Société Anonyme had staged the enormous International Exhibition of Modernism at the very moment that John Quinn's collection was being dissolved, and Dreier had also coined the phrase "Museum of Modern Art" a decade before Alfred Barr took the name for his institution in midtown Manhattan.[1] But the Société Anonyme's peripatetic mode of exhibition, along with Dreier's desire for a more broadly socialized audience for modernism, prevented the Société from cultivating the institutional authority that the Phillips galleries and collection have long enjoyed. After a late attempt to establish her Connecticut home as a public gallery at the end of the 1930s, Dreier bequeathed most of the Société Anonyme collection to Yale University, with Marcel Duchamp's *Large Glass* (1915-23) going to the Arensberg collection at the

Philadelphia Museum of Art. Seventeen other pieces went to the Phillips Collection after Dreier's death in 1952.

It was therefore symbolic in more than one register when the Phillips Collection was among the five institutions to host the 2006-7 exhibition The Société Anonyme: Modernism for America, which brought to Washington, DC, a sizable portion of Dreier's collection.[2] Even more than the Philadelphia Museum's 1999 Mad for Modernism exhibition, which reunited the smaller but more heterogeneous collection of Earl Horter, the Société Anonyme retrospective permitted a glimpse at one mode of modern art's early reception and organization in the United States. Especially memorable was the first gallery, which recreated the effect of the Société's first public exhibition by installing white oil cloth on the walls, gray industrial rubber flooring, and electrolier lighting, while framing each of the paintings with paper doilies (the last of these being the contribution of Dreier's collaborator Duchamp). Yet the very prosperity of the Phillips, which was then celebrating a third expansion of its buildings on Dupont Circle, meant that a palpable subtext of the superb retrospective was Dreier's failure to have provided a permanent building and endowment for her institution.

Indeed, after the imminent move of the Barnes Foundation, the Phillips will be the only modernist collection of the 1920s to remain in its original institutional setting. First opening its doors in 1921, the Phillips is known today for its unparalleled collection of paintings by Pierre Bonnard, for its extensive and important collections of Braque and Georges Rouault, and for one of Pierre-Auguste Renoir's greatest paintings. It was an early supporter of several American modernists; can claim extensive holdings in the work of Arthur Dove, John Marin, Karl Knaths, and John D. Graham; and was among the earliest supporters of figures as diverse as Paul Klee, Milton Avery, and Horace Pippin. By midcentury it was still making major acquisitions from contemporary artists, including half of Jacob Lawrence's monumental *Migration Series* (originally titled *The Migration of the Negro*, 1940-41, purchased in 1943). The continued vitality of the Phillips can be gauged by its continuously expanding collection and buildings. If three significant additions (in 1960, 1989, and 2006) have obscured its original identity as an intimate, domestic set of galleries, it has also strived to maintain a connection to this initial identity. It was with Mark Rothko's approval and assistance that a group of his paintings was hung in a special room in the 1960 annex; now housed in the 2006 annex, the Rothko Room preserves the exact dimensions and qualities of its original installation.[3]

But the early and sustained success of the Phillips cannot be explained solely in terms of its superlative collection or buildings. Equally important was its particular situation within the cultural field, a position from which it became possible for the Phillips Memorial Gallery[4] to exercise an influence over modernism's public reception without being tarred by the brushes of propaganda or radicalism. Using his Dupont Circle mansion as both a literal and figurative home for modern art, Phillips promoted an identity for modernism shorn of its extremist, collectivist associations; his openness to abstraction and experimentation would be coextensive with his gallery's enshrinement of the artist as individual. At the same time, the gallery's institutional program solicited public support for modern art and artists in such a way as to oblige the artist to be responsible to his audience. Through the activity and example of his collection, Phillips aimed in effect to orchestrate and revive a critically engaged public sphere.

Phillips's authority within the transforming cultural field of the 1920s, significantly, preceded his commitment to modernism. He had, for example, written scathing reviews of the Armory Show in 1913 and the Society of Independent Artists exhibition in 1917. His art collection included virtually no postimpressionist acquisitions by the time of John Quinn's death in 1924. Yet it was nevertheless Phillips's advice that was solicited by Quinn's executors as they wrestled with the fraught question of how the Quinn collection would be dissolved. Citing a superfluity of willing "experts," Quinn's executors singled out Phillips's "disinterested[ness]" and "ability," implying that his ambivalence qualified him above those more identifiable as modernist ideologues.[5] Compared to Phillips, Dreier and Quinn's old antagonist Albert Barnes had been more polemical exponents of modernism, and they each had amassed stronger and deeper art collections by 1924.[6] Yet as was then true for neither Dreier nor Barnes, Phillips had both incorporated and opened his gallery, and he had made the major and well-publicized—but also more measured—acquisition of Renoir's *Le Déjeuners des Canotiers* (1880-81), bought from the collection of Paul Durand-Ruel at the cost of $125,000.[7]

Still another factor that undoubtedly recommended Phillips to Quinn's executors was his patrician background. His mother came from a prominent Pittsburgh steel and banking family, and his father was an industrialist who had been an officer in the Civil War. Phillips's family, his connections within the art establishment, and indeed his distrust of modernist polemics all helped to advance him within an aesthetic-financial world guardedly

preparing to accept modernism into its institutions. When Phillips turned his own collection toward modernism—and it is likely that the drama surrounding the Quinn collection helped finally to convince him of the opportunity that such a commitment promised—he also became engaged in the question of the way modernism might transform cultural institutions and social life.

Phillips began collecting art with his brother James in 1916, a venture supported by a $10,000 annual allowance provided by their father. Early acquisitions were weighted strongly toward American artists such as George Luks, Albert Pinkham Ryder, and John Henry Twachtman.[8] At its inception, the art collection was only imagined as a private pursuit, not as part of a larger program of public culture. But Phillips had already been fashioning himself, in his words, as an "interpreter and navigator between the public and [art]."[9] By the time he and James made their first acquisitions, Phillips had been active as a critic for more than a decade and had edited a collection of his essays as *The Enchantment of Art* (1914), a monograph that was ecstatically received in the pages of the *Little Review* (despite its including the searing Armory Show piece).[10] In 1917 he was elected to the Century Association, an establishment New York club for gentleman artists, where he would build friendships with the Princeton art historian Frank Jewett Mather and the artists Gifford Beal and Augustus Vincent Tack.[11]

As the United States entered the war, Phillips went to work in the Division of Pictorial Publicity, a federal program that commissioned American artists to produce posters and other materials to promote the war.[12] With the aid of Tack and the collector A. E. Gallatin, Phillips's government work culminated in organizing the Allied War Salon, an exhibition that brought together posters, lithographs and other government propaganda, drawings from soldiers at the front, and oil paintings promoting the Allies' themes by artists including Luks, George Bellows, and Childe Hassam.[13] As Phillips would describe the project at the end of the war, "the continued existence of art and of all that artists hold dear, had been imperiled by the recrudescence of a barbarism . . . arrogantly devoid of soul. . . . [O]ur American contribution [to the war] ushered in the reign of practical Idealism upon Earth. We wanted the Allied War Salon to express . . . the Holy Alliance."[14]

Such aggressive nationalism was hardly unique in 1917; the Allied War Salon was in this respect of a piece with the surfeit of patriotic poetry anthologies then appearing in the United States and Britain.[15] Phillips's work by the end of the 1920s would itself constitute an implicit repudiation of this very

rhetoric. But it is nevertheless vital to understand the way such sentiments were coextensive with Phillips's early hostile position toward modernism. Four years before the Allied War Salon, Phillips had decried the Armory Show's "orgy of the subjective," which featured "anarchists, not artists."[16] Although the exhibition had featured American artists, Phillips made a point of asserting that the Armory Show's "sensationalism [had been] imported from the old world," and he pointedly insisted that the best remedy was not to return directly to conventional European values, but to trust instead in "the inspiring self-reliance of our own [nineteenth-century] American masters, George Inness and Winslow Homer."[17] By the time of the Society of Independent Artists exhibition, Phillips was ready to make a more striking set of connections: "As I hurried up and down the aisles of [the Grand Central Palace] trying to find my way out of that maze of madness like a dreamer imprisoned in a chamber of horrors, I kept repeating, and I must have said it aloud, 'War is a good cleanser. We need war.' . . . When the sufferings of war have in their inscrutable way ennobled what remains of humanity, art is sure to appear more human, more humane, more inspiring, above all more sincere and contemptuous of sham."[18] The rhetoric of a martial purge of the avant-garde was precisely the attitude that had already been summoned by Joyce Kilmer against imagism in the pages of the New York Times, as we have seen. As the United States prepared to enter the war (the SIA show opened in April 1917, a week after Woodrow Wilson delivered his "War Message" to Congress), Phillips could connect the subjectivism and primitivism of modern art with German "barbarism." This insight was especially insidious since the great majority of exhibitors in need of cleansing from the SIA show were United States citizens, among them contributors to Others and future members of the Société Anonyme. The formally traditional art displayed at the Allied War Salon in the following year was thus in a sense deployed on two fronts, explicitly rallying support against Germany and its allies while also setting an example against the modernists in the galleries.

Both were home fronts. In a speech given at the College Art Association the year after the Salon, Phillips stressed that the production of aesthetic propaganda was critical since it is "[t]he only way we can fight anarchist and pacifist propaganda and save ourselves from sad experiences with our own Bolsheveki."[19] This reference to the recent Russian revolution, and to anarchism and pacifism, indicates that Phillips's earlier designation of the Armory Show artists as "anarchists" was not metaphorical. Members of Kreymborg's Others group had affiliations with anarchism, and, as Allan

Antliff has shown, a faction of the Armory Show's supporters had itself been eager to demonstrate a connection between political anarchism and modernism. Three months earlier, Leon Trotsky's visit to New York heralded "the second Russian Revolution" Trotsky believed imminent in the "city of prose and fantasy, of capital automatism, its streets a triumph of cubism."[20] This tendency of critics and advocates alike to construe the aesthetic avant-garde as politically anarchist clarifies Raymond Williams's thesis concerning the perceived relationship between "crises in [artistic] technique" and "a sense of crisis in the relationship of art to society": "what had been isolated as a medium . . . came to be seen, inevitably, as social practice; or, in the crisis of modern cultural production, as a crisis of social production. This is the crucial common factor, in otherwise diverse tendencies, which links the radical aesthetics of modernism and the revolutionary theory and practice of Marxism."[21] Taken as a piece, Phillips's early writings demonstrate that such associations could be recognized by radicals and conservatives alike.[22]

Even as the resolution of the war allowed him to abandon his militaristic tone, Phillips would continue to understand the relationship between modernist and academic art in social terms. In 1921, the Phillips Memorial Gallery's first official publication eulogized the recently deceased American impressionist Julian Alden Weir in the context of the aristocracy of the American South:

> "From the America of immigration and quantity production [Weir] stood apart. His task was to fix the survival of the older America," the Anglo-Saxon America of the founders of our old families. . . . We may be a shirt-sleeves democracy, but we have our own standards. The attitude of the average American to that indefinable, unmistakable something which the old colored servants of the South used to call "quality"—the quality of their masters—curiously corresponds to that indefinable, unmistakable something in a work of art which artists and critics also call quality, recognizing an air of esthetic aristocracy.[23]

Just as the formal "anarchists" of the Armory Show signaled fears of political anarchism, Phillips divined a necessary correspondence between the aesthetic "quality" embodied by Weir's painting and the social "quality" that the "old colored servants of the South" reportedly recognized in their masters. From this position, a "shirt-sleeves democracy" was acceptable insofar as it did nothing actually to violate an immanent and archaic principle of aesthetic and social "aristocracy."

The point of reviewing these earlier positions is not to expose a secret set of commitments lurking behind the ideology governing the Phillips in the later 1920s, which was liberal cosmopolitan and took seriously the possibility of a democratic form of arts patronage; rather, it is to provide relief and a point of origin for the new positions that emerged as Phillips opened his collection to the public and then turned it toward modernism. Even as he would advertise his new political sympathies, doing so in concert with his support of abstract art, Phillips's later commitments cannot always be characterized as simple reversals of his earlier positions. His homily to Weir is worth revisiting precisely because the domestic scene of the American gentility would play such a fundamental role for the identity of Phillips's institution. Phillips's public turns toward modernism and toward the provisional institutionalization of his collection were accompanied by a strategy that confirmed his authority as an "interpreter and navigator" of the aesthetic experience. The choice to display the collection in his Dupont Circle mansion indicates the possibilities and obligations Phillips wished to unite under the sign of the imperative domestication of modernism.

Subconscious Stimulation, a Professional Public Sphere

The public turn for Phillips's collecting practices came after the unexpected deaths of Phillips's father in 1917 and of his brother the following year. It was at this time, as Phillips would later candidly describe, that he decided to establish the collection as a memorial gallery: "There came a time when sorrow all but overwhelmed me. Then I turned to my love of painting for the will to live. . . . I incorporated the Phillips Memorial Gallery, first, to occupy my mind with a large, constructive social purpose and then to create a Memorial worthy of the virile spirits of my lost leaders—my Father, Major D. Clinch Phillips—an upright, high-minded, high-spirited soldier, manufacturer, and citizen, and my Brother, James Laughlin Phillips, who was on his way to the heights when death overtook him."[24] The gallery was formally incorporated in 1920. After a concerted period of acquisitions and promotional exhibitions in New York galleries, two rooms of the Phillips's Dupont Circle mansion opened in 1921, where a small portion of his collection could be viewed by appointment (comprising by then some 240 paintings). The Main Gallery formally opened in February 1922. Phillips meanwhile busily circulated promotional materials for the gallery and commissioned a design for a permanent building, which he then imagined as a traditional memorial.[25] In this early conception, the establishment of the galleries partici-

pated in the patrilineal concept advanced in the J. Alden Weir essay. When it was finally decided that the galleries would remain in the original Phillips mansion, it was a plan that maintained the intimate connection between the collection and the Phillips name and domicile.[26]

As Phillips's tone suggests, the sensibility governing the Memorial Gallery was less discernibly elegiac than it was therapeutic. In a promotional article written for *Art Bulletin* in 1921 (and reprinted in the gallery's first publications), Phillips characterized his galleries as "a home for the fine arts and a home for all those who love art and go to it for solace and spiritual refreshment."[27] The special weight placed on the word "home" was echoed in Phillips's exhibition techniques, which integrated his collection of paintings among the furniture and accoutrements of the household, associating the art, as Phillips would later write, with "such an intimate, attractive atmosphere as we associate with a beautiful home" (*CM* 6). Phillips provided a detailed example in the early essay:

> In all the rooms the setting will be carefully planned, and executed with the object of enhancing the effect of the paintings . . . and of producing a sympathetic background and a perfect *ensemble*. For instance, in the Twachtman room, those who know the marvelous nuances of color, opalescent and phosphorescent, in the works by this great master will be delighted to find these subtle felicities echoed in the background in choice bits of Chinese pottery, Persian lustre ware, or Greek glass. To complete the room imagine a black carpet and a wall like that in our present gallery, where a gray, transparent mesh hangs over the plaster, which is toned a delicate apricot.[28]

If the arrangements of the Phillips in the 1920s did not always evince the kind of dense orchestration that this passage describes, the situation of his artworks in a scene of patrician domesticity nevertheless remained a hallmark of the gallery. Such harmonious arrangement, as well as the "spiritual refreshment" it prized, instructively contrasts with the whimsical and vaguely industrial setting that Dreier and Duchamp had devised the previous year for the inaugural Société Anonyme exhibition, though both strategies deliberately deviated from the style of the civic museum or the academy.

It scarcely requires pointing out that Phillips's technique—situating works less as autonomous objects than as part of a motivated "ensemble" of artworks and domestic objects—is also very far from the spare formalism that would be the hallmark of Alfred Barr at MoMA, even before the museum moved to its iconic International Style building in 1939. What

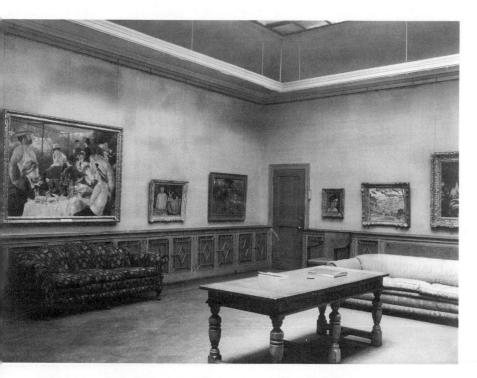

Phillips Memorial Gallery, Main Gallery, 1920s. The Phillips Collection Archives, Washington, DC.

Phillips made most explicit, however, was his practices' opposition to the *older* model of civic museums like the Metropolitan Museum of Art in New York. The Phillips Memorial Gallery opposed "the academic grandeur of marble halls and stairways and . . . the overawing effect of the formal institutional building" and refused to exhibit works according to "chronological sequence" (*CM* 5, 6). As would be true for nearly every modernist collection, Phillips's act of provisional institutionalization was in its rhetoric anti-institutional. As his preface to the collection's first catalog proclaimed, "The Phillips Memorial Gallery is, as yet, something different, something younger and more malleable than an Institution. Its Collection however is purposeful" (*CM* n.p.).

Such purposefulness involved the collection's specifically domestic situation, which, while satisfying a private therapeutic necessity, also comprised an aesthetic sensibility, promotional apparatus, and mode of interpreta-

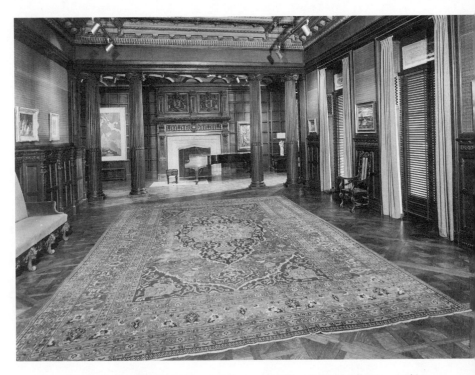

Phillips Memorial Gallery, Lower Gallery, 1920s. The Phillips Collection Archives, Washington, DC.

tion. In a phrase he would use repeatedly, Phillips described his intention to "make our visitors feel at home in the midst of beautiful things and [be] subconsciously stimulated while consciously rested and refreshed."[29] Implicit in this idea was a wish to solicit an audience that might not claim Phillips's patrician class status but was still capable of appreciating the beauty of its expression, an audience that could "feel at home" while not necessarily being at home. This technique subtly made manifest the play upon the two senses of "quality"—aesthetic and social—that had animated Phillips's essay on Weir.

Such concerted self-presentation—and its provisionally institutional quality—contrasts with some better-known examples of modernist domesticity, such as Gertrude and Leo Stein's (after 1913, Gertrude Stein and Alice B. Toklas's) Saturday salons or the numerous examples studied by Christopher Reed in his book *Bloomsbury Rooms*. Drawing, as Phillips did not do,

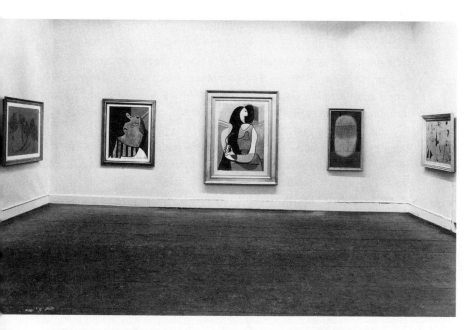

Installation view of the exhibition "Fantastic Art, Dada, Surrealism," curated by Al-
fred H. Barr. The Museum of Modern Art, New York. December 7, 1936, through
January 17, 1937. Now so naturalized as to have become paradigmatic, the austere
exhibition style that Barr crafted for MoMA was a pointed departure from the prac-
tices of Duncan Phillips, Katherine Dreier, and Albert Barnes. Digital Image © The
Museum of Modern Art/Licensed by SCALA/Art Resource, NY.

from the culture of the salon, these examples conceived of the domestic
space as a scene of creation as well as exhibition. Such environments were
designed to foster creative production among more limited cadres of artists
and intellectuals (rather than to enable what I will call a professional public
sphere), and they aimed perhaps above all to produce a constructive mode
of *sociability*, as Janet Lyon has observed in a related context.[30] James Mellow
describes the Stein atelier at 27 Rue de Fleurus as "a jumble of furniture as
well [as of art], crowding guests into a sense of intimacy"; Reed examines
Bloomsbury's desire "to create new forms of domesticity" that would form
"the basis of a new social and aesthetic order."[31] Phillips, by contrast, or-
chestrated a form of sociability among objects more than visitors, and he
invoked an *older* form of domesticity as the frame for his new social and
aesthetic program.

Dreier's practices are again an instructive point of comparison, for she also strategically displayed modern art in domestic situations. At the Société Anonyme's 1926 International Exhibition of Modernism, Dreier staged four small rooms within the Brooklyn Museum as a parlor, library, dining room, and bedroom, installing in them furniture and works from artists including El Lissitzky, Kurt Schwitters, Jean Arp, and William Zorach. The hypothetical home that the rooms modeled was not a mansion, but rather a contemporary middle-class house. Set in the middle of a huge gallery, the rooms resembled furniture showrooms; the furniture was itself procured from Abraham and Straus, which Dreier approvingly described as "the big store where the big middle class Brooklynites buy."[32] As was true for Phillips, Dreier was unconcerned with translating the sociable form of the modernist salon. Yet Phillips's program differed in its suggestion that the galleries' furnishings would be identified by visitors not so much as correspondences with their own domestic situation but as objects of material appreciation or aspiration: Phillips's "beautiful things" were presumably not from Abraham and Straus. Phillips and Dreier both intended that the aura of domesticity might be a means of overcoming the visitor's alienation in the presence of the works of art, as well as a means of liberating the work of art from its alienation within the large civic museum. But Phillips's program was less optimistic about the capability of the work of art; in his view, its agency was initially only available as a form of "subconscious stimulat[ion]."[33]

Phillips's private associations among works and objects were themselves collectively exhibited as a form of experience meant to be shared symbolically by all. Not so much a form of conspicuous consumption, Phillips's strategy was instead closer to what we might call, inverting a Bourdieuian phrase, an "*externalized* form of the class condition." Unlike Dreier, Phillips was relatively unconcerned with the question of his audience becoming future purchasers of art; the goal of his mode of exhibition was instead to cast the appreciation of art as a form of symbolic ownership, and on that basis to reorganize the sensibility of his audience. If the "beautiful things" of the galleries were implicitly objects of appreciation, the appreciation of the artworks could constitute a complementary form of cultural competency.

It has been worth considering the implications of Phillips's domesticating strategy at length because it might usefully be understood as a precondition of his turn in the mid-1920s toward modernism. As early as his review of the first SIA show in 1917, Phillips had acknowledged that "[r]ebellions

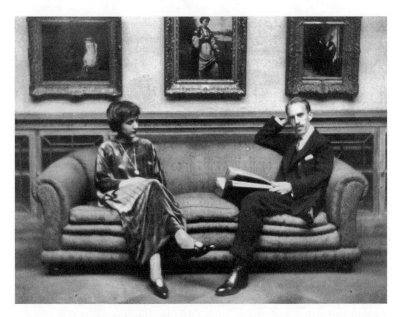

Duncan and Marjorie Phillips seated in the Main Gallery of the Phillips Memorial
Gallery, ca. 1922. Duncan strikes a comfortable pose. Photograph by Clara E. Sipprel.
The Phillips Collection Archives, Washington, DC.

in art may be . . . productive of imperishable good, or . . . of incalculable
harm. It all depends upon the people for whose pleasure and by whose
consent art exists."[34] At this point, in an otherwise aggressive and even
phobic essay, we can discern the potential for Phillips's coming rapproche-
ment with modernist forms (he recognized, for example, a resemblance
between the moment of modernism and the aesthetic and social "rebellion"
of Romanticism). But what was also evident in this essay was the awareness
of modernism's increasing cultural capital among a rapidly transforming
public. As he would go on to explain, "[o]ut of Matisse swarm the spawn
of Post-Impressionists, Cubists and Futurists, who would not have become
so fashionable with the faddists of our enlarged electorate if the eccentric
men of genius whose leadership they claim had only lived a little longer
to repudiate such contemptible followers."[35] There was a continuity be-
tween the "people . . . by whose consent art exists" and the "faddists of
our enlarged electorate." Whereas the phrase "enlarged electorate" may
have euphemistically concealed a certain anti-immigrationism, it also sig-

naled his acknowledgment that fine art in the United States was subject to regimes of popularization (including ones that he might support), and that the public could be recruited as socially responsive agents within those regimes. Thus, he concluded, "Democracy and high standards make art that is worthy of immortality. Democracy and low standards make art 'the talk of the town.'"[36]

As the problematic of "standards" indicates, Phillips had identified the characteristically modernist dilemma of determining cultural value within a democratic, market-driven society—a society in which he otherwise wished to believe. By the mid-1920s, his explicit advocacy of an "esthetic aristocracy" had been transformed by the insistence that a "renaissance" in twentieth-century America "must come not from the ever devoted few but from the awakened interest and enlightened patronage of the many."[37] Yet he would also publicly lament that the hope for a "public which really enjoys and partially understands seems more and more an idle dream," a consequence, he said, revisiting his phrase from the previous decade, of "an enlarged electorate" (*CM* 3). In several ways, Phillips's anxieties anticipate Jürgen Habermas's thesis, forty years later, of the expansion and disintegration of the public sphere—a problematic that Habermas, too, would connect to the rise of modernism.[38] As he himself turned toward modernism, Phillips concluded that the cultivation of an "enlightened patronage" would require a more systematic transformation of the cultural field than his gallery alone could satisfy, and this belief in turn pointed to multiple projects for his collection, each of which aimed to prepare the individual artwork in advance of its encounter with the public. Phillips's solution to the Habermasian problem was to propose what might be termed a *professional public sphere*, a field of intermediaries that would institutionally provide the conditions for the broader reception of contemporary art. It would be here, he believed, that the more meaningful cultural debate and activity would take place.

Thus, while the gallery's exhibition style expressed Phillips's intention to orient his collection toward the public generally, by the mid-1920s the work he viewed as most important privileged a distinct fraction of the gallery's broader audience. As he would write in 1926, "(I) We can awaken the æsthetic consciousness of boys and girls and guide them to such colleges as offer courses in the theory as well as in the history of art. . . . (II) We can do far more, however, for the matured post-graduate students of art who could be recommended to us by . . . famous art teachers" (*CM* 12-13). If

Phillips rightly intuited that college students exposed to art history classes represented a future audience for the fine arts,[39] it is particularly important to appreciate the special weight he places on the imagined postgraduate program:

> These would be the ones who go out into the world to become active workers on the side of the artists. These men and women of special fitness would be enabled to take post-graduate courses in museum work or they would become the teachers in the schools and colleges, or the reviewers for the papers and magazines, and they could become really qualified dealers or, better yet, museum scouts, able to relieve the artists of the need for selling their own works, able and willing to hold the artists up to high standards, to encourage and support with helpful criticism, to offer exhibition space to all the artists in alternating groups, to do away with the need for big miscellaneous exhibitions and their unjust professional jury system for selection and awards. (*CM* 10)

In this passage, we can see the fullest and broadest expression of the Phillips's public "purposefulness." If the collection was not yet ready to identify itself as an "Institution," comparable to the Met, it was nevertheless available for the development of a sophisticated cultural subfield that would mediate between the positions of aesthetic production (individual artworks and artists) and consumption (the public, composed of an ineluctably "enlarged electorate"). In this respect, it is important to hear the ambiguity in Phillips's programmatic declaration, "Art is part of the social purpose of the world and requires appreciation and the bonds of fellowship with all who understand. Art is meant to give pleasure—but pleasure of the right kind" (*CM* 5). Phillips is here explicitly speaking of himself, the collector who must aspire to an appropriately socialized, rather than inappropriately hermetic, ownership. But he also bespeaks the necessity of a professional public sphere charged with the responsibility of directing the *audience* toward the proper experience of art, which in turn suggests the undesired possibility of the audience experiencing inappropriate pleasure.

In the founding document of the Société Anonyme, Dreier had, like Phillips, expressed her wish for what she called "a chain of Galleries which [will] liberate the thoughts in the art world." In her view, the social agency of modern art was by definition salutary: "For there is a closer relationship between all progressive people, all people who are living in the 'now,' rather than those who belong to the past."[40] Phillips, by contrast, took a charier and decidedly less unified view of the agency of modern art as such.

Whereas his exhibitions were directed toward the issue of the public's proper reception of modernist art, what would be most decisive for his new educational program was its emphasis on the positive effect on artistic *production* that could be exercised by the mediating field of postgraduates trained at his gallery. This could be understood as an attempt to establish much more broadly what had been Phillips's own practice of offering constructive criticism to the living American artists whose work he bought.[41] The new institutional field of teachers, critics, dealers, and curators would assist artists by establishing for the public a respectable *lingua franca* about art, but it would also "hold the artists up to high standards" by the activity of that same discourse. This strategy rightly presumed the artist's desire to be represented in such institutions as the Phillips Memorial Gallery. Because these standards were by definition not neutral, the strategy also guarded against the possibility of the artist taking an oppositional position (that of the "avant-garde," in the sense of Peter Bürger's influential thesis) with respect to institutional representation or to the public as conceived by the institution. Indeed, Phillips's justly celebrated support of living artists proposed the immediate integration of the artist into society. In his view, this should be the legitimate aspiration of a culturally advanced society, but it also served the purpose of regulating the artist's activity in accordance with a responsibility to that society. While this formed part of a program whose investments could be traced all the way back to the identification of the Armory Show's "anarchists," such prescriptions also became more difficult to perceive as the collection moved to embrace abstraction and Phillips himself became more politically liberal.

By 1927, Phillips was regularly borrowing work from private collectors for his exhibitions, as well as lending significant parts of his own collection for display at public museums in Cleveland, Chicago, New York, and, especially, Baltimore. He also skillfully prepared press releases and advertising copy, cultivated relationships with influential arts writers throughout the country, and, in 1929, established the house journal *Art and Understanding*. His cultural practices would thus provide a model for, but not exclusive domain over, a new social position for modern art within American society. As he would write, "We should at least aspire to another Renaissance, another age of far-sighted patrons, of an enlightened public, of artists liberated by patrons and public but most of all by trained critics from the need of being organized manufacturers and self-advertisers of sentimental, standardized, smart, sensational pictures instead of fine ones. It is my hope

that there will be other small galleries like ours all over the country—and around them art libraries and lecture rooms to develop and to train critics by contact with pictures thoughtfully exhibited" (*CM* 11). The carefully limited parameters of Phillips's social claims, combined with a relative lack of a demand for authority over those claims, have informed the enduring prosperity and influence of the Phillips Collection. The program implied that a new field of cultural mediators would, like the artists themselves, be integrated within the already existing social structure, without making specific claims on the transformation of that social structure. The wish to facilitate "pleasure of the right kind," in other words, could be seen as a renewed, if translated, appeal for the apprehension of the "esthetic quality" that he made in his earliest writings, one that derived its moral authority from an American gentility that now imagined its situation among, not above, an expanding electorate.

Problems in Collecting Pictures

Phillips's thoughts about postgraduate training appeared in *A Collection in the Making*, the fifth book to be published under the gallery's imprimatur. It provided the most programmatic statement to date of the principles that guided the gallery, and it also included a catalog and assessment of the collection, which by then had finally committed to modernism. Appearing in 1926, the book also signaled Phillips's bid for authority within the field of modernist public culture; it may be read in the context of the opening of the Barnes Foundation (in 1925), the Société Anonyme's Brooklyn exhibition (1926), the Quinn auction (1927), and the opening of A. E. Gallatin's Living Gallery (1927).

Lending itself to many subsequent publications, the phrase "a collection in the making" has since become a motto for the Phillips Collection, signifying the continual evolution and expansion of the collection. Phillips's book also carried a laborious and somewhat clinical subtitle—*A Survey of the Problems Involved in Collecting Pictures together with Brief Estimates of the Painters in the Phillips Memorial Gallery*—that indicated the difficulties of directing the collection toward the wider objectives we have just surveyed. The subtitle also described the dilemmas that were particular to acquiring contemporary art. When Phillips wrote in the book's preface that the gallery was "as yet something different, something younger and more malleable than an Institution," he was writing, as other modernist collectors would, against the intractability of established museums' attitudes toward new work and

audiences. Phillips offered a program for overcoming such intractability by describing a certain ethos of evolution he felt was particular to his collection. If a permanent group of artworks was still a project "in the making," Phillips could buy and also sell pictures "learning from [his] mistakes" along the way: "Why not open the doors to all who would come and watch the building of the edifice—watch the laying of stone upon stone?" (*CM* 4). In this sense, the "problems involved in collecting pictures" became a formal principle of exhibition at the galleries.

Phillips's words also conveyed a subtly polemical purpose that led away from the ostensible mutability of the collection. By claiming it to be "as yet" more fluid than a museum, Phillips explicitly situated his gallery as a provisional institution, while holding out the possibility of the collection's future solidification.[42] In so doing, Phillips was making a covert argument, too, about the destiny and meaning of modernist innovation. This was a matter of great relevance because the publication of *A Collection in the Making* also announced Phillips's new acceptance of artists he had pilloried a decade earlier, most notably Picasso, Matisse, and Cézanne. If Phillips's earlier attitudes were "mistakes," corrected over the course of his personal development, this temporal dimension was also coextensive with the likelihood of the Phillips Memorial Gallery one day becoming an "Institution." Phillips did not in this book directly address his conversion to modernism, and the apology for his earlier resistance was only available by inference.[43] But it was a clear implication of *A Collection in the Making* that modernism should be required to prove itself in relationship to an accepted tradition of earlier work. By 1929, the year MoMA opened its doors, Phillips would move still farther in this direction, describing the gallery as "a museum of modern art and its sources."[44]

Preparing the way for this new orientation had been the purchase, in 1923, of Renoir's great *Déjeuner des Canotiers*, which Phillips intended to be the cornerstone of his growing collection. The acquisition received full-page notices and reproductions in the *New York Times* and in the *Arts*, where Forbes Watson named the work "one of the most delightful paintings of the modern era."[45] The Renoir, a painting then forty years old, was perfectly positioned as a superlative example of a modern masterpiece, satisfying an unassailable standard of acknowledged quality—comparing Renoir to Rubens and Titian, Phillips named the painting "a culmination of the sumptuous representative and decorative art of the Sixteenth and Seventeenth Centuries"[46]—while also indicating an orientation toward the present moment

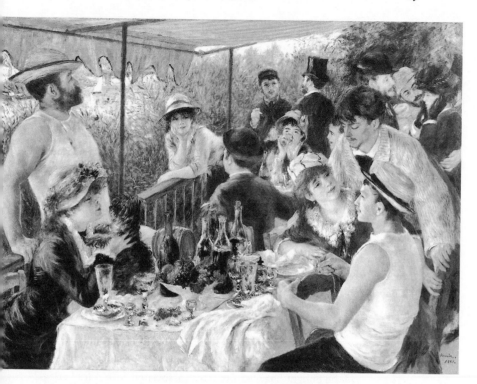

Pierre-Auguste Renoir, *Luncheon of the Boating Party* (*Le Déjeuner des Canotiers*), 1880–81. Oil on canvas, 51¼ × 69⅛ inches (130.2 × 175.6 cm). An unassailable modern masterpiece and the cornerstone of the Phillips collection. The Phillips Collection, Washington, DC.

of modernism. Of additional importance was Phillips's likely recognition of the resonance between the painting's depiction of middle-class leisure and the "enlarged electorate" that constituted his audience. As he would write of the painting in *A Collection in the Making*, "the grim [French] Revolution lay between Fragonard and Renoir and Renoir's art is of the people and for the people" (*CM* 34).

Scores of visitors came to see the painting at the young gallery, a success that in turn encouraged prospects for the future purchase and exhibition of postimpressionist and modernist work. Phillips would be able to advertise those new acquisitions by the time of *A Collection in the Making*. In 1925, Phillips acquired Cézanne's *Mont Sainte-Victoire* (1886–87) and Paul Gauguin's *Idyll of Tahiti* (1901) (two artists he had attacked the decade be-

fore), as well as his first two Bonnards, *Woman with Dog* (1922) and *Early Spring* (1908), inaugurating what would become the largest collection of that artist's work in the United States. Phillips could now go so far as to admit that "[a] number of brilliant European modernists are as yet absent, but I wish to find examples of the inventive genius of Van Gogh, Seurat, Matisse, Picasso, Derain, Segoznac, Bracque [sic] and others" (*CM* 9). By 1930, he would own work by all but two of these artists, as well as his first pieces by Jean-Édouard Vuillard, Raoul Dufy, and le Douanier Rousseau. With the exception of the Bonnard purchases, Phillips was not in the vanguard in collecting these artists, most of whose work was by then the object of considerable financial competition and speculation. But he was ahead of other collectors in his selections from American modernist artists. Whereas Phillips's earliest purchases had been on principle strongly weighted toward Americans, his continued support of American painters was also shaped by economic necessity. Market prices for European modernism had been far lower for American collectors before and during the war, when Barnes made major acquisitions; indeed, Phillips's 1925 purchases, including $45,000 for the Cézanne landscape, had left him unable to acquire any pieces from the Quinn sales in 1926 and 1927.[47] Contemporary American work, in contrast, could be had for hundreds of dollars. Between 1924 and 1926, he bought heavily from artists associated with Alfred Stieglitz's newly founded Intimate Gallery: John Marin, Arthur Dove, Georgia O'Keeffe, Charles Sheeler, Marsden Hartley, and Charles Demuth. Adding these to its other acquisitions, the Phillips Memorial Gallery may now have appeared, in George Heard Hamilton's words, "neither systematically modern nor classical, neither primarily American nor European."[48] But this apparent lack of systematization was itself programmatic and corresponded to an increasingly categorical definition of modernism.

Shortly before the appearance of *A Collection in the Making*, Phillips resigned in protest from the American Federation of the Arts, a group principally concerned with establishing a National Gallery of Art in Washington, DC; the subject of dispute was the organization's denunciation of the Cézanne-inspired work of the American painter Maurice Sterne.[49] Phillips's protest further established him as a public advocate of modern art, but he was careful in the way he delineated the parameters of this commitment, warning that "even among the most tolerant modernists, who are not yet ready to destroy the museums, there is a persistent refusal to acknowledge that as the great representative artists of the past felt about nature so our

contemporaries are still entitled to feel" (CM 7).[50] On the strength of its new acquisitions, the collection was now in a position to put the lie to the originality of the avant-garde (and other modernist myths) by pointedly exhibiting "tolerant modernists" in the context of artists such as Renoir and Claude Monet, but also within an older lineage of painters including Eugène Delacroix, Jean-Baptiste-Siméon Chardin, El Greco, and Honoré Daumier.[51] Implicit in this program was the intention not simply to situate modernism within a continuum of art, but to define it according to its relative felicity for such a situation. Even more explicitly than Amy Lowell had done in her promotion of imagism, Phillips's transhistorical modernism was predicated upon a rejection of the "violent partisanship" of "wild, unbalanced radicals," as well as that of "dogmatic, close-minded conservatives" (CM 8).[52] "[T]here have always been men of experimental minds whom we propose to designate as modernists," he wrote. "A modernist is an individual or a member of an embattled group who is at war with collective and organized expression and the tyranny of tradition."[53] Grouping paintings so as to emphasize affinities across periods rather than a historical master narrative, the Phillips was able to show "the antiquity of modern ideas, or . . . the modernity of some of the old masters," while (and by that same gesture) inveighing against the avant-garde verity of the absolute break or rupture with the past (CM 6).

Embedded within this adaptable and anti-chronological approach were two separate but interrelated practices, the "exhibition unit" and the "experiment station." The former was a group of works acquired over time, "possessed of collective significance,"[54] and staged together; the latter was a more heuristic mode of collecting and display, designed to ascertain the value of the new work in the context of the established collection. They represented, respectively, the extent of Phillips's commitment to American modernism and the degree to which that work was required to respect the continuity of aesthetic tradition. Each form situated the individual artist, above the individual work, as the horizon of critical evaluation. Whereas the "exhibition units" were loosely defined according to their "collective significance," those units that became permanent within the collection were groups of single artists; of the Europeans, Bonnard, Braque, and later Klee would compose significant units at the Phillips, and, still more extensively, the Americans Dove, Graham, Knaths, and Marin were acquired in depth. Implicit in this strategy was a preference for artists among whose work a continuity could be displayed. That continuity for Phillips always bespoke a principle of the artist's sincere personality, which, in turn, could be opposed

to the group mentality he believed characterized radical work. This line of thinking also explains Phillips's abiding resistance to Picasso. If, as Kenneth E. Silver has suggested, the work and personality of the artist Phillips called "King Pablo" were "simply too protean," we can infer that the famous mutability of his corpus made Picasso a difficult candidate for representation in a coherent exhibition unit. This conclusion is all the more likely given that the Picasso of the mid-1920s had developed a more noticeably classical style and would otherwise have been a likely fit for the transhistorical paradigm of the Phillips. By contrast, Braque, in Phillips's words, committed to a particular idiom and "refined Cubism into a characteristic French style," painting "with the distinguished ease and charming grace one likes to associate with aristocracy in sport clothes."[55]

Such individuality nevertheless could not be trusted to emerge autonomously, as was indicated by the gallery's complementary practice of seeing itself as an "experiment station." Installations at the Phillips—particularly those in smaller rooms, such as converted former bedrooms on the second floor—frequently had the function of ascertaining whether examples of newer work could be assimilated within a tradition of already established aesthetic quality. As the collector described the process in *A Collection in the Making*, "The great artists represent what is permanent in the Collection. The lesser and younger men are undergoing an endurance test. If they can survive this test in proximity with the great they will be found in the ultimate, the permanent Collection, in the building which is still 'a castle in Spain'" (*CM* 9). Phillips's "endurance tests" evinced a subtly agonistic character that informs his description of his "malleable" collection, which was by definition always "in the making." The continuous transformations on the walls of the Phillips represented the building "stone upon stone" of a private collection that defined an emerging corpus of modernism by its successful competition and correspondence with a field of accepted masters.[56]

Prizing the collection's "inclusiveness," Phillips could write that "[t]hose who fall out of our ranks have been found wanting, not in conformity to a set of rules, but in that unformulated inexplicable thing which differentiates pure gold from baser metals" (*CM* 7). That claim also spoke, in abstracted form, to the dialectic between the personal taste of the collector and the institutional identity for modernism that the gallery was then concerned to establish. Although Phillips's particular experiment stations often served the purpose of evaluating new work in the context of the established col-

lection, they also had a less inwardly directed purpose, one that publicly expressed a program for perception.

Akhenaten, Patron of Modernism

Between 1925 and 1926 the Phillips Memorial Gallery's special exhibitions included a series of single-artist shows featuring the work of American artists working in impressionist and realist modes (Ernest Lawson, Childe Hassam, Bernard Karfiol, Maurice Sterne, George Luks, Jerome Myers, and the collector's wife Marjorie Phillips), as well as a few group exhibitions, often bringing together Americans who had engaged more strongly with modernism (including Charles Demuth and William Zorach, both of whom had published poetry in *Others*).[57] The exhibitions from this period appear to have been largely directed toward the promotion and evaluation of individual artists, most of them Americans. But by 1927, the Phillips had been brought into communication with the other provisional institutions that were representing modernism, and the new season built on the reception of *A Collection in the Making* by staging a more ambitious and conceptual set of exhibitions.

Of the new exhibitions, the most illustrative of Phillips's ambitions— and of his evolving aesthetic and social thought—was the Tri-Unit Exhibition of Paintings and Sculpture that opened in early February. As the title suggested, the show comprised three discrete units, one in each of the Phillips's galleries. Of these, it was the Main Gallery's unit, titled "Sensibility and Simplification in Ancient Sculpture and Contemporary Painting," that was of greatest interest, pointedly instantiating Phillips's new transhistorical and individualist theory of modernism, while also auguring his internationalist political commitments. More transparently, Sensibility and Simplification served as an opportunity for displaying several newly acquired works, featuring single canvases by Cézanne, Seurat, Twachtman, Vuillard, Matisse, Tack, Knaths, Maurice Prendergast, André Dunoyer de Segonzac, Maurice Utrillo, Marjorie Phillips, Albert Marquet, Edward Bruce, and Samuel Halpert, in addition to five paintings by Bonnard and twelve by Marin.[58] The last two artists were positioned as one of the principal points of comparison, with "a whole wall of [the American] John Marin [facing] another wall of French Modernists, including Matisse and Bonnard at their best," as Phillips would describe it to Alfred Barr.[59] The transatlantic dimension of this comparison was supported by the overall balance of eight American and eight European painters, implicitly a movement beyond the "artificial barriers of

nationality and race" that Phillips now openly decried in his critical writing (*CM* 13).[60] The works were arranged among an assortment of comfortable couches, armchairs, and other furniture in the Main Gallery, lit from above by a skylight.

Between these facing walls was an arrangement that presided spatially and conceptually over the entire exhibition. On this adjoining wall were works by Cézanne, Seurat, Twachtman, and Prendergast, "two French and two American masters," as the gallery notes put it, who provided an internationally specific lineage for the contemporary works by Marin, Bonnard, and the others.[61] These masters' paintings, though, were not the works upon which the argument of the exhibition directly hinged. Rather, the altogether greater stakes of Phillips's historical and institutional situation of modernism were expressed by the pairing of two works in the center of the wall: a large abstract canvas by Phillips's old friend Tack (*The Voice of Many Waters* [1923–24]) that appeared immediately behind an ancient Egyptian bust, which Phillips dated to the Eighteenth Dynasty.

Phillips had recently bought the Egyptian Stone Head for $8,000 from the Parisian dealer Alphonse Kann, with Joseph Brummer brokering the deal.[62] The Egyptian Head piece was an unusual purchase for Phillips. From a promotional standpoint, it undoubtedly alluded to the "Egyptomania" that swept the country in the wake of the discovery of Tutankhamun's tomb in 1922, leaving its image on numerous commodities, architecture, and interior design.[63] But it also named the conceptual center of Phillips's modernist project as such. Two weeks before the exhibition opened, his letter to Barr informed the future MoMA director that he had subsequently "reinforced" the collection with several additional modernist acquisitions: Matisse, Segonzac, Utrillo, Vuillard. "But most important of all," he added, "I have found one of my ancient sources of Modern Art in an exquisite, subtle Stone Head from the 18th Dynasty of Egypt."[64] In citing the Egyptian piece as one of his "ancient sources of Modern Art," Phillips was implicitly engaging with the by-then-conventional practices of collecting and exhibiting modernist work together with African sculpture—practices Phillips had hitherto notably eschewed. Alfred Stieglitz's galleries had exhibited African work together with Picasso canvases as early as 1915, and collectors including Quinn (who bought from Brummer), the Steins, Earl Horter, Walter Arensberg, Sergei Shchukin, and Albert Barnes had all similarly exhibited modernist and African work together. Barnes, as we will see, positioned his formal analysis of African art as a weapon against the primitivist

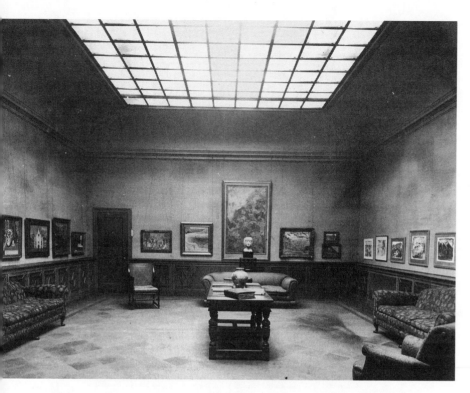

Phillips Memorial Gallery, Main Gallery, installation view of Sensibility and Simpli-
fication in Ancient Sculpture and Contemporary Painting, 1927. *On the left*, works
by Matisse, Bonnard, and Edward Bruce face "a whole wall of John Marin." On the
center wall, Augustus Vincent Tack's *Voice of Many Waters* (1923-24) and the Egyp-
tian Stone Head are flanked by works by "two French and two American masters,"
Cézanne and Seurat (*right*), Prendergast and Twachtman (*left*). The Phillips Collection
Archives, Washington, DC.

racism of Stieglitz's associate Marius de Zayas. In choosing to promote the
Egyptian Stone Head, Phillips may have wished to evade altogether the
questions of primitivism and African art elicited by these other collectors;
but in doing so he appeared to follow the popular academic tendency of
disassociating Egypt from the African continent (and construing its inhabit-
ants as white, not Negro).[65]

As would be untrue of Barnes's strategies of exhibition, the Sensibility
and Simplification show did not concern itself with making a specific point
about technique or what Barnes would call "plastic form." Phillips indeed

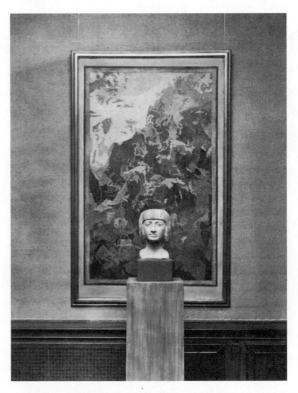

Installation view of Egyptian Stone Head and Augustus Vincent Tack, *The Voice of Many Waters* (1923-24), Phillips Memorial Gallery, 1927. The Phillips Collection Archives, Washington, DC.

admitted that from a formal standpoint a more likely set of painters might have included "Gauguin and Derain and Maurice Sterne, who, at their best, derive more directly from the Egyptian plastic austerity and monumental calm, its zest for pure sculptural planes and masses."[66] As his gallery notes made clear, Phillips was less invested in the comparatively vague formal principles of "simplification" than he was in staging a historical argument about modernism. This argument implied that form was significant to the extent that it could be read as an index of the more crucial category of *sensibility*, which was the unique characteristic—in Phillips's words, "that unformulated inexplicable thing"—that distinguished the artist as an individual. It was in this register of personality that, however idiosyncratically, the true importance of the Egyptian Head was made to reside.

What qualified the ancient piece as an avatar of modernist sensibility were in part its formal properties, but much more pointedly the specificity of its historical provenance, which was understood to have determined that form. The Stone Head dated to the reign of the pharaoh Akhenaten, who had presided over and shaped a period of radical change in Egyptian society. The nature and extent of these transformations in Egyptian social life—which included a revolution in artistic form, the removal of the capital city from Thebes to Amarna, and, most importantly, the unprecedented institution of a monotheistic religion—had led the University of Chicago Egyptologist James Henry Breasted in 1905 to name Akhenaten "the first *individual* in human history."[67] In an engaging study, Dominic Montserrat has revealed what was undoubtedly a robust and multifarious twentieth-century cult of Akhenaten, one for which the pharaoh was the "perfect mediator" between the ancient and modern world.[68] Like a surprising number of his contemporaries, Phillips found Akhenaten to be an attractive father figure; he seemed ideally appropriable for a collector invested in enshrining a modernism "at war with collective and organized expression and the tyranny of tradition" and devoted to individual sensibility.

It would have required no invention on Phillips's part to propose a link between the social transformation of Akhenaten's reign and its art. What has become known as the "Amarna style" was clearly discernible in numerous innovations unique in the history of ancient Egyptian art. Notable were the exaggerations of certain physical features such as elongated necks and accentuated hips, increased attention to the representation of fingers, and the depiction of opposing left and right feet (as opposed to two left or two right feet together). Whereas male figures had heretofore been rendered in terms that emphasized stark physicality, these were softened during Akhenaten's reign, a change discernible especially in the unprecedented feminization of the pharaoh himself. These formal innovations, according to Gay Robins, are presumed to have been "instigated or at least approved by the king," an insight that in turn fostered an early twentieth-century tendency to understand Akhenaten as a great patron of the arts in the Western tradition.[69]

Of these properties, however, it was the apparently humanist character of Akhenaten's patronage that struck Phillips most deeply. The gallery notes breathlessly described the Egyptian bust as if meeting a great artist: "How interested he appears to be in us—this wonderful young man from three thousand three hundred years ago! He is amazingly and thrillingly alive today, a

young man of poise and character—of intellect—of something like genius perhaps for a humorous understanding of all that is going on around him."[70] Phillips's private correspondence with Brummer reveals his interest in ascertaining whether the Stone Head was a representation of one of Akhenaten's sons or heirs (among them, significantly, Tutankhamun), and it is tempting to read this interest in light of Phillips's own personal history and concern with patrilineage.[71] Publicly, though, Phillips wrote of how the work bespoke the larger achievement of Akhenaten's era, a "bright moment in ancient history, when the worth of every human soul was recognized and art consequently became . . . alive with personal inspiration."[72] According to these terms, the presence of the Stone Head among the contemporary pieces in turn exemplified Phillips's theory of a transhistorical modernism: "It was a challenge in its day to the Academies of Egypt just as these paintings [by Bonnard and Marin, Cézanne and Seurat, Twachtman and Tack] are a challenge to our arbiters of art."[73] Phillips's definition of modernism as an individualist attitude in advance of public acceptance and against the prescriptions of a collective "school" was thus augured in the significant example of the Stone Head, whose divergence from what Phillips named the "Academies of Egypt" bore an unmistakably, if awkwardly, contemporary flavor. Sensibility and Simplification in Ancient Sculpture and Contemporary Painting thus elaborated a program for perception pertaining to the history of aesthetic sensibility, in which Akhenaten was positioned as not only the "first *individual* in human history" but also the first modernist.[74]

If it was Phillips's placement of the fourteen-inch Stone Head among the modernist work that made this portrayal of Akhenaten visible, Akhenaten's story in turn endowed the contemporary work, and by extension Phillips's institution, with an explicit social function. Here, Phillips continued to draw strongly on Breasted—he had in fact attempted to persuade Breasted to write an article on the piece[75]—but it was the way he covertly diverged from Breasted's theories that was especially characteristic of Phillips's new social program. Beginning his gallery notes with a lengthy passage from Breasted's recent book *The Conquest of Civilization* (1926), Phillips silently revised the selection in the service of an argument that was faithful to Breasted only in part. The quoted passage was concerned to demonstrate that Akhenaten's revolutionary monotheism had resulted from Egypt's growing global consciousness, and to this extent, Phillips was surely in sympathy with the argument. As Phillips quoted Breasted, Egyptian society under Akhenaten became aware of its place in a world picture, "a world arena larger than the

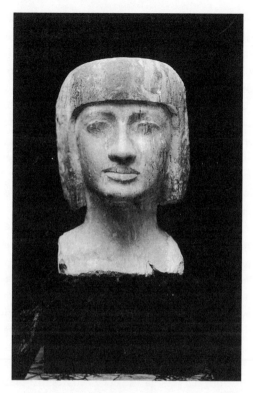

Cover image for *Bulletin of the Phillips Collection* (1927). The Phillips Collection Ar-
chives, Washington, DC. The piece is now the property of the Museum of Fine Arts,
Boston. Head from a statue. Egypt. New Kingdom, late Dynasty 18, 1352–1295 B.C.
Limestone, 2009.5491. Gift of Emmanuel and Argie Tiliakos in memory of their par-
ents, 2009.

lower Nile Valley within the limits of which they had thought of their old
national and local gods as living and ruling." This realization corresponded
to the awareness that "[w]ith the world-idea dawned that idea of a world-
god—the sole sovereign of all." Legislating this new international conscious-
ness, Akhenaten decreed the emergent monotheism to be mandatory,
closing the temples to all other deities, in particular those of Amon, the
"Theban god of the Empire, whose priesthood was reactionary and inhu-
man."[76] While these last three words were Phillips's own, perhaps emphasiz-
ing a connection to the intolerant conservative and avant-garde factions he
himself opposed, they did not contradict Breasted's thesis.

It was Breasted's view of the *political* character of Akhenaten's interna-
tionalism that Phillips sought to revise. Phillips's conclusions, like his at-
traction to Akhenaten, were based on Breasted's belief that "[Akhenaten's]
revolution was essentially an extraordinary emancipation of the human
spirit from old and traditional limitations" (a phrase he quoted). But he
also excised a passage in which Breasted made an explicit reference to
the contemporary American situation, one in which Breasted compared
the new Egyptian world-consciousness to "the fact that the [First] World
War, which for the first time carried [United States] troops to another
continent, has thrust us to an international arena."[77] Phillips also omitted
Breasted's gloss of Egyptian monotheism as "*imperialism in religion*" (Breast-
ed's emphasis), while pointedly interpolating a sentence of his own into
the text: "One life only [Akhenaten's] stood between the beneficent and
kindly influence of the Sun-God on the one hand and the overwhelming
forces of *dogmatic reaction* on the other to a *militaristic priest-ridden Egypt*"
(my emphasis).[78] Reading Breasted's text in the original reveals its striking
amenability to the positions Phillips occupied until at least 1917. Phillips's
unmarked revisions—effacing Akhenaten's "imperialism" while underscor-
ing his enemies' "militaris[m]"—in turn demonstrate his deliberate attempt
quietly to disavow his own earlier positions in favor of an archaic, tolerant
modernism.[79]

Revisiting the original passage also demonstrates that Breasted was not
merely interested in claiming Akhenaten's monotheism as the earliest an-
cestor of Western religion (specifically protestant Christianity, in Mont-
serrat's account).[80] Rather, Breasted's aim was to posit a grand narrative in
which the promise of the ancient Egyptians had been finally realized in con-
temporary American civilization. As Marsha Bryant and Mary Ann Eaverly
have discussed, this became codified as the influential "New Past" theory,
which "viewed civilization as a 'rising trail' extending from Egypt to modern
America. . . . In effect, modern America is poised to assume ancient Egypt's
legacy and continue the march of civilization. As Breasted sees it, Egypt
offers a site through which his own newer, American culture can enter the
panorama of history, ultimately usurping Europe's position and becoming
the culmination of Western civilization's development."[81] It is possible that
Phillips was intrigued to find in Breasted's writing a deep historical justifi-
cation for his own representation of American artists and for an American
renaissance to come. But it is important to note that virtually no traces
of Breasted's Egyptological manifest destiny are evident in Phillips's writ-

ing. And if Breasted's Akhenaten was "not only a proto-Christian" but in fact "a proto-Protestant, who destroyed the images of the idolatrous cult of Amun [as well as] a patron of the arts and a gifted, expressive poet," it was undoubtedly the identity of Akhenaten as patron and artist, not as icono-clast, that Phillips wished to promote in the Sensibility and Simplification exhibition, all of which ideally positioned the pharaoh as an ancestor of the collector himself.[82]

Averse to the rhetoric of imperialism and American exceptionalism in Breasted's writing, Phillips was also reluctant to endorse the sometimes sec-tarian conclusions of Breasted's theory of Akhenaten's monotheism.[83] But Akhenaten's religion ultimately posed less of a problem for Phillips than did his putative imperialism, because it was easily translatable into the language of the gallery's program for institutionalized modernism, which was increas-ingly expressed as a cosmopolitan—and pacifist—religion of art. Two years after the exhibition, Phillips would engage critically with Walter Lippmann's lament, in *A Preface to Morals* (1929), that modern art had not yet found a spiritual form to replace the cultural loss of the Christian faith. Against Lippmann, Phillips argued,

> I contend that there is just such an ideal as Mr. Lippmann claims to be missing in the modern world. A new religion of reverence for personality and faith in and service to all men regardless of race, class or creed, to replace the old order with its emphasis on dogma and worship and the believer's individual salvation would bring Christianity appreciably nearer to the ideal of its Founder. . . . It is an ideal of world peace, of world religion, of world federation, with the artists destined and equipped to convey the symbol of the new synthesis of Occident and Orient.[84]

Although Phillips's thinking was not so fully articulated at the time of the Sensibility and Simplification exhibition, we can nevertheless see in this later essay his preservation of the Egyptian cultural discovery of a "world-idea" (Breasted had also used the more friendly term "universalism"). This interna-tionalist principle, Phillips imagined, might no longer require the agency of violence if it placed artists, rather than armies, on the vanguard of intercul-tural contact: a pacifist, "synthetic" effort replacing an imperial one.[85]

Whether or not he was fully aware of it, the aesthetic expression of such social and political aspirations had already been evident in the 1927 exhibi-tion, in part through the great significance imparted to the Egyptian object in itself, but also in that object's association with the other works displayed,

most obviously with the work that appeared immediately behind the Stone Head, Tack's *The Voice of Many Waters*. Tack's monumental work (it was originally imagined as a public mural) brought the influence of Asian scroll painting to images of the Rocky Mountain (enlarged photographs of which he used as models) in a painting whose subject was the voice of God as described in the Book of Revelation.[86] In this way, Tack had accomplished "the new synthesis of Occident and Orient" for which Phillips would call in his response to Lippmann, and it would do so in a context at once aesthetic and spiritual. Phillips's gallery notes acknowledged each of these elements in language that anticipated its more cosmopolitan expression:

> A single God is in that towering landscape—speaking with the myriad voices of the living streams as with the moulding hands of men. It is Akhnaton's very god. And so behind the head of this young Egyptian, proud in the strength of the creed with which the great young King had chosen to lift up his people, soars now in deep significance this landscape of the 20th Century after Christ, this landscape for the mind that is never weary, and for the upper regions of that spirit which is ever young. Such a spirit knows no insurmountable barriers between ancient and modern art, between Eastern and Western faith.[87]

From this vantage, it may even be possible to see Phillips's employment of the Egyptian Head as a humanist riposte to Henri Gaudier-Brzeska's *Hieratic Head of Ezra Pound* (1914), another semireligious ("hieratic") work that synthesizes ancient Western and Eastern traditions. Not long after the Sensibility and Simplification show, Phillips began corresponding with Florence Brewer Boeckel, the Associate Secretary for the National Council for Prevention of War, and recruiting his associates for participation in a pacifist group called the Artists League, whose headquarters in Geneva coordinated international exhibitions "as a laboratory for the discovery of new means whereby art can serve humanity."[88] Indeed, to the extent that a collection may represent an artistic community, we could even go so far as to propose that the Sensibility and Simplification exhibition represented a kind of ideal Artists League *avant la lettre*.

That kind of collective expression is more common to anthologies than it is to art collections. In chapter 1 I remarked on several anthologies that explicitly invoked the practices of art exhibition in their prefaces; it is perhaps more surprising to see art collectors aspiring to the communitarian ethos of the movement-defining anthology. Yet in 1929, the Barnes Foundation

published *Art and Education*, a collection of critical essays representing the collaborative work of Barnes's institution.[89] And in that same year Phillips published an idiosyncratic article titled "Inter-Creating Intelligence" in the first issue of the house journal *Art and Understanding*. This piece took the form of an imaginary conversation between Phillips and a group of intellectuals including Clive Bell, Charles Beard, John Dewey, Havelock Ellis, and John Galsworthy. Phillips posed a series of questions that were putatively answered by the collector's paraphrased quotations from the works of his hypothetical interlocutors:

THE EDITOR: . . . Mr. Clive Bell has written a little book on Civilization from which I wish he would tell us whether or not congenialities are racial and geographical.

CLIVE BELL: Civilized man sympathizes with other civilized men no matter where they were born or to what race they belong and feels uneasy with blood relations of Philistine persuasion who happen to live in the same street.

JOHN DEWEY: Towards the end of the Eighteenth Century enlightened men in every country were cosmopolitan—aggressively and consciously so. National boundaries were looked upon as artificial.[90]

It is not hard to see in this piece an anthologist's motivations, bringing together as it does disparate works in the name of a common purpose. Such was Phillips's aspiration for the Artists League as well.

But in another sense, the Artists League was an analogue of the field of cultural intermediaries Phillips had proposed in *A Collection in the Making*. His interest in this project indicated not only the abiding necessity for art to be institutionally mediated in advance of its encounter with the public but also the corresponding need for the artist to receive direction from his audience, which now held the responsibility of patronage that had once been exercised autocratically (even by figures like Akhenaten). This point was less obvious in Phillips's gallery notes, which aimed to consecrate the individual artists, but it was nonetheless evident in the exhibitions themselves and in the mode of their promotion. As Phillips would write shortly thereafter, "What the artists really need, what they really want, is an enlightened and sympathetic public which will take more interest in them as comprehensible, lovable, differentiated individuals with many fascinating minds and talents than in their formulation of their particular period or its self imposed doctrine or dogma. What they need and what they want, whether they real-

ize it or not, is a new religion of humanity which will hold up to them higher ideals of cultivated personality and of personal expression."[91] By 1930, then, Phillips had abandoned entirely the combative and aggressive position he had assumed toward the avant-garde. But this attitude was made possible by a situation in which the artist—even the abstract artist—was understood to be a "comprehensible, lovable, differentiated individual." The unintended trace of condescension in this phrase undoubtedly testifies to the confidence in the possibility of a successful institutionalization—in this case a domestication—of the avant-garde. From this point of view it was hardly surprising to discover that the London papers would soon associate the ongoing excavation of Amarna with the garden suburb movement, creating a home for Akhenaten that was, in Montserrat's words, "the most bourgeois place in antiquity."[92]

A final word about the significance of the large Tack painting will help demonstrate the institutional position that the Phillips enjoyed by midcentury. While it was not always the role of the Phillips to determine the canon of modernist art, it exerted a strong role in anticipating its rhetoric and ideology. Despite a slight increase of interest more recently, Tack is not considered a major modernist artist, even if his work could be seen to anticipate abstract field painting of the 1940s and after.[93] Phillips's enthusiasm for Tack (he would eventually own seventy-nine of his works) went against the grain of MoMA's early canon insofar as Tack's work, like that of Dove and Marin, invented abstract forms that were pointedly not cubist.[94] In the end, it was not an agreement about individual artists that ensured the continuity of the Phillips with the institutionalization at MoMA, but rather the institutions' agreement about artists as *individuals*. As John Hay Whitney, chairman of MoMA's board, would write by way of preface to the museum's 1954 catalog,

> To help people enjoy, understand, and use the visual arts of our time is the stated purpose of the Museum of Modern Art. Particularly during a time when conformity enforced through authoritarian pressure is a constant threat to the development of a free society, it is most heartening to turn to the arts and to find in them the vitality and diversity that reflects freedom of thought and of faith. We believe that the collection of the Museum of Modern Art and this publication represent our respect for the individual and for his ability to contribute to society as a whole through free use of his individual gifts in his individual manner. This freedom we believe fundamental to democratic society.[95]

Beginning from a position that associated modernist work with collectivity and anarchism, Phillips was able to anticipate and help shape the rhetoric for a later apparatus of reception in which—almost but not quite antithetically to his original conception—abstraction could be construed as the language of the individual. Such an aesthetic could subsequently be placed, as it is in Whitney's statement, in the service of the Cold War.

3 The Barnes Foundation, Institution of the New Psychologies

Against Dilettantism

As of 2011, the Phillips Collection and suburban Philadelphia's Barnes Foundation were the only two private modern art collections of the American 1920s still housed in their original buildings. Both collections became institutionalized in the context of American civic museums' recalcitrance toward modernist painting, and the collections commanded special authority because of the absence of such museums in their native cities. Whereas the Phillips Memorial Gallery opened in 1921 and the Barnes in 1925, the permanent buildings of the Philadelphia Museum of Art would not open until 1928, and the National Gallery did not open until 1941. In advance of their establishment, the Phillips and the Barnes each sought both to reform and to provide an alternative to the category of the civic museum.

The more recent history of these two collections could not be more dissimilar, however. Today, as we have seen, the Phillips Collection is thriving; it has added to its original building twice and has never ceased to acquire new works and lend pieces from its core collection. In stark contrast, the Barnes Foundation made no acquisitions after the death of its founder Albert C. Barnes in 1951, and it has rarely loaned pieces to other institutions. It has since been involved in numerous controversies concerning the questions of public access to its galleries and, more generally, of its identity as an educational institution, an identity it maintains to this day. The most recent and contentious of these controversies, beginning in the 1990s, were chronicled in John Anderson's 2003 book *Art Held Hostage* and surveyed in Don Argott's tendentious 2009 documentary *The Art of the Steal*. Both works addressed the issue of the Barnes's restrictive indenture and the vexed question of the degree to which that indenture, which left control over the foun-

dation and its $25-$30 billion art collection to the historically black Lincoln University, continued to represent its founder's intentions.[1] Argott's film stridently contested the breaking of the Barnes's indenture of trust, an action that had been necessary to permit the Barnes Foundation's move to Center City Philadelphia. But the film's agency was diminished by the fact that it premiered just as ground was broken on the new building. Scheduled to open in 2012, the state-of-the-art facility designed by Tod Williams Billie Tsien Architects seems certain to transform the identity of the Barnes Foundation by socializing it among Philadelphia's official cultural institutions.

A collector of art since the first decade of the century, Albert Barnes made his first modernist acquisitions in 1912, shortly before the American art market was fundamentally transformed by the Armory Show. A vast personal fortune earned through the patenting and manufacture of the antiseptic compound Argyrol enabled him to build aggressively and relatively freely an important collection in a few short years.[2] Such freedom was a frequent source of exasperation for John Quinn, whose considerable wealth was still not enough to compete with his rival collector.[3] Whereas the cultural and economic value of the Barnes collection is often described by numbers alone—181 Renoirs, 69 Cézannes, 59 Matisses, 46 Picassos— that narrative obscures the extraordinary quality of Barnes's acquisitions, as evinced by numerous masterpieces such as Matisse's *Le bonheur de vivre* (*The Joy of Life*) (1905-6), Seurat's *Models* (1886-88), and Cézanne's *The Card Players* (1890-92).[4] A narrative that, in turn, privileges the "Great French Paintings from the Barnes Foundation" (to borrow the title of the collection's historic and controversial 1993-95 touring exhibition) occludes the more heterogeneous objects—African sculpture, twentieth-century American art, medieval and Renaissance canvases, Chinese and Egyptian pieces, Pennsylvania German chests, utilitarian objects such as ironwork and pottery—that are integrated without respect to period or chronology among the modernist works in the Barnes Foundation galleries.[5] If Duncan Phillips's exhibition units and experiment stations were signature practices of his institution, Albert Barnes's "wall pictures" or "wall ensembles," which have remained unchanged since the collector's death, are central in a still more fundamental sense to the meaning of the Barnes Foundation. The planned move of the Barnes to Center City Philadelphia promises to preserve the highly specific arrangement of works left behind by Barnes in the original galleries.[6] But the question of whether the situation of the new galleries transforms the experience of the individual works and Barnes's ar-

rangements will undoubtedly be a subject of vigorous debate. This chapter will argue for the essential importance of the specific ensembles by working toward an interpretation of several key arrangements in the Barnes galleries. These arrangements not only exemplify Barnes's educational philosophy (as is often pointed out) but are expressive in more idiosyncratic, even private ways and meditate upon the institutional fate of the Barnes itself.[7]

Whereas most accounts have emphasized the particularity of Barnes's vision, they have typically done so without considering the broader context of modernist collecting practices—and the attendant contest for cultural authority—in which Barnes participated. For Barnes that context would include productive but complicated engagements with New Negro intellectuals (including Alain Locke and Charles S. Johnson), institutions (*Opportunity* magazine, *The New Negro* anthology), and artists (Aaron Douglas and Gwendolyn Bennett studied at the Barnes Foundation in the late 1920s, as did Horace Pippin a decade later). We will return to these engagements in this chapter and in the next. It will be instructive first, though, to visit briefly two early and more overtly agonistic exchanges between Barnes and his rival, Duncan Phillips.

One of the pieces of lore that remains popular at the Phillips Collection is a story that involves a visit Barnes paid to Phillips's Washington, DC, galleries. As his son Laughlin recounted the story in a 2004 interview, "Apparently, Barnes once visited The Phillips Collection and talked with my father and asked how many Renoirs we have here, and in the process of asking, he said, 'Of course, I have 53,' or whatever it is, and my father said, 'We have one, and that's all we need.'"[8] This story is meant to illustrate a strain of competition between the collectors: whereas Barnes's superior financial resources and earlier commitment to modern art had allowed him, for example, to amass an unsurpassable collection of Cézannes, Phillips's acquisition of a superior Renoir (*Le Déjeuners des Canotiers*) is presented as a sign of his acumen—and, implicitly, as the object of Barnes's envy as well.

But an equally telling exchange issues from Phillips's trip to the Barnes Foundation in April 1927. This visit is commemorated in a series of letters expressing Barnes's frustration with Phillips, who, after viewing the galleries, declined to attend a lecture scheduled as a part of the foundation's regular course of study.[9] The full meaning of this second exchange can be discovered in a more veiled, but also more public, attack on Phillips that Barnes made two years later. In an undergraduate essay of 1907, "The Need of Art at Yale," Phillips had decried the paucity of art history classes at his alma

mater (the single course in art appreciation having recently been removed from the curriculum). Contrasting this deficiency with the surfeit of classes "offered to the dilettante in literature," Phillips argued that the acquisition of a vocabulary in art appreciation "not only adds to the pleasures of travel but is invaluable to the formation of a respectable standard of public taste." Phillips had not intended to cast dilettantism as a beleaguered category; in this same essay he wrote of his imagined audience, "I have specifically in mind the dilettante—the man who needs art in his life to make it more exhilarating."[10] As the reader will note, this early essay does not adequately describe the more socially engaged forms of cultural mediation Phillips practiced by the mid-1920s. That fact did not deter Barnes from tying Phillips's early salutation of the "dilettante" to the later, well-publicized domestic scheme of the Phillips Memorial Gallery and construing them together as objects against which the Barnes Foundation could be specifically positioned. In the preface to a 1929 anthology of his institution's writings, Barnes wrote, "In everything published under [the Barnes Foundation's] auspices, the prime and unwavering contention has been that art is no trivial matter, *no device for the entertainment of dilettantes, or upholstery for the houses of the wealthy*, but a source of insight into the world, for which there is and can be no substitute, and in which all persons who have the necessary insight may share" (my emphasis).[11] The 1922 bylaws of the Barnes Foundation had expressly forbidden "in any [of its buildings] any society functions commonly designated receptions, tea parties, dinners, banquets, dances, musicales or similar affairs" (a stricture that is all but unimaginable today).[12] By pointedly using the term "dilettante," the very word Phillips's early writings used to name the ideal patron of the arts, and then excoriating the domestic comforts of the Phillips Memorial Gallery, Barnes did not merely underscore the high seriousness of his institution's educational mission; he also expressed forcefully the degree to which that mission aimed entirely to reconstruct the cultural economies governing the experience and meaning of art.[13]

Barnes's assertion that art was "no trivial matter" was deeply involved with the contention that "all persons who have the necessary insight" could gain an understanding of the work of art. This was a statement with profound class-based implications. Barnes himself was born to a working-class background and attended Philadelphia public schools before putting himself through college and earning an M.D. from the University of Pennsylvania in 1892.[14] That experience is undoubtedly reflected in the charter of the Barnes, which proclaimed that "it is the plain people, that is, men and

women who gain their livelihood by daily toil in shops, factories, schools, stores and similar places, who shall have free access to the art gallery."[15] The force of Barnes's project, however, did not consist simply in the question of access to the collection. As we will see, the particular character of Barnes's emphasis on education—which involved reconceptualizing the roles of pedagogy, the viewer, and the aesthetic object—aimed in its grandest ambitions to change fundamentally the entire field of cultural practice in the United States. To this end, the modernist work of art would be both an agent of that change and its representative. The social implications of this project, in turn, would be exemplified most stridently, though not unproblematically, by its claims on behalf of black culture. If, as Pierre Bourdieu epigrammatically noted in his study of French museums, "[t]he 'eye,' is a product of history reproduced by education," Barnes aimed to produce new kinds of "eyes" (and more of them), modeling new social practices through the example of his institutional practices.[16]

Barnes's method and goals were deeply informed by American pragmatism, most markedly by William James's *Principles of Psychology* (1890) and later by John Dewey's *Democracy and Education* (1916), the author of which would become a close friend of Barnes's and the first director of education at the Barnes Foundation. For Barnes the "new psychology" was part of what seemed a larger, socially progressive moment of modernism. In 1920, he sent Dewey a copy of William Carlos Williams's newly published *Kora in Hell*, introducing it with these words: "It seems to me that we have in such books the dawn of a new art that will line up better with your thoughts on democracy than what most artists are doing. They are in a virgin field and necessarily confused if not chaotic—but I believe it to be transitional to something big and important. It is the new spirit of the new times we are entering in the spiritual field which will later be manifested in social and political spheres."[17] For Phillips, as I have argued, modernism represented both a promise and a threat; it therefore required the active mediation of an institution that would fashion an appropriate canon for modernism, regulate the production of new works, and foster a critically engaged public sphere. For Barnes, however, modernism seemed to announce an inevitable and more unambiguously democratizing moment of social transformation. The letter to Dewey specifically implies that pragmatist psychology and modernist art would together revolutionize American institutions and practices. Yet Barnes was also an avid reader of Freud and his followers, and his correspondence makes clear that the social agency of a "new psychology"—a

term coined by Dewey's seminal 1884 essay—was not in his thinking re-
stricted to its pragmatist articulations.[18] He would at times chide Dewey for
repressing what he believed was a latent Freudianism in his thinking, and
he also made an informal pastime of providing extemporaneous psycho-
analytic diagnoses of his associates (and of his enemies).[19] Without laying
excessive weight on this point, it will also be important not to dismiss this
"unofficial" interest out of hand, for it provides a key to what could be called
Barnes's publicly pragmatist, but more privately Freudian, engagements.
Such a dynamic can also be discovered in the way Barnes arranged—or, I
will suggest, *authored*—his collection, simultaneously producing the most
deeply idiosyncratic of modernist collections and also the most systematic
educational and interpretive program on that collection's behalf.

A System for the New Spirit

One of Barnes's first public battles over modernism involved a strategic
association of the new art with both pragmatist and Freudian psychology,
an association Barnes presented as evidence of what his letter to Dewey had
called the "new spirit of the new times." The occasion was the Exhibition
of Paintings and Drawings Showing the Later Tendencies in Art, a landmark
modernist exhibition that opened at the Pennsylvania Academy of Fine
Arts in Philadelphia in April 1921. In response to the exhibition, a group of
anti-Freudian psychologists led by the influential Francis X. Dercum held
a public symposium at which they presented various works from the ex-
hibit as evidence of the artists' insanity, diagnosing various forms of mental
illness on the basis of painterly style and technique. Barnes, meanwhile,
had enthusiastically purchased eight pieces from the exhibition and writ-
ten an open letter congratulating its organizers. When he wrote to respond
to the symposium that attacked the exhibition, however, he did not stress
the value or importance of the artworks, but instead sought to discredit
the antimodernists' qualifications as psychologists. Pronouncing them "old
hats," he went on to observe that "[t]o such men . . . the monumental work
done by Freud, Jung and Adler is a closed book; but to men like Prof. Holt
and Prof. Dewey of Columbia, the work of Freud and his colleagues is of
fundamental significance and importance to normal and mentally-diseased
society. In short, I think that when Drs. Dercum, Burr and Wadsworth make
public statements concerning matters about which they have no scientific
knowledge they can be classed as ignoramuses with a penchant for lime-
lighting."[20] Barnes's response presents publicly what the 1920 letter had ar-

gued privately: that modernist innovation in the arts was of a piece with progressive movements elsewhere. Such developments, he believed, would find their most meaningful articulation in the reform of social institutions, or in the establishment of new ones.

Although this exchange attests to Barnes's interest in psychoanalysis (Edwin Holt had been an important popularizer of Freud), his official writings would increasingly bear the more dominant stamp of pragmatist psychology—James, Dewey, George Santayana. Barnes drew on these figures in producing a coherent method for the objective analysis of painting (to use one of his preferred locutions), a method that was predicated upon the "facts" of the individual work and also upon the individual experiences of both artist and viewer.[21] Published as the Barnes Foundation opened its doors, Barnes's five-hundred-page *The Art in Painting* (1925) comprised three relatively equal sections in which the collector delineated a psychologically informed "scientific" method for studying painting, applied that method to painting from the Renaissance to the nineteenth century, and then finally offered studies of impressionist and postimpressionist works—most of them drawn from Barnes's by-then-unrivaled collection. Explicitly, the book concerned itself with the elaboration and application of a method of aesthetic analysis, but that method aimed to have wide-ranging institutional and social effects. Those implications were presented more openly in the contemporary paratexts that promoted the new Barnes Foundation and then comprehensively elaborated later by Dewey in *Art as Experience* (1934).

Barnes had been a prodigious autodidact, reading widely in philosophy and psychology and applying what he learned in the practices of his factory in West Philadelphia. In 1915, he enlisted Laurence Buermeyer, a University of Pennsylvania graduate student, to lead him in a more systematic program of study in philosophy and aesthetics (*APW* 25-26). Inspired by the publication of Dewey's landmark *Democracy and Education*, Barnes began in the fall of 1917 to attend Dewey's lectures at Columbia. In November of that year, Dewey visited Barnes in Merion, thus inaugurating their thirty-year collaborative friendship.[22] Whereas Dewey had not yet developed a theory of aesthetics, his new student Barnes had for several years been using works from his collection in a series of educational seminars (he called them experiments) with the small interracial group of working-class men and women who were his employees.[23] These seminars constituted an explicit effort to put Jamesian and Deweyan philosophy into practice and laid the conceptual groundwork both for the Barnes Foundation and for *The*

Art in Painting. Barnes dedicated *The Art in Painting* to Dewey, and Dewey in turn dedicated *Art as Experience* to Barnes; Dewey wrote that his book's chapters had been "gone over one by one with him, and yet what I owe to his comments and suggestions . . . is but a small measure of my debt." At the heart of both books was a belief in the fundamentally educative value of the work of art and that value's universal availability. Reading them as companion works, one discovers a practical genealogy for Dewey's late aesthetic theory and also comprehends the extent of Barnes's conceptual and institutional ambitions. "That work is of a pioneer quality," Dewey wrote of the Barnes Foundation, "comparable to the best that has been done in any field during the present generation, that of science not excepted."[24]

The homology that Barnes had intuited between modern art and psychology bespoke the larger pragmatist belief that all social systems and practices were necessarily interrelated and should, ideally, be practically integrated. Barnes's aesthetic theory was predicated upon a similarly integrated, mutually informative relationship between labor and aesthetics, "work and the work of art."[25] This program intended to demythologize the activity of artistic creation while also placing new and specific obligations upon the viewer; artist and audience would now be collaboratively engaged in the activity of creating meaning. The role of the viewer was no longer that of disinterested or passive contemplation, but recast as necessarily "involv[ing] effort and entail[ing] fatigue; work is done, the process is active and not passive" (*AP* 25). This was the appropriate attitude because it involved an empathic understanding of the labor of the painter, which was tellingly described not as an act of creation *ex nihilo*, but as a representation—more strictly, an *organization* and *ordering*—of the artist's individual experience of reality:

> [T]he objective world is a conglomeration of meaningless facts except as it is organized by the interests of living beings. The artist does what no camera, no mere imitation, no mere document, can do, namely, selects aspects for emphasis and gives significant order; that is, his work is a creation. . . . [T]he person who comprehends and appreciates the work of art shares the emotions which prompted the artist to create. The artist gives us satisfaction by seeing for us more clearly than we could see for ourselves, and showing us what an experience more sensitive and profound than our own has shown him. (*AP* 26-27)

Within a philosophy for which work was defined, optimistically, as the remaking of the world for human benefit, the artist was endowed with

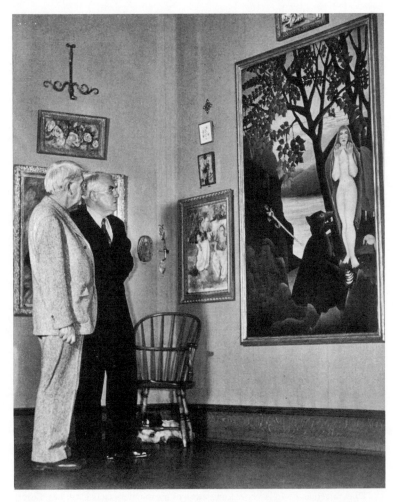

John Dewey and Albert C. Barnes examining Henri Rousseau's *Unpleasant Surprise* (1901) at the Barnes Foundation. John Dewey Photograph Collection, Special Collections Research Center, Morris Library, Southern Illinois University Carbondale.

a vocation that was both educative ("seeing for us more clearly") and instrumental ("giv[ing] significant order"). The artist's contributions thus attained the status of scientific advances, which was no doubt one reason Ezra Pound responded so affirmatively to Barnes's book.[26] "The world of art," wrote Barnes, "is the real world stripped of what is meaningless and

alien and remolded nearer to the heart's desire. Whatever man does of his own free will and for pleasure, is art in some degree" (*AP* 72). By definition, aesthetic experience therefore participated in every human activity. It resided, as Dewey would write, in "the movie, jazzed music, the comic strip, and, too frequently, newspaper accounts of lovenests, murders, and exploits of bandits" (*AE* 5-6), but this was true because it helped constitute the even more primary activity of work, which in turn was not conceived as the source of alienation, but rather as a means of self-expression and self-realization. The distinction between the aesthetic value of the artist's labor and the aesthetic value inherent in more mundane tasks was one of degree, not of kind.[27]

This is not to say that the matter of degree was inconsequential. Some of *The Art in Painting*'s most comprehending reviewers took exception to the strongly phrased judgments of and preferences among artists that Barnes issued throughout the book.[28] And as we will see in chapter 4, the Barnes Foundation could also reserve for itself the right to distinguish between African sculpture that was fine art and that which was mere "handicraft," particularly when it perceived a threat to its own institutional authority. But while it could engage in the public game of praising and discrediting works, the Barnes was nevertheless strident in promoting its democratic conception of the aesthetic. This program could itself be fashioned as a weapon, as Dewey well recognized, against the cultural capital that attended the elite and refined patron of the arts. In April 1925, Buermeyer contributed a promotional essay to the *Nation* that explained how the Barnesian method "asserts the interrelation and mutual dependence of all the parts of life, and affirms that except by force of circumstances and through a failure in intelligence no human activity is lacking in intrinsic interest or in aesthetic and educational potentialities. The realm of industry and the realm of art are not different in kind; let industry be animated by intelligence and so humanized, and the transition to art is not only easy and natural but inevitable."[29] Buermeyer's rhetoric here notably does not emphasize the reform of the worker so much as it urges the reconstruction of educational and also, in this case, industrial practices.[30] That institutional reform, reimagined as a fundamentally cooperative enterprise, would find its "natural [and] inevitable" source in the new conception of the work of art.

The proper understanding of the work of art required exhaustive analysis of its formal, "objective" elements, but unlike more familiar formalisms, this did not imply that the individual work was in any way autonomous (the

Barnes Foundation's tightly constructed wall ensembles also warned against this misprision). This was true because of the central role assigned to the psychology of the student or viewer. Just as the artist did not create the individual work purely on the basis of his autonomous genius, but rather as an expression and creative organization of his prior sensory and cognitive experience of the world, the properly appreciative viewer did not respond to the individual work in a proverbial vacuum, but on the basis of his or her own earlier visual experience. Such experience was itself construed as a kind of practical education (whether formal or informal) that enabled and shaped the understanding of the work of art:

> The aesthetic experience . . . is possible only by virtue of a certain background and training. Appreciation depends partly upon natural aptitude and partly upon previous experience. . . . It is obvious that he who would appreciate and judge of art must provide himself with a first-hand acquaintance with what the artist seeks to show him, that is, the visible aspect of real things. His training in art must include a study of nature as it reveals itself to the eye. . . . The artist is interested in seeing the essential visible reality of things and in showing them in new forms that move us emotionally. Unless the interest in seeing is shared by the observer of a work of art, he cannot share the artist's experience. (*AP* 31, 36)

The appreciation of art was thus figured as a kind of practical skill, rather than as a form of symbolic capital. If these lines apparently serve as an advertisement for the kind of "background and training" made available in the courses of the Barnes Foundation, the deeper point is that the requisite preparation for understanding art (named variously by Barnes the "residue of past experience," "funded experience," "the 'apperceptive mass'") could be obtained by anyone actively receptive to the aesthetic dimension of lived experience. This was true even for those, in theory, who had never walked into a museum.

The agency and meaning of past experience was, however, double-edged. For just as it provided the basis for a knowledge both democratized and fundamentally social (by virtue of the interrelationship of artist and audience), the formative role of "funded experience" also underscored the malign authority of the educational and cultural institutions Barnes aimed to reform. Such institutions, he implied, sublimated ideologies of class division within discourses of taste and refinement. The institutions that Barnes attacked most energetically were schools and universities, as evidenced by the chapter on "Academic Art Criticism" in *The Art in Painting*. Described

by the future MoMA director Alfred Barr as "by far the most entertaining" portion of the book, Barnes here assailed the "sentimentalism" of such influential art historians as Frank Jewett Mather (mentor of Duncan Phillips) and Bernard Berenson before concluding that "[t]he especially lamentable feature of the whole [expert-dealer-author-university] system is that the fetish-worship [of the work of art] is so intrenched and buttressed by prestige that it is a waste of time to suggest that a more rational method of studying art be employed."[31] "'It is a symptom,'" Barnes finished by quoting Buermeyer, "'of the entrenchment of vested interest and unchangeable habits which are as destructive to art as they are to life in general'" (AP 372-73).

Less than a decade later, Dewey's *Art as Experience* made a still more systematic critique of the ideological character of cultural institutions, focusing in this case primarily on the authority of the civic museum. Dewey begins by condemning "European museums [for being] memorials of the rise of nationalism and imperialism" and assailing the "*nouveaux riches*, who . . . have felt especially bound to surround themselves with works of fine art which, being rare, are also costly" (*AE* 8). Dewey here articulates a distinction between European and American cultural institutions (the latter being the referent of the phrase "*nouveaux riches*"), but the larger implication is that they are together both symptom and instrument of a wider crisis of modernity. According to Dewey, industrial capitalism had brought an end to the historical and natural continuity between the categories of individual artist and worker. As a consequence the artist had been "pushed to one side from the main streams of active interest" (*AE* 9). At the same time, the works of the artist (like the work of the laborer, he implies) had been appropriated under the forces of capitalism and employed as objects that appeared both to naturalize and to justify the alienation of art from labor, the aesthetic from craft, artist from audience. Far from being a refuge from this economic system, the public museum—today ineluctably bound to the interests of corporate culture—is perhaps the system's most salient representative. Museums, in Dewey's argument, present culture

> not toward persons as such but toward the interests and occupations that absorb most of the community's time and energy. . . . [T]he conditions that create the gulf which exists generally between producer and consumer in modern society operate to create also a chasm between ordinary and esthetic experience. Finally we have, as the record of this chasm, accepted as if it were normal, the philosophies of art that locate it in a region inhabited by no other creature, and that

emphasize beyond all reason the merely contemplative character of the esthetic.
. . . There is much applause for the wonders of appreciation and the glories of
the transcendent beauty of art indulged in without much regard to capacity for
esthetic perception in the concrete. (*AE* 9-10)

Such a critique of institutions, as Barnes would agree, was especially crucial
because of their fundamental position in the mediation of social, as well as
aesthetic, experience. The common "background" provided by these insti-
tutions "deeply affects the practice of living . . . reducing [esthetic percep-
tions] to the level of compensating transient pleasurable excitations" (*AE*
10). In pointing up the fact that the civic museum, despite its hegemonic au-
thority, was a relatively recent phenomenon, *Art as Experience* presented a
historical and ideological critique of the malady for which Barnes's method
was to be the cure. Barnes for his part rarely, if ever, referred to his galleries
as a museum. If Dewey could starkly claim that "the typical collector is the
typical capitalist," Barnes's collecting practices were clearly far from typical
in Dewey's mind (*AE* 8).

With its sociological orientation, its interest in the authority of edu-
cational and cultural institutions, and its wish to account for a degree of
creative individual agency, the Deweyan position has clear affinities with
Bourdieuian sociology. Bourdieu himself acknowledged this point in a 1988
interview, noting that his own "theory of practical sense presents many simi-
larities with theories, such as Dewey's, that grant a central role to the notion
of habit, understood as an active and creative relation to the world." In Loïc
Wacquant's gloss, Dewey's "definition of 'mind' as the 'active and eager back-
ground which lies in wait and engages whatever comes its way' has obvious
kinship with Bourdieu's habitus."[32] The complementary Deweyan term *habit*
expressed the agency of "funded experience" as a quality that was neither
inherently constricting nor liberating. It could be the basis upon which the
individual actively and creatively (to borrow Bourdieu's words) engages the
work of art, but it could also unquestioningly allow the work of art to be
consigned to "a region inhabited by no other creature" (to borrow Dew-
ey's). Dewey and Bourdieu agree that cultural institutions are instrumental
in structuring specific sets of habits or predispositions; those habits may
be subject to creative engagement or application, but they also bring "with
[their] development demands, expectations, rules, standards."[33]

The Deweyan position departs from Bourdieu, however, precisely in
its attitude toward modernism. For Bourdieu, the historical and cultural

moment of modernism represents the claiming of a form of "relative au-
tonomy" from the economic and social demands of society.[34] In turn, that
hard-won privilege, Bourdieu suggests, recruited (and continues to recruit)
a historically specific mode of aesthetic perception, the "pure gaze" of ap-
preciation, a disposition that has been "objectified in the art museum."[35]
Dewey's critique sympathizes with this assessment of museums, but it does
not follow Bourdieu in finding this situation to be characteristic of the mod-
ernist work of art as such. For Bourdieu, the "pure gaze" is solicited not
by the museum alone but by "all Post-Impressionist painting, for example,
[which] is the product of an artistic intention which asserts the *absolute
primacy of form over function*, of the mode of representation over the object
represented." It is part of an aesthetic system that "lead[s] naturally from
stylistic relativism to the neutralization of the very function of representa-
tion."[36] In contradistinction to Bourdieu, the Deweyan position does not
understand modern artists as complicit with or otherwise exploiting the
encroachment of the market into the world of art; rather, it perceives a form
of democratic agency in the precise feature that Bourdieu believes to be the
most egregious sign of modernism's elitist autonomization.

It is Bourdieu's suggestion that modernism abandoned its concern with
the "object represented," or the "external referent," in order to solicit of
its audience a more rarified form of cultural competence, the "cultivated
disposition." According to this theory, such modes of appreciation consti-
tute a form of cultural decoding available to certain agents but less so to
others. The implication of Dewey's theory, by way of contrast, is that it is
precisely the prioritizing of the "object represented" that makes the work
of art a possible agent of elitism; in this account it is the enlightened under-
standing of a painting's *referential* dimensions that presumes the possession
and application of cultural capital. Dewey's attitude toward the Bourdieuian
"external referent," notably, drew explicitly from Barnes's cautionary cri-
tique in *The Art in Painting*: "We miss the function of a painting if we look
to it either for literal reproduction of subject-matter or for information of
a documentary character. . . . A real work of art may, incidentally, tell a
story, but error arises when we try to judge it by the narrative, or the moral
pointed, instead of by the manner in which the artist has used his materi-
als—color, line, space" (*AP* 21-22). Barnes's qualification was elaborated in
Art as Experience, where Dewey compares the authority of subject matter in
art with the problematic of semiotics: "[A]mbiguity attends the question of
meaning in a work of art. Words are symbols which represent objects and

actions in the sense of standing for them; in that sense they have mean-
ing. A signboard has meaning when it says so many miles to such and such
a place, with an arrow pointing the direction. But meaning in these two
cases has a purely *external reference*; it stands for something by pointing to
it. Meaning does not belong to the word and signboard of its own intrinsic
right" (*AE* 83, my emphasis). Dewey concluded that it was this semiotic di-
mension that required the exercising of cultural capital, since (for example)
interpretation of a Dürer *Crucifixion* presupposed knowledge of Christian
scripture and iconology. Whereas Dewey, like Bourdieu, figures critically
the requirement of cultural competence as a "code," that code in this case
had an entirely different object: "[The word and signboard] have meaning in
the sense in which an algebraic formula or a cipher code has it. But there are
other meanings that present themselves directly as possessions of objects
which are experienced. Here there is no need for a code or convention of
interpretation; the meaning is as inherent in immediate experience as is that
of a flower garden" (*AE* 83).[37] As Barnes had argued in his study of Titian's
Entombment of Christ: "One need not . . . be a Christian, or indeed have
any special interest in the event itself, to obtain from the painting the rich
human values, the nobility intrinsic to sympathy, solemnity, tragedy. These
values are rendered abstractly by means of color, line, mass, space, all uni-
fied into a rich, rhythmic design" (*AP* 105).

The "other meanings" (or "rich human values") that Dewey and Barnes
privileged were produced precisely by what Bourdieu names, critically, the
"mode of representation." From the pragmatist position, it was these formal
qualities that constituted viewerly experience most directly. An analytical
method based strictly on the analysis of what Barnes named "plastic form"
could be instrumental in elaborating a democratized aesthetic theory, since
it could claim to presume no form of competence that was available only
to the elite. The priority that Barnes placed on form, however, did not deny
that the work of art was in any way representational. It was rather, as Mark
Jarzombek has helpfully clarified, to position form "not [as] a mental device,
the referent of which was some philosophical abstraction, but rather [as]
an essential component of the *representational* urge inherent in reality."[38]
Such, indeed, was the basis of Barnes's critique of cubism (a development
that he nevertheless viewed as historically valuable): "The assumption . . .
given currency by the advocates of cubism and other art-forms [falsely pre-
sumes] that pure art involves a complete breach with reality, that plastic
values are *totally* detached from human values" (*AP* 300). The experimen-

tal tendencies exemplified in an extreme way by cubism, however, were nevertheless understood by Barnes as the sign of the liberation of artist and audience—the "new spirit" of which he had written to Dewey in 1920. It is therefore instructive to observe the way Barnes's brief excursus on the Titian painting significantly privileges the Renaissance painter's use of "abstraction." Whereas the ostensible purpose of this quasi-anachronism is to demonstrate the continuity of historical traditions, it also implicitly positions the formal experimentation of modernism as the telos toward which all great painting had been working.[39] Abstraction here refers to artists' creative remaking of the world, and Barnes's privileged term *plastic form* was correspondingly construed as the imaginative *organization* of the artist's individual experience of reality.[40] As Barnes would write in a revised version of *The Art in Painting*, "Design in plastic art is analogous to the thesis of an argument, the plot of a novel . . . : that is, the feature or detail which assigns to each of the other elements its . . . significance."[41]

Barnes's numerous formal studies throughout his book patiently demonstrate the constitutive and interdependent qualities of plastic form—line, color, and space—that the successful artist organizes into a unified individual expression. The studies exemplify what he called the "scientific method," and the clarity and rigor signified by that phrase indicate its strategic opposition to the "sentimentalism" Barnes discerns in prevailing academic criticism: "the method gives results as objective as possible within any field of aesthetic experience and . . . reduces to a minimum the rôle of merely personal and arbitrary preference" (*AP* 10). Because the viewer plays an active role in the aesthetic relationship, however, Barnes is forced to acknowledge a limit to the possibility of interpretive objectivity: "no two men are precisely on a par in their ability to follow the lead given by a painter. Above a certain level, appreciation is always in part the creative appreciation of one who is acutely sensitive to forms or who has a large mass of funded experience" (*AP* 53). It was this very limitation, however, that licensed the greatest ambitions of Barnes's project, for it implied the possibility of a correspondent, perhaps even equivalent, creative agency for the "acutely sensitive" viewer—or collector.[42] From here, it would be possible to understand how a collection and an institution could each be authored works.

With *The Art in Painting*, Barnes introduced his privileged term, plastic form, and positioned modernist painting as its apotheosis. The socially progressive ambitions of Barnes's theory, however, found their paradig-

matic expression not in modernism but elsewhere, in the structure and expressivity of black culture. Barnes was fond of saying, and the Barnes Foundation has remained fond of repeating, that his first aesthetic experience came as he heard a black choir sing spirituals at a camp meeting in Merchantville, New Jersey. Barnes's subsequent accounts of that childhood experience are typically, and tellingly, couched in the language of philosophical pragmatism: "The Negro rhythm is not only more fundamental and all pervasive than in European music, but it is more intricate, because every Negro, as he sings, improvises his own rhythm, one which is different from that of the rest of the chorus. However individual and varied those rhythms are, they merge into the common unity which we term harmony, a fact proved by the absence of jarring elements in the singing of the group as a whole."[43] Barnes here admires both the aesthetic composition of the spiritual and the social organization from which it emerges; both are composed of free individual expressions cooperatively organized to create a harmonious unity. It is no accident that these lines could, with very slight adaptation, apply equally well to the ideal functioning of a place of work: Barnes had elsewhere described how the A. C. Barnes Company "never had a boss and has never needed one, for each participant ha[s] evolved his or her own method of doing a particular job in a way that fitted into the common needs."[44] To champion a "work" both highly organized and spontaneous, collective and individual, was to give voice to desires that were both aesthetic and social.

Such desires were intimated still more clearly by the promotional writings the Barnes Foundation produced on behalf of its African collection. In the book *Primitive Negro Sculpture* (authored by two Barnes Foundation staff members in 1926) and in two issues of the National Urban League's *Opportunity* magazine (which were effectively guest-curated by Barnes in May 1924 and May 1926), the African work was positioned as the product of an ancient civilization that, however archaic, nevertheless exemplified qualities that were offered as the necessary aspiration of democratic modernity. These texts were part of a sustained effort to craft a progressivist reception for African art in the United States. This program elaborated a critical position that we could call "pragmatist primitivism":

> Primitive Negro sculpture was the manifestation of a life which was a stable organization, thoroughly adjusted to its surroundings, and was therefore able to find natural, authentic expression. Before the coming of the Portuguese into Central

Africa, the Negroes had established a mode of life in harmony with their environ-
ment and congenial to their temperament. Their material wants were slight, they
required little shelter or clothing, food was abundant. As they had no commerce
with the world, they were free from economic pressure. Hence they had almost
unlimited leisure for the free exercise of their powers, and especially of their vivid
and dramatic religious instinct, enriched by their luxuriant imagination.[45]

In its fashioned reciprocity of culture and environment, its entirely ade-
quate "organization," and in the fact that it was not (yet) corrupted by the
vagaries of capitalist "economic pressure," this was a theory of ancient Afri-
can civilization conceived in pragmatism's self-image. Like the self-authored
account of the A. C. Barnes Company's antihierarchical structure, the testi-
mony on behalf of the African work undoubtedly evinces a degree of self-
purification. Jean-Louis Paudrat has noted the "extravagance" with which
the Barnes Foundation periodized its African collection, portions of which
they claimed dated as far back as the fifth century, with only two pieces
dated to the nineteenth century and none to the twentieth.[46] And as early
as 1926, the anthropologist Melville Herskovits issued an altogether more
damning critique of *Primitive Negro Sculpture*: "when [the authors] describe
these marvelous Benin bronzes as having been dug up by archæologists,
when actually they were found in use in the [18]80s by a British punitive
expedition which destroyed the city, one loses respect for this and what
follows it."[47]

Without excusing these willful distortions, it is worth remarking their
particular rhetorical function within the context of modernism's American
institutionalization. The paradox of the Barnes Foundation's sanitization of
its own collection's provenance—Barnes's dealer, Paul Guillaume, almost
certainly counted colonial officials among his suppliers of African work[48]—
consisted in the way this distortion was nevertheless figured as a form of an-
ticolonialism. The insistence on the pieces' ancientness served the function
of situating the works not as artifacts of primitive savagery but as products
of a highly organized civilization as yet uncorrupted by industrial capitalism,
colonialism, and the world market. Identifying the formal accomplishment
of the African work as being "a stage *in advance* of European evolution" (my
emphasis), the Barnes Foundation rejected the teleological model of civi-
lizations' development that informed the determinations of ethnographic
exhibitions on the one hand and the more baldly racist promotion of African
work by modernist exhibitors on the other.[49] Marius de Zayas, for example,

had claimed his 1914 exhibition at Alfred Stieglitz's 291 gallery—"Statuary in Wood by African Savages: The Root of Modern Art"—to have been "the first ever held presenting Negro sculpture as Art." But if the exhibition title was not enough, de Zayas also promoted the work as the "product of the 'Land of Fright,' created by a mentality full of fear, and completely devoid of the faculties of observation and analysis, . . . the pure expression of the emotion of a savage race."[50]

It was in the context of Barnes's dissent with such practices that the editorial page of *Opportunity* could describe the Barnes Foundation, without irony, as fundamentally allied with Franz Boas's "consummate attack upon a flourishing system of racial misconceptions."[51] Barnes's critical position, moreover, appears specifically opposed to the tendency Simon Gikandi sees as defining modernism's relationship to Africa: a separation of "aesthetic ideology" (where African art was celebrated and appropriated) from "social formation" (where African culture was implicitly feared and despised).[52] Barnes, by comparison, was anxious to insist upon the necessary relationship of aesthetic accomplishment to social organization. The implication that it was only *ancient* African art that would be culturally legitimated, however, had the effect of precluding a problematic encounter with contemporary Africa.[53] Indeed, at each point that Barnes invoked *contemporary* black culture, it involved a strategic elision of the African in favor of the African American.

The attitude that I am calling pragmatist primitivism served the purpose of making African work available for the socially progressive projects of *Opportunity* and the New Negro movement. But because it appeared to bespeak its origins in a paradigmatically functional society—one that had successfully integrated its expressive, constructive, and intellectual functions—African art was also used to authenticate the political project of the Barnes Foundation in a larger register. It was made to exemplify the social relationship to the work of art, and the social relationship writ large, that Barnes had described in his 1920 letter to Dewey: "the spiritual field which will later be manifested in social and political spheres."

It is in this way that we can finally reintroduce the importance of a "new psychology" that is both pragmatist and psychoanalytic, for Barnes's advocacy of black culture bore a heavy symbolic burden not only in its institutional (Deweyan) function but in a more private (Freudian) sense as well, subject to regimes of desire. This may be briefly demonstrated by glossing Barnes's notorious contention, "The Negro is a poet by birth," which ap-

peared in the pages of Locke's *New Negro* anthology.[54] On one hand, there is a certain interventionist force to the claim, particularly when it is read alongside Thomas Jefferson's famous statement (which Barnes may have been obliquely citing), "Among the blacks is misery enough, God knows, but no poetry."[55] On the other hand, that same conceit betrayed a kind of sentimentalism ("kindly but vague," as Locke would privately comment) that veered toward essentialism and was in any case perilously close to the very sentimentality Barnes pilloried in contemporary art historians.[56] That sentimentality at times acquired an aggressive or even abusive edge, as when he informed Locke of his hope that he was "a poor Lombard Street boy, who had hardly enough to eat and who had to work like the devil to get through school," a presumption Barnes likely knew to be untrue, but which he had already found rhetorically useful.[57] Barnes's pragmatist primitivism is defined by the way it figures black culture for progressive purposes, appropriating it, one might say, "in its own interest." But such appropriation involved the collector's more subjective acts of projection, identification, and desire that were overdetermined (officially) in the name of Barnes's own institutional concerns. Barnes's promotion of African work, as we will see, had a specific role in determining the reception of the Barnes Foundation in the wider cultural field. But in its galleries, the work would be given another responsibility, enabling and bearing witness to the collector's most complex, original, and intimate forms of authorship.

Collection and Institution

Barnes purchased his first African objects in 1922, the same year he purchased the land for the Barnes Foundation, commissioned its buildings, and executed its charter. Even if a single design did not connect these events, in retrospect their interrelationship is crucial since African art was, along with the question of education as such, the issue through which Barnes would most forcefully express his own progressivism. Barnes as we have seen believed forcefully in the social agency of the work of modernism, feeling that it would reform social practice through the very process of its institutionalization. But in a way that is not true of his modernist paintings, Barnes's African collection has always appeared under the sign of this progressive institutionalization and indeed became its public avatar. The galleries themselves are expressive of this fact, as the entrance to the Beaux-Arts building in Merion is adorned with terra-cotta tile designs based on African pieces in the collection. In advance of the question of Barnes's authorship and its

relationship to the African pieces, this obliges us to consider the broader question of the relationship between the development of the collection and the collection's institutional history.

Barnes began collecting art as early as 1905, initially buying from conservative galleries in Philadelphia and New York. Early acquisitions included canvases by Millet, Corot, and other Barbizon school painters.[58] It is easy to see this early phase as corresponding to the expected activities of a man of means (he also briefly took up fox hunting). It was not until 1910 or 1911, when Barnes reestablished a connection with a high school classmate, the painter William Glackens, that the collection became a more serious concern. Glackens had by then moved to New York and established a national reputation as one of The Eight, or the "Ashcan School," a group of American realist painters that included Robert Henri, John Sloan, Arthur B. Davies, Ernest Lawson, and George Luks. The group had recently participated in the 1910 Exhibition of Independent Artists in New York, a precursor to the Armory Show (which Davies would help organize three years later), and they were widely perceived as progressives, affiliated with modernism if not exemplifying its more radical innovations. Barnes appears to have sought out Glackens because he was interested in developing a more serious interest in art. Glackens obliged by gently chiding Barnes for overspending on "safe" paintings and pointing him toward contemporary American artists, whose work he began to buy: Charles Demuth, Alfred Maurer, Maurice Prendergast, as well as Sloan and Henri. He also bought some fifty works by Glackens himself.[59]

The crucial turning point, however, came in February 1912, when Barnes provided Glackens with a $20,000 line of credit and sent him to Paris with instructions to purchase modern European paintings. Traveling with Maurer, Glackens acquired works from the dealers Joseph and Georges Durand-Ruel, Ambroise Vollard, and the Bernheim-Jeune gallery, some of which have retained prominent places in the Barnes collection: Vincent Van Gogh's portrait of the postman *Joseph-Etienne Roulin* (1889), Picasso's *Woman with a Cigarette* (1901). Glackens elsewhere obtained three Renoirs, a Degas, and a Cézanne *Mont Sainte-Victoire* that now hangs in Room XIV of the Barnes Foundation (a painting to which we will return).[60] This was to be the last time Barnes bought art by proxy. He would himself travel to Paris in June and December of that year, during which period he established an important friendship with Leo Stein, who would become a mentor and encourage Barnes to acquire work by Matisse and pre-cubist Picasso. Dur-

Main entrance of the Barnes Foundation, featuring terra-cotta tile designs based on pieces from Barnes's African collection. The Barnes Foundation, Merion, PA. Photograph © 2010 reproduced with the Permission of The Barnes Foundation.

ing the December visit, Barnes acquired his first three Matisses from Stein through Durand-Ruel.[61] On this same visit, Barnes purchased, in the space of a few days, four Renoirs, a Daumier, a Pissarro, and six paintings by Cézanne, including the portrait of *Madame Cézanne* (1886), now at the Detroit Institute of Arts. These were acquired from Vollard's gallery and also at public auction, where Barnes's audacious bidding suddenly established him as a player of consequence in the Paris art market (*GFP* 30–32). Barnes energetically added to his collection in the months that followed, often extending negotiations to an excruciating degree.[62] His accomplishment in a very short period was such that he did not feel obliged to purchase deeply from

the Armory Show: he bought a single landscape by Maurice de Vlaminck for $162, in comparison to the nearly $6000 spent by John Quinn.[63] Despite his relative invisibility at the Armory Show (he also declined to lend works to the exhibition), it was nevertheless possible for Guy Pène Du Bois to proclaim the following year that Barnes's was "probably the most consistently modern collection in America."[64]

By 1915, Barnes could boast of owning fifty Renoirs and fifteen Cézannes, including the superb *Woman in a Green Hat* (1894-95) (*GFP* 36). In January he wrote to Durand-Ruel of his intention one day to donate his collection to the city of Philadelphia.[65] And later this same year he began his systematic studies with Buermeyer, work that would lead to his first association with Dewey in 1917. The most important elements that would define the Barnes Foundation—the modernist and postimpressionist collection, its intended orientation toward the public, pragmatist psychology and aesthetics—were now all present in some form. And by this time the factory of the A. C. Barnes Company had itself begun to resemble the educational institution that the Barnes Foundation would become. As Barnes would later write in the pages of the *New Republic*, the company's operations had been reorganized between 1908 and 1912 "on a cooperative basis [adapting Jamesian] principles of psychology to our business, educational and social needs in their larger conception."[66] This entailed establishing a lending library for his employees, shortening the work day to six hours, and apportioning the two free hours to the collective study of works including James's *Psychology*, *Pragmatism*, and *The Varieties of Religious Experience*; Dewey's *How We Think*; Santayana's *The Sense of Beauty* and *Reason in Art*; and the writings of Bloomsbury art critic Roger Fry.[67] As Barnes expanded his collection, artworks began to line the halls of the factory and became the objects of study. "We have had constantly in the building modern pictures that would stand examination in the light of what we learned," wrote Barnes in 1923; "[t]here have been rarely less than one hundred pictures on view at all times: they are a subject of discussion with most of the workers and are sold at cost price to those employees who express a desire to own them."[68]

If these events provide in retrospect an obvious genealogy of the Barnes Foundation, it is significant that intimations of a progressivist institution are nowhere evident in Barnes's first published article, "How to Judge a Painting," which appeared in the April 1915 issue of *Arts and Decoration*. The essay, on the contrary, valorized an older model of consumption, proclaiming that "when the rabies or pursuit of quality in painting, and its enjoyment,

gets into a man's system[, a]nd when he has surrounded himself with that quality, bought with his blood, he is a King."[69] The conclusion that can be drawn from the incongruity of this article (and its aristocratic metaphor) with the trajectory of Barnes's developing practices is that Barnes had not yet thought to give his collection the specific vocation that it would receive seven years later. By 1920, as we have seen, Barnes could envision the way the "new spirit" of modernism signaled, and could effect, the reform of "social and political" institutions. It is not clear, however, that he was even then at the point of considering the establishment of his own provisional institution to this end.

That possibility first became visible in the fall of 1921 when Barnes made a final gesture in the battle over the Pennsylvania Academy's Later Tendencies exhibition. In the summer, no doubt seeking to recapture the notoriety of Francis X. Dercum's antimodernist symposium, a new series of reactionary protests had been organized against an impressionist exhibition opening at the Metropolitan Museum of Art (an exhibition for which Quinn had been a lender).[70] Barnes took this renewed opposition as the occasion for a last, carefully staged response to the Philadelphia alienists. Placing items to run consecutively in the *Arts* (where it immediately followed a report on the New York protest) and in the *American Art News*, Barnes promised to "donate his entire collection of paintings, valued at millions of dollars, and a gallery to house them, to the city of Philadelphia, if Dr. Dercum could prove himself qualified in the science of normal and abnormal psychology." Barnes went so far as to include a series of eight questions, dutifully reprinted in the pages of *American Art News*, that he invited Dercum to address. These included

First.—Show, in scientific terms, the difference in basic principles between the pictures of Gauguin, Degas and Renoir, which Dr. Dercum says he does not condemn, and those exhibited last spring at the Pennsylvania Academy of the Fine Arts, which Dr. Dercum says are the work of insane people.

and

Fifth.—If he will point out in any authoritative work on psychology the principle that makes common sense, as applied to art, out of the sentence [which had evidently issued from Dercum] "the colors employed in the alleged paintings were in no sense those seen in nature, nor could their use be construed as suggesting or evoking a sense of the beautiful."[71]

As was true of his response earlier in the year, Barnes ostensibly framed the argument with the Philadelphia psychologists according to their comparative authority on "normal and abnormal psychology." But in these documents, Barnes's authority was also supported by what he presented as the *acknowledged* value of his art collection, a significant and determining bequest to a city that did not yet have a major art museum.[72] The munificent proposal nevertheless had a perverse logic, since it offered as a gift to the city of Philadelphia an institutional home for modernist art—precisely the thing that the Philadelphia alienists most feared.

It is perhaps precisely because Barnes's proposal could only have been meant rhetorically that we can appreciate the interventionist logic that governed it (something that had not been evident in 1915). In this first public indication of its future institutionalization, the collection was not merely advanced as a form of cultural capital but fashioned as an instrument in the service of the struggle for the cultural validity of the "new psychology." Although he never expected to be obliged to donate the collection and gallery under the conditions he proposed, the possibility of construing the collection as a progressivist institution was nevertheless finally discernible. Seen in this light, it is surely not coincidental that these exchanges transpired at the very moment that the Phillips Memorial Gallery opened its doors in Washington, DC. The rhetorical offer of building a public gallery for his collection, moreover, would read altogether differently after December 4, 1922, when the Barnes Foundation became officially chartered as an "art gallery . . . founded as an educational experiment under the principles of modern psychology."[73]

With the cultural value of the collection now figured as a means of authorizing his larger institutional project, Barnes sought to increase that authority by substantially expanding the collection as plans for the buildings and educational program of the Barnes Foundation were drafted. In a May 1921 letter to Dewey, Barnes had boasted of owning one hundred Renoirs and thirty Cézannes, but the collection was still relatively unrepresentative of more contemporary artists.[74] This situation was dramatically remedied in a trip to Paris in December 1922 that Howard Greenfeld has called "one of the most extravagant buying sprees in the history of art collecting."[75] What was decisive at this moment was Barnes's new association with the dealer Paul Guillaume. Guillaume had opened his first gallery in 1914 and represented a younger generation of dealers. He was close associates with the modernist poet and art critic Guillaume Apollinaire and

claimed among his discoveries Derain, Vlaminck, Giorgio de Chirico, Marie Laurencin, Roger de La Fresnaye, Maurice Utrillo, and Amedeo Modigliani (*GFP* 38). He was also the preeminent Paris dealer of African sculpture.[76] Guillaume, in fact, had supplied the African work for de Zayas's "Statuary in Wood by African Savages" exhibition at Gallery 291 in 1914, and until his association with Barnes, it seems that he was happy to offer his pieces for the kind of exoticist reverie exemplified by de Zayas's notorious gallery notes. Before long, though, ensconced as the "foreign secretary" of the Barnes Foundation, Guillaume would come to interpret African pieces through the lens of Barnes's "scientific method" and then coauthor the book *Primitive Negro Sculpture* with Thomas Munro, which codified Barnes's approach to African art.

In advance of his purchases from Guillaume on this trip, Barnes had already acquired Matisse's *Joy of Life* (originally owned by Stein) and forty Greek and Egyptian statues.[77] The great majority of Barnes's modernist acquisitions, however, and all of his African purchases were made through Guillaume, who staged an exhibition at his gallery of fifty of Barnes's purchases in advance of their delivery to Merion. Although the exhibition was not cataloged, Anne Distel cites a review in the January 30, 1923, issue of *Comoedia* that identifies pieces by "Daumier (*Les Ribaudes*), Manet, van Gogh, Renoir, Redon, Derain, Utrillo, Pascin, Gritchenko, Soutine, Zadkine, and Lipchitz" (*GFP* 298n33). It was during this same trip of December 1922 that Barnes made his first purchases from a then unknown Chaim Soutine. Together with his first acquisitions of African sculpture, which were substantial, Barnes had suddenly oriented his collection more forcefully toward the representation of contemporary artists and had also (with the African work) prepared himself to enter into an ideological battle about the social meaning of modern art in the United States.[78] Before returning home in January, Barnes placed the first public announcement of the Barnes Foundation; in the January 1923 issue of the *Arts*, the editor Forbes Watson heralded that the United States was to have "at last, a public museum of modern art" and, clearly paraphrasing Barnes's correspondence, went on to add that "[Barnes] is convinced that art has a universal appeal, and that appreciation of art can be developed in almost any intelligent person. Art need not be, in the mind of Dr. Barnes, the exclusive privilege of a few specially endowed individuals whose main use of it is to flatter their own egotism by a display of their superiority."[79] The specific terms of Barnes's interventionism, inspired by his collaboration with Dewey, were finally publicly articulated.

Upon returning to Philadelphia, and with the Barnes Foundation galleries ready to begin construction, Barnes attempted to recapture the triumph of the Paris exhibition by staging an expanded version of that show at the Pennsylvania Academy, where the Later Tendencies had been staged two years before. Opening in April 1923, the Academy's Exhibition of Contemporary European Paintings and Sculpture comprised seventy-five works owned by Barnes including Matisse's *Joy of Life*, Picasso's *Composition: The Peasants*, nineteen works by Soutine, and seven by Modigliani (*GFP* 12).[80] It was in the exhibition's catalog that Barnes first elaborated the psychological principles that would guide the work of the Barnes Foundation. Barnes here hoped to make a more measured case for modern art against the claims of the Philadelphia psychologists who had made waves at the Later Tendencies show. Reminding his readers of similar public reactions to the Philadelphia Orchestra's performance of Arnold Schoenberg's "Kammersymphonie" in 1915 (the first American performance of that piece), Barnes rehearsed the conceptual terms that would guide *The Art in Painting* in arguing that it should be the artist's prerogative to introduce new "forms" of art that would in turn aid in the development of individual psychologies.

Barnes appended a second, more remarkable example to illustrate his point. Noting that the same Schoenberg piece did *not* seem strange when performed in Philadelphia in 1923 (eight years later), Barnes wrote, "We should profit by that experience [of revisiting the Schoenberg piece] in our attitude toward the exhibition of contemporary art which the Academy has opened to the public. Both the paintings and the sculpture will probably seem strange to most people. If the long, attenuated necks of the Modigliani figures seem absurd or grotesque, go to the University Museum and look at the even longer necks on the pieces of ancient African sculpture, so precious in art values."[81] As had been the case in his response to the alienists in 1921, the full extent of Barnes's interventionism was present only in sublimated form, for although Barnes used the example of the museum's African pieces to prepare the viewer's reception of the works then on display in the Academy, the status of the African work "as art" was if anything more contested than would have been the European paintings. It was one thing to present African art, as de Zayas had done, as "completely devoid of the faculties of observation and analysis." It was another to presume the "precious . . . art values" of that work as a precondition for the appreciation of the still unaccepted contribution of modernist art. These were precisely the dynamics that Duncan Phillips would avoid a few years later when he chose

to anchor the Sensibility and Simplification exhibition with the ancient Egyptian Stone Head (an example of ancient African art that was not coded as black); with the aid of the academic writing of Breasted, Phillips aimed to situate the ancient Egyptian work in a continuum whose accomplished telos was contemporary American democracy. When viewed as an augury of his future alliance, the following year, with Harlem Renaissance intellectuals (to be discussed in chap. 4), Barnes's rhetorical appeal to the African work in the University Museum, by contrast, suggested less a celebration of the accomplishment of American democracy than the imperative ongoing *reform* of democratic practice in a country that was still coming to terms with its own legacy with respect to Africa.[82]

Penn's University Museum is not a fine arts museum. Opened to the public in 1899, the University Museum was the first anthropological museum in the country, and its innovations and concerns were quite different from those Barnes was seeking to authorize. By selecting only human-made objects for display, the University Museum drew a distinction between the anthropological object and the objects presented in the natural history museums of the nineteenth century. The endeavor of this new museology was, in John Wesley Powell's words, to create "a new ethnology, in which men are classified by mind rather than by body, by culture rather than by color."[83] As the term "ethnology" implies, however, and as Steven Conn has shown, the University Museum continued to employ a developmental—even teleological—narrative in its mode of display, in a manner that was still consistent with the great natural history museums of the previous century. The top floor of the University Museum showed pieces from "classic," "fully formed" civilizations like Greece, Rome, and, especially important for our purposes, Egypt. A descent to the museum's lower level transported the visitor to the world of artifacts from "primitive" cultures, including Native America, the Far East, and Africa.[84] In Conn's words, "the University Museum tried to conceive of an anthropology that linked the savage and the civilized in the same intellectual construct," but that construct was possessed of a hierarchy and was explicitly inflected with notions of progress.[85] Even a passing familiarity with the ahistorical method of display of the Barnes Foundation shows that its techniques are specifically opposed to such developmental theories, and letters between Barnes and Paul Guillaume in August 1922 stress their shared aversion to the University Museum's ethnological underpinnings.[86] Although he does not say so explicitly, Barnes's invitation to visit the University Museum thus carried with it the implicit demand for a

new kind of institution, one that strategically *integrated* (to use a key Deweyan term) modes of aesthetic achievement across cultures and historical
periods.[87]

As he was in the process of negotiating the details of the Contemporary European Paintings show, Barnes had requested that his recent African
purchases be included as a part of the exhibition, writing to the director of
the Academy, John F. Lewis, "I hope you can get them, because the negro
pieces are better than any two or three of the most important museums in
the world."[88] Lewis responded by gratefully accepting the offer to display the
modernist pieces but failing to acknowledge the offer to include the African
work in the exhibition. This uncannily anticipated the character of Barnes's
negotiations, beginning in 1924, with the University of Pennsylvania. It was a
series of exchanges that expressed Barnes's greatest aspirations for his educational project and also produced his greatest disappointments.

The failed partnership of the Barnes Foundation with his alma mater
has been assiduously chronicled by Mary Ann Meyers and helpfully summarized by Richard Wattenmaker.[89] It is still important to describe it briefly
in order to provide a slightly different perspective on the meaning of the
Barnes's subsequent isolation. Barnes had been long concerned about the
final disposition of his collection, and he had mused, as early as 1923, about
the promise of a cooperative relationship with a university.[90] Barnes was
also aware that Penn's School of Fine Arts was at this time devoted almost
entirely to the training of architects (one of whom, Paul Cret, had designed
the Barnes's buildings). The possibility of establishing a new program devoted to the study of art seemed strong. On January 27, 1924, with the
Barnes Foundation galleries under construction, Barnes wrote to Josiah
Penniman, the University provost, to propose that Penn "establish a Chair
of Modern Art at the University of Pennsylvania with Mr. Laurence Buermeyer as full professor." The credentials of Barnes's tutor were presented
as a mixture of Ivy League training, firsthand research, and experience with
Barnes "in the study of the psychology of aesthetics."[91] His responsibilities
would include two weekly lectures at Penn and two at the Barnes Foundation. Barnes noted that whereas Princeton, Harvard, and Columbia were
now all offering courses in modern art, none of these institutions had a
modern collection from which it could teach.

Penn balked at the bold suggestion of providing a tenure commitment to
the young Buermeyer but proposed a compromise in which he was accepted
as visiting faculty under the title of "Professor of Modern Art of the Barnes

Foundation."[92] Barnes and Penn agreed on a two-year trial arrangement, to begin in the fall of 1924. With Buermeyer's health preventing him from taking the assignment, new staff member Thomas Munro began that semester teaching a class under the Barnes imprimatur "Applied Aesthetics" (*APW* 33). With classes underway at Penn (and at Columbia, where Barnes had negotiated a less ambitious arrangement), Barnes began a study of the methods for training art instructors in Philadelphia public schools and eventually offered, in the autumn of the following year, a course for teachers at the Barnes Foundation (*APW* 33). By the end of the 1924 fall term, Barnes persuaded Penn to offer a second class, in philosophy and psychology, in order to provide a more comprehensive grounding in the practices of the Barnes Foundation.[93] The class was offered in the 1925 spring semester, during which time *The Art in Painting* was published and the Barnes Foundation opened its doors. The galleries' March 19 inaugural ceremony was attended by Leopold Stokowski (director of the Philadelphia Orchestra and conductor of the "Kammersymphonie"), Dewey (who read an inaugural address), the wife of the governor of Pennsylvania, and, representing Penn, philosophy professor Edgar A. Singer, Jr. Despite this impressive list of attendees, Meyers notes, the event went unmentioned in the Philadelphia papers.[94]

During this same semester Barnes made a grand proposal to Penn to purchase seventeen and a half acres adjacent to the Barnes Foundation for which Barnes would commission a series of buildings, including a lecture hall and a school of landscape architecture—in effect a second campus to be administered with the cooperation of the Barnes Foundation staff.[95] This munificent offer appeared, however, concurrently with the first issue of the *Journal of the Barnes Foundation*. The inaugural issue of the Barnes's house organ contained a piece by Guillaume on Barnes's African collections but more ominously included a series of articles that mercilessly attacked the state of art education in the Philadelphia public schools (among them Barnes's own piece "The Shame in the Public Schools of Philadelphia"). This initiated a public fight that caused Penn considerable embarrassment (and also occasioned stern warnings from Dewey). Barnes privately apologized to the university but failed to perceive the wariness with which Penn continued to view their arrangement. By the end of the spring 1926 semester, Penniman nevertheless expressed the university's interest in renewing the arrangement with the Barnes for two additional years. Barnes responded affirmatively but brought up the as-yet-unresolved question of his offer of the school of arboriculture. He then directed Penniman's attention to the

fact that he had recently amended the foundation's bylaws to suggest that control of the Barnes Foundation galleries and collection would go to the university upon the death of Barnes and his wife.[96] For reasons that are unclear, and seem at least in part accidental, Penniman failed to respond to this offer. In November of that year, Barnes wrote to terminate their arrangement.

It is not without reason that the failure of this alliance has been understood as resulting from the chariness of Penn or from Barnes's overreaching efforts. Wattenmaker adds that "in 1920s Philadelphia, Post-Impressionist and Modernist art were not considered culturally valuable enough to galvanize Penn's trustees to accept Barnes's offer" (*APW* 35). Meyers, however, points out that, from quite early in the negotiations, the dean of the School of the Fine Arts, Warren Laird, had advised Penniman that "the University should welcome an opportunity to include in its curriculum the teaching of the principles of modern art. . . . The modernist and his doctrines have created storm centers in each succeeding age, but if sound in essence, the new thought has emerged to lead for its time."[97] It is not irrelevant to point out that Penn stood by its arrangement with Barnes even as the Philadelphia papers were attacking the Barnes ideology as "anarchist" and "Bolshevist."[98] Yet what is equally telling both in Laird's memo and in all of Penniman's correspondence with Barnes is the absence of any reference to Barnes's African collection. In his original proposal, Barnes had stressed that "we have sufficient of the primitive forms of art—ancient Greek, Egyptian, Negro, etc.,—in choice and representative pieces to show the origin of the forms clearly apparent in the best of the moderns."[99] Barnes would continue to draw attention to his African collection in subsequent letters and would advertise the forthcoming book *Primitive Negro Sculpture* in fliers promoting the Barnes's educational program. Recalling John F. Lewis's silent rejection of the African work at the Pennsylvania Academy, Penniman's early response to Barnes is exemplary of the university's strategy: "[W]e recognize and value fully the importance of the collection of Modern Art which you have assembled and the sincerity and earnestness of purpose with which you have organized and endowed the Barnes Foundation to promote the teaching of art as represented by this collection. . . . Standing as it does for art as a whole the University cannot, without lessening the catholicity of its spirit, fail to welcome the proposal which you have made to render accessible to students the treasures of the Barnes Collection and to have them adequately interpreted."[100] By approving the Barnes collection only as

a collection of "Modern Art," Penniman refuses by omission to approve the transhistorical and racially charged dimensions of Barnes's practices. While it is possible to make too much of this point, as Barnes for instance does not raise the issue of African American education in his exchanges with Penn, it is nevertheless important to recognize the way in which Penn succeeded in establishing the terms under which their arrangement with the provisionally institutionalized Barnes Foundation would be conducted.

The historical isolation and insularity of the Barnes Foundation can be dated to this moment. The *Journal of the Barnes Foundation* ceased publication in 1926, and it was at this time that Dewey, Buermeyer, and Munro all departed amicably from the foundation to retain posts in more conventional university and museum institutions.[101] By the early 1930s, as if in symbolic affirmation of Barnes's failure, the three major Philadelphia museums—the University Museum, the Philadelphia Museum of Art (which had opened in 1928), and the Academy of Natural Sciences—entered into an informal agreement not to compete with each other for acquisitions and not to collect in each other's fields.[102] This had the effect of guaranteeing an institutional commitment to what Dewey disparagingly called the "compartmentalized knowledge" that was precisely the enemy Barnes and Dewey had hoped to defeat in their educational strategies. The failure of Barnes's grandest aspirations, it is possible to say, has been the success of our own contemporary institutions.

The Art of Memory in the Age of the Unconscious

Barnes had worried from quite early on about the final institutional disposition of his collection, and many indications suggest that he became equally, if more quietly, concerned with devising a permanent and specific arrangement of the works themselves within the galleries. These are what became known as the "wall ensembles." Wattenmaker quotes a letter of 1929 in which Barnes boasts of the way his purchase of Renoir's *Leaving the Conservatory* (1877) had "necessitated a rearrangement with the result that a number of the rooms make ensembles much finer than anything we had before"; another letter shows the collector passing up the opportunity of acquiring desirable work because it would "break up . . . ensembles that are necessary for teaching purposes. The way we hang pictures is not the ordinary way: each picture on a wall has not only to fit in a definite unity but it has to be adapted to our purpose of teaching the traditions" (*APW* 41). Focusing on the pedagogical dimension of the wall ensembles, it

is possible to read Barnes's permanent arrangements as simply embodying, albeit in a more elaborate and systematic way, the same sensibility then guiding Phillips's exhibition units and experiment stations. By 1926, Phillips was promoting his own practices as supplements to "the required books on art-history [to be used for] the purpose of contrast and analogy" (CM 6). The unique form of the arrangement at the Barnes, however—and indeed its permanence—indicates that the function and meaning of the collection, as it is precisely displayed, differ from those of the Phillips in kind as well as degree.

A 1983 essay written by Barnes's protégé and collaborator Violette de Mazia on the subject of the arrangements is especially instructive in this respect.[103] From one angle, de Mazia's essay would appear mainly to provide a more concentrated meditation on what Phillips named the "purpose of contrast and analogy": "in Room XIV, the contrasts in the traditions represented on the wall having as its center painting Titian's portrait of a man and boy and, around it, fourteenth-century Bavarian panels, eighteenth-century Chinese paintings, late Renoirs and an eighteenth-century piece by Guardi, help to make clear the differences in the character of the means (color, light, line, etc.) employed in each tradition and of their organization."[104] While the concerns here are pedagogical, a critical distinction emerges in de Mazia's understanding of the way Barnes's arrangements (which she notably names "wall-pictures") are devised as works of art in themselves. She explains how they aim specifically to repeat the operations of the individual painting on the level of the gallery wall: "Each wall . . . , in the particular organization of its particular contents of paintings and other objects, makes up a particular 'wall-picture' in the same sense that the artist-painter's particular organization of particular color units makes up his particular picture. . . . Moreover, the paintings and other objects . . . are so hung that . . . they offer examples of certain compositional organizations found also in individual paintings and of other aesthetic features of concern to the artist-painter."[105] If Phillips had, in the 1927 Sensibility and Simplification exhibition, provided an archaic emblem for himself in the figure of Akhenaten (patron avant la lettre of liberal modernism), Barnes's arrangements alternatively figured the collector not as patron but as modernist artist. Here the agency of the collector-educator Barnes is more than imitative: while the aesthetic of the individual painting is echoed in the artful composition of the "wall-picture," the instructive wall ensemble reciprocates in bringing forward, by itself embodying, the educative value of each individual work.[106]

The emphasis de Mazia's essay places on the analogous forms of "organization"—the painter's, the collector's—unmistakably hearkens back to the aesthetic theory of *The Art in Painting*. But this is not the only set of issues that the essay puts into play: to suggest that the wall is a canvas is to raise the question of the collector's authorship, and thirty years after his death de Mazia's helpful essay may also be seen to invoke, in the background, "the one who thus arranged the objects."[107] It is important to respect the formal and pedagogical value of the arrangements, as de Mazia would wish us to do, but it will still be vital to consider the possibility of other authorial agencies that are not officially recognized by the essay or the institution. For on one hand, the wall ensembles are a stunning embodiment of the institution's publicly pragmatist identity. Whereas Rosalind Krauss has suggested that the characteristically "flattened and compressed experience of space" that emerges with impressionism anticipates the way modernism will "internalize the space of exhibition—the wall—and . . . represent it," the technique of the Barnes Foundation seeks to rescue the agencies of the work of art by reversing this corrosive gesture. The individual work does not represent the gallery wall; the gallery wall instead aspires to the condition of the individual work, over against its flattening and compressing agencies.[108] At the same time, however, the authored work that is the Barnes Foundation is expressive not only in pedagogical, public ways but in more hermetic, subjective, inward ways as well. It is in this sense that Barnes's final arrangement—a work that I will contend even bears the collector's signature—bespeaks what I have been calling the collection's privately Freudian identity, one that expresses forms of desire unaccounted for in the Barnes's pedagogical mission. To put the issue somewhat more epigrammatically, the arrangement of the Barnes, in addition to its progressive pragmatism, also practices what may be called, after Frances Yates, the art of memory in the age of the unconscious.[109]

From our contemporary perspective, the style of the Barnes may appear to have an antecedent in the densely packed walls of the Salon, dating from the early eighteenth century until the moment of impressionism.[110] Yet the largely arbitrary association of works at the Salon is clearly countermanded by the strict principle of order that characterizes the Barnes's arrangements. Barnes's wall ensembles, on the contrary, prize a symmetrical relationship among works, forming a unity (to use a Barnesian term) and employing balance and counterpoint as basic dynamics within the unity: hard against soft, masculine against feminine, Cézanne and Picasso against Renoir and

Matisse. This relationship is typically further underscored by works that are not paintings: strong phallic andirons often appear beneath Cézanne, whereas a ceramic bowl placed atop a chest may be found immediately beneath a Renoir.

If this is an adequate description of the Barnes's general system of arrangement, one amenable to numerous pedagogical variations and improvisations, the specific arrangements also often seem to be determined and at times undermined by different and competing logics. To name an obvious example, Matisse's *Joy of Life*, undoubtedly the painting that possessed the greatest aura before the Barnes's touring exhibition of the 1990s, has for the last sixty years hung inconveniently at the top of the stairwell leading to the second-floor galleries. Though it is reasonably well lit, close inspection of the painting is very difficult.[111] Less obvious, but similarly, one of Barnes's most important Van Goghs, the portrait of the postman *Joseph-Etienne Roulin*, is displayed relatively marginally in the corner of Room II, subordinated to Renoir's inferior *Bather and Maid* (1900).

These might seem like perverse idiosyncrasies were it not for the fact that more thematic (we can even use the Barnesian epithet "literary") connections can often be made among works in any given room.[112] Such associations run against the grain of the highly organized, ostensibly symmetrical formal arrangements. Barnes's three *Mont Sainte-Victoire* paintings, for example, animate new associations that unsettle their rooms' symmetrical conceits. In each case, Barnes's strategy of arrangement anticipates Sidney Geist's observation that "Cézanne's rich, precise, muted (and unconscious) symbolism" renders *Mont Sainte-Victoire* as an "excellent cryptomorphic self-portrait . . . where the top of his head coincides with the peak of the mountain."[113] Remembering the image of Cézanne's striking bald head, one can view Mont Sainte-Victoire, in Geist's compelling reading, as an encrypted self-portrait that might be taken as a self-addressed *memento mori*. Antedating by several decades Geist's insight, Barnes places each of these Cézannes so as to make present the same association.[114] On the south wall of Room XIV, *Mont Sainte-Victoire and Road* (1870s) appears immediately next to El Greco's *Saint Francis and Brother Leo Meditating on Death* (ca. 1600), in which Francis is cradling a skull. In Room XIII, Cézanne's famous *Boy with Skull* (1896-98) is hung next to a depiction of the same mountain in *Road at Marines* (1890-94). In a third instance, in Room II, Cézanne's *Still Life with a Skull* (1895-1900) faces directly across the room at another representation of *Mont Sainte-Victoire* (1885-95). The arrangement of each room formally

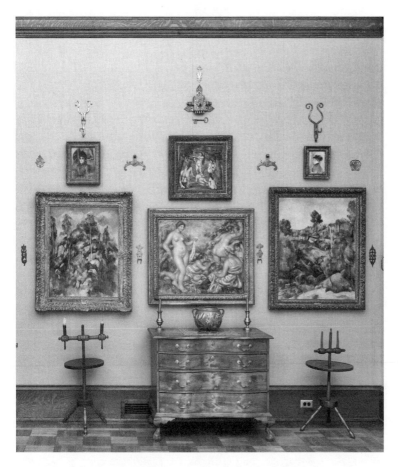

Room VIII of the Barnes Foundation, south wall (detail). Photograph © 2010 repro-
duced with the Permission of The Barnes Foundation.

associates the mountain with the skull and then associates both mountain
and skull with Cézanne's own absent likeness. Such observations do not
diminish the pedagogical function of "organization" within the paintings
and within the larger arrangements, but they do testify to the constitu-
tive importance of the "literary" quality Barnes had publicly denigrated in
The Art in Painting as "subject matter." The method that becomes visible in
these instances involves a system of punningly associative visual references,
bound to subject matter and exceeding the symmetrical organization of the
wall ensembles.

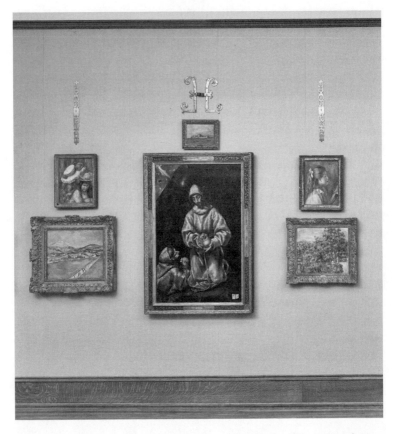

Room XIV of the Barnes Foundation, south wall (detail), featuring Cézanne's *Mont Sainte-Victoire and Road* (1870s) and El Greco's *Saint Francis and Brother Leo Meditating on Death* (ca. 1600). The skull in the El Greco *(center)* occupies the same elevation on the wall as the mountain in Cézanne's painting *(left)*; both are associated with the head of the artist Cézanne. Photograph © 2010 reproduced with the Permission of The Barnes Foundation.

Insights like these do not find a place in the official pedagogical account of the arrangements, nor are they reflected in Barnes's analyses of the individual works in the collection. Here is his reading of *Mont Sainte-Victoire* (1885-95) from *The Art in Painting*:

> There is some tendency in the general composition toward a bilateral symmetrical distribution around central masses. For instance, in the middleground the

clump of trees and the two houses function as a central mass, with the bilaterally balanced masses consisting, on the right side, of a comparatively flat piece of land, and on the left side, of slightly elevated land. . . . Between the central mass in the middleground and the apex of the mountain, there is always a focal point which arrests the attention and a corresponding element to the right and to the left to effect symmetrical balance. But in no case is there an exact duplication of elements: each unit is so varied from the corresponding elements on the opposite side that we get a picturesque variety. (*AP* 487)

With very slight substitutions, this reading could describe the formal organization of a wall at the Barnes Foundation, and indeed it may be objected that it is possible to read the mountain and skull as being related only at the level of form, not subject matter.[115] To follow this line of critical thinking in total faith, however, would preclude the compelling insight acknowledging Cézanne's cryptic signature, an insight that derives neither exclusively from the "objective" qualities of plastic form nor from the conceit of the rigorously balanced agencies of the "wall ensemble." The performance of Barnes's arrangement technique, I am suggesting, extends beyond the scope of both Barnes's critical writings and the official writings of the Barnes Foundation: what Geist proposes in his classical Freudian reading as Cézanne's unconscious self-citation Barnes had staged decades earlier in his visual representation of the activity of the Freudian unconscious.

Given the dense orchestration of the wall ensembles, provocative associations of this kind might reasonably be accounted as peculiar, even inevitable, accidents. Yet it would be easier to discount these unofficial associations as accidents if it were not the case that several other rooms (mostly on the second floor) manifest entirely more elaborate systems of "unconscious" signification. In the large Room XXIII, for example, a thematic homology between Rousseau's *Unpleasant Surprise* (1901) and Renoir's *Leaving the Conservatoire* (1877) is elaborated by means of supporting objects in the room. On top of a chest on the south wall of the room are two bird figures constructed out of lobster shells (the kind still easily found at souvenir stands along the East Coast). This reference to animals draws the viewer's attention to two other paintings in the room, Picasso's *Girl with a Goat* (1906) and de Chirico's *Swan* (n.d.). These two paintings, which specify an animal sexuality (de Chirico's *Swan* also recalls Cézanne's eerie *Leda and the Swan* [1880-82] in the Main Gallery), in turn encourage correspondent interpretations of the Renoir and Rousseau paintings that are displayed

most prominently in the room. Renoir's striking painting now seems more clearly to depict the two young women as being uncomfortably detained by the two dark male figures, as the front figure ominously stretches his left leg forward as if to prevent her from leaving the conversation.[116] In Rousseau's cryptic and fantastical canvas, the bear and the hunter, already associated together by their depiction in shades of deep brown, now appear to present equivalent threats to the surprised female nude, despite the fact that the hunter might otherwise be interpreted as the heroic preserver of feminine virtue (see figure on p. 114). Taken as a whole, the room comprises a system of images that develop the theme of male sexual predation.

If the narrative dimension of these arrangements, or their fundamentally sexual valence, still strikes the reader as dubious, they may refer to Room VII, in which Courbet's *Woman with White Stockings* (1861) is supported by a Pennsylvania German chest inscribed with the name "Suesaena Ackermann," thus making a "literary" association between Courbet's frankly erotic figure (is she putting the stockings on, or taking them off?) and the story of Susanna in the Book of Daniel.[117] Or they may observe the placement of a fine pair of scissors next to a painting of Christ's circumcision in Room IV.[118]

Barnes was an early American reader of Freud, and while it is not necessary to search for a specific source in Freud's writings that inspires Barnes's arrangements, it is nevertheless tempting to speculate whether the collector took special notice of the way *The Interpretation of Dreams* turns to painting when Freud describes, in the section titled "The Dream-Work," the primary mode of dream representation. Here paintings and dreams are described as sharing the common dilemma of muteness, and they also have in common the visual (or "pictorial") as their significant mode of communication. Freud figures the lack of access to language as a weakness that dreams and paintings must each work to overcome: "[J]ust as the art of painting eventually found a way of expressing . . . at least the *intention* of the words of the personages represented . . . so too there is a possible means by which dreams can take account of some of the logical relations between their dream-thoughts, by making an appropriate modification in the method of representation characteristic of dreams."[119] Just as the painter successfully modifies, by translating into a visual language, the primary content of an originary speech or language, the dream similarly modifies the "method of representation" of dream-thoughts that are its source. "[D]reams take into account," Freud writes, "the connection which undeniably exists between

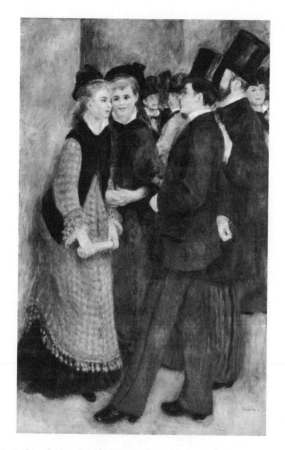

Pierre-Auguste Renoir, *Leaving the Conservatory (La Sortie du conservatoire)*, 1876–77. The central male figure's extended leg obtains a more ominous connotation in the context of the other works in Room XXIII. Oil on canvas, 73½ × 46¼ inches (186.7 × 117.5 cm). BF862, The Barnes Foundation. Photograph © 2010 reproduced with the Permission of The Barnes Foundation.

all the portions of the dream-thoughts by combining the whole material into a single situation or event. They reproduce *logical connection* by *simultaneity in time.*"[120] Whether or not Barnes's technique derives explicitly from Freud's chapter on "The Dream-Work," the unofficial meanings staged in the Barnes galleries are available by means of repetitive associations that "reproduce logical connection by simultaneity in time"; Barnes's most striking act of authorship is to stage materially the "manipulative process" (Freud's

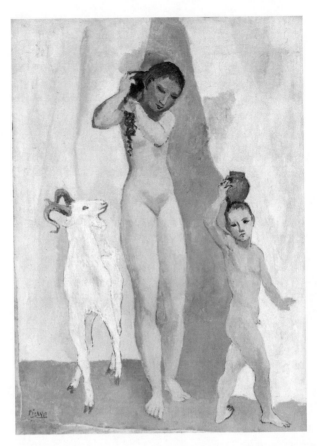

Pablo Picasso, *Girl with a Goat (La jeune fille à la chèvre)*, 1906. Oil on canvas, 54⅞ × 40¼ inches (139.4 × 102.2 cm). BF250, The Barnes Foundation. © 2011 Estate of Pablo Picasso/Artists Rights Society (ARS), New York. Photograph © 2010 reproduced with the Permission of The Barnes Foundation.

words) engaged by the unconscious. Without anywhere ceasing to honor his galleries' pedagogical obligations, Barnes's allusive and punning treatment of subject matter transforms the manifest content of the individual work by embedding it in a new system of latent meaning that is only available through the collective articulation of works.[121]

We are now prepared to address a central problem by asking why, if Barnes had advanced his African collection as the instrument and sign of his institution's social progressivism, the collection's African pieces are

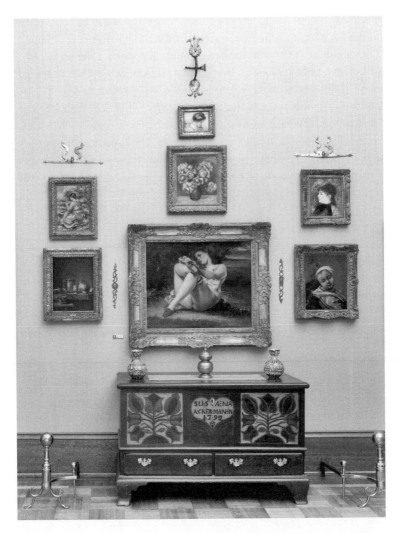

Room VII of the Barnes Foundation, east wall (detail), featuring Courbet's *Woman with White Stockings* (1861) above a Pennsylvania German chest with the inscription "Suesaena Ackermann." Barnes's association of works punningly alludes to the biblical story of Susanna, a reference that is absent from either work when taken in isolation. Photograph © 2010 reproduced with the Permission of The Barnes Foundation.

consigned to three seemingly marginal galleries at the Barnes Foundation (Rooms XX, XXI, and XXII). It is often pointed out that Barnes's commitment to black culture is manifest in the very entrance to the galleries, but this shibboleth cannot account for the fact that the African work has restricted access, if it can be put that way, to the rest of the collection.[122] The Barnes Foundation contains rooms that have particularly high concentrations of American art (XII) or Renaissance work (IV), but there are also numerous examples of such pieces throughout the galleries. This is not true for Barnes's African pieces, and while the concentration of these works may be due in part to the conditions of display necessary for wooden sculpture, it is hard to surmise that their restricted placement results merely from practical concerns.

It is no accident, I contend, that these rooms evince Barnes's most assiduous activity as an authorial collector, and that the African work appears as a crucial authenticator, or witness, of this authorship. I have suggested that Barnes's critical writing identifies black culture—whether from ancient Africa or the contemporary United States—as a model for enlightened democratic practice. What I have called Barnes's pragmatist primitivism was one manifestation of the way black art could be overdetermined; Barnes's interest in the way it could be used politically led him to make some implausible claims on behalf of the African pieces and to repress the works' complicated and inconvenient colonial provenance. The Barnes's progressivist mode at times mediated a black art in its own image, and this position betrayed a need on the part of the institution for its own political and social authentication. This need is reflected, in another register, by the arrangements at the Barnes that involve—or, better, that appear *in the presence of*—African sculpture. The rooms bear witness to the institution's progressivist identity, but they also appear to disclose more private, even confessional, statements that, according to the logic of the works' location, cannot be articulated without the African work. This surprising claim is licensed by the fact that Barnes discreetly included his own image—a small pencil sketch of his head drawn by de Chirico as a study for his portrait of the collector—on the left margin of a wall that contains dozens of small sketches and watercolors in Room XX.[123] Barnes uses the image, I suggest, as the signature for the authored work of his collection.

My discussion will conclude with this room, which is appropriately situated at the back of the building. I will begin at the front, in Room XXII. A photograph of this room's south wall and its impressive collection of West

African masks and figures appears in *Great French Paintings of the Barnes Foundation*. Wattenmaker's gloss notes the relationship of the African work to two female portraits by Modigliani and to two smaller studies made by Picasso in 1907, the year of *Les demoiselles d'Avignon*, and culminates with a dutiful paraphrase from *Primitive Negro Sculpture*: "The interspersion of elegant and rugged, both African and European, obliges us to examine our preconceptions about the traditions of sculpture" (*GFP* 21).[124] Indeed, the wall itself appears to illustrate Barnes's invitation, in the catalog essay for the 1923 Contemporary European Paintings and Sculpture exhibition, for viewers alienated by Modigliani's paintings to visit the African pieces at Penn's University Museum, so they might witness the long tradition in which Modigliani participated. This room represents the realization of Barnes's early frustrated effort, even going so far as to include two Bamana masks on each side of the south wall and a Kota reliquary figure in the southeast corner—all African works that manifest clearly the "even longer necks" of which Barnes wrote in 1923.[125]

As before, however, this room's design contains another, unofficial, semantic dimension. As if slyly joking about the symmetrical balance achieved on the south wall (and throughout the galleries), a dominant countertheme of Room XXII is that of imbalance. In the northwest corner, facing the Kota reliquary in the opposite corner, stands a small New Mexican *santo* figure— an adolescent boy winged like an angel, holding the scales of justice in one hand and a large screw in the other. Immediately above this figure on the wall is a small oil painting by de Chirico, *Mysterious Bathers* (1930), which depicts two bathing tents on a beach (presumably one for each sex). The tents and their shadows echo the halves of the scale beneath the painting, implying that gender and (because of the anomalous screw) sexual power are subject to a measurement of balance, or may be put out of balance.

This arrangement of pieces suggests an imbalance between the sexes that is itself the prominent theme of the largest work in the room, Roger de La Fresnaye's *Conjugal Life* (1913). In this post-cubist work, a clothed man and nude woman sit in a domestic space, conjoined as the woman (with eyes closed) grasps the crook of the man's arm (who looks up from his newspaper out and to the left, outside the field of the painting). The learning and authority of the male figure are confirmed by stacks of books that appropriately frame his head, while a pile of fruit accentuates both the "natural fertility" and the possible commodification of the woman. The painting leaves open a number of possible interpretations. In one reading,

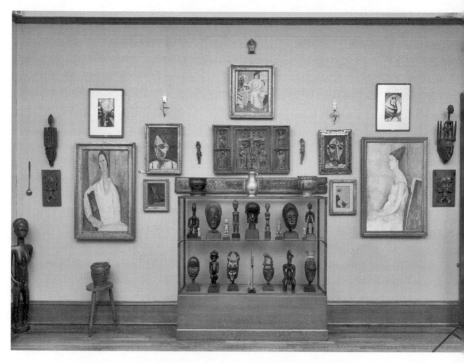

Room XXII of the Barnes Foundation, south wall, featuring two Modigliani portraits, two small Picasso canvases from the year of *Les Demoiselles d'Avignon* (1907), and twenty-one African figures and masks. The Guro mask in the bottom right of the vitrine is also reproduced in the pages of the *New Negro* anthology (see figure on p. 181). Photograph © 2010 reproduced with the Permission of The Barnes Foundation.

we are presented with a husband and wife, whose cultural and biological roles are complementary, but not harmoniously so. In another, what we see is not conjugal life, but a symptom of it, given the likely possibility that the woman is not the man's wife. As Jeffrey S. Weiss notes, "the dynamics of marriage, 'free union' and *concubinage* were a topic of broad moral and legal debate in France during the pre-war period, and it is to this discourse that La Fresnaye's image clearly belongs" (*GFP* 212).

Barnes's arrangement of the room as a whole encourages the latter interpretation. A majority of oil paintings in the room depict women alone, either as portraits (in the case of the Modigliani figures) or in more situational roles. Adjacent to de Chirico's *Mysterious Bathers* is Bonnard's *Woman and*

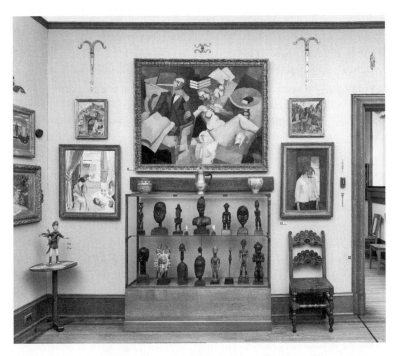

Room XXII of the Barnes Foundation, north wall, featuring Roger de La Fresnaye's *Conjugal Life* (1913), center, and Matisse's *Woman Reading at Dressing Table* (1919), left. The books that occupy the top center of *Conjugal Life* allude to the activity depicted in the Matisse. Photograph © 2010 reproduced with the Permission of The Barnes Foundation.

Dog at Table (1908). Bonnard here depicts a woman (modeled, as Barnes likely knew, by the artist's wife) sitting alone at a breakfast table, looking uncomfortably away from a second place setting before an empty chair. The titular dog stares out of the picture. This scenario is repeated in Matisse's *Interior with Seated Figure* (1920), the painting that sits atop the south wall, and, on the facing wall, in the same artist's *Woman Reading at Dressing Table* (1919). Many of the female figures in the room, including the two Modiglianis on the south wall, could be seen to share the typology of "women alone."

Another look at the south wall shows that the Africanized Picasso heads (*Tête de femme*, *Tête d'homme*, 1907) are placed so as to be unsettlingly surveilling the seated Modigliani female figures. What Weiss notes as the

androgynous quality of Picasso's newly developed technique, "the mor-
phological and iconographical ambiguity inherent in the new schematizing
language of form," permits a reading of the two leering heads as male (*GFP*
207). But it is just as instructive to note that the identifying cards available
to visitors to the Barnes Foundation as recently as the late 1990s referred to
these paintings not by the generic titles *Head of a Woman* and *Head of a Man*,
but in the names of the famous conjugal fighting puppets Punch and Judy.
If these attributions, as one must suspect, represent Barnes's pet names for
the paintings, it can only lend further validity to this reading of the over-
arching arrangement. It is possible to suggest that, as opposed to the more
general representation of sexual predation that seems to be elaborated in
Room XXIII, Room XXII performs a rather more specific meditation upon
marital discord, and it may specifically invoke Barnes's long romantic rela-
tionship with Violette de Mazia.[126] The female figures in this room could rep-
resent either de Mazia or Barnes's wife Laura (or both), the latter of whom
was herself actively engaged at the Barnes in overseeing its arboretum. The
theme of unequal power within marriage, and of women's consequent iso-
lation as a result of it, is in any event difficult to ignore in the room. And
these associations are thrown into relief, indeed made unavoidable, by the
vitrine in the center of the room that displays the Barnes's famous *Dogon
Couple* (19th c.), a male and female figure seated harmoniously, the man's
arm around the woman's shoulders.

In Room XX, the gallery that contains the collector's authorial signature
(de Chirico's study of Barnes), the key themes are impotence, torment, dis-
guise, and failure. As is true for many of the Barnes's corner rooms, there
are no large canvases. Three of its walls display dozens of small sketches,
etchings, and watercolors. Two of them include vitrines containing African
masks and figures. All three walls are organized around a central work that
depicts in some way a man in torment. The focal work of the south wall
is Pietro Longhi's *Conversation Piece: Masqueraders* (18th c.), an oil paint-
ing that depicts a drawing room adjacent to a masked ball. The west wall's
pieces surround four central works: Georges Rouault's *Clown in Top Hat*
(1907), a depiction of a drunk harlequin, and two Goya ink drawings, one
of which (*Dogs Chasing a Cat on a Man on a Donkey*, 1815-20) shows a man
being attacked by dogs. On the north wall, the major work is the West-
phalian *Healing of Lazarus* (ca. 1400), in which a disfigured Lazarus, too, is
surrounded by threatening dogs. The dejected man in the Longhi painting,
unable to remove his mask in front of the two female figures, obviously

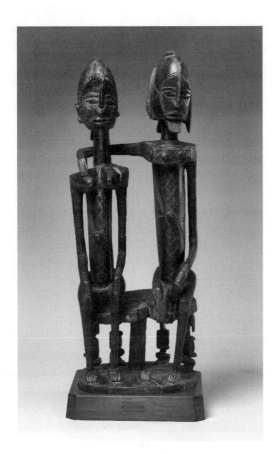

This figure of marital harmony occupies the center of the otherwise inharmonious Gallery XXII. Unidentified artist, Inagaki, *Seated Couple*, Dogon Peoples, Mali, Late 19th-early 20th Century, Wood, 27⅜ × 11 × D 10½ inches (69.5 × 27.9 × 26.7 cm). A197, The Barnes Foundation. Photograph © 2010 reproduced with the Permission of The Barnes Foundation.

recalls the themes of Room XXII. Here, though, it is the male figure that is isolated, while the two women (one thinks of de Mazia and Laura Barnes) have removed their masks and seem comfortably sociable. By contrast, what is most formally remarkable about the painting is the way the man's mask appears actually to constitute his face. A possible source of all this suffering can be found on the west wall, which is also significantly the wall that includes the image of Barnes. Among the dozens of small pieces on

this wall the theme of woman and child appears repeatedly, an association that points up the fact that Barnes never fathered a child, or heir. Such an interpretation is encouraged by the male figures on this wall, which, apart from the picture of Barnes himself, are largely clowning harlequins (like the costumed figure in the Longhi canvas) or drunks. These emasculated male figures are clearly associated with de Chirico's sketch of Barnes. This gesture acts as Barnes's authorial signature for the performance of the collection as a whole, but rather than claiming a heroic position it depicts the author as a tormented and isolated figure—even ambiguously raising the issue of alcoholism.[127]

The most outrageous suggestion made in the room, and one fully congruent with Barnes's ribald sensibility, involves three stone sculptures—abstracted human figures—by Jacques Lipchitz positioned at the foot of the north and west walls.[128] Apparently three of a series of four, the place for the absent fourth sculpture is occupied by a nineteenth-century farm instrument that possesses roughly the same dimensions as the Lipchitz sculptures. The instrument, significantly, is a jack, whose arm has turned so far as to raise the jack only partway from its closed position. Viewers who have elsewhere noticed the perilous juxtaposition of scissors with Christ's circumcision will be more ready to recognize the joke about impotence that Barnes seems to make here. It is a joke that in turn supplies a determining logic for the association of clowns, tormented men, and children throughout the room. Because this is the gallery that also bears the collector's own image—what I am calling his *signature*—in this context it is hardly irrelevant to remark that Barnes and Laura never had children, since this fact supplies an absent "literary" referent unifying the apparently disparate work displayed in this final room. Such a theme is especially charged because of the institutional, as well as personal, implications that accompany Barnes's lack of an heir. Duncan Phillips's son Laughlin served as director of the Phillips Collection from 1979 to 1991 (and chaired its board from 1966 to 2001), securing its hugely successful transition to the contemporary period.[129] A different history awaited the Barnes, where de Mazia remained in control from Barnes's death in 1951 until her own death in 1988. That event initiated the protracted and bitter struggle that appears finally to have been resolved, though not to universal acclaim, with the move of the collection to Center City Philadelphia. If the transfer of the collection to its new buildings preserves Barnes's arrangements, it will also preserve a record of the more private meditations that I have proposed are present within them.

Taken as a name for a set of cultural and institutional practices, the Barnes Foundation represents an extreme instance of the institutional mediation of modernist art; it also represents a strangely literal example of the institutional production of authorship. The former point, especially, testifies to Barnes's very great ambitions: the moment of modernism's institutionalization would also be the moment that American cultural practice, writ large, would be progressively transformed. Because of the scope of these ambitions, Barnes has often been portrayed by acolytes and enemies alike as a brilliant outlier, utterly distinct and isolated from the prevailing trends of the culture of American modernism. But it is possible to argue, on the contrary, that Barnes's practices were in fact paradigmatic of the farthest-reaching aspirations of modernist culture in the United States, resembling in a more intensified way Pound's understanding of the literary collection as an object in itself, or Phillips's efforts to use the collection as a means of both inspiring and regulating aesthetic production. More specifically still, as I will argue next, as both provisional institution and authored work, the Barnes Foundation strongly resembles the landmark anthology to which Barnes himself contributed: Alain Locke's *New Negro*. Seen in the light of all these associations, the best argument for the exact preservation of Barnes's arrangements—something the move to Center City will nevertheless in some way transform—is that together they represent one of the most remarkable and characteristic authored works of American modernism.

4 *The New Negro* in the Field of Collections

Sage Homme Noir

In Paris, December 1923, Albert Barnes met Alain Locke, professor of philosophy at Howard University, the first African American Rhodes scholar, and friend to Countee Cullen, Langston Hughes, and Jean Toomer—young writers soon to be claimed as principal poets of the New Negro Renaissance. The following month, Barnes wrote Locke to ask for his assistance in identifying "negro poets, writers, thinkers, musicians and other creators" for the purposes of an article he was writing for the journal of the American Library in Paris. In March he invited Locke, Charles S. Johnson, and James Weldon Johnson to spend a day at his home in Merion, offering "dinner, bed, breakfast, views of negro art, paintings and the new buildings."[1] The visit, which occurred after the chartering of the Barnes Foundation but before its official opening, may be read as an exchange of symbolic authority from which both Barnes and Locke would benefit. Locke, who ended up staying two full days with Barnes,[2] stood to gain from his association with a wealthy collector who was also politically progressive; Barnes looked to benefit from a prospective alliance with two leaders of the nascent New Negro movement. By the late 1920s, this relationship would become agonistic, with Locke and Barnes competing against each other for acquisitions of African objects, and Barnes soliciting public attacks on Locke in the pages of the *Nation* and private ones through intermediaries such as Aaron Douglas and Gwendolyn Bennett.[3] In the short term, however, the relationship produced a cooperative intellectual exchange that involved Barnes's contribution of photographs of his African pieces, as well as his essay "Negro Art and America," to Locke's seminal *New Negro* anthology, which would appear the year the Barnes Foundation opened, 1925.

Although it is a commonplace to cite Locke's *New Negro* as the defining text of the Harlem Renaissance, it is possible to make the broader claim that it is the most important and influential anthology of the modernist period, irrespective of race, nationality, or aesthetic. It is one of only a very few anthologies of the period that have been consistently available in a trade edition for the last forty years, and it is certainly the only one regularly assigned in college classes. The reevaluation of Harlem Renaissance writing that began in the late 1980s[4] has more recently culminated in major studies of *The New Negro* by George Hutchinson and Barbara Foley, each of which painstakingly reveal—though with quite different sympathies—the degree to which Locke's anthology participated in a wider discourse of American cultural nationalism.[5] Those recent studies have proven indispensable for revealing intellectual, cultural, and institutional genealogies of Locke's anthology and, in Foley's case, for providing the grounds for a critique of the New Negro Renaissance's cultural pluralism. Without erasing these crucial accounts of the book's ideological affiliations, it is worth providing a different consideration of the anthology's meaning, one that demonstrates its relationship to the institutionalization of modernism as such.

This chapter surveys the field of anthologies that both preceded and succeeded *The New Negro* and also considers Locke's interest in the institutional representation of African sculpture, which was at first strongly affiliated with his interest in modernist culture. This approach will show how *The New Negro* not only articulated a specifically nativist American modernism—though this it surely did—but also participated in an argument about the social agency of modernist art, more broadly conceived, as that art was received, translated, and produced in the United States. It will also offer interpretations of two anthologized poems—Countee Cullen's "Heritage" and Helene Johnson's "Bottled"—that meditate on the agency of collections and on the agency of the collectivities those collections were imagined to represent or call into being. As we will see, these poems present the problematic of the collection far more thoroughly and reflexively than do the symptomatic poems discussed in chapter 1: Amy Lowell's "Astigmatism," Carl Sandburg's "Others," and William Carlos Williams's "On First Opening *The Lyric Year*."

It was not, of course, the exclusive function of Locke's anthology to situate the New Negro movement as definitively "modernist." Locke felt obliged to balance several competing imperatives in the book, and these were often not amenable to a synthetic statement. Not all of the salient

"modernist" characteristics of Locke's project should be understood as intentional responses to, say, Pound (to whom Locke never made direct reference). But Locke's anthology project was nevertheless enabled by a cultural field that had been in part determined by interventions of Pound, Lowell, and Kreymborg, just as later "high modernist" work of the 1920s would be conditioned by a field that had been affected by the movement announced in *The New Negro*.[6] Although it was not the first African American literary anthology, *The New Negro* set the stage for the explosion of black anthologies that followed, each of which required a gesture of identification or disavowal, in a way that recalls the obligations of modernist anthologies that followed Pound's *Des Imagistes*. Indeed, we may appreciate the homology between Pound's and Locke's positions based on Locke's subsequent self-identification as the New Negro movement's "midwife" and Pound's self-designation as the "Sage Homme" (or male midwife) of *The Waste Land*, the poem that Pound named "the justification of the 'movement,' of our modern experiment to date."[7] In naming themselves midwives, Locke and Pound not only figured their activities as forms of creative "labor" but also claimed a form of symbolic authority over their respective movements. It was an authority that obliged the engagement of the anthologists that followed them.

Pursuing the aesthetic and political effects of the modernist collection's material form, this chapter aims to illuminate a field of associations and identifications more conceptual than the ones offered in Hutchinson's institutional genealogy. Specifically, I claim that *The New Negro* may be seen as a paradigmatically modernist collection in at least two respects. First, it realizes many of the ambitions and implications of the interventionist anthology form as they had been imperfectly practiced by Pound, Lowell, and Kreymborg (some of which had been satirically comprehended by Bynner and Ficke's *Spectra* anthology). Second, *The New Negro*—the first modernist anthology to integrate poetry so thoroughly with other media—represents the most successful textual representation of the visual appeal and cultural prestige of the modernist art collection. As we have seen, throughout the 1910s, modernist anthologies repeatedly presented themselves (and were received) according to the logic of the art exhibition, in an effort to obtain the cultural currency of events like the Armory Show or the first Society of Independent Artists exhibition. In the wake of the Quinn auction, as we have also seen, the question of modernist art's social form and meaning became the purview of private collectors like Phillips and Barnes. This

point goes a long way toward explaining why Locke would increasingly be drawn toward the field of art in the late 1920s and 1930s, during which time he would unsuccessfully attempt to found a Harlem Museum of African Art. But in a more immediate sense, it also helps account for the striking composition and visual appeal of *The New Negro* as a textual object. For the compelling heterogeneity of the texts and images that compose Locke's anthology—a book that also apparently violates its own categories of classification—bears a meaningful resemblance to the idiosyncratic and suggestive association of objects at the Barnes Foundation. This, I suggest, is the most powerful evidence of Barnes and Locke's brief affiliation. It was on the basis of such aesthetic sensibilities that the Barnes Foundation and *The New Negro* each claimed agency for themselves as provisional institutions, each performing a powerful rearticulation of cultural objects which, while they may be exemplary of a particular strain of cultural nationalism, also described and intervened in a broader modernist problematic. If Locke hoped it would be possible to separate black cultural production from radical politics, as is frequently acknowledged, he did so by attempting to force modernist aesthetics and practices to be available for and accountable to the black American subject.

Precursor Anthologies

By the mid-1920s, it had become less common for the poetry anthology to function as an instrument of aesthetic intervention and collective self-identification. After Kreymborg's final *Others* anthology in 1920 and the last volume of *Wheels* the following year, it would not be until 1932, when Louis Zukofsky published *An "Objectivists" Anthology*, that the form would be used to name a specifically poetic formation. With the decline of the coterie anthology, the more conventional and official form of the canon-defining anthology became operative within the field of literary modernism. Beginning in the late 1910s, and with an eye specifically upon the classroom, the established houses Macmillan and Harcourt began to produce canon-defining anthologies of modern poetry, issuing competing volumes edited by Harriet Monroe and Alice Corbin Henderson, Louis Untermeyer, and Marguerite Wilkinson.[8] Monroe and Henderson's *The New Poetry* (1917) especially emphasized the degree to which the interventionist anthologies of the mid-1910s were now considered to be historical documents, as their bibliography carefully documented which of the selected poems had been drawn from Pound's *Des Imagistes* and *Catholic Anthology*, Lowell's *Some Im-*

agist Poets, and Kreymborg's *Others*. Meanwhile, Pound himself had begun what would be a long and fruitless campaign to publish a historical anthology of world poetry.[9] And in 1925, the year of Amy Lowell's sudden and unexpected death, Kreymborg issued his own memoir, scribed at the ripe age of forty-two.[10]

As I have argued, even occasional anthologies such as *The Masque of Poets* and the series of *American Poetry* miscellanies implicitly argued against the concept of group identification or intervention and attempted to neutralize the conflicts that had provided free verse with much of its social force in the 1910s. But if the specifically presentist, school-defining mode of the coterie anthology had fallen into disfavor, the still uncertain parameters of what could be claimed as modernist poetry remained the object of other modernist anthology projects, including those that were not specifically canon-defining. A brief look at two quite different collections will demonstrate how the anthology's interventionist mode persisted, albeit in a transformed mode, as a way of institutionalizing modernism in contradistinction to the examples of Monroe, Untermeyer, and Wilkinson. Both of these collections, George W. Cronyn's *The Path on the Rainbow* (1918) and Genevieve Taggard's *May Days* (1925), figured modernism less as a canon of works than as a set of aesthetic and cultural practices.

Both books were also published by Boni and Liveright, a firm founded in 1917 when Albert and Charles Boni—the American publishers of *Des Imagistes*—joined forces with the iconoclastic Horace Liveright. At this same time, Liveright and Albert Boni also founded the Modern Library, which quickly became an important American publisher of modernist novels; by 1918, the Bonis split with Liveright, who retained the rights to the Boni and Liveright imprint.[11] It was in this year that *The Path on the Rainbow* appeared, a book that at first blush presents itself as a semi-scholarly collection of American Indian songs and chants, transcribed by such figures as the anthropologists Franz Boas and Natalie Curtis Burlin and lineated in the anthology as poems. Cronyn's dedication expresses its gratitude to these collectors and professes that the book's contents represent "very ancient . . . Art Forms of a Vanishing Race . . . none exhibit[ing] the slightest traces of European influence; they are genuine American Classics."[12] Cronyn organizes the poems ethnographically by region, but the book concludes with a section of looser "Interpretations" by figures including Monroe's former assistant Alice Corbin Henderson (who had moved to

New Mexico in 1916, after having been diagnosed with tuberculosis). These less literal translations, together with Cronyn's insistence upon the source material's absolutely American quality, signaled an agenda for the anthology that exceeded the purely ethnographic and mark it as a relatively early articulation of the "nativist modernism" that Walter Benn Michaels has identified in the somewhat later work of Willa Cather and Hart Crane (which figured the Indian as the quintessential "vanishing American").[13] One express purpose of the anthology, then, was to act as a historical archive for the nourishment of contemporary American writing. As Mary Austin explained in the book's introduction, "I know of no task so salutory [sic] to the poet who would, first of all, put himself in touch with the resident genius of his own land."[14]

In this respect, *The Path on the Rainbow* anticipated Alain Locke's call, in *The New Negro*, for African American artists to embrace both Negro folk material and African forms in the creation of a new racial art. But Austin's introduction evinced another, complementary mode of rearticulation, not of Indian songs but of modernist poetry, which situated *The Path on the Rainbow* less as an intervention than as evidence of a *fait accompli* in the contemporary field:

> [A] greater interest still attaches to the relationship which seems about to develop between Indian verse and the ultimate literary destiny of America.
>
> That there is such a relationship any one at all familiar with current verse of the past three or four years must immediately conclude on turning over a few pages. He will be struck at once with the extraordinary likeness between much of this native product and the recent work of the Imagists, *vers librists*, and other literary fashionables. He may, indeed, congratulate himself on the confirmation of his secret suspicion that Imagism is a very primitive form; he may, if he happens to be of the Imagist's party, suffer a check in the discovery that the first free movement of poetic originality in America finds us just about where the Medicine Man left off. But what else could he have expected?[15]

The American Indian texts were thus instrumentalized as an unclaimed, or perhaps already unconsciously claimed, patrimony of the poetic modernism that had been circulated in Pound's, Lowell's, and Kreymborg's anthologies. To this end, Austin's introduction adduced examples of the affinity of imagism with the Indian texts, for example, in the Cheyenne ghost dance song:

I bring the whirlwind
That you may know one another

.

We shall live again!

Choosing a poem that echoes "Oread," Austin glosses the text in terms that
unmistakably evoke H. D.: it presents "flashes of revelation brought from
the dead in dreams."[16] Without explicitly denying the Greek and Chinese
source material that had shaped the Poundian phase of imagism, Austin
summoned an alternative past and future for free verse, one that necessar-
ily and strategically suppressed the transnationalism of imagism's original
authors and sources while preserving its definitively archaic character.

Considered more broadly, *The Path on the Rainbow* demonstrates the
degree to which the cultural meaning of modernist writing remained in
flux—and was available for rearticulation—in 1918. This condition of pos-
sibility was still extant seven years later, when a competing account of
modernism's American history and future, as well as a different modernist
constituency, was claimed by Genevieve Taggard's *May Days: An Anthology
of Verse from Masses-Liberator*. Boni and Liveright published *May Days* in
1925, the year Liveright's former partners Albert and Charles Boni issued
The New Negro. Like Cronyn's anthology, *May Days* presented itself as a form
of literary recovery, albeit of a different kind.[17] *May Days* did not salvage
ancient, "genuine[ly] American" texts, but rather set itself the task of docu-
menting the already forgotten political charge that had accompanied and
conditioned the American reception of modernism in the 1910s.

Specifically, *May Days* brought together verse, much of it formally tradi-
tional, that had appeared in the socialist journal the *Masses* (1911-17) and in
its successor the *Liberator* (1918-24), which had been founded after *Masses*
had been suppressed during the war, and where Taggard had been poetry
editor.[18] Claiming as its heroic figures John Reed and the poet-editors Floyd
Dell and Max Eastman, the anthology functioned as a eulogy for the jour-
nals, as well as a form of recovery and corrective historiography, for as Tag-
gard's preface observed, in a few short years "*Masses* seem[ed] to have van-
ished from the gaze of the literary historian—underground it went, to cut
channels in the bed rock."[19] But Taggard also situated the book as a part of
a much larger, unwritten history of modernism's political potential. Look-
ing back on the prewar era, she writes, "To put the whole portrait together
I would have to get files of *Others*, *Seven Arts*, and the *Little Review*; find

pictures of the first suffrage parades, and the speeches of social reformers reported in the New York *Times*; follow the editorial risings and sinkings of the *Nation* and the *New Republic*; and see by some act of the imagination, the expression on the faces of the crowds who went to the Armory Show in 1912 to watch the Nude descend the stairs."[20] It was during this moment that Picasso "lay down together between the same editorial sheets" as the Marxist journalist Reginald Wright Kauffman; now, however, "[t]he artists who were attracted to the *Masses* for its art have gone one way; the revolutionists another. The two factions regard each other with hostility and suspicion."[21]

Taggard was here specifically referring to a schism within *Masses* itself that concerned the relationship of aesthetics to politics.[22] But her identification of the contours of "the whole portrait"—which included *Others*, the *Little Review*, and the Armory Show—indicated that the division within *Masses* was emblematic of a cultural problematic writ large. The implication of the *May Days* anthology was that the insoluble elements of the rift between "art" and "revolution" were primarily literary. While she went on to lament the bourgeois, "High Brow" orientation of the little magazines, Taggard notably declined to question the revolutionary force of Picasso's paintings or Duchamp's *Nude Descending a Staircase*. In this respect, *May Days* can be read, in part, as still another attempt to claim the political force of the first modern art exhibitions in New York, providing a reading that agreed with Duncan Phillips's assessment of the works' "anarchism" more than it did with the *American Poetry* miscellany's apolitical citation of the Society of Independent Artists exhibition (the exhibition whose radicalism had caused Phillips to murmur, "War is a good cleanser. We need war.").[23]

Yet if it was possible to suppose that Taggard believed that the American reception of European modernist painting had been homologous with a similar reception and translation of European Marxism,[24] she was notably more uncertain about the political agency of modernist poetic language, which appeared to her to have signaled in advance the failure of political discourse as such: "In [Woodrow Wilson], as in his generation, ended the beautiful belief in the beautiful efficacy of—beautiful words. Even the gangling free verse movement had not shaken that faith. . . . Even the I.W.W. and the extreme left wing of the revolutionary movement shared the verbosity and romanticism of the time."[25] Taggard thus situated free verse ambiguously as either harbinger or symptom of the present crisis in civic discourse, but in neither situation was free verse a political agent within the crisis.

Taggard's carefully qualified assessment of the political value of free verse spoke to her own literary and political dispositions, which she shared with the anthology's primary figures—Eastman, Dell, and Reed. Themselves skeptical about literary modernism, the three writers accounted for nine sonnets in the anthology. As Mark Morrisson has shown, however, the *Masses* was not itself overtly hostile to free verse.[26] Even the anthologized poems, taken as a whole, did not fail to register an ambivalence about the efficacy of modernist form within the history of "Masses-Liberator." Though it did not reprint poems by William Carlos Williams and Baroness Else von Freytag-Loringhoven, each of whom had published in the *Masses, May Days* did include poems by *Others* contributors Helen Hoyt and Maxwell Bodenheim, as well as free verse poems by James Oppenheim, Carl Sandburg, E. E. Cummings, and even Amy Lowell (whose politics were hardly assimilable to those of the *Masses*). Taggard also included a poem that remarkably anticipated the leftist documentary poetry of the 1930s,[27] as well as at least one poem on whose basis a political argument about free verse could have been made. Eve Lott's poem "Freedom" was explicitly programmatic in this regard:

> i dont see any need for any law of any
> kind in anything life love or the seven
> arts why i ask you why is a comma or a
>
> question mark or meter or a foot or
> paragraph let us assume that the
> reader has a noodle too this reading
>
> business has been made too easy
>
>
>
> i believe in putting my
> thoughts down on a
>
> shakespearian stage and
> letting the pit create its
>
> own scenery this comrade by your
> leave is a poem with rhythm
> rhyme and
> figure of speech as you
> please if you don't like it revise

> it thats art the creator starts something and
> you finish it thought is dynamic and will
> out just as murder will if you dont get it[28]

Lott not only decries standardized form as a kind of arbitrary and politicized "law" but also renounces her own special rights as author in the name of the reader's ethical obligation to engage and transform the poem: "you finish it." The poem, furthermore, implies no distinction between poetic and political "thought."

Such works could conceivably have been promoted in the book's preface, but Taggard was evidently uncertain about Lott's claim that "this reading / business had been made too easy," particularly because such a claim would have called into question many of the other poems in the anthology. Indeed, in concluding her preface, Taggard stressed that she had "not tried to restrict th[e] anthology to verse of conspicuous poetic merit" and acknowledged that "[m]uch of the best is light verse."[29] This claim did not appear to trouble the copious numbers of sonnets that appeared in the collection, which in many cases presented their own forms of difficulty and complexity. But it did run afoul of the implications of modernist poetic form's difficulty, which evoked anxieties of readership and audience in a way that had not been true either for the sonnet form or for the paintings of the Armory Show. Such uncertainty prevented Taggard from clearly perceiving and identifying a future direction for literary production. Yet that very ambivalence makes all the more striking Taggard's desire to document, in order some day to reclaim, the social formation in which aesthetic modernism's political potential seemed more unquestionably apparent. In this sense, *May Days* was a homily to a lost moment where, in Raymond Williams's words, "crises of technique [were] directly linked with a sense of crisis in the relationship of art to society."[30]

If *The Path on the Rainbow* indicated a future for modernist writing that was to be bound to an archaic American folk culture, thus anticipating one of Locke's characteristic strategies in *The New Negro*, *May Days* bore witness to the historical disarticulation of socialist politics from the activities of modernist culture and thus resembled the disarticulation from socialism that would also mark Locke's anthology. The prefatory apparatuses of all three anthologies, moreover, availed themselves of a rhetorical trope of the "soil," which Foley has shown to be characteristic of a "metonymic nationalism" employed by the American left to "represent 'our America' and contest

the hegemony of 'Kultur Ku Klux Klan'"—a progressive attitude, but not a revolutionary one.[31]

Against these meaningful resemblances, the quite different investments of Cronyn's and Taggard's collections also demonstrate that the social significance of the modernist project—as well as its constitutive texts—remained undecided at the time Locke published his anthology. They also show how the anthology form continued to be a powerful means of mediating contemporary (and shaping future) cultural practices, even at the moment that a canon of literary modernism was beginning to be constructed through more conventional anthologies like those of Monroe and Untermeyer. The very question of what might be effected socially through the institutional mediation of modern art remained subject to contest. Acknowledging this situation obliges us to revise our conception of modernist poetry's "inevitable" destiny as an object of literary study. It also helps to support the characterization of Locke's anthology as a modernist collection, which circulated in the context of these other examples of modernist self-definition.

The New Negro also, perhaps more obviously, appeared in the wake of three pioneering (and specifically canon-defining) anthologies of African American poetry.[32] Besides James Weldon Johnson's famous *Book of American Negro Poetry* (1922), there were two collections by white editors that appeared in advance of *The New Negro*: Robert Kerlin's *Negro Poets and Their Poems* (1923) and Newman Ivey White and Walter Clinton Jackson's *Anthology of Verse by American Negroes* (1924). All three were indebted to Arthur Schomburg's pioneering *Bibliographic Checklist of American Negro Poetry* (1916), and all three were destined for classroom use; in 1931 Johnson and Sterling Brown would go so far as to collaborate on a pedagogical companion volume to the revised second edition of *The Book of American Negro Poetry*.[33] Each was also conceived as being the first, and therefore the foundational, collection of its kind (White and Jackson made a point of asserting that their anthology had been completed as early as 1921, "when it would have been a pioneer in the field").[34] It is therefore appropriate to consider them synchronically, as well as in the terms we have just considered, according to their positions on folk material, free verse, and political orientation. These anthologies, and Johnson's in particular, determined the conditions of possibility for Locke's more expressly presentist anthology.

White and Jackson's *Anthology of Verse by American Negroes* is by far the most conventional and conservative of the anthologies. An introductory

note awkwardly claims that it presents an account "both critical and sympa-
thetic and quite free from any implication of patronage or favor," a remark
that betrayed anxiety about the book's reception by a presumptively white
audience.[35] If such anxiety extended to the anthology project as such, this
was largely produced by the editors' very traditional formalism. The an-
thology conscientiously represents poets from Jupiter Hammon and Phillis
Wheatley to the contemporary writers Cullen, Claude McKay, and Geor-
gia Douglas Johnson, but it is not until Paul Laurence Dunbar that African
American letters, in the editors' view, can claim its first poet of quality.
This assessment was hardly original by 1923, and it would be shared by
Kerlin and James Weldon Johnson, but the grounds for that judgment were
telling. "Negro poetry," they wrote, "that can be praised without abasing
critical standards does not really begin until after 1870. . . . Before that date
Negro poetry was in the hands of the illiterate or semi-literate; there were
practically no Negroes with the cultural background generally necessary for
the writing of good poetry. Since the Negro has acquired liberty and prop-
erty he has shown increased activity and ability in all the arts."[36] Though it
was not a dominant concern of the anthology, we can see that White and
Jackson intended to endow their introduction with a modicum of politi-
cal force: the quality of aesthetic production is presented as a function of
the rights of citizenship. While this formulation is clearly intended to be
read as supportive of the salutary process of further providing "liberty and
property" to African Americans, it notably fails to acknowledge the pos-
sibility of a literary tradition that draws from an "illiterate or semi-literate"
folk tradition or, more saliently, from the conditions of dispossession or
political oppression. Any question of free verse is likewise conspicuously
avoided. Although McKay (who himself only wrote in traditional forms) is
represented as "unquestionably strik[ing] a new note in Negro poetry" (19),
for White and Jackson it is the belletristic verse of William Stanley Braith-
waite that represents the apogee of black poetic achievement: "In finish and
grace his poems are superior to those of Dunbar; they are superior also in
another and less important respect—literary allusiveness."[37] Despite their
representation—and celebration—of Dunbar's dialect poetry (which itself
largely corresponded to English traditions of rhyme and meter), White and
Jackson figured the horizon of black literary achievement among standards
that American poets were leaving behind.

A quite different consideration of these issues was articulated by Robert
Kerlin's *Negro Poets and Their Poems*, which was published by the African

American press Associated Publishers in 1923. As George Hutchinson has discussed, Kerlin was a white radical academic who had "lost two faculty positions in a row for his public stance against racism and black peonage" and had edited a militant text titled *The Voice of the Negro, 1919*, "a survey of editorials from the black press in the year of the Red Summer."[38] True to these commitments; Kerlin provided his anthology with a more expressly political valence. Although *Negro Poets and Their Poems* was ostensibly a historical anthology (including substantial critical commentary), its dominant mode of organization was thematic, culminating in a substantial section on "The Poetry of Protest." Kerlin emphasized the breadth of this subfield of poetry by choosing poems on a variety of themes, including lynching, and he pointedly concluded the chapter with McKay's seminal Red Summer sonnet "If We Must Die." When Kerlin introduced the volume by writing that contemporary black poets do not wrap themselves in "'the mantle of Dunbar' [but in] an unborrowed singing robe, that better fits 'the New Negro,'" he was speaking of the pre-*New Negro* New Negro that Henry Louis Gates, Jr., would sensationally describe as the "militant, card-carrying, gun-toting socialist who refused to turn the other cheek."[39] Emblematic in this regard was Lucian B. Watkins's sonnet "The New Negro," which began by proclaiming "He thinks in black" and concluded "Deep in his soul / He feels the manly majesty of power."[40]

Such polemical verse, moreover, was not confined to the section explicitly devoted to political poetry. Four additional McKay poems, including "The Lynching," appeared in a section titled "The Present Renaissance of the Negro," and poems such as Will Sexton's "The Bomb Thrower" and Andrea Razafkeriefo's critical poem "The Negro Church" were also prominently featured.[41] Sexton's and Razafkeriefo's work, along with a young Langston Hughes's Whitmanian "The Negro," was included in a chapter that was notably devoted to free verse. Kerlin's attention to what he called the "new forms of poetry," moreover, was tied to the much stronger role he allowed oral traditions in the formation of African American poetics. His introductory chapter had been divided into two sections, one on folk song called "Untaught Melodies" and the other titled "Earlier Poetry of Art" (which originated with Hammon and Wheatley); Kerlin placed clear emphasis on the first of these sections. When he turned to modernist forms, Kerlin acknowledged that "[t]he newer methods . . . —free-verse, rhythmic strophes, polyphonic prose—have been tried with success by only a few Negroes." Yet he stressed that the reason for this was that black poetics

were as yet primarily imitative of anthologized English forms—precisely the horizon of accomplishment advocated by White and Jackson: "[t]hey are as much the heirs of Palgrave's *Golden Treasury* as their white contemporaries." Kerlin implied that a field of black free verse would direct itself anew to folk traditions and that the political examples of Sexton and Razafkeriefo were already suggesting a homology between formal and political "freedom": "for artistic freedom he has an authority older than free-verse, and that authority is not outside his own race. It is found in the old plantation melodies—rich in artistic potentiality beyond exaggeration."[42]

In contradistinction to Kerlin's anthology, James Weldon Johnson's *Book of American Negro Poetry* did not explicitly address itself to the questions either of political poetry or of modernist verse forms. Whereas even White and Jackson had tied the fate of black letters to economic and social conditions, Johnson claimed that the very "status of the Negro in the United States is more a question of national mental attitude toward the race than of actual conditions."[43] Compared with Kerlin's collection, Johnson's anthology chose less overtly confrontational poems from Watkins and omitted Razafkeriefo entirely. On the question of free verse, too, he was almost entirely silent, despite the fact that his own poem "The Creation," which he included in the anthology, had been a pathbreaking free verse setting of a sermon from the black church. Although he included work from Fenton Johnson (the only African American poet to have published in Kreymborg's *Others*) and named him "a young poet of the ultra-modern school," the formal questions to which Johnson addressed himself were not elaborated in the language of modernist verse, as it had to that point been defined (*ANP* xliv). Indeed, it is telling that when Locke reprinted "The Creation" in *The New Negro*—an anthology that was invested in articulating a connection between African American verse and poetic modernism—he authenticated the poem precisely according to the terms Johnson eschewed. As Michael North has pointed out, "[w]hen Alain Locke . . . wanted an example of 'the newer motive' in African-American literature, he turned to 'The Creation,' the first of Johnson's sermons to be published. In this 'interesting experiment,' says Locke, is to be seen one of the 'modernistic styles of expression' coming into being in the 1920s."[44]

Johnson declined to employ the *lingua franca* of poetic modernism, but his anthology nevertheless bore some of the hallmarks of the modernist anthology form in a way that Kerlin's did not, thus preparing the way for the strategies of Locke's subsequent collection. This is true not simply because

it was published by a mainstream trade publisher, Harcourt Brace, whose list included Untermeyer's *Modern American Poetry* anthology of 1919, as well as Harold Stearns's *Civilization in the United States* (1922) (a collection of essays Barbara Foley has named "the first anthology in the history of American letters that could make a claim to multiculturalism").[45] It is true because of the manner in which it embraced the cultural potential of its own intervention, not simply occupying "the beginning rather than the end of literary history making," as Theodore O. Mason, Jr., has written, but extending its concerns even more forcefully to the conditions of contemporary and future African American literary production.[46]

The specifically presentist intervention of Johnson's famous preface "On the Negro's Creative Genius," moreover, also quietly determined the historical scope of the collection. Whereas Johnson's prefatory essay discussed the work of forebears beginning with Hammon and Wheatley, the selection of anthologized poems began with Dunbar, who was significant not simply because he was "the first poet from the Negro race to show a combined mastery over poetic material and poetic technique" (as everyone agreed), but because in retrospect his career appeared, from the editor's perspective, to have foretold the animating problematic of contemporary black literary production (*ANP* xxxiii). Johnson recounted how Dunbar, the acknowledged master of dialect poetry, had initially felt that dialect was the only form in which he could gain a "hearing," and that the effect of his success in that form was to have foreclosed any question of aesthetic development: "the public had held him to the things for which it had accorded him recognition" (*ANP* xxxiv). In the sixteen years since Dunbar's death, dialect poetry had become, as the preface put it, "conventional," a form that could now only conjure what Locke would soon call "Old Negro" stereotypes. Johnson noted that the young poets were no longer writing in dialect, and it was on the basis of this observation that Johnson identified both the present crisis in black poetry and the conditions of an emergent solution to that crisis: "[T]hese [contemporary] poets are working through a problem not realized by the reader, and, perhaps, by many of these poets themselves not realized consciously. They are trying to break away from, not Negro dialect itself, but the limitations on Negro dialect imposed by the fixing effects of long convention" (*ANP* xl). The preface thus performed the work of identifying a cultural formation, while at the same time calling it into existence. The logic and the stakes of this intervention were neither fully formal nor fully social. As Johnson would stress, he intended no ideological "indictment against

the dialect as dialect." Yet owing to the vagaries of the form's social his-
tory, and in particular to that form's reception by a white readership, dialect
writing had nevertheless proven inadequate to the treatment of the "varied
conditions of Negro life in the United States" (notably the experience of the
northern metropolis) and would remain so for the foreseeable future (*ANP*
xli). In order one day to redeem the dialect form, a new form—vanguardist
but as yet unnamed—would have to be coined. The success of this project
would be judged according to its social agency in transforming the "national
mental attitude" toward black culture.

The model that the preface explicitly cited for that new poetics was not
Anglo-American free verse, but the Celtic revival as emblematized by the
playwright J. M. Synge. Thus, while the mode of the interventionist preface
contained echoes of the paratextual writings of figures like Pound and Lowell
on behalf of their own "schools," the contemporary object of identification in
Johnson's preface was not the modernism to which Kerlin had referred, but
the minority literary revival as represented by colonized Irish writers: "What
the colored poet in the United States needs to do is something like what
Synge did for the Irish" (*ANP* xl). This was a strategy Locke's prefatory essay
to *The New Negro* would borrow and expand, when it claimed that "Harlem
has the same rôle to play for the New Negro as Dublin has had for the New
Ireland or Prague for the New Czechoslovakia."[47]

It is worth noting that Johnson was writing in the immediate aftermath
of the Irish War of Independence (January 1919–July 1921) and just before
the establishment of the Irish Free State (in December 1922). Yet this vio-
lent context of national, anticolonial self-determination was not discern-
ible in Johnson's preface. What was instead immediately available in the
reference to Synge and the Celtic Revival was the cultural priority of reviv-
ing folk traditions and instrumentalizing them for the purposes of estab-
lishing a new mode of cultural expression—"a form that will express the
racial spirit by symbols from within, rather than by symbols from without"
(*ANP* xli). To this end, Johnson had begun his preface by making the "star-
tling statement . . . that the Negro [is] the creator of the only things artistic
that have yet sprung from American soil and been universally acknowl-
edged as distinctive American products" (*ANP* viii). These things artistic
startlingly did not include poetry, but instead comprised the vernacular
forms of folklore, spirituals, dance (the cakewalk), and ragtime. This claim
for the *national* priority of "low" culture amounted to a more thorough-
going intervention on behalf of the vernacular than Kerlin had offered, in

fact extending the more comprehensive logic that had animated *The Path on the Rainbow*, which similarly designated its Native American materials as "genuine American classics."

Yet there was a crucial distinction in Johnson's gesture, one that William J. Maxwell and Joseph Valente have identified as characteristic of the "paradoxically avant-gardist" orientation of the minority literary revival as such. Whereas Austin had positioned Indian folklore as fundamentally continuous with the modernist writing that had itself become subject to the process of literary canonization, Johnson's preface evoked black folk culture in the service of a still unrealized aesthetic form and social situation. In Maxwell and Valente's words, such a strategy amounts to a "performative gesture of identification . . . which can, in turn, supplant the recovery operation in its very essence."[48] In this way, Johnson's historical anthology became, on the basis of its preface, a provisional institution on behalf of a literature and a cultural situation that it could not yet represent, addressing future literary production in a way that Taggard was unable to do, and intervening more radically (and with less nostalgia) than Austin had done. It had made this claim, moreover, through the official cultural economy of "literature and art," as represented by the legitimating form of the canonical anthology, for such is the "only . . . measure by which [a people's] greatness is recognized and acknowledged" (*ANP* vii).

In his own preface to *The Practice of Diaspora*, Brent Hayes Edwards has remarked on the multiple ways that *The Book of American Negro Poetry* undermined, or exceeded, the institutional form of the anthology. This was true of the anthology's contents, which represented within the parameters of an ostensibly *national* literature the Caribbean poets McKay and George Reginald Margetson, a translation of the Haitian poet Massilon Coicou, and (in Spanish and two English-language translations) the Cuban poet Plácido. The anthology's commitments to lyric poetry were complicated, moreover, by the very nature of the book's appeal to folk culture. Whereas Negro poetry had not yet discovered "a form that will express the racial spirit by symbols from within rather than by symbols from without," such had already been the accomplishment not simply of the more vestigial forms of folklore and spirituals, but of cultural forms such as the cakewalk and ragtime, which had been produced by the conditions of modernity (*ANP* xli). As Edwards observes, it is immediately after the preface appeals to the official aesthetic economies of "literature and art" that Weldon Johnson engages a lengthy digression on these vernacular forms. If, as he argues, the logic of this strategy

is to "digress[] precisely in order to contend that Negro expression is both constitutive of the American 'cultural store' and excessive to it," a complementary point may also be made about the poetry anthology and the very destiny and agency of literary production.[49] The paradoxical, indeed "paradoxically avant-gardist," implication of *The Book of American Negro Poetry* is that its claims to modernity resided in the collection's obligation to represent a cultural formation that is neither bound to the American nation-state nor exclusively literary in its productions or occupations.

Coterie, Movement, Race

Locke's *New Negro* extended and in several ways transformed the implications of Johnson's anthology. At the most obvious material level, Locke's dazzling textual representation of visual artifacts in concert with poetry, fiction, drama, folklore, musical scores, and critical essays realizes Johnson's provocative rhetorical gestures beyond the category of the traditionally literary. The importance of *The New Negro*'s material form (only partially visible in the edition currently in print) is not to be underestimated, as it represents more broadly the ambitions and possibilities of the genre to an extent that has since been approximated very rarely. Locke also moved away from the more historicist mode of *The Book of American Negro Poetry* and toward the modernist economy of the "new" in choosing to represent a group of exclusively *living* (and mostly young) writers and artists. Like the modernist anthologies of the 1910s, *The New Negro* represented an unambiguously presentist intervention.

The specifically societal intervention that *The New Negro* was designed to effect was nevertheless an extension of Johnson's preface, representing both figures' belief in the social agency of culture. But the rhetoric of Locke's appeal at the same time led away from the transnational literary formation that had been represented in *The Book of American Negro Poetry*. (The possibilities of a truly Pan-Africanist anthology would not be tested until Nancy Cunard's epochal *Negro* anthology in 1934, which was even less of a poetic anthology than *The New Negro*.[50]) Whereas the social horizon of *The Book of American Negro Poetry* consisted in the universal recognition of the validity of black cultural expression, Locke made the more local and specific demand for "the fullest sharing of American culture and institutions," an articulation that unmistakably evoked segregation, even as it avoided the more confrontational racial politics of the immediate postwar period. Yet as Maxwell has recognized, those more specifically Marxist politics are "more

than absent presences in the text," and Locke specifically names the radical movements (as Johnson had not done) in order to admit that "he has rebuilt [their political claims] to a less radical design."[51] Central to this strategy is the calculated ambiguity of the term "institution," which may apply to arms of the legal state, social-cultural bodies like universities or museums, or even habits of custom or behavior.[52] If we may understand *The New Negro* as a provisional institution, it is precisely in its conception of the necessary interrelation of these three senses of the word; as had been true for Barnes, it was an understanding that presumed the necessarily political character of cultural institutions.

It was in this respect that we can both claim *The New Negro* as a paradigmatically provisional institution and also understand the particular agency Locke attaches in the anthology to *modernism*—a word and concept notably absent from *The Book of American Negro Poetry*. For whereas Locke follows Johnson in articulating the enabling performative gestures of identification with the minoritarian renaissance associated with Synge, transnational identification extends in *The New Negro* not only to the resurgent cultural nationalisms found in Dublin and Prague but also to European modernism and to the question of its cultural and institutional fate in the United States. In *The New Negro*, the terms *modern* ("the first sincere attempt to sound the depths of our experience for modern drama"), *modernity* ("for modernity of style . . . and substance the young Negro writers dig deep into the racy peasant undersoil of the race"), *modernist* ("serious modernist music and musicians . . . have become the confessed debtors of American Negro jazz"), *modernistic* (see above), and *ultramodern* (see below) are typically directed toward the prestige of modernist art in the dominant sense (*NN* 157, 51, 222). I emphasize this context not in the name of valorizing (or redeeming) modernist aesthetics as the proper agent of black (or any other) politics. I rather draw attention to the way that modernism for Locke above all names a set of cultural *practices* that produced but also surrounded, engaged, and mediated works of art. Beginning with but not limited to the interventionist anthology form, these were practices that Locke attempted to appropriate in the name of American Negro culture.

This may be briefly demonstrated by looking more closely at the particular way Locke rearticulates Johnson's appeal to the Celtic Revival. Both editors specifically wished for the folk material to be used in the service of developing a new literary *form*: "to find a form that will express the racial spirit by symbols from within, rather than by symbols from without," in Johnson's

words; "to evolve from the racial substance something technically distinctive," as Locke put it (*NN* 51). Locke also included transcriptions of spirituals and folklore (which were consistently identified in footnotes having already been "collected") as examples of such folk material. Locke's and Johnson's formulations each avoided associating a new African American poetics, as Kerlin had done, with the school of free verse associated with Pound, Lowell, and Kreymborg (forms of literary writing that had defined the very form of the interventionist anthology that Locke was appropriating). Locke thus indicated that the invention of a new aesthetic form would be contingent upon other cultural practices, not only the vernacular forms themselves but the mediating activity of collecting as well. The most important distinction of Locke's intervention consisted in the way he couched his specific reference to Synge. Whereas Johnson had presented Synge as a relatively autonomous author, for Locke the example of Synge was significant less for its aesthetic contribution than for the conflicting, but culturally productive, practices of mediation and reception that surrounded it. "Just as with the Irish Renaissance," Locke observed, "there were the riots and controversies over Synge's folk plays and other frank realisms of the younger school, so we are having and will have turbulent discussion and dissatisfaction with the stories, plays and poems of the younger Negro group" (*NN* 50).

In a way that has not been fully appreciated, however, the idea of modernism also circulated throughout *The New Negro* in a way that superseded the minoritarian sense that was intended by the reference to Synge and "the New Ireland." For Locke modernism also named a set of practices whose energies and protocols he specifically aimed to appropriate for the social and aesthetic advancement of African American culture. This conception of modernism resonated in three senses in the anthology: first in the identification and refiguring of the modernist coterie as a cultural formation that could be emulated but also surpassed by the category of the "New Negro," second in revealing the identity of European modernism as having been constitutively determined by its appropriative engagement with black culture (African and African American), and finally in the arrangement of the volume as a whole, which shares aesthetic and epistemological implications with the "wall ensembles" evident today at the Barnes Foundation. Because the ultimate object of these modernist rearticulations was the transformation of American institutional practice, none of these points are meant to refute the body of scholarship that has located Locke in the context of American cultural nationalism. Only in the United States, one might say,

could such institutional claims have been made on behalf of modernist art. But it does oblige us to consider modernism as a specifically *international* term in Locke's case. If this was not true for many of the contributors of the volume, it was true for its editor, a former Rhodes scholar, student of Georg Simmel in Berlin, and frequent visitor to Paris.

In appropriating the form of the interventionist coterie anthology, *The New Negro* employed the language of the avant-garde collectivity in two ways. First, Locke imagined that the New Negro movement as a social for-mation—an "internal reorganization [of] a race out of its own disunited and apathetic elements" (*NN* xxvii)—might intervene in American cultural practice in a way that resembled the modernist avant-garde's interventions in specifically aesthetic economies. In asserting that "[t]he American mind must reckon with a fundamentally changed Negro," Locke could demon-strate that such an intervention was indeed all the more meaningful both for the higher political stakes it named and for its origins in the "fundamentally changed" status of the Negro out of slavery and toward its "fullest shar-ing of American culture and institutions" (*NN* 8). Second, and perhaps con-tradictorily, Locke also identified coteries *within* this social formation that were advancing the claims (in part by means of the "turbulent discussions and dissatisfactions" that attended the works' reception) of the larger racial collectivity. The interventionist economy of the movement had evidently attracted Locke for a significant period preceding the *New Negro* project. Responding to a suggestive letter from Locke in May 1923, Langston Hughes wrote, "You are right that we have enough talent now to begin a move-ment. I wish we had some gathering place of our artists—some little Green-wich Village of our own."[53] Because Hughes went on to indicate his distaste for the "pretension" of "so many of the Villagers," we should not rush to identify the collectivist aspirations of the New Negro movement with the received image of the downtown avant-garde. But it was the currency of this rhetoric that Locke expressly engaged in his most programmatic state-ment about the new racial art in *The New Negro*. This did not appear in the famous introductory essay, but in "Negro Youth Speaks," Locke's preface to the anthology's literary selections. Locke began by describing the "Younger Generation" as possessed of an urgency and validity that would displace the moribund social economy of modernism: "in a day when art has run to classes, cliques and coteries . . . the Negro artist, out of the depths of his group and personal experience, has to his hand almost the conditions of a classical art" (*NN* 47). Locke signaled a form of racial collectivity that had

been determined in advance by political oppression—"social pressure," in Locke's milder phrase—that could produce an art that had not been riven by modernist factionalization. At the same time, this representative art, steeped in the "depths" of a common experience, would nevertheless have the force of a modernist intervention, not as one more "clique [or] coterie" within the limited field of modernist cultural production, but as a movement within the body politic as a whole.

The importance of the modernist economy of the movement became especially apparent as the essay progressed, as Locke allowed himself recourse to the very dynamics of the factional group that he had at first deprecated in the present economy of modern art. If the depth of a shared experience was sufficient to produce a structure of feeling that could in turn produce a racially representative art, that structure of feeling was experienced unequally throughout the population. Whereas it stirred "inarticulately in the masses," it was "already vocal on the lips of the *talented few*," who were on this basis promoted to the modernist status of the *"artistic vanguard"* (*NN* 47, 48, my emphasis). Locke's "New Negro" can here be clearly seen to conflate W. E. B. Du Bois's concept of the "Talented Tenth" with the white avant-garde. It would be by means of the ability to express this emergent feeling *among* the masses, Locke suggested—not speaking "for the Negro" but "as Negroes"—that black artists could fully participate in, by appropriating, the interventionist and modernist economy of the "new" (*NN* 48). Such was the most telling rearticulation of the more politically strident version of the term "New Negro," for having already identified the project of his anthology with the "new psychology" associated with Deweyan pragmatism (*NN* 8), Locke went on to name the present moment's "new aesthetic" and "new philosophy" (*NN* 49), which had in turn enabled formations that paralleled the ones the essay had begun by criticizing in white modernism: "the development for the first time among us of literary coteries and channels for the contact of creative minds. . . . They are thoroughly modern, some of them ultra-modern, and Negro thoughts now wear the uniform of the age" (*NN* 49-50). It was in this context that he identified, as Johnson had not done, the "modernistic styles of expression" that characterized Johnson's own poem "The Creation" and was able to name a field of writers actively "evolv[ing] . . . something technically distinctive, something that as an idiom of style may become a contribution to the general resources of art" (*NN* 51), a list that concluded with the poets McKay, Toomer, Hughes, and Cullen. It was nevertheless on the basis of the interpellated movement's *social* dynam-

ics that such an argument could more safely be made; it was in the context of the vanguardism *within* the group that he cited the importance of Synge for having been at the center of the enabling "riots and controversies" that were constitutive of Irish modernism.

This emphasis on the social dynamics that defined the modernist movements—rather than the possibility of identifying an already developed "idiom of style"—was perhaps necessary in order to claim as modernists the formal traditionalists McKay and Cullen, together with the more experimental poets Toomer and Hughes.[54] Deferring the question of formal, or "technical," achievement into the (near) future, while insisting on the social agency of *contemporary* literary production, permitted Locke to do what Taggard had felt unable to do that same year in her preface to *May Days*: he both reclaimed the agency of modernism as a social formation and programmatically created a space for the necessarily socialized aesthetic forms to come. At the very moment that Taggard was eulogizing the disconnection of radical aesthetics from radical politics, Locke cited the specter of socialism as an inevitable mode of recourse in the event that his own modernist anthology should fail to find a receptive and discerning audience: "Harlem's quixotic radicalisms call for their ounce of democracy to-day lest to-morrow they be beyond cure" (*NN* 11). Locke's refiguring of racial identity as a form of avant-gardism, moreover, made manifest the economies that Bynner and Ficke had satirically brought together in the Spectra hoax, not simply by fashioning the fictitious figure of the Jewish spectrist Anne Knish, but by devising as the hoax movement's emblem a device that conflated the Star of David with an abstracted figure of interracial sex (see figure on p. 67).

The rhetorical value of the coterie as both the denuded category that the New Negro movement aimed to supersede and the "artistic vanguard" that was driving the larger movement from within was present elsewhere in *The New Negro*, specifically in a place that demonstrated the degree to which Locke's conception of modernism was neither an exclusively formalist matter nor a mere artifact of cultural nationalism. Locke referred to the agency of the coterie also in his citation of European modernist groups whose work had already discovered and appropriated older black forms, African as well as African American, as a source for their formal experimentation. This reference appeared, notably, in Locke's essay on the contemporary significance of African art, "The Legacy of the Ancestral Arts," a piece indebted to Albert Barnes's own thinking on the subject. "In Paris," Locke wrote, "centering around Paul Guillaume, one of its pioneer exponents [and

Barnes's dealer], there has grown up an art coterie profoundly influenced by an æsthetic developed largely from the idioms of African art" (*NN* 261). This influence, Locke went on to argue, was not restricted to the fine arts: "poets like Guillaume Appolinaire [sic] and Blaisé [sic] Cendrars have attempted artistic re-expression of African idioms in poetic symbols and verse forms. So that what is a recognized school of modern French poetry professes the inspiration of African sources,—Appolinaire, Reverdy, Salmon, Fargue and others. The bible of this coterie has been Cendrars' *Anthologie Nègre*, now in its sixth edition" (*NN* 261). If these examples brought attention to the cooperative labor of modernist coteries around the galvanizing examples of African art, it must also be observed that Locke specifically recognized these Parisian groups as identified with two *collections*: the textual collection of Cendrars's *Anthologie Nègre* (whose agency *The New Negro*, on the basis of this Parisian example, aimed to replicate) and the African collections at Guillaume's gallery (whose agency, as we will see, Locke would soon aim to capture in his efforts to establish the Harlem Museum of African Art). Locke thus stressed the relationship between the agency of a collection of cultural objects and the agency of a collectivity of artists.

This is not to efface Locke's specific advocacy of African art, by way of the achievements of European modernism, as a formal example for the contemporary individual black artist.[55] Such advocacy required particular skill on Locke's part because he wished to avoid the assertion of "any direct [or essential] connection of the American Negro with his ancestral arts" (*NN* 254). "There is a vital connection between this new artistic respect for African idiom [i.e., within modernism] and the natural ambition of Negro artists for a racial idiom in their art expression. . . . The work of these European artists should even now be the inspiration and guide-posts" (*NN* 262, 264). "But led by these tendencies," Locke claimed, "there is the possibility that the sensitive artistic mind of the American Negro, stimulated by a cultural pride and interest, will receive from African art a profound and galvanizing influence" (*NN* 256). In these phrases, modernism became the crucial mediator between the modern Negro artist and the aesthetic accomplishment of a distant African past.

At the same time, however, the superfluity of names Locke provides—on one page alone he names the artists Matisse, Picasso, Derain, Modigliani, Utrillo, Archipenko, Lipchitz, Zadkine, Jacob Epstein, Max Pechstein, Elaine Stern, Franz Marc, Wilhelm Lehmbruck, and Alfeo Faggi, as well as the composers Robert Bernard, Erik Satie, Francis Poulenc, Georges Auric,

Arthur Honegger, and Darius Milhaud, in addition to the writers I have already cited—indicates what Sieglinde Lemke has named the "hidden agenda" of *The New Negro*: "to synthesize a unified theory of the germinal role of the African presence in European modernism."[56] Nor was this strategy limited to African work, as Locke elsewhere noted the modernist borrowings of Negro spirituals in the work of composers such as Dvořák (*NN* 209-10). While Locke's roll call appeared to take the form of modernist star worship, it also demonstrated that modernism should not be understood as the autonomous product of the European artists in whose name the new aesthetics had been internationally circulating, but rather as having been definitively constituted as a result of its engagement with black culture. The apotheosis of the New Negro, Locke hoped, would require the institutionalization of modernism in the United States as a fundamentally interracial enterprise.

The third, most original and decisive way in which *The New Negro* engaged with modernist aesthetics and epistemology was in its material form. In both its organizational and its visual elements, *The New Negro* expressly deviated from the protocols of the modernist poetry anthology in order strikingly to realize the form's competitive ambitions with the practices of modernist art display. In this respect, Locke's encounter with Barnes was decisive, as we may immediately see by comparing the presence of African work as a framing device in the Barnes Foundation's very buildings with the Africanist devices that Locke commissioned from Winold Reiss to frame the texts throughout his anthology, as well as Aaron Douglas's drawings in a comparable style. But it was also apparent in the sheer variety of materials that Locke represented and in the composition of the book as an art object itself—from the color plates that reproduced Reiss's portraits of race leaders and Negro "representatives," to the abstract blue and white design on the book's boards, to the Africanist designs on the book's pink endpapers.[57] These all placed the book at a step removed from the typical poetry anthology.[58]

The Book of American Negro Poetry had differed from both Kerlin's and White and Jackson's anthologies at the level of what George Bornstein would name its "bibliographic code"—the specificities of page layout and presentation of its individual poems.[59] Whereas those other anthologies had followed a procedure more characteristic of canonical and critical anthologies by including multiple poems on the page (in Kerlin's anthology the poems were interspersed with his running commentary), Johnson's collection

THE LEGACY
OF THE ANCESTRAL ARTS[1]

ALAIN LOCKE

MUSIC and poetry, and to an extent the dance, have been the predominant arts of the American Negro. This is an emphasis quite different from that of the African cultures, where the plastic and craft arts predominate; Africa being one of the great fountain sources of the arts of decoration and design. Except then in his remarkable carry-over of the rhythmic gift, there is little evidence of any direct connection of the American Negro with his ancestral arts. But even with the rude transplanting of slavery, that uprooted the technical elements of his former culture, the American Negro brought over as an emotional inheritance a deep-seated æsthetic endowment. And with a versatility of a very high order, this offshoot of the African spirit blended itself in with entirely different culture elements and blossomed in strange new forms.

There was in this more than a change of art-forms and an exchange of cultural patterns; there was a curious reversal of emotional temper and attitude. The characteristic African art expressions are rigid, controlled, disciplined, abstract, heavily conventionalized; those of the Aframerican,—free, exuberant, emotional, sentimental and human. Only by the misinterpretation of the African spirit, can one claim any emotional kinship between them—for the spirit of African expression, by and large, is disciplined, sophisticated, laconic and fatalistic. The emotional temper of the American Negro is exactly opposite. What we have thought primitive in the American Negro —his naïveté, his sentimentalism, his exuberance and his improvizing spontaneity are then neither characteristically African nor to be explained as an ancestral heritage. They are the result of his peculiar experience in America and the emotional up-

[1] Illustrations are from the Barnes Foundation Collection.

254

heaval of its trials and ordeals. True, these are now very characteristic traits, and they have their artistic, and perhaps even their moral compensations; but they represent essentially the working of environmental forces rather than the outcropping of a race psychology; they are really the acquired and not the original artistic temperament.

BUSHONGO

A further proof of this is the fact that the American Negro, even when he confronts the various forms of African art expression with a sense of its ethnic claims upon him, meets them as alienated and misunderstanding an attitude as the average European Westerner. Christianity and all the other European conventions operate to make this inevitable. So there would be little hope of an influence of African art upon the western African descendants if there were not at present a growing in-

Alain Locke, "The Legacy of the Ancestral Arts," with book design by Winold Reiss and an African mask from the Barnes Foundation. Two pages earlier, another of Albert Barnes's African masks illustrates the Countee Cullen poem "Heritage." Alain Locke, ed., *The New Negro: An Interpretation*. New York: Albert and Charles Boni, 1925. 254-55. Reprinted with the permission of Scribner, a Division of Simon & Schuster, Inc., from *The New Negro* by Alain Locke. Copyright © 1925 by Albert & Charles Boni, Inc. All rights reserved.

isolated poems on the individual page with ample white space surrounding the text, thus construing each poem as an object of contemplation for itself. This bibliographic strategy resembled the one that *Poetry* magazine had fashioned for imagism, borrowing the protocols of fine books as part of an explicit effort, as Bartholomew Brinkman has shown, to endow the individual poem with the aura of a painting, as the magazine strove to obtain the currency, as one of its circulars put it, of "the ideal art gallery."[60] This technique would also characterize the layout of Pound's, Kreymborg's, and Lowell's anthologies. Thus, even as Johnson chose not to refer to the economies or aesthetics of American free verse, the bibliographic code of his anthology was continuous with the material practices of representing

imagist and post-imagist poetry. In contrast, the bibliographic code of *The New Negro*—at the level of the individual page but above all in the terms of the many forms and media that constitute the collection as such—is pointedly one that does not isolate its poems, but rather persistently articulates its disparate materials together. It thus obtains the status of a "curated" volume, going further than Pound had in his arrangement of *Des Imagistes*—which, like *The New Negro*, refused to organize its authors chronologically or alphabetically—to mediate the individual works in the service of a larger cultural intervention.

This strategy was evident in the special function that was given to poetry in the anthology. Even though *The New Negro* was not an expressly poetic anthology, it printed poems not only in the twenty-page section specifically devoted to poetry but also included them as entries in the book's other sections as well. McKay's "Negro Dancers" and Hughes's "Jazzonia" and "Nude Young Dancer" both appeared in the Music section of the anthology.[61] Similarly, "Heritage," which was arguably the centerpiece of the entire book, was not included among Cullen's other poems, but in the section "The Negro Digs Up His Past," where it formed a bridge between two transcriptions of African American folklore and Locke's essay on African art, "The Legacy of the Ancestral Arts." These poems did not appear as "illustrations" of the official positions represented by the essays and documents among which they appeared, much less were they merely filling space in the tradition of magazine verse; their aesthetic validity was not qualified by their failure to be included in the poetry section. Rather, this technique represented, in a Barnesian spirit, an instrumentalization of the aesthetic, in the most affirmative possible register. The poems, moreover, could affirm the anthology's general strategies, as in "Jazzonia," which synchronically presented historical time (Egypt), mythic or biblical time (Eve), and modernity (the Harlem cabaret) in a way that resembled the unusual historicism of the volume as a whole. But the specially placed poems could also interrogate some of the premises of the anthology project, as in the case, as I will argue below, of "Heritage."

What was true of the poems was true, in a related register, of many of the visual documents of the anthology. For example, whereas the frontispieces from Schomburg's pioneering collection of Negro books had been subordinated as illustrations in "Harlem: Mecca of the New Negro" (the special issue of the *Survey Graphic* that preceded the anthology), in *The New Negro* they were given the status of exhibits equal to the poems, artworks, and

essays. These were nevertheless not presented as autonomous objects of contemplation, but were articulated in such a way as to require the reader to perform the intellectual labor of identifying—and creating—connections among the pieces. Thus, Schomburg's essay, "The Negro Digs Up His Past," with its resounding opening line, "The American Negro must remake his past in order to make his future," was framed by an Africanist design by Reiss and appeared opposite the frontispiece of the Ghanaian Jacobus Eliza Capitein's 1742 tract, *Servitute, Libertati, Christianæ Non Contraria*. The layout of these pages provided material evidence of Schomburg's foundational book collection (which the essay promoted) and of the context of slavery (the subject of Capitein's work, and the crucial fact that the collection must redress: "History must restore what slavery took away" [*NN* 231]). But it also directed the reader to the essay's culminating appeal to study the African, as well as the African American, past; Schomburg valorized "the corrective influence of the more scientific study of African institutions and early cultural history" as well as "the signal recognition . . . the astonishing art of the African sculptures has received" (*NN* 237). Focusing on the artworks from Douglas and Reiss, Martha Jane Nadell has argued that *The New Negro* should not be seen "as a purely literary anthology but as an interartistic text whose final form was meant to depict black Americans from a variety of angles, including realistic portraits and a native African American modernism."[62] Yet if we take seriously the notion of the art and literature of the anthology not simply as evidence of the aestheticism of which *The New Negro* is so often accused, but as instruments of knowledge, we can see that the social stakes of the anthology involved the highly charged politics not only of identity in the sense of self-representation but of identity in a more deeply epistemological sense. The strategy of its anti-chronological approach, which found an idiosyncratic echo in Hughes's "Jazzonia," was to present historical and contemporary materials together for the purposes of future aesthetic and historical rearticulation.

In emulating the mode of arrangement of the Barnes Foundation (and also perhaps influencing its later development and organization), *The New Negro* on the one hand appeared to be possessed of a modernist logic that depicted all of its objects—from the texts by contemporary writers to the paintings and drawings to the folklore and historical documents—as existing in an undifferentiated synchronic present, emptied of its historical value. It was this very situation that had characterized modernist appropriations of African art. But naming this as the condition of modernity did not

Pages 230-31 of Alain Locke's *New Negro* anthology, including the frontispiece of Jacobus Eliza Capitein's *Servitute, Libertati, Christianæ Non Contraria* (1742), from the book collection of Arthur A. Schomburg. Manuscripts, Archives and Rare Books Division, Schomburg Center for Research in Black Culture, The New York Public Library, Astor, Lenox and Tilden Foundations.

evacuate the historical value of the objects, precisely because these objects were unavoidable evidence of a fragmentary unwritten, or miswritten, history. *The New Negro* thus spoke to what Locke would call the necessarily "composite" nature of contemporary African American subjectivity, but also to the necessity of "remaking the past" out of the contingencies of a fractured historical record. Documents such as Schomburg's frontispieces, or the transcriptions of folklore and spirituals, thus possessed a synchronic dimension (as records that existed in the present) but an urgently diachronic one as well (as the objects from which a past could be "remade"). The ideological underpinnings of Locke's project have been compared to Van Wyck Brooks's injunction to "create a usable past," but in the case of *The New Negro*, this historical dimension contained the political charge not of a naive American exceptionalism but of an engagement with the epistemological

and historical consequences (if not the causes) of African Americans' violent dispossession. As Schomburg wrote, "[t]hough it is orthodox to think of America as the one country where it is unnecessary to have a past, what is a luxury for the nation as a whole becomes a prime social responsibility for the Negro" (*NN* 231). It would be these very weighty obligations in whose services Locke placed Cullen's poem "Heritage."

The Heritage of *The New Negro*

In the period leading up to *The New Negro*, Cullen's reputation had become established as the preeminent young poet of the Harlem scene. Carl Van Vechten introduced a set of Cullen's poems for the June 1925 *Vanity Fair* by observing that "[h]e was barely twenty-one when 'The Shroud of Color' . . . created a sensation analogous to that created by the appearance of Edna St. Vincent Millay's 'Renascence' in 1912."[63] Van Vechten suggested that the publication of Cullen's early poem had obtained the status of a larger cultural event, one equivalent to the enabling controversy that had surrounded Millay's debut. That controversy, as discussed in chapter 1, had in turn identified an audience that would be receptive to the new poetics of imagism and free verse more generally. Cullen had written his 1923 undergraduate thesis on Millay; clearly taking "Renascence" as a model, he had composed "The Shroud of Color" as a complementary major poem, in this case about racial identity. While also writing a series of shorter lyrics, Cullen began work in 1924 on "Heritage," a second long poem, this time addressing the problematic of the African past for African American modernity.

Letters from Cullen in Locke's papers at Howard University reveal the extent to which Locke was invested in this poem from its earliest stages of composition. Locke had been a mentor to Cullen from a very early stage, but within their correspondence it is only about "Heritage" that an extended conversation was maintained. It is evident that Locke was interested in controlling the conditions of the poem's publication, and he succeeded in persuading Cullen to withhold "Heritage" for consideration in the first annual literary contest sponsored by *Opportunity* (which was consequently won by Hughes for "The Weary Blues"), in favor of reserving the poem's debut for the Harlem issue of the *Survey Graphic* and its subsequent printing in *The New Negro*. Locke was also an exacting editor of the poem, repeatedly returning Cullen's drafts for correction and revision. By the end of 1924, Cullen would pleadingly write to Locke for permission to cease his revisions.[64] Here, too, Locke's role in determining the textual and material form

of "Heritage" resembled Ezra Pound's activities, specifically in the latter's editing and brokering of *The Waste Land* (a poem to which "Heritage" would itself be compared).[65] But if Locke believed that "Heritage" would be, as Pound wrote of *The Waste Land*, "the justification of the 'movement' . . . to date," it would be in a cultural field where the conditions of possibility and reward were more restricted. Locke's suggestion that "Heritage" be reserved for *The New Negro* project was evidence of this fact, as it was clearly based either in his fear for the poem's overexposure or in his own desire to claim publicly symbolic authority over the poem (or both). The *Opportunity* competition, to which Locke successfully convinced Cullen not to submit "Heritage," had offered a prize of $40, in comparison with the $2,000 award from the *Dial* that had been silently guaranteed in advance to Eliot for *The Waste Land*. Eliot's poem was then successively published in the *Criterion* (London, October 1922), in the *Dial* (New York, November 1922), as a book by Boni and Liveright (New York, December 1922), and finally in a limited, elite edition by Leonard and Virginia Woolf's Hogarth Press (London, September 1923).[66] Forgoing the *Opportunity* contest, whose winners were announced in May 1925, "Heritage" appeared in the March issue of the *Survey Graphic*, then in *The New Negro* anthology in December 1925, and finally in Cullen's first poetic monograph, *Color*, which appeared at the end of that same month.[67]

Because Locke's letters to Cullen have not survived, it is difficult to know the extent to which he imposed his own changes to "Heritage" after Cullen finally submitted it to him in December 1924. But it is surely significant that when Cullen began assembling poems early the following year for *Color*, he would write to Locke asking for a copy of *Heritage* in the form in which he intended to use it.[68] It was a substantially revised version of "Heritage" that would be published in *Color*, and it is this later version, as I have argued elsewhere, that powerfully expresses a queer epistemology, one specific to black modernity, within its more public obligations to speak to the problematic of an African heritage.[69] Whereas Cullen's revised version is notably much more rhetorically discontinuous, the more rarely discussed version that appears in *The New Negro* represents a more methodical working through of the problematic of "remaking one's past." It also notably foregrounds the agency of the two forms of the collection—the anthology and the art collection—that Locke promotes in "The Legacy of the Ancestral Arts," which is the piece that immediately follows "Heritage" in the pages of *The New Negro*. If this attention to collections was the specific result either

of Locke's suggestion or of his editorial intervention, it nevertheless did not prevent even this version of "Heritage" from troubling some of the key assumptions of Locke's appropriative identification with modernist cultural practices.

Walter Benn Michaels is one of the few critics to have based a reading on the earlier, *New Negro* version of "Heritage." In his argument, the achievement and investments of Cullen's poem in accounting for an African past are set against Melville Herskovits's denial, which appeared later in Locke's anthology, that any such residual connection could exist. For Herskovits the American Negro represents a "case of complete acculturation," a thesis that Michaels takes as synonymous with the poem's famous first lines (*NN* 356):[70]

> What is Africa to me:
> Copper sun, a scarlet sea,
> Jungle star and jungle track,
> Strong bronzed men and regal black
> Women from whose loins I sprang
> When the birds of Eden sang?
> *One three centuries removed*
> *From the scenes his fathers loved*
> *Spicy grove and banyan tree,*
> *What is Africa to me?* (*NN* 250)

Michaels argues that the indifference toward Africa that is expressed in these lines is the problem the poem will work precisely to overcome: "For although the scenes the father loved are initially presented as 'unremembered' by the son, the tendency to *forget* (as if Africa were too distant to matter) is immediately reinterpreted as a requirement to *repress* (as if Africa were too near to be forgotten)."[71] Michaels thus helpfully thematizes the speaker's denials—"So I lie," "Thus I lie"—that follow from the lines "One thing only must I do / Quench my pride and cool my blood / Lest I perish in the flood / . . . / Lest the grave restore its dead" (*NN* 250–51).

Though he does not say so directly, Michaels implies that the desire to repress the dangerous "nearness" of Africa is motivated by the threat to the speaking subject's belief in his own acculturated modernity; in the *revised* version of the poem, as I have argued, this obligation is tied to the necessity of publicly repressing homosexual desire. Yet what interests Michaels most of all is the way the very act of repression apparently produces an authentic

experience of the African past: "the metaphor through which Africa is sup-
posed to be kept out—'Though I cram against my ear / Both my thumbs and
keep them there'—is in fact the technique through which it is discovered
that Africa is already inside—'So I lie, who always hear . . . Great drums
beating through the air' ([*NN*] 251). Trying not to hear the drums outside
involves hearing instead the drums inside, the circulation of one's own 'dark
blood.' Thus Africa is, in the end, triumphantly, not only 'remembered' but
repeated."[72] The "triumph" that Michaels identifies as issuing from "Heri-
tage" implicitly represents in a broader way Locke's claim in "The Legacy
of the Ancestral Arts" that if "African sculpture has been for contempo-
rary European painting and sculpture . . . a mine of fresh *motifs*, . . . this
art can scarcely have less influence upon the blood descendents, bound
to it by a sense of direct cultural kinship" (*NN* 256). From this perspec-
tive, Cullen's poem is seen as thematizing the agency of the "*sense*" of kin-
ship ambiguously figured in Locke's adjectival, but nearly essentialist, use
of the word "blood." It would be possible, moreover, also to extend what
we might call Michaels's Lockean reading by arguing that it allows us to see
that the poem's assertions of its own acts of repressive "lying"—which are
dispersed, without apparent resolution, throughout the revised version of
"Heritage"—are here condensed within three stanzas of the poem before
"triumphantly" producing the lost Africanist experience. These stanzas are
preceded by the initial claim that Africa is "unremembered" and followed by
the problem's apparent resolution: "In an old remembered way / Rain works
on me night and day / Though three centuries removed / From the scenes
my fathers loved" (*NN* 252).

In Michaels's reading, this marks the successful recovery (or remaking)
of an African past. Yet it is surely significant that the apotheosis Michaels
identifies does not appear at the poem's end, but at its midpoint. The tran-
sition of an "unremembered" to a "remembered" Africa, moreover, is not
produced simply by the speaker's experience of his own body; it is instead
also determined (and framed) by the only two material representations of
Africa that Cullen chooses to include in the poem. These artifacts, point-
edly, echo the collections that Locke's essay claimed had galvanized the
Parisian avant-garde coteries. The *New Negro* version of "Heritage" thus
engages the question of an African past less in the sense of its inexorably
"felt" presence than through the unavoidable conditions of its prior media-
tion in modernist art.

The first such material expression appears immediately after the first stanza, which concludes by repeating the question "What is Africa to me?" In the same Herskovitsian spirit, the second stanza begins, "Africa? A book one thumbs / Listlessly till slumber comes," a denial that then produces vivid images of otherwise "unremembered" "cats / Crouching in the river reeds" and "Silver snakes" (*NN* 250). Although the hypothetical book is not named, it is not unreasonable to assume a reference to Cendrars's *Anthologie Nègre*, whose pages are populated by a large cast of African animals, including cats and snakes.[73] It was Cendrars's book, moreover, that Locke's essay would name as "[t]he bible of [the Apollinaire] coterie." It is possible, too, to presume a reference to the African collections of Paul Guillaume in the lines that follow the speaker's "remembering" of Africa. If the animals of the *Anthologie Nègre* were "unremembered" by Cullen's modern speaker, it is important to recognize the difference he imposes upon African objects as well:

> My conversion came high-priced.
> I belong to Jesus Christ,
> Preacher of humility:
> Heathen gods are naught to me—
> Quaint, outlandish heathen gods
> Black men fashion out of rods,
> Clay and brittle bits of stone,
> In a likeness like their own. (*NN* 252)

The speaker's insistence upon the irrelevance to him of "heathen gods" should, at the very least, complicate Michaels's sense of a triumphant repetition of an African past as gleaned from the poem's previous lines. For the poem concludes not with an unqualified affirmation of the presence of the African past (one that would more nearly resemble the situation of Hughes's "Jazzonia"), but rather with a negotiation of that past in the context of the speaker's "high-priced" (and implicitly colonial-imperialist) "conversion" to Christianity. It is in this sense that the African idiom is indeed "repeated," but it is not in a triumphant register:

> Lord, I fashion dark gods, too,
> Daring even to give to You
> Dark, despairing features where
> Crowned with dark rebellious hair,

Patience wavers just so much as
Mortal grief compels, while touches
Faint and slow, of anger, rise
To smitten cheek and weary eyes.

Lord, forgive me if my need
Sometime shapes a human creed. (*NN* 252–53)

Cullen thus uses the example of the African fetish as a model for construct-
ing a black Christ, one marked not only by Christian "grief," but by an im-
plicitly African *American* "anger," an anger that bears witness to the history
of slavery and the present context of racial violence and dispossession.

If this challenges Michaels's alert but incomplete reading, it is neverthe-
less possible to read this reappropriation of the African form as realizing
Locke's suggestion, in "The Legacy of the Ancestral Arts," that "after absorb-
ing the new content of American life and experience, and after assimilating
new patterns of art, the original artistic endowment [i.e., the sensibility of
African forms] can be sufficiently augmented to express itself with equal
power in more complex patterns and substance, then the Negro may well
become what some have predicted, the artist of American life" (*NN* 256–58).
This would not amount to a simple, or triumphant, repetition in any case,
despite Locke's placing an image of a mask from the Barnes Foundation im-
mediately below the poem's final lines, as if to propose a model for the "dark
god" "Heritage" has poetically constructed. Nor would it account for the
dubiously Africanist images that dominate the earlier stanzas of the poem,
of which Marisa Parham has rightly argued, "even to write against the nos-
talgia of the constructed site of memory Cullen must use images gleaned
from those very sites."[74] As the poem's final plea for Christian forgiveness
indicates, what is at stake are the *conditions of availability* of the African
past, which are unavoidably mediated both by the speaker's unchosen but
genuine Christian faith and by the modernist recovery and "discovery" of
African art. "Heritage" thus must be read as a highly complex (and skeptical)
negotiation of Schomburg's injunction that African history "must be cor-
rected at its source" (*NN* 237).

The poem also troubles the Lockean presumption that such engagement
should imply a cohesive, collectivist movement. Although the poem's open-
ing stanza, with its famous framing question, was often taken to identify a
concern common to black American modernity (Nella Larsen, for example,
took these lines as the epigraph for her 1929 novel *Passing*), the poem's

engagement with the problematic of an African past is a deeply private and solitary one. There is no second figure in the poem, indeed no obvious addressee until the final lines that address Jesus directly. This contradicts the spirit of Schomburg's essay, which had discovered "among the rising democratic millions . . . the Negro thinking more collectively" and argued that "weightier surely than any evidence of individual talent and scholarship could ever be, is the evidence of important collaboration" (*NN* 231, 233). And it is at odds also with the spirit of the Locke essay that follows the poem, which advertised the galvanizing agency of the Paris coterie around African collections.

Cullen's disinclination to pay homage to modernist cultural practices (like those of the coterie) was also echoed at the level of the poem's formal innovation, which did propose something "technically distinctive," but notably did so without allowing itself recourse either to free verse forms or to the vernacular expression Locke and Johnson promoted for modern black writing. Whereas every other poem Cullen would ever write employed rhymed iambic lines (almost all of them ballads or sonnets), "Heritage" was composed in rhymed trochaic tetrameter, imposing a quite different rhythmic effect evident from its very first lines, "Whát is Áfricá to mé: / Cópper sún, a scárlet séa." The insistent meter is clearly meant to resemble African drums and therefore stages a form of Africanist identification in lines that semantically question the possibility of such knowledge. This effect is evident from the very beginning of the poem, which is to say that it appears *before* the performative act of repression can succeed in "remembering" or "repeating" the speaker's sense of the African past. Such a distinction therefore obliges us to consider the primary agency not of the *speaker's* act of repression—which Michaels views as the means of perhaps accidentally producing an experience of Africa—but of the *poet's* volitional choice of form.

However unusual, this meter was not original to "Heritage," but rather invoked an older tradition of English-language verse. On one hand, it recalled the meter of Blake's "The Tyger" (or "Twinkle Twinkle Little Star") and thus confirmed the claim Kerlin had made, in *Negro Poets and Their Poems*, that the current Negro poets were "as much the heirs of Palgrave's Golden Treasury as their white contemporaries."[75] It was this tradition that Kerlin had hoped would be left behind as black poets devised a form of free verse from the example of "old plantation melodies"—two poetic modes, *vers libre* and spirituals, that Cullen eschewed. On the other hand, the me-

ter of "Heritage" in fact served as an indictment of the free verse writing of
the Illinois modernist Vachel Lindsay, as it replicated exactly the meter of
the refrain in Lindsay's notorious "The Congo: A Study of the Negro Race":
"Boomlay, boomlay, boomlay, BOOM."[76] While on its face this may seem
like an adventitious reference, it should be recognized that Lindsay's other-
wise rhythmically various poem (which had been condemned by W. E. B.
Du Bois in the pages of the *Crisis* after it first appeared in 1914) provided im-
ages that Cullen notably refashioned in "Heritage." Lindsay's "THEN I SAW
THE CONGO, CREEPING THROUGH THE BLACK, / CUTTING THROUGH
THE JUNGLE WITH A GOLDEN TRACK,"[77] for instance, was undoubtably
signified by Cullen's lines

> Thus I lie, and find no peace
> Night or day, no slight release
> From the unremittant beat
> Made by cruel padded feet
> Walking through my body's street.
> Up and down they go, and back
> Treading out a jungle track. (*NN* 251)

Indeed, with its reference to "cruel padded feet," these lines may be read
precisely as a commentary on the politics of poetic form and meter, a prob-
lematic Cullen does not seek to leave behind by following the suggestions
of Kerlin or of Johnson. Rather, "Heritage" condemns Lindsay's primitivist
racism (as evidenced in lines such as "And the black crowd laughed till their
sides were sore / At the baboon butler in the agate door") while also testi-
fying to the way it mediates and determines his own speaker's subjective
experience: the poetic "feet" are "[w]alking through my body's street." Find-
ing no succor in the formal examples of free verse or vernacular form, Cul-
len appeals to the dignifying example of the English tradition represented
by the abolitionist Blake, whose meter shapes the entirety of the poem,
not just the primitivist apotheoses communicated in Lindsay's "Boomlay,
boomlay, boomlay, BOOM."[78]

This reading does not mean to valorize unproblematically the recourse to
the English canon that Cullen provides himself, but it should permit a more
complete context for evaluating Hughes's oft-quoted attack on Cullen, in
"The Negro Artist and the Racial Mountain," as the poet who "would like to
be white."[79] It should be remembered also that it had been Lindsay's discov-
ery of Hughes in 1925 that was instrumental in helping to establish Hughes's

career.[80] But it is finally worth comparing the two poets' approaches to black history and epistemology as representing the two forms of historicization, synchronic and diachronic, that characterize more broadly *The New Negro*. In her excellent essay, Parham presents the later version of "Heritage" and Hughes's "The Negro Speaks of Rivers" as two attempts to engage with the ruptured "sites of memory" that characterize African American experience. Parham notes that Hughes's strategy is a recuperative one, finding in the poem's introductory lines ("I've known rivers: / I've known rivers ancient as the world and older than the flow of human blood in human veins") "an implicit similarity between water and the 'flow of human blood in human veins,' and it is through the construction of this identity-potentiate that Hughes is able to articulate a mobile and fluid subject, an enunciative 'I' who has become as ahistorical as water itself."[81] It is precisely this ahistorical "I" that is able to propose a timeless identity among the rivers the poem subsequently names: the Euphrates, Nile, Congo, and Mississippi. The "river" thus becomes a metaphor for the Negro "soul," and it is through this projective agency that Hughes, in Parham's words, "allows the speaker to graft onto a black collectivity a historical soul herein made continuous with his own, no-longer-problematic identity."[82] "The Negro Speaks of Rivers" recuperates the sense of loss by imaginatively proposing the synchronic presence of historically alienated sites of memory. This is a strategy also adopted, in a slightly different register, by "Jazzonia," as we have seen. In the pages of *The New Negro*, where both poems appeared, such a strategy was materially represented by the decision to intersperse contemporary and historical texts and objects within the parameters of a presentist anthology.

If this characterized an optimistic, indeed "triumphant," belief in the capability of overcoming the epistemological violence of the middle passage, Cullen's poem, which is grounded in the absolute present, represents in Parham's view an altogether more complex and pessimistic vision. Parham's critique of Hughes concludes that "Hughes's rivers are posited firmly in the symbolic and do not in fact exist outside of language." This is precisely the condition that knowingly determines "Heritage," which Parham reads as "a poem about the failure of art as compensation for reality," hence the self-consciously inauthentic language with which the poem describes a hypothetical Africa. It is language, I have argued, derived to a significant degree from texts associated with the forms and practices of modernism, among them Cendrars's *Anthologie Nègre* and Lindsay's "The Congo." Whereas Hughes's poem presents "multiple I's that can be expressed as one," Par-

ham notes the way "[t]he refrain, 'What is Africa to me,' has, by the end of the [first] stanza, become 'removed / from the scenes his fathers loved,' with no ostensible transition from the first to third persons. This transition [throughout the poem], from *me* to *I* to *his*, and back to *me* again, makes suspicious the very notion of subjecthood."[83] Though it does so very skeptically, and in a very immediate sense, the role of "Heritage" in *The New Negro* is to amplify the diachronic sense of historical loss that its documents represent, and which Schomburg and Locke aim partially to redress. It is, however, the effect on the isolated, rather than collectively empowered, subject that "Heritage" ultimately aims to demonstrate. And it is in this respect most of all, it may finally be observed, that "Heritage" resembles the epistemological stance of *The Waste Land* (a poem whose famous first line is rhythmically identical to the meter of "Heritage").[84] The many speaking voices and quoted texts that characterize Eliot's poem find their dialectical counterpart in Cullen's speaker, who, far from being able to speak synthetically in the voices of Cendrars's characters or Guillaume's objects (much less Shakespeare, Ovid, or Spenser), is a fractured subject who speaks in a canonical form but may not appropriatively quote from the texts that compose a ruined or absent tradition.[85]

Downstairs from the Harlem Museum

In chapter 1, I argued that Pound's *Des Imagistes* (1914) established the anthology form as the principal mode of intervention for poetic modernism, enabling a host of subsequent collections that simultaneously emulated Pound's editorial strategies and were also obliged to disown or disaffiliate themselves from him. The key year for these successor volumes was 1916, when the first of the Sitwells' *Wheels* anthologies in Great Britain joined, in the United States, the first of Kreymborg's *Others* books, the second volume of *Some Imagist Poets*, and the *Spectra* anthology, among many other modernist and non-modernist collections of verse. Nearly a decade later, an almost identical economy came to define the field of African American literary production, as the enormous success of *The New Negro* in 1925 (its sales far surpassed any of Pound's anthologies) elicited a proliferation of black anthologies that reached its apogee in 1927.

Three of these successor anthologies were Locke's own. In that year, Locke exhibited an astonishing degree of productivity by issuing a revised second printing of *The New Negro*, publishing a small collection of *Four Negro Poets* (Hughes, McKay, Cullen, and Toomer: "modernists among the

moderns"), and collaborating with Montgomery Gregory on *Plays of Negro Life* (which, like *The New Negro*, was illustrated by Aaron Douglas).[86] This same year Locke was also instrumental in promoting the English translation of Cendrars's *Anthologie Nègre* (the "bible" of the Apollinaire coterie), where Arthur Spingarn's introduction unmistakably echoed the principles that had governed *The New Negro*: "[With this translation,] English readers have their first opportunity to appraise Africa's contribution to the literature of the world. I venture to believe that they will find it not unworthy to stand beside American Negro Spirituals and African Sculpture."[87]

Whereas each of these collections followed as a result of the enabling example of *The New Negro*, Locke's seminal anthology also generated opposition within the literary field. Such opposition did not merely manifest itself privately among individual writers, like McKay, who resented Locke's strong editorial hand. It was also evident in public criticisms of the anthology as a whole. Even in the pages of *Opportunity*, the journal with which Locke had been most closely associated, Robert W. Bagnall's otherwise ecstatic review pauses to remark on "one glaring fault . . . we cannot overlook. It is the frequency with which the editor Mr. Locke, obtrudes himself upon the scene . . . reminding one of those chairmen who must make a new speech everytime he introduces a new speaker."[88] As had been the case with Pound's successors, it was the strongly mediating character of Locke's editorial presence that subsequent anthologists were obliged to disown.

With a title taken from Voltaire, *Ebony and Topaz* was a self-described "collectanea" assembled by the *Opportunity* editor Charles S. Johnson in 1927. Its format strongly resembled that of *The New Negro*, bringing together creative and critical pieces with copious illustrations from Douglas, Richard Bruce Nugent, and Charles Cullen, two more reproductions of African work from the Barnes Foundation, and numerous documents in facsimile, including two Dunbar manuscripts. Extending Locke's commitment to the "Younger Generation," *Ebony and Topaz* also included many examples of undergraduate verse by students at black colleges and universities. But in express opposition to Locke's example, Johnson's introduction began by insisting that the anthology did not "set forth to prove a thesis, nor to plead a cause, nor, stranger still, to offer a progress report on the state of Negro letters."[89] Such a claim subordinated and qualified Locke's own contribution to the volume, a short essay that followed in the mode of his texts for *The New Negro*, but notably retreated from the force of its central claims: "Need we then be censured for turning our adjective into an affectionate diminu-

tive and for choosing, at least for the present, to call it hopefully 'our little renaissance'?"[90]

Countee Cullen's *Caroling Dusk* anthology opposed Locke's example in different ways. A strictly poetic anthology, much of the work contemporary, *Caroling Dusk* made a point of acknowledging its debt to predecessor anthologies edited by Johnson, Kerlin, and White and Jackson. As was true for *Ebony and Topaz*, it too declined to name *The New Negro* as a forebear. This was true, I suggest, not simply because *Caroling Dusk* was a more conventional anthology, but also because Cullen intended to use the collection as a way of dissenting from Locke's ongoing attempt to identify a racially specific field of letters. It was in this very year that Locke and Gregory were defining Negro drama not according to the racial identity of its playwrights, actors, or audiences, but as a field constituted by its subject: their anthology included the work of Eugene O'Neill, Ridgely Torrence, and Paul Green, white playwrights who had recognized "the dramatically undeveloped potentialities of Negro life and folkways."[91] Cullen, by contrast, pointedly wrote in his foreword that "I have called this collection an anthology of verse by Negro poets rather than an anthology of Negro verse, since this latter designation would be more confusing than accurate. . . . [T]he attempt to corral the outbursts of the ebony muse into some definite mold to which all poetry by Negroes will conform seems altogether futile and aside from the facts."[92] The purpose of Cullen's anthology was to work on behalf of Negro poets, not on behalf of a Negro literature, and it took as its principal goal the gathering together and wider dissemination of poems that in many cases had only appeared in magazines. Perhaps even more strongly implicit in Cullen's essay was his disinterest in the modernist economy of the movement that had animated Locke's thought just two years earlier. *Caroling Dusk* is also noteworthy for having preserved a poem that called into question Locke's faith in the agency of collections as such, and it is toward a reading of this poem, Helene Johnson's "Bottled," that this chapter will finally work. "Bottled," as Cullen could not have failed to recognize, was a poem dialectically opposed to the purposes toward which Locke had oriented Cullen's "Heritage" in the pages of *The New Negro*.

The specific points of reference in "Bottled" require a consideration of Locke's other collecting activities in 1927, for amidst his seemingly indefatigable editorial work Locke had begun another ambitious project in attempting to acquire a collection for and found a Harlem Museum of African Art. His hope for such a project dates at least to 1925, when he mentioned in a

letter to Carl Van Vechten his interest in acquiring one of two Belgian col-
lections of African objects he had studied as a student in the 1910s. Locke
noted Spingarn's recent acquisitions from the German collection of Leo
Frobenius, made especially attractive by the foreign exchange rate of the
mid-1920s, and he also remarked on a factor that would weigh heavily on
the objects he would eventually be able to acquire: "Of course Paul Guil-
laume in Paris has beautiful things, but he knows the American market and
charges accordingly—moreover he reserves his best pieces for the Barnes
Foundation collection."[93] It was in the context of Barnes's own practices of
acquisition and mediation that the Harlem Museum would be compelled to
operate, although Locke was surely unaware of the difficulties this competi-
tion would produce.

Four months before this letter to Van Vechten, Locke had begun a corre-
spondence with a pivotal figure for the Harlem Museum project, Edith J. R.
Isaacs, editor of the modernist-friendly journal *Theatre Arts*. Shortly before
the appearance of *The New Negro*, Isaacs had solicited from Locke two ar-
ticles about black American theatre, "The Negro and the American Stage"
and "The Drama of Negro Life." As Locke drafted the essays, he and Isaacs
maintained a correspondence based on their mutual interest in collecting
African art. In the summer of 1926, Locke informed Isaacs about the possi-
bility of buying a collection from Henri Pareyn, a dealer and collector based
in Antwerp whose clients included the surrealists André Breton and Tristan
Tzara.[94] Isaacs responded enthusiastically, adding that she had herself just
learned that a very large collection of works from the Congo—nearly a
thousand pieces—was soon to be sold in a block for 200,000 francs by the
Belgian collector Raoul Blondiau. Bankrolled by Isaacs, Locke purchased the
134 objects from the Pareyn Collection, for $488.[95] By November, Isaacs
had secured the much larger Blondiau collection, which was to be held by
Isaacs at the *Theatre Arts* offices. The Blondiau collection was shipped on
December 31, 1926. Now retitled the Blondiau-Theatre Arts Collection of
Primitive African Art, half of this major acquisition went on display at J. B.
Neumann's New Art Circle gallery in midtown Manhattan on February 7.
It remained there for a month, garnering significant attention in the press
(two separate articles in the February 13 *New York Times* alone) at the very
moment that John Quinn's collection, including his African sculpture, was
finally being dissolved at auction.

Already thinking of establishing a portion of the collection in Harlem,
Locke promoted the collection in articles for the *Survey Graphic* and the

Arts and wrote the catalog essay for the New Art Circle exhibition. Taken together, these essays are of interest for the way they represent Locke's developing thinking about the relationship of African art to European modernism. This development was influenced both by the nature of the objects in the Blondiau collection and by the changing attitude of the Barnes Foundation toward Locke. At first, Locke attempted to foster congenial relations both with modernism and with the Barnes Foundation. If anything, Locke's catalog essay for the February exhibition amplified the determinative role of modernist art in the reception of African work, while also approvingly quoting from the Barnes Foundation's book *Primitive Negro Sculpture*, which had appeared the previous year. Much like his writing in *The New Negro*, the essay expressed hope for the work's galvanizing influence on American Negro artists, but this wish was subordinated to "our general appreciation of it as a notable phase of the art development of the past and our appreciation of its technical influences on modern art."[96] An unsigned promotional piece that appeared in the March *Theatre Arts* (probably not written by Locke) also demonstrated that the enrichment of modernist art by African work was an ongoing phenomenon. Underneath the first of three photographs from the Blondiau collection, a caption claimed, "The modern theatre has been going back to primitive dramatic origins in an effort to recapture their vitality, and has been aided in its search of abstract mood presentation by the masks of primitive peoples."[97]

A different strain of Locke's thinking, however, is apparent in the other writings that appeared at precisely this time, and these tended in the direction of disarticulating the African work from modernist interpretation. This new trajectory was reflective of substantive differences between the objects of the Blondiau-Theatre Arts Collection and those at the Barnes Foundation—the collection upon which he had largely based his writings until then. As Christa J. Clarke has shown, the African collection of the Barnes exhibits a fundamentally restrictive definition of African art, being composed primarily of figural statuary and masks from a relatively small set of regions.[98] The Blondiau-Theatre Arts Collection, by contrast, included objects that were much more directly functional than Barnes's: cups and bowls, throne stools, musical instruments, staffs and scepters, and also some weaponry. The origin of these pieces in crafts traditions led Locke toward a critical position that could, in Mary Ann Calo's words, "bridge the gap between the aesthetic and the cultural," redressing in the process the respective failures of ethnography and modernist formalism.[99] The example of the Blondiau collection thus

encouraged Locke finally to present African work without the obligatory authentication of European modernism's mediation and discovery of the field, as well as to develop an aesthetics that—ironically given his coming contretemps with Barnes—strongly anticipated Dewey's *Art as Experience* (1934). As Locke wrote in the *Survey Graphic*, "[w]e have discovered that to capitalize Art, we have robbed it of some of its basic values and devitalized its taproots in the crafts."[100]

Locke, however, did not abandon completely the possibility of invoking the cultural capital of modernism; nine months later, when a portion of the collection was exhibited at the Art Institute of Chicago, Locke's catalog essay again cited the importance of the African work "both for modern art appreciation and contemporary creative inspiration."[101] But he was by this time obliged to situate the Harlem Museum project as a provisional institution in competition with, rather than allied to, the Barnes Foundation. As the first purchases from the Pareyn and Blondiau collections were being negotiated, Isaacs had mentioned seeking the advice of Barnes's dealer Guillaume. By November, however, Isaacs was actively avoiding Barnes and cautioning Locke not to mention the name of Blondiau until the collection had safely arrived in New York: "we don't want to give Barnes a chance to send Guillaume over to Brussels to discredit the collection."[102] Isaacs correctly anticipated the Barnes's public denunciation of the Blondiau collection, which appeared in the pages of the *Nation*, just as the New Arts Circle exhibition closed in early March. While the substance of this exchange is significant, it is important to underscore the extent to which the debate does not simply consist of ideological differences but speaks directly to the cultural stakes of authoritatively representing and defining African art. This is evident not only in the way the *Nation* article archly speculates on the future disposition of the Blondiau pieces—"the expressed hope that it will be given to a museum presumably means to an art museum"—but perhaps even more pointedly in Isaacs's ability to have anticipated the attack.[103]

The article appeared under the name of Thomas Munro, Barnes Foundation staff member and coauthor with Guillaume of *Primitive Negro Sculpture*. Undoubtedly representing the Barnes's official position, Munro's overt objection to the Blondiau collection consisted in its exclusive origins in the Congo, and in the kind and variety of objects it represented. This ran against the grain of a central dynamic of *Primitive Negro Sculpture*, which made a strict distinction between "art" and "artifact."[104] Munro insisted, "If the exhibit were labeled Handicrafts from the Belgian Congo, and destined for

some ethnological museum, nothing adverse could be said. . . . [But] [t]he
exhibit deserves . . . neither the word 'primitive,' nor 'African,' nor 'art.'"[105]
The literally categorical nature of Munro's attack indicates that the stakes of
the critique were institutional as much as they were ideological; the wider
range of objects Locke admitted under the category of African art was taken
as a dilution of the symbolic authority over the field that the Barnes hoped
to exercise by defining it more narrowly. Locke's recognition of this sym-
bolic economy is clear in his response, which now unmistakably indicted
the entire premise of the Barnes Foundation, just weeks after having paid
homage to that same institution in the exhibition catalog: "The obvious
ethnological character of much of the Blondiau Collection, to which Mr.
Munro takes such exception, is its best certification. Certainly it is at least
as legitimate a modern use of African art to promote it as key to African
culture and as a stimulus to the development of Negro art as to promote it
as a side exhibit to modernist painting and to use it as a stalking-horse for
a particular school of aesthetics."[106] Its institutional position determined in
part by the material particularity of the Blondiau collection, and to some de-
gree too by Barnes's competitive disaffiliation, the Harlem Museum project
was henceforth oriented more explicitly toward the twin imperatives of his-
torical study and the enabling of contemporary African American artists.[107]
Despite the occasional reference, the project was now largely disarticulated
from modernism.

 Upon the closing of the New Art Circle show, Locke moved to secure a
portion of the collection for Harlem. Isaacs agreed to sell sixty-five pieces
from the Blondiau-Theatre Arts Collection at the price of $2,500 to form
the basis of the Harlem Museum of African Art, and in April 1927, a Harlem
Museum Committee began meeting at the 135th Street branch of the public
library in Harlem. A subscription plea was sent around, and Paul Robeson
agreed to hold a benefit concert for the museum at Town Hall. By May,
those pieces had been transferred to the 135th Street branch, where they
were exhibited on the top floor, while Locke sought to make additional
acquisitions for the museum. Yet the project lacked sufficient financial sup-
port. The Town Hall benefit had raised $500, but this succeeded in paying
off only a portion of the debt to Isaacs and left the issue of an endowment
for future purchases as well as buildings unresolved. The solution, approved
by the committee on May 2, 1927, was to purchase from Isaacs an additional
thirty-eight objects from the Blondiau collection, at a 20 percent discount,
for $1,000. These pieces became the museum's "Travelling [sic] Collection,"

which could be loaned at a fee to institutions across the country. These would include civic museums such as the Art Institute of Chicago (where they were displayed as a part of the "Negro in Art Week" in November 1927) and Buffalo's Albright Gallery, as well as black universities including Fisk, Howard, and the Hampton Institute (where they would travel in 1928). Locke promised the committee that "the travelling collection will be an eventual source of income, to be applied to its own purchase or to the collection funds of the Museum," but his efforts did not succeed in acquiring the backing or capital necessary for the collection to advance beyond its provisionally institutional stage and become a civic museum.[108] After fruitless appeals in 1929 to "fifty representative Negroes appealing to them to do their bit for what is primarily their cause," and to the Carnegie Corporation in 1930, the museum project was abandoned, its failure occurring at the precise time that the Museum of Modern Art was successfully established in midtown Manhattan.[109] The debt to Isaacs was finally paid off in early 1931, and the Blondiau-Theatre Arts Collection remains at the 135th Street branch of the public library, where it is held as part of the collection of the Schomburg Center for Research in Black Culture.

It was in May 1927, during the period of the greatest optimism for Locke's museum project, that Helene Johnson's "Bottled" was first published. It first appeared not in a Harlem publication, but in the pages of *Vanity Fair*, the New York magazine most strongly associated with the commercialized circulation of modernism.[110] This has some significance for the meaning of the poem, but it is perhaps more important to stress the significance of its appearing in the May 1927 issue, the very month that the first objects from the Blondiau-Theatre Arts Collection were transferred to the top floor of the 135th Street library. Later that year, Countee Cullen included the poem in the *Caroling Dusk* anthology. Cullen would certainly have recognized the way "Bottled" critically engaged with issues he had addressed in his own poem "Heritage," which had been a centerpiece of *The New Negro*. "Heritage" had represented the letter, if not the spirit, of Locke's stated desire for contemporary black artists to use African work as a formal resource. "Bottled" did not identify a work of African sculpture, but it took as one of its named locations the very room where Locke's African acquisitions were displayed.[111]

"Bottled" meditates on the agency of the institutionalized African collection as such, and in particular its effect on the experience of the observing subject, which always exceeds or evades, to some significant degree,

the pedagogical imperatives in whose name the collection was established. Johnson may have been responding to an ambiguity between the explicitly stated goals of Locke's museum and its mode of presentation and display. In his brief forward to an exhibit of the collection at Howard in 1928, Locke had written of his wish for "the Harlem Museum of African Art . . . to promote a more thorough knowledge of African life and institutions, of Negro cultural origins, and of the background of the American Negro."[112] Although Locke's arrangements undoubtedly met this responsibility, and did so increasingly without the mediation of modernism, it is also worth noting the calculatedly *affective* impression he evidently sought to achieve at the 135th Street branch. That effect is suggested in a letter written to Locke by the museum patron Charlotte Osgood Mason: "I love your putting the four masks to brood over and hold at bay any unbelieving being who enters that Library hereafter—for African Art stands as a sentinel a Champion for the Negro Race—take care who interferes!!!!"[113]

Against this overdetermined context, the conceit of "Bottled" is to present an unidentified (presumably black and female) speaker's imaginative interrelation of two discrete experiences of Harlem modernity: the speaker's visit to the third floor of the Harlem library and her presence the previous day at a street performance one block away from the library:

> Upstairs on the third floor
> Of the 135th Street Library
> In Harlem, I saw a little
> Bottle of sand, brown sand,
> Just like the kids make pies
> Out of down at the beach.
> But the label said: "This
> Sand was taken from the Sahara desert."
> Imagine that! The Sahara desert!
>
> Some bozo's been all the way to Africa to get some sand.
> And yesterday on Seventh Avenue
> I saw a darky dressed fit to kill
> In yellow gloves and swallow tail coat
> And swirling a cane.[114]

In free verse lines that become progressively longer, and language that becomes noticeably more vernacular (and increasingly marks the speaker as

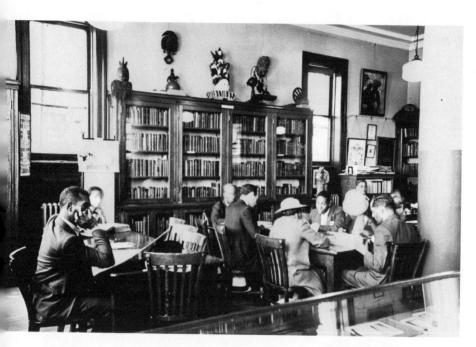

Undated photograph of the third floor of the 135th St. branch of the New York Public Library, installed with pieces from the Blondiau-Theatre Arts Collection of Primitive African Sculpture. New York Public Library Archives, The New York Public Library, Astor, Lenox and Tilden Foundations.

African American), Johnson's speaker describes the performer's progress down Seventh Avenue past an organ grinder, whose music inspires him to dance. The dance occurs ambiguously in defiance, or perhaps for the benefit, of a crowd of onlookers who have been "laughing at him." Johnson's speaker admits at first to laughing as well, but her attitude changes, and this attitude leads her, significantly, to refer back to her experience of the objects on the top floor of the library:

> But say, I was where I could see his face,
> And somehow, I could see him dancin' in a jungle,
> A real honest-to-cripe jungle, and he wouldn't have on them
> Trick clothes—those yaller shoes and yaller gloves.
> And swallow-tail coat. He wouldn't have on nothing.
> And he wouldn't be carrying no cane.

He'd be carrying a spear with a sharp fine point
Like the bayonets we had "over there."

.

No one would laugh at him then, I bet.
Say! That man that took that sand from the Sahara desert
And put it in a little bottle on a shelf in the library,
That's what they done to this shine, ain't it? Bottled him.
Trick shoes, trick coat, trick cane, trick everything—all glass—
But inside—
Gee, that poor shine!

The comparison of the dancing man to the bottled African sand appears as the speaker's sudden realization of the affinity between two cultural objects. The imagined Africanicity of the performer, however, may also be explained as the effect of the speaker's figurative language, as the idiomatic phrase "dressed to kill" prefigures the subsequent image of the performer as "carrying a spear with a sharp fine point . . . And the end of it would be dipped in some kind of / Hoo-doo poison."

Katherine R. Lynes has provided a revealing reading of this poem, one that proposes the importance of Johnson's friendship with Zora Neale Hurston and thus the poet's presumptive familiarity with the "modernist theories of culture" associated with Hurston's teacher Franz Boas. Wishing to amplify the authorization of the poem's black speaker as "part of the process of constructing the concept of culture," Lynes is nevertheless alert to the constitutive contradictions of the speaker's language. In her reading, Johnson's speaker understands the performer's attire as evidence of his being "trapped within the 'bottle' of America, with its history of slavery and its cultural trappings of middle-class desires—the suit, the coat, the cane." The speaker's Africanist vision of the performer is meant to lend him a form of symbolic agency or potential, subject as he is to what Lynes sees as "the crowd's derision." Yet, as Lynes also concludes, "Africa as ordinary bottled sand becomes [for the poem's speaker] Africa as site of potential empowerment [but this] ironically relies upon [her] power to bottle up the man, as well." In Lynes's reading, Johnson employs an unreliable narrator but does not negate absolutely the critical value of that narrator's described experience: "by placing the dancing man into an imagined but 'honest-to-cripe jungle,' one that could transform the man into an object of admiration and not just curiosity, the speaker asserts [with Johnson's approval] a theory of

cultural relativism that was coming of age in the early decades of the twentieth century. But she also calls into question the very possibility of finding and displaying genuine objects—the man, the spear with its poison tip, the jazz, even the swallowtail coat—while she asserts the need for making that very move."[115]

While the contemporary presence of "genuine objects" from the Blondiau collection on the 135th Street library's third floor immediately problematizes some of Lynes's conclusions, her reading importantly contributes to our understanding of the poem in many ways, in particular by asking us to be alive to the possibility of something progressive emerging from the primitivism of the speaker's response to the performer. By connecting the imagined spear to "the bayonets we had 'over there'" (and thus invoking the black regiments that had fought abroad in the First World War), Johnson's speaker might be said to create a primitivist allegory of Du Bois's famous 1919 essay "Returning Soldiers," with its ringing phrase "We Return Fighting."[116]

Even before pursuing the significant question of the objects that were actually on display in the library, however, it is important to point out that a reading that gives priority to the *speaker's* active construction of culture, however critically it is framed, prevents a fully reflexive interpretation of the poem. A fuller interpretation must allow not only for the agency of the speaker's (primitivist) construction of culture but also for the critical agency inherent in the cultural performance she describes. It is in this way that "Bottled," deliberately I believe, satirically informs against both the speaker and the original situation of the poem in *Vanity Fair*, a magazine whose first twenty-five pages, in the May 1927 issue, were devoted to advertisements of luxury clothing that strongly resembles the costume of the performer. If the speaker is allowed a certain agency in appropriating for herself the primitivist tropes of an imagined Africa, it comes at the expense of allowing a similar agency to the performer's appropriation and satirical repurposing of jazz-age *couture*. I have preferred to refer to this figure as a street performer, rather than a dancer, in order to stress that his performance has already begun by the time the speaker crosses paths with him; it begins *before* he starts to dance. This is strongly suggested by the way he is provocatively "swirling his cane" in advance of happening upon the organ grinder. Moreover, the speaker's assertion that "everyone / Was laughing at him" includes the possibility, which the speaker fails to remark, that the crowd may not be gathering around the performer to deride him, but rather may do so in

comprehension and appreciation. They may realize, as the speaker does not, that the street performance expressly aims to satirize the downtown fascination with the New Negro (as promoted in organs such as *Vanity Fair*) and the bourgeois aspirations of the social formation associated with the New Negro as such. In this respect, "Bottled" anticipates more recent representations of the Harlem Renaissance, such as Isaac Julien's film *Looking for Langston* and Reg E. Gaines and Savion Glover's Broadway show *Bring in 'da Noise, Bring in 'da Funk*, both of which have depicted, with heavy irony, New Negro intellectuals in evening dress.[117]

The performer's satire of class pretension is especially significant for the poem because of the fungibility of some—but not all—of the markers of class in the speaker's verbal performance. The poem's increasingly long lines connote a growing excitement and enthusiasm in the speaker, and they also involve her increasingly frequent use of colloquial or vernacular expression. This diction intensifies as the initial citation of the library exhibit fades into the background. Most noticeably, the "yellow gloves" in the second stanza are refigured as "yaller shoes and yaller gloves" in the third stanza, a shift that is accompanied by the dropped g's in "yellin'" and "dancin'" as well as the use of the colloquial "ain't." While these signal an attitude appropriate to the street culture she is observing, they do not result in a wholesale linguistic promotion of the performer; though it is a "man" who "took that sand from the Sahara desert," the second stanza's "darky dressed to kill" is figured at the end of the poem with an epithet that cannot be fully explained away: "that poor shine." Whereas the speaker's verbal performance evinces her own comfort in shifting between standard and colloquial forms of speech, it does not finally promote the apostrophized subject beyond the parameters of racist language (however familiarly presented). The difference, I suggest, does not mark an identification with the performer but rather an insistence upon class difference, one that the speaker fails to realize may have been satirically anticipated by the performance of the dancer (to the appreciative response of the laughing crowd).

It is at this point that we can bring renewed attention to the importance of the poem's origin "Upstairs on the third floor / Of the 135th Street Library / In Harlem," a location that was by May 1927 home not only to the first acquisitions of the Harlem Museum of African Art but also to the even more foundational textual collections of the New York Public Library's Division of Negro History, Literature, and Prints (founded in May 1925) and Schomburg's seminal collection of books and manuscripts (whose official opening

had occurred at the 135th Street branch in January 1927).[118] For Johnson's contemporary audience, and especially for her Harlem readership, these collections would all have been obvious absent referents for the perhaps entirely fictitious "[b]ottle of sand" that serves as the poem's governing image. The problems that animate the poem are thus twofold. First, Johnson presents a performance, misunderstood by the poem's speaker, that signifies on the class aspirations of the Harlem elite. For if, as Lynes astutely recognizes, Johnson's speaker "assumes the dancer rejects the 'Charleston or Black Bottom'—dances that by this period had been made popular for white audiences . . . by black performers," she poignantly fails to recognize the critical potential of this as-yet-uncommodified expression.[119] The second and more troubling question (from Locke's point of view) concerns the fact that the speaker's Africanist fantasy is notably unenriched by the unremarked objects in the 135th Street library, thus calling into question his hope for effecting "a more thorough knowledge of African life and institutions, of Negro cultural origins, and of the background of the American Negro."

Johnson's poem situates these precisely as questions, rather than as an indictment of the epistemological credibility and authority of institutional collections as such. But what is finally at stake, in this reading of the poem, is the availability of collections for further, unimagined, and, we may also say, *aesthetic* appropriations that exceed the intentions of their collectors. In this sense, we may even suggest that this text, which appears to undermine Locke's official educational ambitions, at another level unexpectedly realizes his aspirations to discover "something technically distinctive, something that as an idiom of style may become a contribution to the general resources of art." At the same time, it does so in a characteristically reflexive way, bringing forward for interrogation the practices that shaped all the modernist collections we have considered, but in particular those of *The New Negro*, which attempted both to articulate a *New Negro* épistème and to interpellate its artists as the constituents of a movement. We cannot say that "Bottled" is the centerpiece of *Caroling Dusk* in the way that "Heritage" had been for *The New Negro*. But it is nevertheless important to note the congruity of the poem with Countee Cullen's more general critique of the racially specific agency of the collection as such—that is, the assumption that the collection may be presented as a metonym of a collective formation of artists and intellectuals. In this sense, the dominant subject of "Bottled" is not the white "negrotarians" that would be caustically satirized in Langston Hughes's 1933 short story "Slave on the Block" (white collectors so enthusiastic that

they "keep" an African American boy named Luther—"[t]he essence in the flesh"—to serve as a model for their own painting).[120] Rather, it is closer to the dominant trope of Wallace Thurman's Harlem Renaissance roman à clef *Infants of the Spring*, in which the cultural logic of the collection is so determinate as not only to cause Raymond Taylor (Thurman's figure for himself) to remark repeatedly that Niggeratti Manor is home to "a rare collection of individuals," but to have Dr. A. L. Parkes (Thurman's figure for Locke) summon New Negro artists to a "distinguished salon" with the words, "I hope you are intrigued by the idea and willing to coöperate. Please wire me your answer. Collect, of course."[121]

5 Modernism's Archives

Afterlives of the Modernist Collection

Two Termini

The New Negro was both a paradigmatic and an exceptional modernist anthology of the 1920s. It exceeded the poetic anthology form in a way that few collections have since attempted, but it also reclaimed the anthology's collectivist and interventionist mode and made the form available for subsequent rearticulations. In the late 1920s, the anthology remained a, if not *the*, dominant textual form for the circulation of African American writing. Numerous black collections appeared after 1925 that emulated or, more often, challenged the authority of Locke's example. Exactly contemporaneously with *The New Negro*, Genevieve Taggard's leftist collection *May Days* was itself followed by a host of leftist anthologies that replaced Taggard's retrospective and eulogistic approach with a more presentist, interventionist mode; these included Ralph Cheyney and Lucia Trent's *America Arraigned!*, Cheyney and Jack Conroy's *Unrest* series, Marcus Graham's *Anthology of Revolutionary Poetry*, and Henry Harrison's *Sacco-Vanzetti Anthology of Verse*.[1] But whereas Locke and Taggard were each concerned with the question of modernism's institutionalization, the black anthologies and leftist anthologies of the late 1920s did not visibly address themselves to such a question. The new obligations and functions for the anthology form bespoke broader changes then affecting the literary institutional field in the United States.

Emblematic of this shifting cultural field were two very different anthologies, each appearing in the early 1930s, each edited by a figure that had been central to the production and circulation of what would be enshrined as high modernism, and each representing leftist politics in its pages together with black culture (and thus engaging the dominant anthological trends of

the late modernist period). Together, the books represent antithetical, but complementary, termini of the modernist anthology form.

The two collections were Ezra Pound's *Profile* (1932) and Nancy Cunard's *Negro* anthology (1934). The former evinced an extreme gesture of authorial self-representation (in which the anthology becomes akin to a common-place book) and the latter an extreme form of politicization (in which the social function of poetry is greatly diminished). Both of these anthologies have proved to be exclusive volumes. In Pound's case this was by design: *Profile* appeared in an extremely limited edition of 250 copies from the press of the Italian publisher Giovanni Scheiwiller. In Cunard's case it was circumstantial: the enormous eight-hundred-page anthology proved too expensive for wide dissemination, and many of its one thousand copies were later destroyed during the London bombings of the Second World War. In another register, the anthologists themselves represented two responses to the rise of European fascism: shameful enthusiasm in Pound's case, and a passionate, communist-identified antifascism in Cunard's case. It is not irrelevant to observe that both volumes were also published abroad.

The anthologies were opposed at the level of their very reason for being. Soliciting an enormous and globally inclusive range of materials, Cunard's call for contributions spoke to a dominant concern of 1930s cultural production in requesting materials that were "entirely *Documentary*, exclusive of romance or fiction" in the form of "*outspoken criticism, comment and comparison from the Negro . . . individual documents, letters, photographs.*"[2] Pound, by contrast, proclaimed that *Profile* represented "merely the collection of poems that I happen to remember, that is, it is selected by a given chemical process."[3] As he clarified in a letter to Alice Corbin Henderson, "What I propose to do is to tell the story (as I have seen it) in poems that I still remember. . . . My introd. says that the list of contents has been made out from memory and without opening a book, that ought to give one sort of test, one dimension at least, without getting into academic solemnity, pretending to ascribe merit and pass grades :: and without the strain and hypocrisy [sic] of putting in a lot of rot from a sense of gorsloppum duty or justice or whatever."[4] *Profile* thus obtained the status of what Riding and Graves had in their *Pamphlet against Anthologies* decreed to be one of the very few legitimate instances of the anthology form, what they called a "personal anthology," which in Pound's case nevertheless also acted as something of a *curriculum vitae* for him, including as it did many poems whose reputa-

tions he had been instrumental in securing.[5] Cunard's anthology, on the other hand, would have represented to Riding and Graves the undesirable but inevitable culmination of such politically instrumental anthologies from Braithwaite's patriotic *Victory! Celebrated by Thirty-Eight American Poets* to Harrison's Sacco-Vanzetti collection, both of which the 1928 *Pamphlet* had derided by name. Cunard's introduction to the *Negro* collection insisted that "[i]t was necessary to make this book . . . for the recording of the struggles and achievements, the persecutions and the revolts against them, of the Negro peoples" and concluded, "The Communist world-order is the solution of the race problem for the Negro."[6]

In another register, however, the two anthologies were surprisingly comparable in their desire to participate in—whether extending or appropriating—the culturally prominent models of the black and the leftist anthology. Such was the explicit program of *Negro*, which inveighed heavily against the prosecution of the nine black youths on trial in the Scottsboro case while also presenting an unprecedented textual account of global black political culture in the name of a militant anticolonial politics. But it was also surprisingly true of *Profile*, which included (anonymously) several poems that had appeared in the socialist journal *New Masses* and also reprinted (again from the pages of *New Masses*) transcriptions of "Negro Songs of Protest," a series of confrontational songs collected by the communist folklorist Lawrence Gellert. This was the single piece that *Profile* would have in common with Cunard's anthology, and Gellert's work was unsurprisingly mediated to very different ends in each collection. Pound was at pains to depoliticize all of his selections from *New Masses*, reprinting eight of the songs but omitting all of Gellert's explanatory text; in the *Negro* anthology, Cunard reprinted the entirety of Gellert's transcriptions and all of his critical apparatus.[7] Yet even Pound, in his idiosyncratic and adventitious way, bore witness to the necessary interrelation of leftism and black culture: he removed the authors' names from the *New Masses* poetry so as to effect a stronger connection to the songs Gellert collected, for which "no individual authorship can be assigned."[8]

Brent Hayes Edwards has dubbed Cunard's *Negro* "the last anthology."[9] But we may claim a complementary form of finality for *Profile*, since Pound's 1932 collection represented an extreme example of the *subjective* dimension of anthology practice, just as Cunard's volume exhibited an extreme form of interventionism two years later. Pound at this same time compiled a more

conventional anthology (Faber and Faber's *Active Anthology*), but it is *Profile* that is the more instructive from the point of view of the anthology form, representing a final turning away from the interventionist mode that *Des Imagistes* had initiated, even as Pound's selections from *New Masses* weakly attempted to demonstrate a familiarity with the currents that animated the American scene. And whereas Cunard had been an important publisher of literary modernism with her Hours Press (which issued Beckett's debut, as well as Pound's *Draft of XXX Cantos*, Bob Brown's *Words*, and works by the surrealist group), the *Negro* anthology seemed to suggest a crisis of confidence with respect to the question of poetry's social or political agency. Although *Negro*'s poetry section significantly occupied the exact center of the volume, at eleven pages it represented by far the smallest section of the anthology. With its encyclopedic reach and wide diversity of documentary materials, the *Negro* anthology anticipates a new category of late modernist collection: the archive. It is in this institutional register that we will eventually return to Pound and Cunard—though not to their anthologies per se—by way of conclusion.

Two Consecrations

Pound's and Cunard's collections did not signal the demise of the interventionist anthology as such, but they did confirm that the interventionist mode could no longer serve as the basis for the institutionalization of modernism (provisional or otherwise).[10] At the moment that these anthologies appeared, the increasing authority of the Museum of Modern Art (est. 1929) was coming to mark a similar terminus for the interventionist function of the modernist art collection. From among that field of ambitious collectors, only Duncan Phillips had successfully fashioned an institution that could complement the waxing authority of MoMA. By the early 1930s, the Barnes Foundation was isolated, Dreier's Société Anonyme had passed its phase of greatest activity, and A. E. Gallatin's Living Gallery was overshadowed by MoMA's stronger financial backing and more felicitous location.[11] By midcentury, Gallatin's collection would be installed together with the Arensbergs' collection at the Philadelphia Museum of Art, the Société Anonyme collection bequeathed to Yale, and the works at the Barnes Foundation virtually inaccessible to the public.

The period of MoMA's hegemony in the field of modern art began slightly later, in the late 1930s. It was at this time, too, that literary modernism established its patrimony in archives and special collections, most but

not all of them at university libraries. During its first several years MoMA had been devoted to temporary exhibitions consisting almost entirely of borrowed works. In the wake of the Depression, it was not until the mid-1930s that the museum could begin a concerted effort to acquire works, an effort initiated by purchasing the collection of the late Lillie Bliss.[12] MoMA moved into its first permanent building, the International Style structure on West 53rd Street, designed by Philip L. Goodwin and Edward Durell Stone, in 1939. The permanent collection and facility were steps decisive for securing MoMA's dominant institutional position. From 1939, MoMA drew authority both from its iconic and centrally located museum building and from its permanent holdings, which canonized modernism primarily as both *field* and *period*, not as an ever-renewing and evolving set of aesthetic and cultural practices.[13]

Significantly, it was also at this precise time that Cleanth Brooks and Robert Penn Warren's landmark pedagogical anthology *Understanding Poetry* appeared (1938), codifying the practices of the New Criticism and definitively situating twentieth-century poetry as an object of university study.[14] This anthology influentially crafted a teaching canon of modernist poetry, which had the effect of endowing the New Criticism with an institutional hegemony that far surpassed the canonizing efforts represented by the anthologies of Harriet Monroe, Louis Untermeyer, and Marguerite Wilkinson in the late 1910s. *Understanding Poetry*'s canon was famously white (it was not until the 1976 edition that any minority authors were included), male, and Anglocentric. Its resistance to free verse, which also contributed to the first two editions' surprising deficiency in modern American poets, owed to a somewhat restrictive conception of form and meter, categories the anthology nevertheless privileged. As Alan Golding has demonstrated, the revolutionary character of *Understanding Poetry* was "pedagogical, rather than critical," and it "shifted teachers' attention from sociological to formal categories."[15]

These two hegemonic institutions, MoMA and *Understanding Poetry*, made modernism available to a rising American middle class, but they also signaled a transformation of modernism into a canon of objects and texts to be studied and enjoyed within the purview of specific institutional protocols. Perhaps most tellingly, modernist art and poetry were now established as separate domains, largely independent of the contested cultural formations that had motivated the very notion of modernism and modernist collecting as forms of social practice.[16]

Two Archives

A continent away, the 1936 translation into French of Walter Benjamin's "The Work of Art in the Age of Its Technological Reproducibility" inspired a thirty-five-year-old André Malraux to begin devising what may be called the first anthology of fine arts. Eventually published in 1947, Malraux's *Le Musée imaginaire* (translated in English as *A Museum without Walls*) represented the museum's final appropriation of material qualities that had hitherto only been enjoyed by anthologies: portability, reproducibility, amenability to infinite recombinations. "[T]he plastic arts have invented their own printing press," wrote Malraux, "it will carry infinitely farther that revelation of the world of art, limited perforce, which the 'real' museums offer us within their walls."[17] If such democratization represented an imaginative harnessing of the agencies of the anthology form for the fine arts, it was perhaps inevitable that an institutional form would be devised that could overcome the vagaries of reproduction for the literary field and thereby establish the work of the literary author as a set of rare or singular objects. The rise of institutional collections of rare books and manuscripts represented a way of finally valuing officially the rarity of the first edition, the association copy, and, especially, the manuscript for literary modernism, thus devising a version of the economy from which modernist painters had benefited for so long.

Two of the earliest such collections, Charles D. Abbott's Poetry Collection at the University of Buffalo and Carl Van Vechten's James Weldon Johnson Memorial Collection of Negro Arts and Letters at Yale, represent two distinct approaches to the field, but they were equally dedicated to establishing an economy of rarity for the literary field and took pains to assure the authors they represented that the new archival collections would promote their value, both in terms of money (it will "insure a protection of the value of your manuscripts, in case you are accustomed to sell from them," as Abbott's form letter stressed) and in terms of prestige (Yale is "an excellent place to insure your future immortality," as Van Vechten wrote to Claude McKay).[18] It is fascinating to consider that these collections were established as the New Criticism was rising to institutional dominance. Abbott's and Van Vechten's archives were specifically designed both to support and to transform forms of academic "scholarship" to which "criticism" would remain fundamentally hostile.[19] The distinctions between these two collections are nevertheless significant, not only for the relationship to our

own contemporary practices but also for demonstrating the relative openness of the modernist archival field in the late 1930s.

Abbott began the work of assembling the modern poetry collection in 1935. The James Weldon Johnson Collection was bequeathed to Yale slightly later, in 1941, but had its origins in Van Vechten's enormous personal collection, which he had begun amassing much earlier. Each would be officially consecrated somewhat later, closer in fact to the time Malraux was able to publish his anthology: Abbott's collection was formalized with the publication of the book *Poets at Work* in 1948, Van Vechten's with a dedicatory ceremony at Yale on January 7, 1950.[20] Both collections were unusual in the sense that they were concerned almost exclusively with representing living writers, and in this respect they resembled the modernist collections we have been considering. But these near-contemporary archives also differed from each other in several important ways: with respect to the composition and scope of the collections, the scholarly purposes that the materials were imagined to enable and serve, the larger institutional contributions (or interventions) that the collections hoped to effect, and the public (Buffalo) and private (Yale) nature of the institutions that now house and sponsor the archives—a point whose importance was not limited to the significant economic disparity between the two universities. Finally, these institutional scholarly collections differed on the very grounds that merit their consideration as second-generation modernist collections, that is, in the way they represented the subjective dispositions and investments of their collectors.

Abbott's project had its origins in the construction of a new library at the University of Buffalo, a building endowed by Thomas B. Lockwood, whose rare book collection was at this same time presented to the university.[21] Abbott was appointed as the new institution's first librarian. Abbott arrived at a time, as he would remember, "before its policies were formulated, its habits and methods developed. It had no past interlaced with traditions which the present must honor."[22] With a freedom that it is now difficult to imagine, Abbott was given license to develop a collection for the Lockwood Library whose parameters he was permitted to determine. For Abbott, as had been true for the art collectors Phillips and Barnes, it was a combination of enthusiasm for the field and economic considerations that determined his turn toward modern and contemporary work. Because the university's limited funds made impractical any hopes to build a collection based on rare books and manuscripts, Abbott elected to invest in a collection based in British

and American modern poetry, addressing a field whose artists were mostly still living and active, and whose books were relatively available and affordable. The first stage of acquisitions involved securing first editions of monographs, with the aim of assembling, in Abbott's words, "piece by piece, a collection of books which would include every text by a twentieth-century poet writing in English."[23] With remarkable foresight, Abbott also actively sought to acquire more ephemeral poetic materials, which were not yet the objects of speculation and investment in the book trade. This resulted in the library's enviable collection of broadsides and little magazines, as well as an unequalled collection of anthologies, a genre that rarely finds a place in rare book rooms even today.[24]

But Abbott's most remarkable innovation, both in terms of immediate strategy and also with respect to shaping future scholarship, concerned his solicitation of manuscripts from living poets according to the designation of what he would soon call "worksheets." The limited funding of the project, the absence at that time of an established reputation for the library, and also what Abbott identified as the "unsettled" values of contemporary manuscripts all conspired against the possibility either of purchasing manuscripts or of soliciting what are now called "organic collections"—relatively complete collections of letters and manuscripts from a particular author or collector.[25] Abbott's solution to this dilemma was to compile a list of two hundred living English-language poets and to request that each of them donate a single poem in manuscript. That initial list was reduced to fifty poets (including the African American poets Countee Cullen and Langston Hughes), each of whom received a letter of solicitation in the fall of 1936. The ingenuity of Abbott's plan lay in the way it quickly and inexpensively provided a record of a broad field of modern poetry, rather than concentrating on a relatively thick set of materials associated with a few particular writers (an endeavor that would also have required more money and negotiation). The initial response was overwhelmingly positive, but many of the poets nevertheless misinterpreted Abbott's imprecisely phrased letter and sent in a fair copy manuscript (i.e., a transcription, written in the poet's hand, of a completed poem) rather than the various stages of a poem in draft: this confusion led to the library's adoption of the term "worksheets." A notable exception to this tendency was the response of Genevieve Taggard, who sent a set of materials, Abbott would remember, "so detailed, so exhaustive, that almost no footprint of the mind was lost in the record;

materials that conveyed, like nothing I had ever seen before, the sense of excitement, of agonizing growth, that accompanies invention."[26]

The success of the first push to build the worksheet collection encouraged Abbott to write again to the twenty-five poets who had sent fair copy and to expand the field of poets he hoped to represent in the collection. In 1937, he was awarded a grant from the Carnegie Corporation that allowed him to travel to meet, solicit, and negotiate with additional poets in the United States and abroad. During this time, Abbott was also able to formulate more clearly the scholarly purposes he imagined for his collection. By 1948, Abbott could claim that his own survey of academic writing had revealed that, however varied the aims of the scholarship, "nearly all had one thing in common: they were the verdicts of deductive reasoning. . . . They were absorbed in the explication of causes while their evidence consisted almost wholly of effects."[27] The worksheets would provide this absent evidence. As he had written nine years earlier in the pages of *Poetry* magazine,

> [The scholar] would like everything that went to the making of the work he is investigating: the rapid and often chaotic notes that show the first impulse towards creation; the rough draft in which the material begins to take shape; the intermediate versions, however many there may be, through which the composition progresses towards its final form; the proof-sheets, if they contain revisions; and the final form itself as seen in the printed text. With such a *dossier* . . . the scholar could see his author at work, could follow the active creation step by step, could understand the processes of thought which produced the final work. Such a *dossier* would constitute, in fact, a kind of biography of the author's mind.[28]

While Abbott here described his project as one that responded to an existing scholarly need—one that seems strikingly to anticipate the recent turn of literary studies toward cognitive science[29]—his greatest wish and ambition for the collection was to enable an entirely new kind of inquiry, one that would be uniquely possible at Buffalo because of the comparative study enabled by the broad field of authors represented in his collection. "[A]n eminent scientist has pointed out to me," Abbott wrote in 1939, that the collection "will provide the psychologist with tools which he has not hitherto possessed for the investigation of that seemingly most inexplicable phenomenon, the creative imagination."[30] Abbott's most cherished ambition for the collection was to service the study not of individual authors but

of the psychological origin of aesthetics as such, and it was for this reason that one of the four figures he commissioned to write essays for *Poets at Work* was the psychologist Rudolf Arnheim. This project for which Abbott had such high hopes, however, has not been subsequently taken up by the archive's patrons.

By 1948, Abbott could boast of holding 3,000 sets of worksheets, as well as 2,500 letters. This formed a prestigious and pioneering archive on whose basis the Poetry Collection could later acquire organic collections of individual writers, including William Carlos Williams (beginning in the 1940s), James Joyce (1950), Wyndham Lewis (1953), and Robert Graves (1960). Abbott's acquisition of multiple successive manuscripts in draft, moreover, prefigured and has since supported (especially in the case of the Joyce materials) the present field of genetic criticism. In 1958, the poet A. Alvarez concluded an essay on the Buffalo Collection by asking, "Will [the collection] be used to provide the clearest understanding of the best versions of twentieth-century poems? Or will it be used as a museum of psychological curiosities, devoted not to poems, but to the mystique of being a poet?"[31] The example of genetic criticism, as well as the work of the present book, suggests that new uses for the collection will continue to be discovered. These examples, however, also unapologetically confirm Alvarez's observation that the Buffalo Collection "is, in short, wholly a product of the age of analysis."[32]

The James Weldon Johnson Memorial Collection of Negro Arts and Letters Founded by Carl Van Vechten, to use its complete name, differs from the Poetry Collection at Buffalo not only because of its different focus (black literature and culture as opposed to modern poetry) but also because of its basis in the personal collection of its founder. This distinction is still evident in the collection today—despite the fact that, like Buffalo's collection, it still continues to expand. The difference lies in its materials, a great many of which literally bear the mark of Van Vechten, and in the methods of its classification and organization, many of which are still used by the Beinecke Rare Book and Manuscript Library, where the collection is now held. Compared with Abbott's innovative strategy, the Van Vechten materials more nearly resembled the organic author-based collections for which libraries still compete today; unlike many such collections, however, the materials were constituted as a research archive in advance of their institutionalization. As Arna Bontemps, then the newly appointed librarian

of Fisk University, described it in 1943, "The books, manuscripts, letters, pamphlets, papers, clippings, phonograph records, and photographs assembled in the Collection are essentially an expansion of research materials accumulated by a meticulous white writer while preparing a story of Negro life in America."[33] According to this account, the transfer of Van Vechten's collection to Yale in 1941 reconstituted the archive for a single work of fiction (Van Vechten's 1926 novel *Nigger Heaven*) as a set of research materials for a much wider, not fully imagined set of scholarly practices.[34]

The location of the collection at Yale was significant in determining the collection not simply as an institutional archive but also as a form of intervention. Shortly before he promised his Negro materials to Yale, Van Vechten had been instrumental in establishing Gertude Stein's archive in New Haven, with the first delivery of materials going to Yale in January of 1941; as the conditions of this bequest were being negotiated, Yale head librarian Bernhard Knollenberg remarked to Van Vechten on the paucity of African American texts and documents at Yale.[35] Writing in the *Crisis* in 1942, Van Vechten announced his intention that the collection would "become an active and growing source of *propaganda*, for no student hitherto uninformed on the subject could read these letters, these inscriptions in the books, or even the books themselves, without asking himself, and others, many questions" (my emphasis).[36] The former editor of *Opportunity* Charles S. Johnson echoed these sentiments in a letter to Walter White when he wrote that "at such an institution as Yale, the Collection would be available to thousands of 'convertables' who otherwise would never know that a Negro had ever written a book."[37] While these comments give the sense that the true audience of the collection was white scholars and students, they also explicitly assume the interest of black readers. The Yale location, indeed, was viewed as attractive because of its proximity to eastern cities and their black populations (while also sufficiently far to avoid competing with Schomburg's collection in Harlem). At the same time, however, the collection's interventionism specifically addressed white institutional culture. Van Vechten worked (unsuccessfully) to establish positions at the library for the African Americans Harold Jackman and Bontemps (Bontemps would later become curator of the James Weldon Johnson Collection after he retired from Fisk in the late 1960s). And he wrote confidently to Langston Hughes in 1943, "I have the DEFINITE FEELING that in LESS than five years Yale will have a chair of Negro life and culture."[38] The logic of Van Vechten's official

activities was thus integrationist, as would be indicated in a different regis-
ter when he donated his collection of music materials to Fisk University in
1946, aiming to draw white scholars to a black institution.

Because the donated materials focused so strongly on a relatively short
and recent historical period and cultural formation, it is possible to read the
collection as a *chronotope* of the New Negro Renaissance, organized around
the mediating and determining figure of Van Vechten. Although Van Vech-
ten could proudly claim ownership of some very rare items—most notably a
first edition of Phillis Wheatley's *Poems on Various Subjects* (1773)—he would
also admit that, compared with the collections of Schomburg (in New York)
and Arthur Spingarn (at Howard University), his was not especially deep his-
torically. This deficiency was due in large part to the disposition of the col-
lector, as Bontemps would explain: "[I]t was inevitable that the collection . . .
would be strong in materials relating to Negroes in the twentieth century,
weak in historical lore—the controversy about slavery, for example, was
virtually ignored. As a collection, it would be primarily influenced by aes-
thetic values, only incidentally by what is known as 'the race problem.' As
a view of Negro life, it would *unfold from within*; in other words, it would
be a highly personal collection, rich in association items and abounding in
records of warm friendships across an artificial gulf" (my emphasis).[39] As
Bontemps observed, the collection could be said to have been in a sense *au-
thored* by Van Vechten. In this way it resembled more closely the modernist
collections of the 1920s than did Abbott's conceptually innovative archive.
The collection's focus on twentieth-century materials admits constructive
comparison with Abbott's in other ways as well. Whereas Abbott's modern
poetry collection was geographically broad (English-language writers) and
generically specific (poetry), Van Vechten's was more circumscribed the-
matically (Negro arts and letters), but was also more receptive to a wide
range of media, all of which, Van Vechten insisted, should be "preserved as
an entity."[40] In this way, Van Vechten's collection brought together in one
location a wealth of materials that have helped to constitute the Harlem
Renaissance as a field, while also bearing the mark of those objects' associa-
tion with the collector in a way that is only distantly evident, if it is evident
at all, at Buffalo.

Van Vechten was surely aware of the possibilities as well as the dangers
of creating this kind of a collection. From the beginning, he insisted on
endowing the collection in the name of James Weldon Johnson (who had
died suddenly in 1938), not only as a memorial to a close friend who had

been a crucial defender of the controversial *Nigger Heaven*, but also as a way of rhetorically effecting the transition from a personal to an institutional collection. As he wrote to Knollenberg, "[t]he name I have chosen makes it easier for me (and you) to persuade others to add to it in the future."[41] The titling of the collection would be given further legitimacy in 1945 when Johnson's widow Grace Nail Johnson added her husband's papers to the Yale collection. By that time Van Vechten had also succeeded in securing the assistance of several black intermediaries to solicit materials from their contemporaries on the collection's behalf. The key figures here were Langston Hughes, the Harlem educator and salonnière Dorothy Peterson, and, above all, Harold Jackman, whose pivotal and underacknowledged role in the formation of the collection has been the subject of a compelling essay by Jacqueline C. Jones.[42] Together with Van Vechten, these figures expanded the collection to include significant sets of letters and manuscripts from Toomer, Cullen, Hurston, Thurman, and McKay, as well as smaller quantities of material from a host of other New Negro intellectuals. It was on this basis that Yale could later add to the collection the papers of Richard Wright and Chester Himes.[43]

The James Weldon Johnson Collection thus not only maintained but, in a sense, expanded the appearance of Van Vechten's centrality to the movement, even as it became constituted as a more officially institutional collection. Although Van Vechten's importance is unquestionable, it is nevertheless very revealing to discover how assiduously the collector worked to make the numerous association items[44] of which Bontemps had written (for instance, copies of books inscribed to the collector) bear the visible mark of their relationship to him. It was notably at the moment that he was preparing the materials to be deposited at Yale—rather than earlier, when he initially acquired the items—that he most energetically sought inscriptions for the books. His letter to McKay on October 22, 1941, is characteristic. After cajoling McKay to donate several manuscripts, he writes, "I've found an old Pearson's and several Liberators or New Masses I'd like you to sign (for Yale) in addition to Arna Bontemps's anthology in which you play an important role."[45] Van Vechten's request that McKay sign copies not only of his poetic volumes but also of the magazines in which McKay was published (or that he edited) represents a desire for a very unusual degree of authentication. Van Vechten's push to establish these objects as association items was intended to confirm the *singularity*, and thus the unique value, of the published works that entered the collection at Yale. But it also provided

a material record that testified, perhaps excessively, to Van Vechten's cen-
trality within the social formation that the collection documented.[46] This
concern extended also to the prodigious amounts of correspondence that
Van Vechten generated and preserved, as well as, most famously, to the col-
lection of photographs taken by the collector of a great many of the figures
represented in the archive. It was only half-jokingly, as Michele Birnbaum
has recognized, that Van Vechten would conclude a 1959 letter to Hughes
by styling himself "Carlo, the Patriarch."[47]

The earliest correspondence with Knollenberg concerning the collection
stresses Van Vechten's intention to remain actively involved in its devel-
opment. He continued to add materials to it until his death in 1964, and
he also maintained a diligently annotated catalog of those materials. The
massive 658-page typescript testifies to Van Vechten's concern to make in-
tellectually available to scholars some of the more hermetic materials he is
depositing; in one instance, he suggests to the Yale librarians that they hire
someone (he suggests Hughes) to transcribe the sung lyrics from his enor-
mous phonograph record collection "before it is too late," for fear that the
regionally specific accents and figures of speech of the singers will in time
make the material impossible to comprehend.[48]

The catalog is also of interest because many of the protocols that con-
tinue to determine the organization and constitution of the collection are
manifest in the catalog typescript. Here, for instance, is the record for his
personal copy of *The New Negro*:

> The New Negro, edited by Alain Locke (N). First edition in dust jacket, designed by
> Winold Reiss (W) who supplied portraits for this book. (See The Survey Graphic:
> Harlem: Mecca of the New Negro, in box: Langston Hughes: Pamphlets II . . .)
> Presentation copy, inscribed to CVV, and signed by Alain Locke, who has written
> a further, and later, note on the dedication page. William Stanley Braithwaite's
> autograph is laid in at page 29. There is an inscription to CVV from Rudolph
> Fisher on page 56. Aaron Douglas signed his design on page 112. Countee Cullen
> has signed his portrait facing page 132. There is an inscription by Claude McKay
> on page 135. James Weldon Johnson has a signed inscription to CVV, on page
> 139. Langston Hughes has signed on page 145. Miguel Covarrubias has signed a
> note about his pictures facing page 224. Langston Hughes has an inscription on
> page 226. Walter White has an inscription, signed, to CVV on p 361. All these,
> save Covarrubias, are Negro. Further Negro contributors are Jean Toomer, Zora
> Neale Hurston, Bruce Nugent, Eric Walrond, Arthur A. Schomburg, Arthur Huff

Association copy of *The New Negro*, signed by Alain Leroy Locke, James Weldon Johnson, Jessie Fauset, Jean Toomer, W. E. B. Du Bois, Paul U. Kellogg, Irita Van Doren, Charles S. Johnson, Charles Boni, Zora Neale Hurston, Rudolph Fisher, Walter White, and Eric Walrond. This particular copy probably belonged to Grace Nail Johnson, but Van Vechten was himself unusually concerned to ensure that the individual objects of his collection bear the visible mark of their association value. James Weldon Johnson Memorial Collection, Beinecke Rare Book and Manuscript Library.

Fauset, Jessie Fauset, Charles S Johnson, Kelly Miller, and W E B Du Bois. There are a few contributions from white men such as Dr A C Barnes and Melville J Herskovitz. Practically everything in this book should be catalogued separately. BIBLIOGRAPHY. A Clipping is laid in the back. The end papers, I think, are by Aaron Douglas. (N)[49]

This entry (which errs in attributing the end papers, which were done by Winold Reiss, to Aaron Douglas) testifies to the very great importance Van

Vechten attached to the association value of the individual texts in the collection. It also bears witness to another of Van Vechten's documentary enthusiasms, which was to ascertain the racial identity of each author represented in the collection, designated throughout the catalog as Negro (N), white (W), or unknown (?). Much of his correspondence from the period concerns this issue (including, for example, an exchange with Bontemps about the rumored Negro identity of John James Audubon). This concern also marked Van Vechten's organization of his own correspondence, still used by the Beinecke today, which distributes into separate files his letters from black and white correspondents.[50] While this method of organization has no bearing on the conditions of access to the material, it remains an artifact of the way the collection as a whole was conceived, articulated, and mediated by its collector. Notably, it is only Van Vechten's letters with his black correspondents that have to date been completely cataloged by the Beinecke.

In considering the remarkable scope and depth of the collection, it is finally worth remarking on the fact that so many of the authors who were solicited for manuscripts and letters had in fact maintained their records. This is impressively true of Langston Hughes's papers (considering the poet's itinerant career), which were carefully self-edited and curated with an eye toward crafting Hughes's long-term reputation. But it is a situation perhaps more revealingly demonstrated in a letter written to Jackman by Anne Spencer, a poet who had been included in *The New Negro* anthology, but who by 1942 was living far from the New York scene in Lynchburg, Virginia:

> Dear Mr Jackman,
> Your kind note was tonic for me at this time: a long, moody period has let me forget, as we oldsters say, the good old days. But I must say with deep chagrin that I own no manuscript at all of my few things. Years ago when I did the poems, I knew so little of author-practice it never occurred to me to save the sheets written in my nonesuch hand. Now that I do know more of the rules, I no longer practice being an author. Otherwise I'd be lucky and proud to send what you ask to so notable acollection [sic].[51]

Spencer's letter throws into relief the "author-practice" in which so many of her contemporaries did engage, namely, the documentation and curation of one's identity as an artist. These individual practices were vindicated, but

also transformed, by the event of their accession into the James Weldon Johnson Collection under the aegis of its founder.

In her excellent reading of Van Vechten's correspondence about the collection with Hughes, most of it dating from a later period of acquisitions in the 1950s, Birnbaum has revealed the two figures' "joint effort to write themselves into history—or, more precisely, to construct tautologically a history in which they would be historically significant." "[B]y the 1950s," she writes,

> most of the letters are dominated by their own self-referential metacommentary: letters about getting their letters to the Collection. . . .
>
> Van Vechten's shameless self-congratulation about the Collection in many of his letters frequently functions, then, to generate a form of triangulated desire in which he narrates someone else's appreciation of him not only to inspire it in Hughes (usually to goad him into sending more materials, out of guilt) but also to inspire it in whoever, ostensibly, might eventually be reading the letter to Hughes in the Collection.[52]

Birnbaum's perceptive reading of the letters demonstrates, among other things, another way in which we may read Van Vechten as the author of his collection. But her insight also has far-reaching implications for archival scholars researching figures from the modernist period, a period that we might even think to call, borrowing Spencer's phrase, the age of "author-practice." For Van Vechten's repeated pronouncements of the importance of his collection (which is in any case self-evident) only represent in an extreme way a more general recognition among many, if not all, authors that their private correspondence might eventually find a more public audience, whether in the archive or elsewhere. To recognize this is not to evacuate the possibility of knowledge from archival scholarship, but rather to oblige a reflexive mode of inquiry when approaching these documents: we must consider the possibility of ourselves as one *intended* audience of the seemingly private letters.[53] But these exchanges also, in a more general way, oblige us to consider the nature of the desire to be included in an archival collection. For if it required the intercession of Alain Locke, for example, to obtain manuscripts for the James Weldon Johnson Collection from Sterling Brown, who loathed Van Vechten, Brown's final agreement to contribute the manuscripts nevertheless indicates, if not his approval, at least his acknowledgment of the value and importance of the institutional

project as such, a project that was met with altogether greater enthusiasm by other contributors.

In this sense, it is worth finally surveying some of the reactions from the poets who were solicited to contribute to the project at Buffalo, focusing once again on the instructive contrast of Ezra Pound and Nancy Cunard. Although the poets Abbott contacted generally responded enthusiastically and cooperatively to his initial requests, one of the most prized documents in the collection is Pound's furious response to Abbott's solicitation of worksheets. It is worth quoting here at length:

> I shd/ be delighted to befriend ANY university that wd/ open its mind and DO one single stroke of work for the benefit of american letters and the life of the mind in america.
>
> The endowers' attitude that Creative writing shd/ support passivity and accumulators is ROTTEN. . . .
>
> You cant move any hired hand and stipendiated American to take ANY action either re/ comparative literature or AMERICAN history.
>
> I don't care a damn about storing mss/ in a safe.
>
> It wd/ be rank injustice for ANY writer who has fought the disgusting inertia of the american publication system to do ANYthing for librarians who do NOT rebel against the N. York smotherers. . . .
>
> If your damn library wd/ DO anything toward production; if ANY beastly university in our dead country wd/ even hold a faculty meeting to CONSIDER the easily practicable steps toward AIDING the intellectual life of the country or village one might in time open communications like yours with less annoyance & even comply with requests.[54]

Pound here categorically refuses to approve the comparatist dimension of Abbott's project, which he rejects in the name of reiterating his long-standing complaints about publishing and American intellectual life. This rejection is motivated by his larger objection that the collection by definition refuses to orient itself "toward production": it is not, in Pound's view, a sufficiently interventionist collection.

However one may feel about these sentiments, it is crucial to question his claim that he does not "care a damn about storing mss/ in a safe," for, as the Pound collection at the Beinecke now amply demonstrates, Pound himself was an assiduous collector and curator of his own work and correspondence. This is worth foregrounding in light of the overwhelmingly approving—and indeed identificatory—response Abbott received from

Nancy Cunard, a figure whose own collections were largely destroyed by Nazi soldiers during World War II.[55] In her first letter to Abbott, she sub-mitted a manuscript (most likely for the poem "The Heart Will Win") and apologetically quoted Tristan Tzara's Dadaist "*recipe* for the poem," before concluding, "[w]ith greetings and best wishes for your immense work. I feel we are fellow-sufferers in all this chasing of others, editing and publishing."[56] This would be followed by numerous additional letters from Paris, Spain (where she worked in support of the Republicans during the civil war), and Chile, where she continuously brought poets to Abbott's attention (Kay Boyle, Langston Hughes, Randall Swingler, Brian Howard, Nicolas Guillen, Sterling Brown, Jacques Roumain, the Ecuadorans Pedro Jorge Vera and Al-fonso Cuesta y Cuesta) and repeatedly urged him, at times desperately, to keep her informed of his progress.

What may first be observed in these two wildly disparate reactions is that Pound responds to the Poetry Collection as institution, while Cunard writes to Abbott as a collector (indeed a "fellow-sufferer"). Taken together, they name the very dynamic that animated the problematic of the mod-ernist collection as such: identifying it, that is, as a provisional institution whose unique agency derives from the individual subject who constructs it. Pound presents the accession of manuscripts to the university collection as an ossification of the agency of the literary and, worse, a contribution to the forces that conspire against the circulation of new ideas. Cunard, on the other hand, views Abbott not so much as performing the neces-sary work of preserving a historical record, but, perhaps romantically, as fostering a textual community of disparate writers. Her understanding is no doubt informed by the degree to which her enormous documentary *Negro* anthology itself presaged the archival collections of modernism that followed it.

Both of these impassioned responses point to the necessarily ideologi-cal, indeed political, character of information, even in an ostensibly non-partisan collection such as Abbott's (which claimed affiliation to neither radical nor conservative form or politics).[57] In a more general way, they point to the necessarily mediating character of libraries and of librarians, a mediation that transforms but also articulates and makes accessible forms of knowledge that are not necessarily inherent to the individual documents taken in isolation. If Cunard mistakenly takes the unknowable poetic and scholarly *future* value of the Poetry Collection for a living community in a violently fractured *present*, it is Pound's account that evinces the more

distorted caricature of what an archival collection might be. For unlike Cunard, he fails to recognize that the collection's vocation is not simply to preserve a vanishing past, but to make the fragments of that past, as well as the records of those fragments' historical and present mediations, available to the conditions of unforeseeable futures.

Notes

Introduction. Collections Mediation Modernism

1. Perloff 44-79; Diepeveen, *Changing Voices* 89-93. See also Paul K. Saint-Amour's fascinating discussion of the Victorian cento or "mosaic" poem as a precursor to these modernist practices (40-47).

2. Topia quotes Michel Foucault's preface to Flaubert's *La Tentation de Saint Antoine*: "It pertains to that literature which exists only in and by the network of what has already been written. . . . Flaubert is to the library what Manet is to the museum. . . . Their art arises with the birth of archives" (103).

3. "Both are built out of fragments and quotations, and adhere to the high-modernist aesthetics of image and montage. Both have economic ambitions and economists as presiding figures (Marx in one case, Gesell and Douglas in the other). Both authors have investments in antiquarian bodies of knowledge whose relevance to their own times they overestimate. Neither knows when to stop. And both in the end were consumed by the monster of fascism, Benjamin tragically, Pound shamefully." Coetzee 33.

4. See the special factography issue of *October* edited by Devin Fore.

5. These literary practices find an analogue in the music of Béla Bartók, Leoš Janácek, and Igor Stravinsky—composers who drew from and, in the cases of Bartók and Janácek, themselves assembled collections of folk songs. Taruskin 891-923; A. Ross 80-129.

6. Haines also tells Stephen Dedalus, "I intend to make a collection of your sayings if you will let me." Joyce 1.480.

7. Pound, *Letters of Ezra Pound* 180; Hughes, "Negro Artist" 694.

8. As was true of art institutions in the United States, where most major public museums were established beginning in the late 1920s, the American poetic institutions were also at this time in the process of formation. A number of national anthologies had been published in the nineteenth century, culminating in Edmund Clarence Stedman's *American Anthology* of 1900, but the United States would not

have an institution comparable to the Poet Laureate until 1937. See Golding 3-21 and McGuire 23-50.

9. Baudrillard 103. For a survey of recent work on collecting, see Monaghan A17.

10. Rainey, *Institutions of Modernism* 5.

11. See Dewey et al., *Art and Education*; and D. Phillips, "Inter-Creating Intelligence" 21-37.

12. Bourdieu, *Field of Cultural Production* 136.

13. Ibid. 118. Along these lines, Bourdieu sustains a virtuoso study of Flaubert's *Sentimental Education* in *The Rules of Art*.

14. R. Williams, *Keywords* 206. See Jonathan P. Eburne's helpful gloss (74-75).

15. In his essay "Genesis of the Media Concept," John Guillory presents Williams's brief statements on mediation as "the most synthetic accounts available to date," but he also recognizes Williams's uncertainty as to whether mediation is ultimately separable from the blunter theories of reflection or representation. Guillory looks to work through the impasse by situating mediation within the system of communication:

> In that context, the enabling condition of mediation is the interposition of *distance* (spatial, temporal, or even notional) between the terminal poles of the communication process (these can be persons but also now machines, even persons and machines). Distanciation is another way of looking at the operation of *transmission* (what Bacon called tradition, but meaning now something much more inclusive than he imagined). The notion of interpolated distance should not be understood, then, as identical to *absence* or to a term in the philosophical antinomy of presence and absence. Distanciation creates the possibility of media, which become both means and ends in themselves—not the default substitute for an absent object.

Although Guillory's argument is ultimately directed toward the humanistic study of new media, it will become clear that my own approach to collections "as means and ends in themselves" is informed by this understanding of mediation as communication and transmission. Guillory, "Genesis of the Media Concept" 355, 357.

16. R. Williams, *Marxism and Literature* 163.

17. Pound, *Literary Essays* 58, 297.

18. Simpson 20.

19. For the most complete checklist of Quinn's collection, see Zilczer, *"Noble Buyer"* 149-92.

20. Rosenberg had, in fact, been Quinn's principal resource for buying Picasso's paintings in the 1920s. See FitzGerald 112-14, 151-52.

21. Quinn bought Matisse's *Blue Nude* from the collection of Leo Stein in 1920. The Duchamp *Nude Descending a Staircase* that was exhibited at the Armory Show was the second version, from 1912; it was purchased from the Armory Show by a San Francisco collector named Frederic C. Torrey. In 1915 Quinn bought the earlier

version, painted on cardboard rather than canvas, intending it as "a personal souvenir of the Armory Exhibition." Pach 270.

22. Zilczer, "Dispersal" 15.

23. Ibid. 16, 18.

24. See Bruccoli 151–62.

25. FitzGerald 17.

26. Reid 157–60.

27. Cabanne and Duchamp 73.

28. Zilczer, "Dispersal" 19.

29. Reid 661.

30. Saarinen 236; Zilczer, "Dispersal" 17–18.

31. "Chavannes Picture" 44. In the popular press, distinction was often made between the "moderns" and "ultra-moderns," a difference intended to pertain to style, but which in practical terms typically corresponded to period and chronology.

32. Whereas the *Times* was more concerned to emphasize the certain future economic value of the collection, the art critic of the New York *American* did attempt to discredit Quinn's collection specifically on the basis of its perceived poor performance at auction. But this was met with a thorough and categorical rebuttal in the pages of *Art News*, a publication sympathetic to modernism, but not specifically modernist in its orientation. "'Failure of Modern Art'" 8.

33. On Quinn's instructions, see Materer 66.

34. Zilczer, *"Noble Buyer"* 54–55.

35. Within a few years, Goodyear would be the first president of MoMA's board of trustees. Goodyear 2–4. My thanks to Gabriela Zoller of the Albright-Knox Art Gallery for bringing this to my attention.

36. "[A comprehensive exhibition and auction, with catalog,] would have served as a permanent memorial and would have been an invaluable work of reference." Gregg 240. See also Reid 653. This view was also held by some of Quinn's associates, including Walter Pach, Alfred Stieglitz, and Mitchell Kennerley. The *Dial*'s art critic Henry McBride also favored the idea of one massive auction, although he dismissed the idea of a memorial exhibition as appealing to the "sentimentalists." McBride's idea was that the example of such a massive event would force major museums like the Met finally to begin investing in modernism. McBride 170–72. One unintended consequence of arranging the sale in a series of private and public events was that the entire collection was never catalogued in its entirety. As Zilczer has observed, "the most telling effect of the Quinn sales has been the disappearance of approximately three-quarters of his collection. Today, little more than five hundred works from Quinn's rich holdings can be identified with certainty." Zilczer, "Dispersal" 20.

37. Zilczer, "Dispersal" 20n13. Brummer was one of the principal advisors to Quinn's executors and orchestrated several of the exhibitions and sales through which the collection was dissolved.

38. In a penetrating study of museum culture, Didier Maleuvre has written that

[w]ith the decline of ownership comes also an increased alienation between subject and object. Something that may account for the aloofness of art in the modern museum is the fact that it does not belong to anyone. . . . No doubt the emancipation of art from ownership means that art can begin to stand on its own, its artistic integrity no longer overshadowed by the collector's prestige. That art is not to be "had" agrees with the emancipatory thrust of art. On the other hand, the separation of art from ownership contributed to the autonomization of art and the frigid division of subject and object. Today the subject no longer has a place in the space of art. (Maleuvre 99)

39. Marinetti 42.

40. Simonson, "Land of Sunday Afternoon" 22–23.

41. Simonson, "Refugees and Mausoleums" 25.

42. Marinetti 43.

43. The full title of Dreier's institution was the "Société Anonyme: Museum of Modern Art," yet she alone of these figures at first resisted and later failed to provide a permanent building for her collection. The use of the term *museum* should therefore be understood rhetorically.

44. See the *Times* critic Sheldon Cheney's account of visiting Quinn at his home in 1923:

It was an evening some three years ago that I first went to see some of the treasures that were piled apparently without rhyme or reason against the walls, under the beds and in unexpected nooks and corners in John Quinn's apartmet [sic] on Central Park West. There was little of art to be seen immediately as one entered the dim rooms; rather an impression of a theatrical prop room, with strange-shaped objects peeping out from under dustcaps—the bulgy Brancusi sculptures, no doubt—and only here or there a painting hung openly on the wall. And the works so hung seemed little likely to justify the reports which had excited me, of vast treasures of Cézanne and Derain and Matisse, or Picasso, Redon and Rousseau. (Cheney 10)

45. Quoted in Zilczer, "John Quinn" 69.

46. Quoted in Reid 600.

47. Barnes, "How to Judge a Painting" 249.

48. "By-Laws of the Barnes Foundation," printed in Cantor 196.

49. Benedict 211.

50. Smart 771.

51. Lillie P. Bliss's collection formed the basis of the Museum of Modern Art's permanent holdings; after serious courtship from MoMA, the majority of the works from Katherine Dreier's Société Anonyme collection were bequeathed to Yale Uni-

versity in 1941, with a number of additional pieces ending up at the Phillips Collection; the postimpressionist collection of Frederick Clay and Helen Birch Bartlett was a pathbreaking acquisition by the Art Institute of Chicago in 1926; the heart of Arthur Jerome Eddy's collection is now also at the Art Institute, although the museum had not been ready to commit to modernism upon his death in 1920; the Philadelphia Museum of Art now houses the collections of Walter Arensberg and of A. E. Gallatin, although it passed up the opportunity to purchase Earl Horter's collection, which was later put up for auction; the collection of Etta and Claribel Cone was given to the Baltimore Museum of Art in 1950. Expanding the range of inquiry beyond the field of modern art would only bring more such examples: the collection of Washington's National Gallery is based on the founding bequests of the Mellon and Widener collections, Alain Locke's personal collection of African sculpture is now owned by Howard University, and so on.

52. Reading the passage in its context, it is clear that Benjamin's sympathies are drawn toward the private form of the collection: "[O]ne thing should be noted: the phenomenon of collecting loses its meaning when it loses its subject [i.e., the individual collector]. Even though public collections may be less objectionable socially and more useful academically than private collections, the objects get their due only in the latter." Benjamin, "Unpacking My Library" 491-92.

53. Berman 10-15, 17, 20.

54. Reif C18.

55. Rabaté 204. It is worth mentioning in this context, too, that Benjamin makes use of the same Hegelian reference in his first published essay on the phenomenon of collecting: "I do know that night is coming for the type [of collector] that I am discussing here and have been representing before you a bit *ex officio*. But, as Hegel put it, only when it is dark does the owl of Minerva begin its flight. Only in extinction is the collector comprehended." Benjamin, "Unpacking My Library" 492. Benjamin is speaking here of an older form of collecting and ownership more assimilable to the example of John Quinn, but his later writing on collecting will attempt to redeem a progressive and at times revolutionary capability for the practice of collecting.

56. On the origin of the canonical anthology of modern poetry, see Craig Abbott 209-21. Alan Golding, conversely, has considered the canonical and interventionist anthologies together (21-40). In a similar vein, Leonard Diepeveen has argued that "the twentieth century . . . sees a movement in poetry anthologies . . . towards ideology and chronology" ("When Did Modernism Begin?" 141).

57. R. Ross 99.

58. Ezra Pound was asked to contribute to the first volume, but he and Marsh were unable to agree on selections, and no other Americans were asked; similarly, the older poets G. K. Chesterton and T. Sturge Moore appeared only in the first volume. The female poets Fredegond Shove and Vita Sackville-West were included in the fourth and fifth installments of the anthology, respectively.

59. Marsh, "Prefatory Note," *Georgian Poetry 1911–1912* n.p. Brooke quoted in R. Ross 98.

60. Edmund Gosse, "Knocking at the Door," *The Morning Post* (27 Jan. 1913): 3. Rpt. in Rogers, *Georgian Poetry, 1911–1922* 77.

61. Marsh wrote to Rupert Brooke on December 14, 1913, "[Marinetti] is beyond doubt an extraordinary man, full of force and fire, with a surprising gift of turgid lucidity, a full and roaring and foaming flood of indubitable half-truths. He gave us two of the 'poems' on the Bulgarian War. The appeal to the sensations was great—to the emotions, nothing. As a piece of art, I thought it was about on the level of a very good farmyard-imitation—a supreme music-hall turn. I could not feel that it detracted in any respect from the position of *Paradise Lost* or the *Grecian Urn*." Quoted in R. Ross 37. On Marinetti's London lectures, see Rainey 10–41.

62. Brooke's more original and provocative idea had been to fabricate an anthology entirely written by himself under a series of pseudonyms, thus interestingly anticipating the Spectra hoax. R. Ross 97.

63. Gosse, "Knocking at the Door." In Rogers 73.

64. According to Marsh, the third volume sold sixteen thousand copies, the fourth fifteen thousand, and the fifth eight thousand. Marsh, *Number of People* 329.

65. Jaffe 144. Pursuing the effects of Marsh's project largely in the scene of wartime Britain, Jaffe argues that, "strategized as an aggressive, quasi-militaristic, all-male advertising campaign," *Georgian Poetry* established protocols of male authority and exclusivity (including the deification of soldier-poets) that would later be taken up by Pound in *Des Imagistes* and Edith Sitwell in her *Wheels* volumes (148).

66. *American Poetry 1922* iv.

67. Edmund Gosse, "Some Soldier Poets," *Edinburgh Review* (Oct. 1917): 296–316. Rpt. in Rogers 183.

68. Unsigned review [John Middleton Murry], "Modern Poetry and Society," *Athenaeum* (16 May 1919): 325–26. Rpt. in Rogers 219.

69. The review claimed that Tennyson's authority was distinct from his position as Poet Laureate, yet his authority, like that of *Georgian Poetry*, was posited as an effect of the combination of popular approval and institutional authorization: "We want an academy vaguely respected by the public as an official institution, and fiercely attacked by every poet (until he becomes a member of it) as an obstruction to all light and liberty. . . . For the present our Georgians have to make the best of their misfortune that nobody wishes to interfere with them." Unsigned review, "Georgian Poetry," *Times Literary Supplement* (27 Feb. 1913): 81–82. Rpt. in Rogers 79.

70. In his preface to the fifth and final *Georgian Poetry* in 1922, Marsh made note of the authoritative position that he was now believed to hold as a result of his project's success: "[Critics wrote] as if the Editor of *Georgian Poetry* were a kind of public functionary, like the President of the Royal Academy; and they asked . . . who was E.M.

that he should bestow and withhold crowns and scepters, and decide that this or that poet was or was not to count. . . . I have wished for an opportunity of disowning the pretension which I found attributed to me of setting up as a pundit, or a pontiff, or a Petronius Arbiter." Marsh, "Prefatory Note," *Georgian Poetry 1920-1922* n.p.

71. Monro 136.

72. Quoted in Hassall 229.

73. Pound, "Patria Mia," *Selected Prose 1909-1965* 104.

74. For a longer discussion of this comparison, see chap. 1. D. Phillips, "Revolutions and Reactions in Modern Painting," *Enchantment of Art* 46-47.

75. Knish and Morgan, *Spectra,* ix.

76. Smith 11-12.

77. "The real task is, in fact, not to explain modernism in poetry but to separate false modernism, or faith in history, from genuine modernism, or faith in the immediate, the *new* doings of poems (or poets or poetry) as not necessarily derived from history. . . . *Modernist,* indeed, should describe a quality in poetry which has nothing to do with the date or with responding to civilization." Riding and Graves 76, 87 (hereafter cited as RG).

78. For an excellent discussion of the Riding-Graves collaboration, and *A Survey of Modernist Poetry* in particular, see Rabaté 204-10.

79. For an example of a "narcotic" anthology, see Schauffler.

80. See, e.g., Price; Ferry.

81. Remarking in 1917 on the "almost politically English" quality of contemporary poetry in general, T. S. Eliot singled out the "even positively patriotic" orientation of the Georgians. Eliot, "Reflections on Contemporary Poetry" 118.

82. Edwards 44.

83. I. Reed 81.

84. Lukács 33.

85. Ibid. 53-54.

86. Ibid. 43.

87. Jameson 42.

88. Jameson 237, 238-39. He goes on to explain, "[T]he rhetoric of mortality [that characterizes the description of Stein's collecting practices] is here but a disguise for the sharper pain of exclusion by history, just as the passion for butterfly collecting must be read as the fable and the allegory of the ideology of the image, and of Conrad's own passionate choice of impressionism—the vocation to assert the living raw material of life, and by wrenching it from the historical situation in which alone its change is meaningful, to preserve it, beyond time, in the imaginary" (238).

89. Benjamin, *Arcades Project,* H1a, 2.

90. Max Pensky's gloss of this passage reveals the difficulty that attends Benjamin's thought on the subject: "The collector knows supremely how to rescue the objects. But for this very reason, he does not know how to use them" (244).

91. Holdengräber 118.
92. Clifford 220.

Chapter 1. After *Imagisme*

1. By the time of *The Lyric Year*, Kennerley had published Upton Sinclair, Edward Carpenter, and Van Wyck Brooks, as well as several texts related to Oscar Wilde. He would publish the expanded version of Wilde's "The Portrait of Mr. W.H." in 1921 and Carpenter's interventionist queer anthology *Ioläus: An Anthology of Friendship* in 1917. Alain Locke, the future anthologist of the *New Negro*, presented the young poet Countee Cullen with a copy of *Ioläus* in 1923. See Braddock, "The Poetics of Conjecture" 1254-59.

2. Kreymborg, *Troubadour* 199.

3. "The Case of Poetry" 478.

4. Bruccoli 58-60.

5. In fact, it was Johns whose verse subsequently grew more radically experimental, as both he and Millay became fixtures in bohemian New York and contributors to modernist little magazines. Even as Millay's poetry and public persona became synonymous with the New Woman in bohemian New York, her abiding interest in traditional poetic forms would later make her a figurehead for those who opposed free verse and imagism. Millay's use of form, however, had its progressive edge, enacting, in Debra Fried's words, a critique of the gendered "hierarchy of verse genres." Fried 6.

6. Edna St. Vincent Millay, "Renascence," Earle 181-87.

7. Johns wrote,

Nothing had been further from my expectations, and when the book arrived I realized that it was an unmerited award. The outstanding poem in that book was "Renascence" by Edna St. Vincent Millay. . . . The choice of "Second Avenue" had been largely due to one man, the late Edward J. Wheeler, editor of Current Opinion. It appealed to him for the same reason that it delighted father; it had a "social content." It was the cry of the *plebs urbana* of my youthful environment, the expression of the "little" middle class of the previous century. Its theme was: economic quality, more leisure, high-thinking—all very romantic and confused, of course, but something that found an echo in the political feeling of the older liberals of that day. (O. Johns, *Time of Our Lives* 203-4)

8. Monroe 128-29.

9. "The Case of Poetry" 478.

10. Williams, "On First Opening *The Lyric Year*" 114-15. On Williams's disappointment see Mariani 101.

11. Marinetti 42.

12. See Babcock 201-16.

13. Despite Marsh's conservative tastes, the system of valuation that determined *Georgian Poetry* explicitly distinguished itself from the academy system that Earle's anthology emulated. Marsh's preface more nearly emulates the interventionist anthologies that followed it, as it made "no pretension to cover the field" and was "limited by a definite aim." Marsh, "Prefatory Note to the First Edition," *Georgian Poetry 1911-1912* n.p.

14. Pound, "Status Rerum" 126.

15. Rainey has argued that the term "school" indicated Pound's wariness of the "ethos of collective identity" conveyed by Marinetti's preferred term "movement." In his account, *imagisme* is the "first anti-avant-garde." Rainey, *Institutions of Modernism* 30.

16. The anthology does so without the prefatory apparatus that set forth the claims of its predecessors *Georgian Poetry* and *I poeti futuristi*. Instead, Pound appends to the end of the volume an idiosyncratic set of texts under the heading "Documents." These include a Greek-language fragment submitted by Ford Madox Hueffer, a poem from Aldington mocking political verse, and a parody of Robert Burns's "A Man's a Man for A' That," presciently rewritten on the theme of the commercial unviability of Pound's own verse. These bring together discrete aspects of Pound's interest in the anthology as such: it is a medium preserving fragments of the ancient knowledge, and at the same time a salutary modern commercial form.

17. Qian 28-32.

18. Pound, "Patria Mia," *Selected Prose* 126. See also the contemporary essay "I Gather the Limbs of Osiris," *Selected Prose* 21-43.

19. Aaron Jaffe points up the degree to which Pound, like Marsh before him, worked to obscure the signs of his own authority as editor: "The phallus . . . is veiled, the outward signs of authority hidden, tacit, and consequently more mystified and tenacious." Jaffe 153.

20. Earle, "Note by the Editor" vii.

21. Monroe 130.

22. *American Poetry 1922: A Miscellany* iv-v.

23. *Catalogue of the First Exhibition of the Society of Independent Artists*. Alfred Stieglitz suggested that the gesture of the SIA show would be even more authentic if the works were exhibited without any attribution of authorship. This was nevertheless the same exhibition that famously refused to exhibit Duchamp's *Fountain*, when it was submitted pseudonymously by "R. Mutt" from Philadelphia.

24. Masters wrote,

[Reedy] knew that Imagism was not a new thing, though he kept urging me to make the Anthology more imagistic, and I refused. . . . I had too much study in verse, too much practice too, to be interested in such worthless experiments as Dadaism or Cubism or Futurism or Unanimism, all grotesqueries of the hour,

and all worthless, since they were without thought, sincerity, substance. Reedy was always referring to the classics, to rich old books like the Greek Anthology, and I used to buy these books as he brought them to my attention. He used to present me with books; he may have given me the Greek Anthology. I remember distinctly his references in the Mirror to it, from which I gathered that I could have Plato and Simonides and Theocritus in one book. At any rate, I read the Greek Anthology about 1909. (Masters xxi)

25. Quoted in E. Williams 134.

26. Kenner 173-91, 291-98; Munich and Bradshaw xiii-xv. For an earlier account of the schism see Levenson 137-64.

27. See, for example, Rainey's famous account of the publication of *The Waste Land*, "The Price of Modernism" 279-300. For a complementary study of Lowell, see Bradshaw 141-69.

28. Pound, *Letters of Ezra Pound to James Joyce* 57, 60-61; Pound, "Date Line," *Literary Essays of Ezra Pound* 80.

29. "The tone of Pound's letter . . . is oddly extravagant; the pressure of the Great War was already pushing him to extremes, and he began to feel that a great deal more than perpetuating an aesthetic rested on the compilation of an anthology. Properly edited, an anthology could begin to counteract the war's threat to the progress of civilization. Or so Pound thought, and in opposition to Lowell's *Some Imagist Poets* he put together his own *Catholic Anthology*." Longenbach 137.

30. Ibid. 140.

31. See Pound's discussion of his plan to produce a twelve-volume anthology to replace "that doddard Palgrave['s]" *Golden Treasury* in "How to Read" (*Literary Essays* 15-40). Pound presents another version of the anecdote in Canto XXII. See also Frank Lentricchia's discussion of "How to Read" (Lentricchia 53-56).

32. E. Williams 135.

33. The *Masses/Liberator* anthology was Genevieve Taggard's *May Days*, which is discussed in chap. 4.

34. In his review for *Poetry Journal*, Conrad Aiken wrote, "When Mr. Pound says Catholic it appears that he means catholic as regards the comparatively small group of radicals with whom, for the moment, he is in sympathy—with the addition of two conservatives who must be conciliated, Harold Monro and Harriet Monroe." Aiken, "Esoteric Catholicity" 127.

35. "Portrait of a Lady" appeared in the September 1915 issue of *Others*; "Prufrock" was in the June 1915 *Poetry*. The additional Eliot poems in the *Catholic Anthology* were "The Boston Evening Transcript," "Hysteria," and "Miss Helen Slingsby" (retitled in the *Collected Poems* as "Aunt Helen").

36. On March 22, Pound wrote to ask the writer if she minded being listed as "Alice Corbin Henderson," since "[t]he rest of the book goes so well in alphabetical

order & you fit so much better as 'H' than as 'C.'" The poet responded that she didn't care, but preferred to be represented as Corbin. Pound compromised by obliging her, but nevertheless placed her poem "One City Only" between contributions from Douglas Goldring and T. E. Hulme. *Letters of Ezra Pound to Alice Corbin Henderson* 95, 99.

37. Eliot, *Letters of T. S. Eliot* 149.

38. Aldington took pleasure in drawing Lowell's attention to some of Pound's selections: "he is getting out a 'new' anthology & has asked—*Monro*!! to contribute" (Aldington 13). And shortly after *Catholic Anthology* was published, Pound himself confided to Henderson, "I'm landed with [Harriet Monroe's] damn stuff in my anthology (not that it matters, ma che, one *has* got artistic beliefs. <O>f course one *couldnt* leave her out after all she has done, but damn it all it aint art," *Letters of Ezra Pound to Alice Corbin Henderson* 138.

39. Braithwaite, *Poetic Year for 1916* 80.

40. Ibid.; Michelson, "Independents" 95–96.

41. J. Nelson 157–58.

42. Damon 301, 368.

43. Lane 27–35.

44. Aiken's review, published just a month after the anthology appeared, indicated how much advance preparation had been done on behalf of the book: "Is there no end to the pretensions of the imagists? . . . When, indeed, the imagists have become nothing but a very loud-voiced little mutual-admiration society, surely the time has arrived when they should be adjusted to their places. They may do themselves, and possibly other poets, great harm. We must realize that the fad of *vers libre*, or imagism, as in its later and acuter phase it is called, is not the panacea for poetic ills we had hoped it might be" (Aiken, "The Place of Imagism" 75).

45. Lowell's original plan had been to include a poem from Ford Madox Hueffer, who had also been among the original *imagistes*. But Hueffer's poem "On Heaven" drew objections from both Macmillan and Houghton Mifflin, and the remaining contributors agreed to sacrifice Hueffer's contribution in order to secure a place for the volume at a prestigious and established publishing house. Marek 156.

46. Damon 238.

47. Ibid. 302.

48. Marek 157.

49. Damon 279. Fletcher's book *Irradiations* was published simultaneously with the first *Some Imagist Poets* in 1915.

50. Quoted in Marek 157.

51. See Lowell's indignant letter to Monroe at *Poetry*, "Miss Lowell Not the Editor" 52. Jayne Marek's assessment of Lowell's centrality to the project is instructive: "As the sole contributor with the freedom, the funds, and the drive to see the books through, Lowell worked virtually by herself to bring the anthologies to print. She was

the locus of the other imagists' correspondence about which poems to include; she placed the volumes; and she finalized the organization of selected poems, assembled the typescripts, consolidated the prefaces for the 1915 and 1916 volumes, read proofs, and stood firm in favor of preserving the poems' exact spacing and lineation despite printers' urge to standardize" (155).

52. Lowell, *Sword Blades and Poppy Seed* 45-46.

53. Thacker 49-59.

54. *Oxford English Dictionary*, s.v., "Anthology."

55. Melissa Bradshaw understands the poem as having a "twofold function": "it very publicly disavows any sympathies with an increasingly elitist Pound, while on the other it memorializes (cashes in on?) their brief alliance" (158). While it is tempting to follow Thacker in discovering Lowell's critique of Pound's misogyny, it must be allowed that Lowell plays the gender card in sophisticated ways, rarely situating herself as a victim. Writing to Monroe following her return from London in the summer of 1914, Lowell depicts Pound's failures as the impresario of imagism in terms of impotence and emasculation: "[E]ven Hueffer tells me that Ezra is very unhappy because he is so unsuccessful. The opinion of everyone is that he has nothing more to say. . . . His Imagiste movement is petering out because of the lack of vigor in his poets, and the complete indifference of the public. Only one hundred copies of the 'Imagiste' Anthology have been sold in England! Much less than in America. It seems now as though it were simply a flair of young men with nothing more in them." Parisi and Young 155.

56. On the latter, see von Hallberg 63-79.

57. Lane 27. In the later study Lowell formally regretted being obliged to "pass by" Pound's poetry, although she did give him credit for being the first to have recognized H. D.'s genius. Lowell, *Tendencies in Modern American Poetry* viii, 252.

58. Marek 158-59.

59. "Preface," *Some Imagist Poets* v-vi.

60. Parisi and Young 164.

61. This was recognized by Braithwaite in a piece he wrote in response to Conrad Aiken's scathing review of *Some Imagist Poets* in the *New Republic*. Braithwaite, "Imagism: Another View" 154.

62. Lyon, *Manifestoes* 128.

63. Flint 199; "Preface," *Some Imagist Poets* vi.

64. Pound, "A Few Don'ts by an *Imagiste*" 200-206; "Preface," *Some Imagist Poets* vi-vii.

65. "Preface," *Some Imagist Poets* vi.

66. Flint 199.

67. Eliot, "Tradition and the Individual Talent" 14.

68. Pound, *Letters* 48.

69. "Preface," *Some Imagist Poets 1916* xi.

70. Damon 424.

71. Bradshaw 163.

72. Stansell 164.

73. The origin of this passage on Lowell is mysterious. The original version of the essay was published at the time of the Amory Show, before *Des Imagistes*; it does not mention Lowell, whose poetry in any case had not yet abandoned conventional forms. The essay was then among those Phillips collected together in *The Enchantment of Art* (1914), but Lowell is not mentioned in that version either, which itself appeared before the first *Some Imagist Poets*. The comments about Lowell appear instead in the 1927 edition of that book, published after Phillips's conversion to modernism, where the preface includes the disclaimer, "As I turn back to the essays of *The Enchantment of Art*, written from twelve to fifteen years ago, I am embarrassed by some of the premature judgments of my youth." This last version of the essay appears, however, two years after Lowell had died, which suggests that the attack on Lowell survived from an unpublished revision of the essay from the late 1910s. D. Phillips, "Revolutions and Reactions in Modern Painting," *Enchantment of Art* 46–47.

74. Kilmer SM14. Damon describes the controversy this piece elicited, 335–39.

75. Stansell 95–100.

76. Antliff 79–80.

77. Kreymborg abandoned the project in reaction to the Bonis' strong preference for European over American writing. Hoffman, Allen, and Ulrich 82.

78. Kreymborg, *Troubadour* 233. On Sebastien Liberty, see Antliff 235n36.

79. M. Johns sec. 3, p. 2.

80. Braithwaite, *Anthology of Magazine Verse for 1916* xv.

81. Heap 14.

82. Churchill 46.

83. See O. Johns, *Time of Our Lives* 226. "My 'Somewhere' also came in for a little caustic kidding. [These poems] aroused the public risibilities at the time, and by so doing they drew attention to the movement, and literary people began to be interested." What Johns identifies as "risibilities" signal a reception different from the more caustic attacks to which Lowell was subjected, from figures like Aiken on one hand and the conservative Poetry Society on the other. The critical difference is not primarily about the poetry. Whereas the surely comic poem Johns mentions ("Now I know / I have been eating apple pie for breakfast / in the New England / of your sexuality") has no great pretensions, Loy's "Love Songs," which opens with the lines

Spawn of fantasies
Sitting the appraisable
Pig Cupid his rosy snout
Rooting erotic garbage
"Once upon a time"

was more radical in form and substance than anything that appeared in Lowell's anthologies. Johns's and Loy's poems appeared in the first issue of *Others* and in its first anthology. What determined the harsher reception of Lowell's imagism was Lowell's intention to situate the new poetry squarely in the public sphere, as an object of general debate and consumption. Kreymborg, *Others: An Anthology of the New Verse* 61, 72.

84. Bourdieu, *Field of Cultural Production* 115. Lawrence Rainey's concept of an "institutional counterspace," as cited in the introduction, is another way of describing this strategy. But as I will argue, the *Others* anthologies also served the purpose of establishing Kreymborg's project as a provisional institution.

85. Hoffman, Allen, and Ulrich 80.

86. See, for example, Wolff's poem "Prison Weeds," which appeared in the November 1915 *Others* and in the first *Others* anthology.

87. Resisting the impulse to build an institution for their collection, the Arensbergs moved to California in 1920 (the year of the founding of the Société Anonyme), selling some of their pieces and putting much of the rest in storage. Their collection was bequeathed to the Philadelphia Museum of Art in 1953. See Naumann 3–32.

88. See Voyce 627–46; Crunden 409–43.

89. "Because of periodic visits to art galleries, where he revised his ideas considerably, Krimmie [i.e., Kreymborg] discarded his desire for an American magazine in the blunderbuss style. . . . The issues he hoped to present with his new ally [Man Ray] were to be one-man shows on an intimate scale; a few pages per issue or an occasional broadsheet." The early issues of the *Glebe* were typically devoted to a single poet; the *Des Imagistes* issue was an exception. Kreymborg, *Troubadour* 203.

90. Kreymborg, *Troubadour* 221.

91. There is no information that contradicts this account, but the slogan would not appear in print until February 1916 when it headed a circular advertising Alfred A. Knopf's first *Others* anthology; it also appeared on the title page of the anthology. Orrick Johns's not entirely reliable memoir claims that Kreymborg had come up with the motto well in advance of the journal (*Time of Our Lives* 222).

92. On the "open door" policy, see Brinkman 30–33.

93. Parisi and Young 118.

94. Kreymborg, *Our Singing Strength* 339–40.

95. Although the Ivy League-educated William Carlos Williams—himself a crucial participant in *Others*—overstates the case, he would retrospectively make a similar point: "[l]iterary allusions, save in very attenuated form, were unknown to us. Few had the necessary reading" (*Autobiography* 148). Kreymborg's insistence on "our environment" also bespoke a form of cultural nationalism that became increasingly explicit throughout the run of the *Others* magazine, participating in a larger structure of feeling that would also partially determine the position of *The New Negro* anthology and movement (see chap. 4).

96. See Joe Strummer's interview in Fields and Gramaglia; Andersen and Jenkins 32-36. It is worth extending this digression to point out the seminal role of a compilation album—Lenny Kaye's collection of obscure 1960s garage rock *Nuggets*—for the New York punk scene that produced the Ramones. Other compilations (musical anthologies) have played similar roles: Harry Smith's *Anthology of American Folk Music* for the folk revival of the 1950s and early 1960s, or *Techno! The New Dance Sound of Detroit* for the UK acid house scene of the late 1980s and early 1990s. All are examples of assembled traditions that inspire new forms of translated specialized practice.

97. Churchill 45-46.

98. Ibid. 46n53. Loy appeared in the first issue of *Others*; Moore's first appearance was in the December 1915 issue.

99. Parisi and Young 122; M. Johns 2.

100. W. Williams, "Great Opportunity" 137. The sense of a formation, for which I am arguing here, should not be taken as applying equally among all poets who appeared in the *Others* anthologies or in the journal. Certainly figures such as Eliot, Robert Frost, or Fenton Johnson (the only African American whose work was published in *Others*) were more peripheral and would not have identified themselves as affiliated with the group that convened at Grantwood. What I am suggesting, however, is the degree to which the Grantwood colony was permitted, on the strength of these submissions, to conceive of itself as a formation that attracted the affiliation of a broader constituency of poets.

101. For a genealogy and discussion of the Saturday Nighters, see McHenry 251-96.

102. Locke quoted in Hutchinson 390.

103. Kreymborg, Preface 1.

104. This structure was perhaps characteristic of bohemian collectivities in the period more generally. Janet Lyon identifies a similar paradigm in her discussion of "Garsington," the bohemian community established by Lady Ottoline Morrell at her Oxfordshire manor: "a site of both autonomous community and individualism" ("Sociability in the Metropole" 696).

105. See Gross 1-15.

106. S. Watson 317. For another view of this same interartistic formation, including a discussion of Loy's and Williams's readings at the 1917 exhibition, see Bochner 161-216.

107. The passage is worth quoting at greater length. "Moreover, within an apparent hegemony, which can be readily described in generalizing ways, there are . . . alternative and oppositional formations (some of them, at certain historical stages, having become or in the process of becoming alternative and oppositional institutions)" (R. Williams, *Marxism and Literature* 119). Williams's parenthetical comment here has affinities with what I am naming a *provisional institution*. In their useful meditation on formations (which they illustrate by referring to a little magazine, the Brit-

ish *Dial*), David Peters Corbett and Andrew Thacker gloss Williams's term as follows: "an association of individuals which can be more or less formal, who are engaged in cultural practice which can be narrow or broad in scope. A formation occupies the middle ground in cultural analysis between the general social history and the specific cultural forms. The point of the term 'formation' rather than 'group' is that it expresses its relation to the general social history, and its extension into the specific forms and practices of the group, aesthetic and otherwise" (91).

108. Although the Société Anonyme collection dates to the early 1920s, it was not until the 1930s that Dreier fully devoted herself to its assembly. See Gross 10-14.

109. Société Anonyme, "Report 1920-1921," *Société Anonyme* 12-13; Kreymborg, Preface 1.

110. Société Anonyme, "Report 1920-1921" 11.

111. O. Johns, *Time of Our Lives* 221-22.

112. Kreymborg, *Troubadour* 241.

113. In addition to having contributed poems to its second issue, Lowell had been an early financial supporter of *Others*. In June 1916, she wrote to Williams to inform him that she and John Gould Fletcher would no longer support the project, because of their objection to "poems of the Minna [sic] Loy type, which we felt could only hurt the cause of the new poetry for which we are all striving." When informed of this letter, Kreymborg wrote a furious letter of his own to Williams, from which I have just quoted:

> I'd like to write her a response—in pure cold blood. . . . The woman is a snob, a fraud, a self-advertiser, and what is worst, dirty, filthy. Your letter may have played into her hands—I don't know—anyhow, it made her play into ours. Perhaps, one had better not respond to it. I never do. But I'd like to place myself on record just once.
>
> Can you meet me at the Boni's Saturday at 2 o'clock or 3 o'clock or any hour you say? It will be good to place Amy's letter on record. After all, it might be best to pursue the old policy of ignoring her & everybody else entirely.

Amy Lowell, letter to William Carlos Williams (28 June 1916), William Carlos Williams Papers, The Poetry Collection, The State University of New York at Buffalo; Alfred Kreymborg, letter to William Carlos Williams (19 Oct. 1916), William Carlos Williams Papers, The Poetry Collection, The State University of New York at Buffalo.

114. Advertising circular for *Others: An Anthology of the New Verse* (1916). Felton Collection, Stanford University Library.

115. This is not to say that the marketing of the anthology went so far as to render it an object whose purpose, in Rainey's words, "was not so much to encourage reading as to render it superfluous" (*Institutions of Modernism* 56), but it nevertheless shows the way Knopf's strategy anticipated the high modernist economy Rainey examines.

116. Kreymborg, *Troubadour* 222.

117. [Henderson] 103-5.

118. Wood 64, 76.

119. Parisi and Young 124.

120. Ibid. 118.

121. To name a few poems in the first anthology: Loy's "Love Songs," Stevens's "Peter Quince at the Clavier," Moore's "To Statecraft Embalmed," Eliot's "Portrait of a Lady."

122. Michelson, "Radicals" 155.

123. This was not, moreover, the only homily that had borne the title "Others": Ferdinand Reyher's "Others" was one of two poems in the first anthology that had not first appeared in the magazine. Sandburg's poem, subtitled "Fantasia for Musk-melon Days," appeared in both the July 1916 *Others* and the *Others* anthology of 1917 (102). On Kreymborg's visit to Chicago, see *Troubadour* 279-91.

124. Churchill provides an illuminating reading of this poem and of Williams's strategic placement of it in the July 1916 *Others*, where it led off the issue and was followed by Moore's "Critics and Connoisseurs" (110-16). In addition to Sandburg's and Reyher's poems, Kreymborg himself wrote at least two poems titled "Others." See Kreymborg, *Mushrooms* 134; Kreymborg, "Others" 141.

125. Churchill 53.

126. Alfred Kreymborg, letter to William Carlos Williams (9 Nov. 1916), William Carlos Williams Papers, The Poetry Collection, The State University of New York at Buffalo.

127. W. Williams, "Great Opportunity" 137.

128. W. Williams, *Autobiography* 141.

129. O. Johns, *Time of Our Lives* 226; W. Williams, "Great Opportunity" 137.

130. Quoted in Gross 13.

131. Moore 20. Schulze cited in Churchill 155.

132. Dreier quoted in Gross 3.

133. Churchill 58.

134. Quoted in Churchill 25-26.

135. Knish and Morgan, "Spectric School of Poetry" 675-78.

136. Knish, "Preface," *Spectra* ix-x; Pound, "A Few Don'ts by an *Imagiste*" 200.

137. Knish, "Preface," *Spectra* xii.

138. Churchill 100.

139. Ibid. 96.

140. C. Miller 456.

141. [Kling]. Kling's journal also published early work by Malcolm Cowley and Eugene Jolas.

142. I am grateful to Elizabeth Abel for pointing this out to me.

143. Arthur Davison Ficke, quoted in Smith 33. When Ficke writes "twice over," he means that the design was repeated, with the colors reversed, on the book's back cover.

144. This is not to suggest that the cultural aspirations of the free verse project should be uncritically lionized. Michael North, for instance, has importantly cast a critical eye on the desire of several figures associated with *Others* to invoke black figures as "'anti-bodies' against the machine [which seemingly] enter the white body not by injection or transfusion but by sexual transmission." It is rather to suggest that the project that called such aspirations into question, *Spectra*, was one that simultaneously sought to discredit the form of group expression as such, the anthology. It is also notable that it failed to propose a progressive counterweight to what it saw as a naive wish to establish affiliation with cultural "others." North, *Dialect of Modernism* 136.

145. Locke, *New Negro* 14. It should be noted that it would be wrong to paint Bynner and Ficke as political reactionaries. Bynner, for example, contributed work to *Debs and the Poets*, an anthology protesting the incarceration of the socialist leader Eugene V. Debs, and he eagerly wrote to Countee Cullen, indicating his desire to write an introduction to Cullen's first volume of poems, *Color*, which appeared in 1925. Bynner and Ficke would both also contribute poems to Jack Conroy and Ralph Cheyney's radical leftist anthology, *Unrest*, in 1931.

146. O'Brien xi.

147. Ibid. xiii–xiv.

148. Smith 39.

149. Colum and O'Brien. The four poets were Thomas Macdonagh, Patrick Pearse, Joseph Mary Plukett, and Roger Casement.

150. The second installment of the series included Kreymborg, Lowell, H. D., Aiken, Sandburg, Millay, Sandburg, Frost, Lindsay, James Oppenheim, Louis Untermeyer, Jean Starr Untermeyer, and Sara Teasdale.

Chapter 2. The Domestication of Modernism

1. The full title of her institution was "The Société Anonyme, Inc.: Museum of Modern Art." After MoMA opened, Dreier changed the name to "Société Anonyme: Museum of Modern Art, 1920." Writing to Dreier two years before her death, Barr offered an apology: "In 1929 when we opened our doors, the Museum of Modern Art quite unwittingly assumed the second half of the Société Anonyme's name." The letter was written by Barr but signed by Nelson Rockefeller. Quoted in Kantor 111.

2. *The Large Glass* (Duchamp's *Bride Stripped Bare by Her Bachelors, Even*) did not travel in the exhibition. See also Erika D. Passantino, "The Dreier Bequest and Other European Modernists," in Passantino 267–70 (hereafter cited as *EDP*).

3. Eliza Rathbone and Grayson Harris Lane, "Mark Rothko," *EDP* 562–63.

4. Phillips's institution was originally named the Phillips Memorial Art Gallery. In 1923, its name was changed to the Phillips Memorial Gallery. It was retitled the Phillips Gallery in 1948 and the Phillips Collection in 1961. It will be most historically appropriate hereafter to refer to the institution as the Phillips Memorial Gallery.

5. Quoted in Zilczer, "Dispersal" 16.

6. Their class backgrounds also more nearly resembled Quinn's. Quinn had been the son of an Ohio baker and went on to build his fortune as a corporate lawyer in New York, and Dreier and Barnes were second-generation immigrants, too, neither from old money.

7. Phillips bought the painting from Durand-Ruel's son, Joseph. "Because Durand-Ruel had stated publicly that he would allow [the painting] to leave France permanently only if it went to a museum, the purchase . . . lent status and credibility to [the Phillips Memorial Gallery]." Grayson Harris Lane, "Pierre-Auguste Renoir," *EDP* 108. See also M. Phillips 63-64.

8. George Heard Hamilton, "Collection in the Making," *EDP* 27.

9. Quoted in Laughlin Phillips, "Preface," *EDP* x.

10. "Truly, it is a book of religious joy." K. 65.

11. Hamilton, "Collection in the Making," *EDP* 26.

12. D. Phillips, "Art and War" 24-37.

13. *Allied War Salon.*

14. D. Phillips, "Allied War Salon" 120.

15. See, for example, *Songs and Sonnets for England in War Time*; Wheeler; G. Clarke.

16. D. Phillips, "Revolutions and Reactions" cxxvii, cxxiii. This is the same piece in which, in revised form, Phillips attacked Amy Lowell, as discussed in chap. 1.

17. Ibid. cxxix.

18. D. Phillips, "Fallacies of the New Dogmatism" (pt. 1) 44.

19. D. Phillips, "Art and War" 30. Phillips's rhetoric and thinking were clearly influenced by President Wilson's own public pronouncements. As Christine Stansell has written, "Wilson's first speech calling for the country to prepare for the possibility of war equated domestic support for socialism, anarchism, and trade unions with a lurking foreign menace. In the rumblings of interventionist sentiment, the left and the unions blended in the public mind into a mass of pacifist quislings, immigrants of shaky loyalties, and anarchist saboteurs" (205).

20. The anarchist journalist Hutchins Hapgood described the show as being "dynamite" and as "[d]isturbing in one field as the IWW is in another." Quoted in Antliff 41. Trotsky quoted in Bochner 185.

21. R. Williams, *Marxism and Literature* 163-64.

22. Such sentiments reached their apogee with Royal Cortissoz's notorious essay on "Ellis Island Art" in his 1923 book *American Artists*. Here he construed both immigration and modernism as invasive, alien forces that threatened the "body politic"

and the "republic of art," respectively. The evolution of Phillips's aesthetic and politi-
cal positions can be judged by the negative review he gave this book, despite his re-
spect for Cortissoz as a critic. D. Phillips, "Principles and Practice" 165–71. Cortissoz
quoted in North, *Dialect of Modernism* 131.

23. D. Phillips, "Julian Alden Weir" 8, 10–11. The essay was originally published
in 1920.

24. D. Phillips, *Collection in the Making* 3 (hereafter cited as *CM*).

25. Hamilton, "Collection in the Making," *EDP* 28.

26. Phillips was still making reference to the plans for a new building as late as
1927, until finally building a new residence for his family in 1929. Hamilton, "Collec-
tion in the Making," *EDP* 28. Kenneth E. Silver has remarked on the role of patrilin-
eage in Phillips's conception of art, quoting a 1927 essay: "[French painters] realize
that a tradition, like an old family, must constantly renew itself with the body and
soul of each new age." In Silver's words, Phillips "saw in French art . . . a kind of mir-
ror of himself within the context of his own great American family." "Modernism
in France, Part II: Braque, Picasso, and Other Cubists," *EDP* 234. The tradition was
extended when Phillips's son Laughlin became the full-time director of the Phillips
in 1978, twelve years after his father's death.

27. D. Phillips, "Phillips Memorial Art Gallery" 147. Reprinted in D. Phillips, *Hon-
oré Daumier* 3–9.

28. D. Phillips, "Phillips Memorial Art Gallery" 149. John Henry Twachtman (1853–
1902), along with J. Alden Weir, was a member of a group of The Ten, a group of Amer-
ican impressionist painters who broke from the Society of American Artists in 1897.

29. D. Phillips, "Phillips Memorial Art Gallery" 150. See also *CM* 6.

30. Lyon, "Sociability in the Metropole" 687–711.

31. Mellow 7; C. Reed 15. On Stein, Toklas, and the domestic scene of 27 Rue de
Fleurus, see also Blair 417–37.

32. Quoted in Kristina Wilson, "'One Big Painting': A New View of Modern Art
at the Brooklyn Museum," in Gross 88. See also Bohan 59–60.

33. Another point of reference is Elizabeth Outka's discussion of Selfridges de-
partment store, which opened in London in 1909. Addressing a set of customers from
the upper middle class to the petite bourgeoisie, Selfridges carefully produced an at-
mosphere of patrician domesticity and cultural refinement and promoted its objects
as the products of craftsmanship (rather than mass production). In Outka's words,
the modern department store offered a "modern space open enough both physically
and metaphorically to allow a range of possible models, models that would include
nostalgic appeals to the domestic home, the comfortable familiarity of classical refer-
ences, and the suggestion of a refined, high-class aesthetic. . . . Selfridges did not seek
to abolish the distinction between a low, commercialized commerce and a high, non-
commercialized one . . . the store merely made each side of these distinctions more
readily available to a wider audience." At a slight geographical and historical remove,

Phillips and Dreier elaborated similar atmospheres for similar audiences, this time in the service of modern art rather than commerce—Dreier going so far as to invoke the middle-class department store Abraham and Straus. Outka 108.

34. D. Phillips, "Fallacies of the New Dogmatism" (pt. 2) 102.

35. Ibid. 104.

36. Ibid. 104.

37. D. Phillips, "Phillips Memorial Art Gallery" 150.

38. The social basis of Phillips's concern for the characteristically modern misinterpretation of the work of art anticipates Habermas's "culture that no longer trusts the power of the printed word." Habermas describes a historical shift from the comprehensive societal experience of Richardson's novel *Pamela* (1740) "by the entire public, that is by 'everyone' who read at all," to a situation in which a "public that had been 'left behind' [had] lost its critical power over the producers," after which point "modern art lived under a shroud of propaganda." Phillips shared exactly Habermas's negative view of modernist "propaganda," and his anxious hope for a "public which really enjoys and partially understands" clearly bears a resemblance to Habermas's theory of a twentieth-century culture-consuming, rather than culture-debating, public. Habermas 163, 174.

39. Paul J. DiMaggio has written on the relationship of the increase in college art history classes in the 1930s to an increased audience for American museums (273).

40. Société Anonyme, "Its Why and Its Wherefore" (1920), *Société Anonyme* n.p.

41. In her memoir, Marjorie Phillips reprints a revealing series of letters written by her husband to the artist Karl Knaths in 1929. Describing Knaths's *The Fisherman* (a painting the gallery did not purchase), Duncan writes, "As a whimsical, almost farcical impression of the funny shapes of the rubber boots and the sprawl and spread of the hound it is diverting but of no great consequence, and this mood of flippancy, which it insists upon, jars on one's sense of the grandeur of the composition and the extraordinary beauty of the color. Here, if ever, was a chance to paint a masterpiece. . . . Mrs. Phillips and I admire your work so much . . . and we feel confident that you would be repaid not only in working out a solution of the Fishermen picture so that we can acquire it, but in seeing a great Collection in which you are one of the favorite contemporary artists." As Timothy Robert Rodgers has revealed, Phillips also frequently invoked the right to return or exchange work he had purchased: "His constant haggling with artists and dealers over prices was well-known among the cognoscenti in New York. . . . To be or not to be represented in the Phillips Collection was a threat continually deployed. . . . All too often, Phillips asked artists to sympathize with his alleged indebtedness and, if they did not, he threatened to discontinue collecting their work." M. Phillips 130. Rodgers, "Alfred Stieglitz" 58.

42. As early as 1922, Phillips had imagined the gallery as one day becoming an "American Prado," an idea subsequently abandoned. Quoted in Erika D. Passantino, "Editor's Preface," *EDP* xiii.

43. Phillips addressed the matter more specifically in a prefatory note to a revised edition of *The Enchantment of Art* the following year. The new edition of the book retained his earlier antimodernist writings.

44. It is surely no accident that Phillips first used this phrase in 1929. Phillips had met MoMA's first director, Alfred H. Barr, Jr., in 1927, and it has been speculated that Barr encouraged Phillips's increasing openness to the avant-garde. The phrase "a museum of modern art and its sources" was first used in a flier inserted into the inaugural issue of the Phillips journal *Art and Understanding* in November 1929. See Hamilton, "Collection in the Making," *EDP* 31; David W. Scott, "The Spirit of Revolt and the Beginning of American Modernism," *EDP* 747n2.

45. F. Watson, "Le Déjeuner des Canotiers" 203. "World of Art" SM8, 12.

46. D. Phillips, "Collection Still in the Making," *Artist Sees Differently* 19. For a discussion of how impressionism became the standard by which later modernist painting—and Western art generally—came to be judged, see Jensen 235–56.

47. Eight months earlier Josef Stransky had written to Phillips informing him that Barnes had effectively bought out the international market of Cézannes. Thus, Phillips wrote to Forbes Watson, "I have no chance now to get anything from the tempting Quinn Collection. . . . We are enthusiastically launched, however, as you can see, upon a policy of supporting young artists in all sound and rational experiments which give us fresh and thrilling air to breathe." Josef Stransky, letter to Duncan Phillips, 14 May 1925; Duncan Phillips, letter to Forbes Watson, 6 Jan. 1926, The Phillips Collection Archives, Washington, DC.

48. Hamilton, "Collection in the Making," *EDP* 30.

49. Passantino and Martin 34. The National Gallery would not open until 1941.

50. This statement, though given in the context of his support of modernist work, was largely consistent with assessments that appeared in his earlier, antimodernist writing. See, for instance, "Fallacies of the New Dogmatism," pt. 1: "Desperate in their desire to exhibit something new, Modernists have experimented with various methods and patterns only to be met by the critics with the comment that they have simply skipped over a dozen centuries. . . . When they throw overboard art history entirely and seek to forget that any picture was ever painted, and try to paint as if with a mind wiped clean of all preconception, they are not yet worthy to be called original" (44).

51. Phillips had a high estimation of Daumier, recognizing as Charles Baudelaire had done, and Benjamin would do after them, the artist's importance in inaugurating a modern style and subject matter for painting. It would soon become a commonplace to understand El Greco's strong influence on Picasso. See Barr, *Picasso* 48.

52. Phillips's cosmopolitanism was itself an extension of this sensibility: tolerant of diversity, but not in its extreme forms. In the inaugural issue of *Art and Understanding* in 1929, Phillips issued

a fine warning to the artist to avoid extremes both in life and art or to renounce the right to be called artists, since art is the cultivation of our sense of moderation and balance. It is also a no less timely warning to artists of the aesthetically snobbish type to avoid a total loss of contact with humanity. . . . Out of the invigorating clash of all our differences will come a new age and perhaps a new art, rich and strong in its blend of opposites. . . . The [Phillips] Collection is a symbol of tolerance for diversity of taste and opinion and of reverence for human personality and individual expression. (D. Phillips, "Art and Understanding" 10, 14–15; "Inter-Creating Intelligence" 21)

53. Phillips and Watkins 160, 164.

54. D. Phillips, "Collection Still in the Making," Artist Sees Differently 15.

55. Compared to Matisse, Braque was "a more aristocratic type, endowed with a more unusual sensibility." See Silver, EDP 236.

56. When considered in the galleries' overarching "domesticating" context, the Phillips's vaguely agonistic program also appears as a surprising reconciliation of the opposing principles surveyed in Adorno's essay "Valéry Proust Museum." Paul Valéry and Marcel Proust agree that the museum forces works to submit to the dynamics of enmity and competition. For Proust, "competition among works is the test of truth," whereas for Valéry it is the sign of the barbaric wresting of the work from its most functional context, the home (or studio). Adorno, "Valéry Proust Museum" 179.

57. For a complete list of exhibitions at the Phillips, see Appendix A, EDP 659–74.

58. On the origins of Phillips's interest in Marin, see Rodgers, "Alfred Stieglitz."

59. Duncan Phillips, letter to Alfred H. Barr, Jr., 8 Feb. 1927, The Phillips Collection Archives, Washington, DC.

60. The following year's tri-unit exhibition "Art Is International," "An International Group," and "Art Is Symbolical" further developed this strategy.

61. D. Phillips, "Sensibility and Simplification" 10.

62. M. Phillips 117. Phillips became fond of this pairing of the Egyptian head with Tack's painting and would use it in subsequent exhibitions.

63. See North, Reading 1922 19–27; Elliott 114–35.

64. Duncan Phillips, letter to Alfred H. Barr, Jr., 15 Jan. 1927, The Phillips Collection Archives, Washington, DC.

65. As Marsha Bryant and Mary Ann Eaverly point out, this strategy would even hold true for Nancy Cunard's Negro anthology, which did not include Egypt in its map of Africa. It should be noted, however, that this intellectual tendency was not entirely hegemonic. Alain Locke, whose collection of African art we consider in chap. 4, had been present at the official opening of Tutankhamun's tomb in Luxor in 1924 and wrote that the artworks discovered therein were "highly composite, both culturally and artistically," produced by a "polyglot civilization that must have included

more African, and possibly even Negro components than will ordinarily be admitted." Similarly, Caroline Goeser has shown how black artists of the 1920s themselves traded on a popular "Egyptomania" and, against the grain of the tendency described by Bryant and Eaverly, figured ancient Egypt as a source for modern African American culture. Bryant and Eaverly 441-44; Locke, "Impressions of Luxor" 78. Goeser 174-81. See also Harris and Molesworth 146.

66. D. Phillips, "Sensibility and Simplification" 9.

67. Breasted, *History of Egypt* 356.

68. Montserrat 5. Among the most famous acolytes of Akhenaten was Sigmund Freud, whose *Totem and Taboo* posited Akhenaten's monotheism as an ancestor of Judaism. Montserrat notes that Freud annotates the passage describing the pharaoh as "the first *individual* in human history" in his heavily marked copy of Breasted's book (194n14).

69. Robins 150.

70. D. Phillips, "Sensibility and Simplification" 9.

71. Duncan Phillips, letter to Joseph Brummer, 25. Jan 1927, The Phillips Collection Archives, Washington, DC.

72. D. Phillips, "Sensibility and Simplification" 8.

73. Ibid. 9.

74. The Stone Head was not recommended for accession in the Phillips Collection's 1984-85 inventory and sold the following year for $950. This suggests that the Phillips may have grown to harbor doubts about the piece's authenticity. In December 2009, however, it was authenticated and accepted as a gift by the Museum of Fine Arts in Boston. Disposition Record, Egyptian Stone Head, The Phillips Collection Archives, Washington, DC.

75. Duncan Phillips, letter to Arthur Stanley Riggs, 12 Feb. 1927, The Phillips Collection Archives, Washington, DC.

76. D. Phillips, "Sensibility and Simplification" 7.

77. Breasted, *Conquest of Civilization* 105.

78. Ibid. 101; D. Phillips, "Sensibility and Simplification" 8.

79. Montserrat has remarked on Breasted's great uneasiness about the effects of European immigration into the United States, his phrase "great unassimilable masses" echoing several of Phillips's early anxieties. Montserrat 102.

80. Ibid. 98.

81. Bryant and Eaverly 444-45. By the 1930s, Breasted would recoil from the evidence of the World War and revise his position. He nevertheless continued to posit ancient Egypt as the ideal toward which American civilization should aspire (see Bryant and Eaverly 450).

82. Montserrat 98. "[I]n the tomb chapels we may still read on the walls the hymns of praise to the Sun-God which Akhnaton himself wrote." D. Phillips, "Sensibility and Simplification" 8.

83. As Montserrat writes,

> Breasted often lets his anti-Catholic prejudices slip through. If Akhenaten's Aten religion was the precursor of monotheism, it was a robustly Protestant monotheism, purged of the anthropomorphic images and corrupt priesthood that irresistibly reminded him of Catholicism. To Breasted, the priests of Amun were evil popes like the Borgias who stopped individual communion with god; the gods of polytheistic religion were like saints, idols for the worship of the ignorant. The vocabulary of Protestant anti-papism filters into Breasted's discussion of the priesthood of Amun, which he called "the earliest national priesthood yet known" and the first *pontifex maximus*. This Amonite papacy constituted a powerful political obstacle in the way of realizing the supremacy of the ancient Sun god. (101–2)

84. D. Phillips, "Art and Understanding" 13–14.

85. The question of "world federation" raised here and elsewhere invites the question of whether Phillips, knowingly or not, promotes a form of imperialism by other means. In this very passage Phillips suggests that the Stresemann-Briand Pact (which reconciled Germany and France, its cosigners then winning the Nobel Peace Prize) anticipated the "gradual union and disarmament of Europe" (14).

86. Leslie Furth, "Augustus Vincent Tack," *EDP* 334–37.

87. D. Phillips, "Sensibility and Simplification" 10.

88. Duncan Phillips, letter to Mrs. Herbert Hoover, 1 Jan. 1928, The Phillips Collection Archives, Washington, DC.

89. Dewey et al.

90. D. Phillips, "Inter-Creating Intelligence" 23.

91. D. Phillips, "Art and Understanding" 13.

92. Montserrat 10. In middlebrow publications such as the *Illustrated London News*, "Akhenaten would himself come to be associated with the garden suburb movement[,] a predictable conclusion of the way he had been presented in the late nineteenth and early twentieth centuries, as the most up-to-date pharaoh, the ancient precursor of modern progress" (76).

93. As Robert Rosenblum writes,

> As a *fin-de-siècle* Symbolist, born in 1870, he is much too retardataire, exploring his cosmic visions only in the 1920s and 1930s; whereas if he is thought of as a member of the interwar period of American abstract innovation, with Dove, O'Keeffe, and Hartley, he not only seems almost neurasthenic in his pictorial effeteness but compromises his visionary abstract cause with his pragmatic approach to painting public murals or journeyman portraits of Washington officialdom. And though he may be construed as a St. John prophesying the coming of abstract developments after 1945, his impact is more a matter of high probability than demonstrable fact. (15)

94. "Cubism never entered into his approach. It is precisely this opposing tradi-tion—stemming from impressionism and the flat patterning of the French symbolists and the Japanese aesthetic—that is fulfilled in Tack and undeniably anticipates more recent color field painting" (Eliza E. Rathbone, "Preface," Furth 10).

95. John Hay Whitney, "Foreword," in Barr, *Masters of Modern Art* 7. This may be compared to the final words of Phillips's introduction to his own 1952 catalogue: "As we move into a future menaced by evil forces of tyranny and total war we must cling to our faith in art as the symbol of the creative life and as the stronghold of the free and aspiring individual" (Duncan Phillips, Introduction, *Phillips Collection* x).

Chapter 3. The Barnes Foundation, Institution of the New Psychologies

1. J. Anderson; Argott.

2. Argyrol was a silver-based compound used for treating gonorrhea in adults and associated eye infections in newborn children. Very widely prescribed in the first half of the twentieth century, it is still available today. "Argyrol."

3. Reid 555–59. See also Gertrude Stein's brief citation of the day "Barnes came to [27 Rue de Fleurus] and waved his cheque-book." G. Stein 11.

4. A related, but equally interesting, question concerns the more debatable value and importance of the works in the collection by Barnes's favorite artist, Renoir.

5. For an excellent critical discussion of the touring exhibition, see Higonnet 62–69. The misleading sense that the importance of the Barnes resides primarily in its collection of "Great French Paintings" has begun to be redressed by two excellent recent publications: a CD-ROM that allows the user virtually to peruse the Barnes Foundation galleries, and Richard J. Wattenmaker's complete catalog of American works in the Barnes collection, which includes many pieces that have not been ex-hibited in the galleries since Barnes's death. *Passion for Art*; Wattenmaker (hereafter cited as *APW*).

6. According to a statement on the Barnes Foundation's website, "The Collection will continue to be displayed in an exhibition space that replicates the hang of the art ensembles in the original galleries in Merion. The new galleries will be the same scale as the original galleries in Merion and will provide the same intimate experience intended by Dr. Barnes." "Barnes Foundation FAQs."

7. On the pedagogical function of the wall ensembles, see de Mazia. See also Richard J. Wattenmaker, "Dr. Albert C. Barnes and the Barnes Foundation," *Great French Paintings* 20–21 (hereafter cited as *GFP*).

8. L. Phillips.

9. See Duncan Phillips, letter to Albert C. Barnes, 10 May 1927, The Phillips Col-lection Archives, Washington, DC.

10. Quoted in Hormats 36–37. Phillips means the term in the sense that Terry Eagleton describes the critical function of the nineteenth century's "man of letters":

"[A]ble to survey the whole cultural and intellectual landscape of his age . . . the man of letters sees as widely as he does because material necessity requires him to be a *bricoleur*, dilettante, jack-of-all-trades, deeply embroiled for survival in the very commercial literary world from which Carlyle beat his disdainful retreat." Eagleton 45.

11. Barnes, "Preface," Dewey et al. vi.

12. Quoted in Cantor 200. Cantor includes the By-Laws and Indenture of Trust of the Barnes Foundation as an appendix.

13. Barnes had already disparagingly used the term in the opening pages of his 1925 book *The Art in Painting*: "A man who believes that he is interested in paintings, but who takes no pains to acquaint himself with the problems to be solved, who will not study the methods of presentation proposed, form some judgment through actual experience of their adequacy, is a mere *dilettante*" (my emphasis). Barnes, *Art in Painting* 25 (hereafter cited as *AP*).

14. Meyers 8.

15. Quoted in Cantor 196.

16. Bourdieu, *Distinction* 3.

17. Barnes continued, "I wanted to read Gertrude Stein's 'Three Lives' again in connection with this new stuff but Evelyn writes me she can't find the book and it's out of print." Albert C. Barnes, letter to John Dewey, 11 Nov. 1920 (04112), in Dewey, *Correspondence*.

18. Dewey, "New Psychology" 278–89.

19. In a 1921 letter to Dewey, Barnes both argued for the fundamental Freudianism of Dewey's *Reconstruction in Philosophy* (1920) and issued his own gently Freudian reading of Dewey's repression of his debt:

Rather provoking at times was your reference such as "there is a school of psychology which teaches" all that subliminal stuff from Myers to Freud, Jung and Adler; provoking, I mean, because without what they had done, R. of P. could never have been written; because it is the backbone of the book, as it is of life as it exists in human beings. Provoking, I say, because your gallantry and comeraderie [sic] should have prompted you (your reason does so subconsciously) to bow deeply several times with the specific mention of those great men whose work has proved that every mothers son of us is the victim of his subconscious self. Is'nt [sic] the tacit recognition of their work almost the main thesis of the book?

Meyers writes, "It was a practice he seemed unable to resist, and over and over again through the years, he would make similar assessments of people based on his reading of Freud, Adler, and Jung, and their various followers and interpreters" (46; see also 53–55). Albert C. Barnes, letter to John Dewey, 7 Jan. 1921 (04117), in Dewey, *Correspondence*.

20. Field 22. For a longer discussion of this exchange, see my "Neurotic Cities" 46–61; see also Yount 9–14.

21. Wattenmaker observes that Barnes's interest in systematizing the analysis of art ran counter to both James's and Santayana's specific beliefs, and he quotes a tart letter from the latter on the subject to Barnes Foundation staff member Thomas Munro (*APW* 36).

22. Meyers 42.

23. See Barnes, "Barnes Foundation" 65-67; Mullen 160-61.

24. Dewey, *Art as Experience* viii (hereafter cited as *AE*).

25. This phrase is borrowed from Megan Granda Bahr's valuable study "Transferring Values."

26. Pound learned of Barnes when his father Homer sent him copies of the *Journal of the Barnes Foundation*, after which he initiated a brief correspondence with the collector. His short piece on Barnes was never published:

> Not only has Monsieur Barnes spent a deal of money on painting by dead and living painters, and spent it with great intelligence. . . . But he has put these pictures in a gallery open to serious members of the public, and provided instructors for those who are bewildered by being introduced to so much at once.
>
> He has also written that very rare thing THE RIGHT KIND of book about painting. By which I mean that he has not criticized art in order to climb on top of the artist. . . . [H]e has not tried to drag down genius to the level of mediocrity, or to tell everybody that it is better for them to do doilies at home than to look at masterwork.
>
> No. He has written a book that aims to make the reader LOOK AT the painting, or even the half tone reproduction of the painting, and SEE what the artist was driving at, and what the artist has attained. . . . Barnes' aim is so right that he is almost bound to eliminate the margin of error as he goes on. He wants to augment the visual faculty, or at any rate augment the efficiency of the eye by coupling it with the efficiency of the perceptive intelligence. . . .
>
> And as his gallery is open as a school, he obviously does not intend it simply as cold storage; any fool can see that he wants painting to exist in America, on a par with, and ultimately above the level of painting in Europe.
>
> Such a man is worth more to the country than 6000 Calvin Coolidges.

Pound, "Albert C. Barnes" 309-10.

27. See also Dewey's *Human Nature and Conduct* (1922): "The eternal dignity of labor and art lies in their effecting that permanent reshaping of environment which is the substantial foundation of future security and progress" (20).

28. See L. Stein. Leo Stein was an old mentor and friend of Barnes's. He responded enthusiastically to the clarity and concision of Barnes's analytic method, but he objected to such negatively categorical judgments as the following: "Turner's form is that of flashy illustration united with virtuosity and his pictures have no place in art"; "Corot's romanticism, in comparison with Courbet's realistic poetry, seems weaker,

less dignified, less real and less well suited to the everyday needs of life"; "Unfortunately, [Manet's] brushwork survives also as an academic *cliché*, as in Henri and his tradesmen-followers, while his form as a whole is caricatured and commercialized by such portrait-manufacturers as Sargent" (*AP* 231, 299-300).

29. Buermeyer, "Experiment in Education" 442.

30. Meyers has observed the relationship of this program to the dubious contemporary practices of company schools, each of them products of "an era in which a new progressive spirit was streaked with paternalism." "Mostly segregated along racial lines," Meyers writes, the "main purpose [of company schools] was to facilitate the assimilation of immigrants. . . . [W]orkers in the Boston Woven Hose and Rubber Company studied English and those enrolled in the Ford Company's factory classes were instructed about hygiene and the routine of naturalization" (19). Barnes's more intellectually demanding educational experiments, Meyers suggests, aimed to produce more efficient workers on the basis of their creative investment in their work.

31. Barr, "Plastic Values" 948.

32. Wacquant's gloss quotes Dewey in *Art as Experience*. Bourdieu goes on to discuss his hallmark concept habitus, "To speak of habitus is to assert that the individual, and even the personal, the subjective, is social, collective. Habitus is a socialized subjectivity. . . . Habitus contributes to constituting the field as a meaningful world, a world endowed with sense and value, in which it is worth investing one's energy." Bourdieu and Wacquant 122, 126-27.

33. Dewey, *Human Nature and Conduct* 80. Dewey suggests that institutions are habits taken in collective form. He uses the term *institution* to bring together social customs, language, property, and family relationships, as well as schools, churches, and museums. This does not imply that institutions are consciously constructed to serve particular ends: "We often fancy that institutions, social custom, collective habit, have been formed by the consolidation of individual habits. In the main this supposition is false to fact. To a considerable extent customs, or widespread uniformities of habit, exist because individuals face the same situation and react in like fashion. But to a larger extent customs persist because individuals form their personal habits under conditions set by prior customs" (58).

34. See "The Market of Symbolic Goods" in Bourdieu, *Field of Cultural Production* 112-41.

35. Bourdieu, *Distinction* 30.

36. Ibid. 30.

37. Compare Bourdieu's words in *Distinction*: "[T]he encounter with a work of art is not 'love at first sight' as is generally supposed, and the act of empathy, *Einfühlung*, which is the art-lover's pleasure, presupposes an act of cognition, a decoding operation, which implies the implementation of . . . a cultural code" (3).

38. Jarzombek thus distinguishes from the "purer" formalism associated with Clement Greenberg in naming the Deweyan/Barnesian method "ontological formal-

ism": "theorists who argued about 'form' were often opponents of 'formalism'" (29). By emphasizing form as a "series of relationships," Barnes's gloss in *The Art in Painting* underscores its fundamentally ontological dimension: "The word form in connection with art is frequently used with a subjective meaning implied, but here too it is a series of relationships. All experience leaves in the memory a residue, a comparatively permanent possession, and that is employed to interpret new situations analogous to the original. Such a residue consists of the series of relationships which gave the experience its distinctive and individual characteristics, that is, its form" (*AP* 38).

39. After Renoir and Cézanne, modern painting had "in its possession as never before two all-important principles. First, the principle of pure design, embodying the values of human experience but not tied down to a literal reproduction of the situations in which these values are found in ordinary life. Second, the principle of color as the most essential of all the plastic elements, the means most entirely intrinsic to the medium of paint." Upon this foundation, contemporary painters now use "[c]olor [to] compose[] the painting; it replaces foreground, middle-distance and background with a homogeneous color-mass that makes perspective itself chiefly color. The general tendency is to sacrifice everything toward the achievement of design. Decoration is rampant and so are obvious human values, as is inevitable when painting is expressive and when its subject-matter is the objects and events of the real world" (*AP* 305, 311).

40. "Form, in its widest sense, is the plan of organization by which the details that constitute the matter of an object are brought into relation, so that they unite to produce a single aesthetic effect" (*AP* 39).

41. Barnes, *Art in Painting* (3rd rev. ed.) 61.

42. Barnes's first published article explicitly intimates a similar thought, though without any concern for the objective values of plastic form: "That is one of the joys of a collection, the elasticity with which paintings stretch to the beholder's personal vision which they progressively develop. And that is universal, for a painting is justly proportionate to what a man thinks he sees in it." Barnes, "How to Judge a Painting" 248.

43. Barnes, "Art of the American Negro" 383.

44. Barnes, "Barnes Foundation" 65.

45. Barnes, "Negro Art, Past and Present" 148–49.

46. Paudrat 160. The Barnes's African collection has since been cataloged more accurately.

47. Herskovits, "African Art" 242.

48. How Guillaume acquired his African pieces, Marius de Zayas wrote, "will always remain a mystery" (55).

49. Guillaume and Munro 1.

50. De Zayas 55, 59. De Zayas anticipated the critical writing of Clive Bell, who would assert, "lack of artistic self-consciousness . . . accounts for the essential in-

feriority of Negro to the very greatest art. Savages lack self-consciousness and the critical sense because they lack intelligence. And because they lack intelligence they are incapable of profound conceptions." Barnes's position echoed, and attempted to institutionalize, Roger Fry's observation that African art is "greater . . . than anything we produced even in the Middle Ages." Bell 116; Fry 100.

51. C. Johnson, "Negro Art" 142.

52. Gikandi 40.

53. Gikandi reads this, too, as characteristic of modernism as such: "except in a few instances—Conrad in Africa and South Asia and Lawrence in the Americas, for example—very few modern artists actually traveled in the domain of the other. . . . We could speculate that the modernists feared a concrete engagement with the other precisely because they felt . . . that a real encounter with the radically different would deprive it of its aura" (46).

54. Albert C. Barnes, "Negro Art and America," in Locke, *New Negro* 19.

55. Jefferson 120. My thanks to Dagmawi Woubshet for recognizing this connection.

56. Alain Locke, letter to Carl Van Vechten, 24 May 1925, letters from Blacks, Carl Van Vechten Papers, James Weldon Johnson Collection, Beinecke Rare Book and Manuscript Library.

57. Very conceivably ghostwritten by Barnes, the letter is signed by Barnes's employee Laura Geiger. The occasion of the correspondence is to inform Locke of Barnes's recent public address on behalf of Negro causes. The letter urges, "If he [Barnes] misrepresented either one of you [Locke or Charles S. Johnson] please do not say anything about it as he does not want the beautiful lesson which he was trying to put over spoiled by such irrelevant details as whether you were poor or rich during your youth." L. V. Geiger, letter to Alain Locke, 15 Apr. 1924, box 164-12 folder 29, Alain Locke Papers, Moorland-Spingarn Research Center, Howard University.

58. Meyers 27.

59. Ibid. 28-29.

60. Ibid. 29-30.

61. *GFP* 297n16. Anne Distel's essay, "Dr. Barnes in Paris" (*GFP* 29-43), collates much useful information about Barnes's purchases. See also Rewald 263-80.

62. Rewald, for example, describes a 1913 transaction in which the Durand-Ruels secretly acted as intermediaries for Barnes, purchasing Cézanne's *Still Life with Bottle, Tablecloth, and Fruits* (ca. 1890) from Vollard at a reduced rate and passing the discount on to Barnes, who then proceeded to negotiate his commission with the Durand-Ruels. "The remarkable thing," Rewald writes, "was not so much that Barnes haggled over the commission for a drawn-out and complicated affair, but that the Durand-Ruels, extremely upright and honorable people conducting their business in an impeccable style, became involved in outright lies and petty deals with a conniving and penny-pinching American millionaire. However, Barnes had probably hinted

at the many future purchases he planned to make . . . and the Durand-Ruels were obviously anxious to please a customer with such potential" (264-65).

63. Meyers 34.

64. Du Bois 305.

65. Rewald 268.

66. Barnes, "Barnes Foundation" 65.

67. See also Buermeyer, "Experiment in Education" 442-44; Meyers 19-25.

68. Barnes, "Barnes Foundation" 66.

69. Barnes, "How to Judge a Painting" 217, 249.

70. Roberts 25-26.

71. "Counter Attack in Fight on Modernists."

72. For a discussion of the cultural politics that were shaping the establishment of the Philadelphia Museum of Art during these years, see Conn 192-232.

73. "By-Laws of the Barnes Foundation," reprinted in Cantor 195.

74. Quoted in Meyers 59.

75. Greenfeld 76.

76. On Guillaume's career as a dealer of African art, see Paudrat 152-62.

77. Meyers 66.

78. Wattenmaker notes that Barnes continued to make major acquisitions in advance of the Barnes Foundation's dedication in March 1925. In 1924, he bought Picasso's *Acrobat and Young Harlequin* (1905), and in January 1925 he acquired several important works by Matisse, including the *Blue Still Life* (1907), *Red Madras Headdress* (1907), and *Seated Riffian* (1912 or 1913) (*GFP* 12).

79. F. Watson, "Barnes Foundation" 9, 16.

80. Other artists in the Contemporary European Paintings exhibition included Derain, Utrillo, de Chirico, Laurencin, Segonzac, Hélène Perdriat, Ossip Zadkine, Moise Kisling, Irène Lagut, Robert Lotiron, and Georges Kars (*GFP* 298n33).

81. Barnes, "Introduction" 5.

82. In the pages of *The New Negro* anthology, Barnes would write, "The emancipation of the Negro slave in America gave him only a nominal freedom. . . . The relationship of master and slave has changed but little in the sixty years of freedom. He is still a slave to the ignorance, the prejudice, the cruelty which were the fate of his forefathers" (Locke, *New Negro* 21). It is appropriate to highlight, however, Barnes's surprisingly thin holdings in work by black artists. The Barnes owns four works by Horace Pippin (who studied at the Barnes in 1940), but none by Aaron Douglas, who had also been a student at the Barnes. The Phillips Collection owns two Pippins, but it also owns half of Jacob Lawrence's sixty-panel *Migration of the Negro* (1940-41).

83. Quoted in Conn 86.

84. In 1926, the University Museum would purchase eighteen African works from John Quinn's estate for the significant sum of $2,500. Wardwell 15-22.

85. Conn 91.

86. Cited in C. Clarke, "Defining Taste" 65.

87. Barnes makes an interesting test case for another of the key arguments of the Gikandi essay cited above. One of the aims of that essay is to understand the origins of modernism's particular institutionalization, a process of "monumentalization" that "came to negate the very radical alterity that was modernism's condition of possibility" (34). Barnes's suggestion that audiences compare Modigliani with the African work at the University Museum is indeed an operation that seeks to "negate the radical alterity" of the African work, in the sense that it denies its otherness. It does not negate the work in the sense of denying its existence or relation to modernism. This portion of Gikandi's argument culminates by indicting modernist institutions for this second sense of denial, that is, for their failure to represent primitive art in any way at all: "Gone was Picasso's dream of an open space in which all art would be in one place, where African art would sit next to the statues of Minorca, and Goya could gaze on 'Guernica'; gone, too, was André Malraux's dream of a Louvre in which the rooms of 'Negro art will call into question those devoted to ancient arts, which are organized in accordance with the evolution of our history'" (36). If this is the condition Gikandi laments, in representing African work (but denying its alterity) Barnes represents an exception to the rule of modernism's monumentalized "epiphany."

88. Albert C. Barnes, letter to John F. Lewis, 21 Mar. 1923. Pennsylvania Academy of the Fine Arts, Secretary and Managing Director, General Office Files.

89. *APW* 32–35; Meyers 73–85, 113–30.

90. "We hope to effect some working plan with colleges and universities in which the scientific approach to the study of our resources shall be made a part of the curriculum." Barnes, "Barnes Foundation" 66.

91. Albert C. Barnes, letter to Josiah H. Penniman, 27 Jan. 1924, Josiah H. Penniman Papers, University of Pennsylvania Archives.

92. Meyers 78.

93. Ibid. 81.

94. Ibid. 84–85.

95. Ibid. 115.

96. Ibid. 125.

97. Quoted in ibid. 76.

98. Ibid. 79.

99. Albert C. Barnes, letter to Josiah H. Penniman, 27 Jan. 1924, Josiah H. Penniman Papers, University of Pennsylvania Archives.

100. Josiah H. Penniman, letter to Albert C. Barnes, 4 Apr. 1924, Josiah H. Penniman Papers, University of Pennsylvania Archives.

101. Greenfeld 142.

102. By this agreement, the University Museum collected human remains and artifacts from the ancient world up to the fall of the Roman Empire, except that for China the cutoff date was extended to the end of the Tang Dynasty. In addition,

the museum collected "primitive" art from areas including the Americas, Africa, and Polynesia up to present times. The PMA restricted itself to fine and decorative art. The Academy of Natural Sciences collected natural history specimens from all areas except human remains and artifacts. My thanks to Alex Pezzati of the University Museum for this information.

103. De Mazia joined the staff of the Barnes Foundation in its inaugural year, 1925, and coauthored four books with Barnes: *The French Primitives and Their Forms from Their Origin to the End of the Fifteenth Century* (1931), *The Art of Henri-Matisse* (1933), *The Art of Renoir* (1935), and *The Art of Cézanne* (1939). She served as Director of Education at the Barnes from the collector's death in 1951 until her own in 1989.

104. De Mazia 4.

105. Ibid. 3.

106. For a patient exposition of and intellectual genealogy for the pedagogical function of the wall ensembles, see Bahr 141–307.

107. De Mazia 7.

108. Krauss 133.

109. Yates's famous study begins by recounting the invention of the classical art of memory by the Greek poet Simonides. Simonides's key insight, as Barnes would have approved, is that "orderly arrangement is essential for good memory." As the art of memory became elaborated as a skill of rhetoric vital for orators, "[t]he commonest . . . type of mnemonic place system used was the architectural type." Yates gives the account of the Roman rhetorician Quintilian describing the way an orator would assign segments of a long speech to the various rooms and ornaments of a house. There are limitations to this association I am making here somewhat playfully, and it will not be necessary to force the comparison. What the following argument stresses, however, is the way the intensively orderly organization of Barnes's arrangements dramatizes the energies of a Freudian unconscious, as opposed to a classical mnemotechnic. Yates 1–3.

110. See Newhouse 19–22. Anne Distel writes, "The installation of the collection, criticized today, must have seemed familiar to Matisse [when he visited Barnes in 1930]. It was very similar, in fact, to those in the houses of collectors of his work before the war: paintings in gold frames, old and modern together and responding to one another, the largest works hung high. The austere interior spaces of the Foundation building were not unlike those of the Italianate villas that had harbored for a time the works of Cézanne and Renoir" (*GFP* 43).

111. Christopher Knight has made a persuasive defense of Barnes's seemingly perverse installation of *The Joy of Life*:

The stairwell installation . . . is a brilliant articulation of Matisse's artistic breakthrough. The painting shows an old-fashioned bacchanal—nudes in a sylvan setting dancing, playing music, making love, picking flowers and more. . . . Flat, hot

and cool colors create optical space through their juxtaposition and dispersal. . . . Matisse made a painting where your eye does not look at the nudes, which had been art's visual habit for centuries. Instead, responding to the new dynamism of modern life, his painting's use of color and linear drawing sends your eye on a wild ride around the scene. In the process of looking, a viewer joins the excited bacchanal, actively partaking in "the joy of life" rather than merely witnessing it. That's why Barnes installed the breakthrough painting in a stairway, a place of lively movement and circulation, rather than on a static wall in a room. . . . The stairwell installation embodies the painting's experiential meaning.

Knight also observes that Barnes's contemporary, the Russian collector Sergei Shchukin, had designs to install an earlier and related work, Matisse's *Dance (I)* (1909), above a stairwell in his Moscow house.

112. See, for example, Barnes's critique of Fra Angelico: "While we see an abundance of detail, we see that it is mere expressive detail, treated diffusely and largely by means of line which approaches literal reproduction of the actual manifestations of such sentiments as fear, humility, abnegation, suffering. All this substitution of *literary values* for plastic equivalents is unconvincing; we feel it as affectation, sentimentality, unreality" (*AP* 153, my emphasis).

113. Geist 184–86. I thank Steven Z. Levine for this reference.

114. My thanks to Jean-Michel Rabaté, who pointed out to me the first of Barnes's three associations of Mont Sainte-Victoire with the *memento mori* in an adjacent painting.

115. Here is a long excerpt from the Barnes Foundation catalog, written by de Mazia's protégé Richard J. Wattenmaker, describing the north wall of the Main Gallery:

The sober monumentality of Cézanne's *Woman in a Green Hat*, 1894–1895, anchors the wall. His glowing, translucent *Red Earth* c. 1890, to the left, is balanced by Renoir's *Bathers*, 1916, whose complex, classically inspired figures are likewise set in a colorful space. The sensuous appeal of color in these two compositions, as well as their recession into space, enframes the dominant purple-blue-gray sculptural power of *Woman in a Green Hat*.

At opposite ends of the first row are Cézanne's *Boy in a Red Vest*, 1888–1890, and *Gardener*, c. 1892, the latter a solid volume set in a mandorlalike niche recalling a figure from a Florentine gothic cathedral. The in-and-out spatial organization of this level of the wall is surmounted by a contrasting layer of small paintings of bathers, figures, and still lifes, which are, in turn, crowned by four Renoirs. This upper level is centered by the large *Reclining Nude*, c. 1895–1897, with graceful, firm volumes and decorative qualities recalling the eighteenth-century French tradition. Its variegated color suffusion and mother-of-pearl surface is an enriched version of Boucher, by way of Titian and Rubens. *Girl with a Basket of Fish* and *Girl with a Basket of Oranges*, both c. 1889, are vertical canvases

with single figures that face each other. Their bright, silhouetted volumes join with *Boy in a Red Vest* and *Gardener* in forming a clear perimeter to the wall and with *Woman in a Green Hat* in a V-shaped pattern to unify the upper and lower registers. Renoir's *Girl with Glove*, c. 1893–1895, with its fluid drawing, cool green tapestrylike background, and lustrous white glove, acts as a crowning for the overall architectural organization. (*GFP* 20)

116. This contradicts Anne Distel's reading of the scene as a "moment of amiable civility . . . scarcely more than a pleasant conversation" (*GFP* 50).

117. Here is an excerpt:

Once, while they were waiting for an opportune day, she went in as before with only two maids, and wished to bathe in the garden, for it was very hot. And no one was there except the two elders, who had hid themselves and were watching her. She said to her maids, "Bring me oil and ointments, and shut the garden doors so I may bathe." They did as she said, shut the garden doors, and went out by the side doors to bring what they had been commanded; and they did not see the elders, because they were hidden. When the maids had gone out, the two elders rose and ran to her and said: "Look, the garden doors are shut, no one sees us, and we are in love with you, so give your consent, and lie with us. If you refuse, we will testify against you that a young man was with you, and this was why you sent your maids away."

The story is considered apocryphal in the Protestant Church and appears only in the Catholic Bible. Dan. 13:15–21, *The Holy Bible*, RSV, Second Catholic Edition.

118. It should be mentioned that the scissors are absent from the image of the wall in the Barnes Foundation's *A Passion for Art* CD-ROM. While there may be many reasons for this, it does raise concerns about the transfer of the collection to the new facility in Center City Philadelphia.

119. Freud 424.

120. Ibid.

121. Barnes might have left a further clue toward this kind of signifying system in the display of his large collection of iron keys, which appear in nearly every room of the Barnes Foundation. These objects are both functional and beautiful, neatly exemplifying the publicly pragmatist aesthetic program of the institution. Keys, particularly when situated with locks, as they sometimes are in these rooms, also possess an easily recognizable sexual valence, which reinforces the dynamic we have been considering from the perspectives both of balance and symmetry and of a Freudian unconscious. Perhaps most immediately of all, though, they present an obvious invitation for the viewer to interpret each room hermeneutically. Since the keys always appear either on top of a wall ensemble or, even more frequently, over a doorway between two rooms, their position implies a special function, suggesting that unof-

ficial, as well as official, meanings are locked within the room the viewer is entering. As invitations for interpretation, they are also encrypted announcements of Barnes's authorship of his own collection. In a similar key, Barnes kept a special room at his country house for his friend and frequent guest Charles Laughton, identifying the room by hanging a cookie cutter shaped like the rotund actor over its doorway (Greenfeld 283).

122. See Wattenmaker's account: "[V]isitors to the Barnes Foundation are confronted by the central presence of African culture. The juxtaposition of Doric columns and powerful tribal motifs asserts Barnes' point of view. The porch tells us that this is not another conventional grandiloquent monument to classicism. Lipchitz's reliefs underscore the debt owed by modern Western art to the art of black Africa. This theme is further reinforced by the cast iron railings with their Baule mask motif on the interior and exterior of the building" (*GFP* 11).

123. The finished portrait was not displayed in the Barnes Foundation galleries, but rather in its library, where it was inaccessible to visitors.

124. Picasso's "solution" to the problem of completing *Les Demoiselles d'Avignon* involved, of course, his "discovery" of African and Iberian art at the Musée Ethnographie de Trocadéro: "dans une vision personnelle, les aspirations profundes et perderables de la sculpture ibérique. . . . Picasso parle avec une profunde émotion du choc qu'il reçut ce jour là, à la vue des sculptures africaines." Barr, *Picasso*. See also Paudrat 141–42.

125. See C. Clarke's discussion of this wall ensemble in "Defining Taste" 127–32.

126. Speaking with the *New Yorker* writer Jeffrey Toobin in 2002, Kimberly Camp, then executive director of the Barnes, broke with the traditional silence of past administrations and spoke openly about the relationship. Toobin 36.

127. Barnes was a prolific collector of single-malt whiskeys (*APW* 43), but it is also worth noting that the charge of drunkenness was one of his preferred strategies of attacking his enemies.

128. The works are *Bather* (1917), *Reader II* (1919), and *Harlequin with Mandolin* (1920).

129. Bernstein.

Chapter 4. *The New Negro* in the Field of Collections

1. Locke and Charles S. Johnson accepted Barnes's invitation; it does not appear that James Weldon Johnson ended up coming. Albert C. Barnes, letters to Alain Locke, 25 Jan. 1924 and 31 Mar. 1924, box 164-12, folder 28, Alain Locke Papers, Moorland-Spingarn Research Center, Howard University (hereafter cited as ALP MSRC).

2. See C. Clarke, "Defining Taste" 155.

3. See Munro 242–43; on the attacks Barnes attempted to solicit from Douglas and Bennett, see Kirschke 109.

4. Writing in 1987, Houston A. Baker, Jr., saw in the anthology a paradigmatic "broadening and enlargement of the field of traditional Afro-American discursive possibilities" and named it, more famously and dubiously, a form of black nationalist "*radical marronage.*" Shortly thereafter, Cary Nelson named it "the most indispensable book of the period" and identified the way it demonstrated "the widest ambitions of the Harlem Renaissance [and] also its multiple and differential achievements across all cultural domains." At the same time, Henry Louis Gates, Jr., perceived the way in which Locke's project had evacuated an earlier, more confrontational, explicitly social-ist position that had been signaled by the term "New Negro" in the postwar period. "[I]t would be in the sublimity of the fine arts," as Gates glossed Locke's strategy, "and *not* in the political sphere of action or protest poetry, that white America . . . would at last embrace the Negro of 1925." Baker 73, 75; C. Nelson 90; Gates 147.

5. Hutchinson; Foley.

6. See, for example, North, *Dialect of Modernism,* esp. chap. 4, "Old Possum and Brer Rabbit: Pound and Eliot's Racial Masquerade," 77–99.

7. Pound, *Letters of Ezra Pound, 1907–1941* 180. The first published citation of Locke as midwife of the Harlem Renaissance is Langston Hughes's in *The Big Sea,* where he famously named Locke, Charles S. Johnson, and Jessie Redmun Fauset as the "three people who midwived the so-called New Negro literature into being" (218). Locke, though, used the term on subsequent occasions, for example, naming himself the "philosophical mid-wife to a generation of younger Negro poets." See Locke, *American Philosophy Today and Tomorrow* 312. The complete text of Pound's poem "Sage Homme" is in Eliot, *Letters* 498–99.

8. Monroe and Henderson; Untermeyer; and Wilkinson, *New Voices* and *Contemporary Poetry.* On all of these anthologies, see Craig Abbott 209–21.

9. Pound makes an oblique (and oft-cited) reference to the project in the essay "How to Read" and again in Canto XXII. Pound, "How to Read" 15–40.

10. Kreymborg, *Troubadour.*

11. See Hutchinson 367–72. On Boni and Liveright's publication and promotion of African American literature in the Harlem Renaissance period, see Davis 169–212.

12. Cronyn n.p. The May 1914 issue of Kreymborg and Man Ray's journal the *Glebe* had been devoted to Cronyn's poems.

13. Michaels.

14. Mary Austin, "Introduction," Cronyn xxxii. Michaels also briefly discusses Mary Austin's later work *American Rhythm,* which situates Amy Lowell and Carl Sand-burg as the heirs of Indian forms (85). Richard Drinnon has an appreciative chapter on Austin in *Facing West* 219–31.

15. Austin xv–xvi.

16. Austin xxvi.

17. My thinking about the agencies and practices of literary recovery has been informed by Corinna K. Lee's work on the republication, in the 1970s and 1980s, of works from the 1930s by Zora Neale Hurston, Tillie Olsen, and Mike Gold.

18. Taggard would go on to be a contributing editor at *New Masses*, which was founded in 1926. *May Days* was not the first socialist literary anthology to be published in the United States. As early as 1914, Margaret Anderson reported that Big Bill Haywood planned to compile a verse anthology "connected with the activities of the Industrial Workers of the World." And the following year, Upton Sinclair had published *The Cry for Justice*, a nine-hundred-page anthology of "the writings of philosophers, poets, novelists, social reformers, and others who have voiced the struggle against social injustice, selected from twenty-five languages, covering a period of five thousand years"! In 1920, an anthology protesting the imprisonment of Eugene Debs, *Debs and the Poets*, appeared under Sinclair's imprint in a limited edition (each copy signed by Debs himself), and *The Cry for Justice* was reissued the following year. *May Days* was unique among these anthologies in addressing itself to the question of modernism. Berke 10; [M. Anderson] 37; Sinclair; Le Prade. On the *Masses*, see Fishbein; Morrisson 167–202. On the *Liberator*, see Foley 187–94; McKible 17–38, 109–32.

19. Taggard 5.

20. Ibid. 1.

21. Ibid. 5, 13.

22. See Morrisson 199–201.

23. See chaps. 2 and 1, respectively.

24. "A point of view, known as Marxian, hitherto expressed in this land chiefly in undomesticated foreign gutturals, became, when simplified and translated . . . , the new Yankee wisdom." Taggard 9.

25. Ibid. 3.

26. See Morrisson 183–88.

27. Facetiously credited to Earl B. Barnes (the government attorney who had prosecuted *Masses* editors Eastman, Dell, and Art Young in 1918 under the Espionage Act), "A Tribute" consisted of quotations from Barnes taken from the court record and lineated as free verse. Taggard 220–21.

28. Eve Lott, "Freedom," Taggard 206.

29. Taggard 15.

30. R. Williams, *Marxism and Literature* 163. Taggard's uncertainty about poetic form was ameliorated by her inspired organization of the anthology as a whole, which revealed abiding concerns that had animated the journal, irrespective of poetic form. The effect is all the more striking because Taggard does not signal such groupings in the table of contents, and the associations are only available by reading the anthology sequentially. A series of poems concerned with farming, for instance, passes into a series of poems about industrial labor, linked by Keene Wallis's poem "A Harvest Stiff Comes Back to Town," which depicts the radicalization of a farmer

who comes to the city and joins an interracial union: "As they sit there in a row /
On the curbstone singing low: / 'Join the union, fellow-workers?'—'Home Sweet
Home' and 'Old Black Joe'!" (47). The book also contains a short sequence of Negro-
themed poems, including work from Claude McKay and Jean Toomer, as well as Rolfe
Humphries's "To an Unhappy Negro." Given the *Masses*' interest in engaging the issue
of race, however (which Morrisson discusses at length), not to mention the fact that
McKay had assumed coeditorship of the *Liberator* with Mike Gold in 1922, the anthol-
ogy could be questioned on the extent of its commitment to African American writ-
ing and politics. Although McKay's "Negro Spiritual," which Taggard included in *May
Days*, does communicate the extent to which black spirituals were formed in a con-
text of racial violence, Taggard does not include some of his more confrontational
poems from the *Liberator*, such as "To the White Fiends," "If We Must Die," and "The
White House." If Taggard was reluctant to represent the fullness of McKay's political
verse, Locke's own representation of McKay would go farther in his famous retitling
of the sonnet "The White House" as "White Houses."

 31. Foley 176.

 32. It is important also to mention the collections of black folk materials, in a
sense resembling *The Path on the Rainbow*, that preceded *The New Negro*. See, for
example, F. Work; J. Work; Burlin. Burlin, whose husband exhibited work at the
Armory Show, is a particularly interesting figure; in addition to her books of African
American folk songs, she also compiled well-regarded collections of both American
Indian (1907) and African (1920) folklore. Unlike *The Path on the Rainbow*, these col-
lections did not promote their contents to the hypostatized status of "poetry," but
it is worth remarking the way these collections prefigure not only the spirituals and
folklore that appear in *The New Negro* but also J. W. Johnson, *Book of American Negro
Spirituals*; and Handy and Niles.

 33. Brown.

 34. Schomburg; White and Jackson iii.

 35. James Hardy Dillard, introductory note, White and Jackson x.

 36. White and Jackson 10–11.

 37. Ibid. 15.

 38. Hutchinson 187–88.

 39. Kerlin 1; Gates 147.

 40. Lucian B. Watkins, "The New Negro," in Kerlin 238.

 41. Sexton's "The Bomb Thrower" was a poem about Southern racial violence:
"Down with everything black! / Down with law and order! / Up with the red flag! /
Up with the white South! / I am America's evil genius" (Kerlin 197). On Razafkeriefo
and his omission in the subsequent canonization of the Harlem Renaissance, see
Maxwell 13–62.

 42. Kerlin 196.

 43. J. W. Johnson, *Book of American Negro Poetry* vii (hereafter cited as *ANP*).

44. North continues, "'The Creation' hardly seems 'modernistic' in comparison to its exact contemporary [T. S. Eliot's] *Sweeney Agonistes*: it has no contemporary references, no stylistic tricks, nothing overtly 'experimental.' But it could seem modern in the context of *The New Negro* simply by avoiding certain nearly inescapable stereotypes suggested by its subject, stereotypes Eliot had naturally drawn upon for his character the Reverend Hammond Aigs. As [Carl] Van Vechten put it, 'The Creation' was the poem that 'broke the chain of dialect which bound Paul Laurence Dunbar and freed the younger generation from this dangerous restraint'" (*Dialect of Modernism* 10–11).

45. Foley 179.

46. Writing on the occasion of the publication of *The Norton Anthology of African American Literature*, Mason extends this claim to all historical anthologies (187). On Johnson's *Book of American Negro Poetry*, see also Chakkalakal 521–41.

47. Locke, *New Negro* 7 (hereafter cited as *NN*).

48. Presented to the University of Pennsylvania Modernist Reading Group in March 2000, Maxwell and Valente's unpublished essay remains by far the best comparative treatment of the Irish and Harlem Renaissances. On the specific question of the revival, or renovation, of archaic forms, they argue for a necessary distinction between high modernist nostalgia (for example, Pound's for Confucius or Malatesta), which *metaphorically* presents a "presumptively shared version of the past as the preferred image of the future," and the operational logic of the minority renaissance, which *metonymically* "instrumentalize[s] the associations of the past as a means of reclaiming a still unimaginable future in the name of the people." This amounts to a gesture that is "paradoxically avant-gardist" in comparison with imagism's evocations of Greek or with the nostalgic project signaled by Mary Austin in her introduction to *The Path on the Rainbow*. In the case of Johnson's preface, the appropriate literary form remains itself unimagined, even as the vestigial cultural sources are identified and discussed at some length. Maxwell and Valente 5–6.

49. Edwards 47.

50. See ibid. 306–18.

51. Maxwell 48–49. Building upon Maxwell's insight, Barbara Foley has remarked that the specter of a renewed black militancy remains in Locke's introductory essay as a "veiled threat," a likely, if undesired, consequence of the failure of the culturalist program being advanced not only by Locke but by the anti-revolutionary American left more generally (1–7).

52. This last sense of the term is one particularly associated with Deweyan pragmatism, an important influence on Locke as it was on Barnes. On the question of mob psychology, for instance, Dewey writes, "A political democracy exhibits an overriding of thought like that seen in any convention or institution. That is, thought is submerged in habit. In the crowd and mob, it is submerged in undefined emotion" (*Human Nature and Conduct* 61).

53. Quoted in Harris and Molesworth 167.

54. Locke would nevertheless two years later claim all four writers together as major contributors to "the brilliance of contemporary American poetry. They are modernists among the moderns, and reflectors of common trends and current tendencies" (*Four Negro Poets* 6).

55. See Calo 33–42.

56. Lemke 120.

57. As Martha Jane Nadell has pointed out, Locke paid particular attention to the material form of the second edition, writing to Charles Boni in detail about the paper stock, cardboard, and the "ivory tint or softer finish plate paper for softer values of color plates." Quoted in Nadell 65.

58. They also illustrate Locke's own ambitions beyond the original vision of Albert Boni, who had commissioned Locke's development of the anthology out of the special issue of the *Survey Graphic* where the project had originated. In March 1925, the *Survey* editor Paul U. Kellogg had written to Locke of Boni's plan: "what is in the back of his head is not to bring out the Harlem number in book form; but to use the materials as perhaps half of the contents of a much more formidable volume which would sell for $4.50, and which he hopes would be taken by every college and library in the country." Kellogg reserved the possibility, however, of a more marketable volume along the lines of a typical trade anthology: "It seems to me that this is the first question to be decided—and we should be very glad to have you decide it:—whether a $2 or $2.50 book with perhaps a larger circulation would count for more or less than a volume such as Mr. Boni suggests." *The New Negro*, however, combined these strategies, appearing as a book that was both a reference work and an interventionist anthology; exceeding Boni's original estimates, the book sold for five dollars a copy, but nevertheless went through two printings by 1927 and sold 4,300 copies by 1930. Paul U. Kellogg, letter to Alain Locke, 20 Mar. 1925, box 164-88, folder 6, ALP MSRC.

59. Bornstein 1, 149–50.

60. Brinkman 22, 29.

61. In the 1927 printing of the anthology, Gwendolyn Bennett's "Song" was added to this section and Helene Johnson's "The Road" prefaced the section titled "The New Scene."

62. Nadell 62.

63. Reprinted in Van Vechten, *"Keep A-Inchin' Along"* 140.

64. Countee Cullen, letter to Alain Locke, 28 Dec. 1924, box 164-22, folder 37, ALP MSRC.

65. See George Hutchinson's citation of E. Merrill Root's review, which approved "Heritage" above the "wasteland" visions of literary modernism (188). See also Kirby 14–20.

66. Rainey, *Institutions of Modernism* 77–106.

67. "Contest Awards" 142–43.

68. Countee Cullen, letter to Alain Locke, 6 Jan. 1925, box 164-22, folder 38, ALP MSRC.

69. Braddock, "Poetics of Conjecture" 1250-71. It is important to stress that Locke would have been neither unaware nor, one strongly suspects, unapproving of the queer valence that characterizes the later version of "Heritage," as well as many other poems in *Color*. Indeed, as Alden Reimonenq was the first to discover, Locke had been decisive in encouraging Cullen to recognize and embrace his own homosexuality. He did so, significantly, by lending to Cullen his copy of Edward Carpenter's homoerotic anthology *Ioläus: An Anthology of Friendship*. While this example is further evidence of the very great agency that Locke believed could be effected by the anthology form, it is too much to suggest that *The New Negro* aimed also to be a queer anthology in the sense that Carpenter's *Ioläus* explicitly was. It is nevertheless worth remarking the number of male homosexual or bisexual writers that Locke included in *The New Negro*: Cullen, McKay, Eric Walrond, Lewis Alexander, Richard Bruce Nugent, and (perhaps) Langston Hughes. Reimonenq. For a longer discussion of *Ioläus*, see my "Poetics of Conjecture" (1254-59).

70. Quoted in Michaels 123.

71. Ibid. 123.

72. Ibid. 124.

73. The story "Kaskapaleza," for example, features a witch who keeps a pet tiger; her son is able to kill her with the assistance of his friends the leopards. In the story "The Magic Mirror" a boy named Tembo helps a boa constrictor when the head of a gazelle sticks in his mouth, and he is rewarded by a mirror that grants him wishes; when the mirror is stolen, Tembo hides in a stable with his cat. Cendrars 88-90, 131-34.

74. Parham 440.

75. Kerlin 196.

76. Lindsay 3.

77. Ibid. 3-4.

78. On Lindsay's "The Congo," see DuPlessis 86-97. "The Congo" had by this time been reprinted in Untermeyer's canon-defining *Modern American Poetry* and in Monroe and Henderson's *The New Poetry*. In his introduction, Untermeyer had enjoined his readers to "[l]isten to Vachel Lindsay and catch with him the buoyant and even burly music of camp-meetings, negro 'revivals' and religious gatherings. Read him aloud, and hear how his words roll with the solemnity of a great prayer, or snap, crackle, wink and dance with all the rhythms of a humorous piece of 'rag-time'" (ix).

79. Hughes, "Negro Artist" 692.

80. Hughes would warmly eulogize Lindsay at his funeral in 1931 and, according to Arnold Rampersad, structure his late major poem *Ask Your Mama* upon the musical cues and sectional divisions of Lindsay's "The Congo." Rampersad 1:229-30, 2:317. See also Hughes, *Big Sea* 210-13.

81. Parham 435.

82. Ibid. 436.

83. Ibid. 437, 439, 435, 440.

84. I am grateful to Benjamin Glaser for observing this point about *The Waste Land*'s opening rhythm.

85. This argument resembles one of the key theses of North's *Dialect of Modernism*, in which it is dialect writing, as well as the canon, that white modernists felt entitled to appropriate.

86. On the revisions that distinguish the first and second printings of *The New Negro*, see Nadell 35–36. On *Plays of Negro Life*, see Goeser 133–36.

87. Arthur B. Spingarn, Introduction, Cendrars 6.

88. Bagnall 74.

89. C. Johnson, Introduction, *Ebony and Topaz* 11. See Goeser's discussion of *Ebony and Topaz* (246–69).

90. Alain Locke, "Our Little Renaissance," C. Johnson, *Ebony and Topaz* 118.

91. Alain Locke, "The Drama of Negro Life," Locke and Gregory xiii.

92. Cullen xi.

93. Alain Locke, letter to Carl Van Vechten, 21 Oct. 1925, letters from Blacks, Carl Van Vechten Papers, James Weldon Johnson Collection, Beinecke Rare Book and Manuscript Library.

94. Corbey 12.

95. Edith J. R. Isaacs, letter to Alain Locke, 18 Aug. 1926, box 164-39, folder 8, ALP MSRC. Alain Locke, letter to Edith J. R. Isaacs, 26 Oct. 1926, box 164-89, folder 26, ALP MSRC.

96. Locke, "Blondiau-Theatre Arts Collection."

97. "Three Masks" 181.

98. C. Clarke, "Defining African Art" 47.

99. Calo 40.

100. Alain Locke, "Art Lessons from the Congo," *Survey Graphic* 57 (1 Feb. 1927), reprinted in Locke, *Critical Temper* 137.

101. Quoted in Meyerowitz 82.

102. Edith J. R. Isaacs, letter to Alain Locke, 8 Nov. 1926, box 164-89, folder 26, ALP MSRC.

103. Munro 242.

104. C. Clarke, "Defining African Art" 47.

105. Munro 242.

106. Locke, "African Art in America" 290.

107. Further evidence of Locke and the New Negro movement's increasingly fraught relationship with the Barnes would appear in the May 1927 issue of *Opportunity*, where Charles S. Johnson's editorial simultaneously announced Locke's plans to use a portion of the Blondiau-Theatre Arts Collection as a basis for the Harlem

Museum while "dedicating the issue, in a spirit of appreciation, to the Barnes Foundation." Despite this encomium, the issue contained no contributions, as others had before it, from Barnes or his associates. [C. Johnson], "More on African Art" 126.

108. Alain Locke, undated letter to the Committee on African Art, box 164-68, folder 21, ALP MSRC.

109. Alain Locke, letter to Hollingsworth Wood, 28 Feb. 1929, box 164-94, folder 40, ALP MSRC. A 1929 letter to the Reverend Shelton Bishop indicates the broadest extent of Locke's ambition for the Harlem Museum project:

> [M]y conception of the museum is a living art center and laboratory for the Harlem community. Your dreams for child education link up, if you will see this as I do. First, a respectable race temple in which the community may take pride and to which both white and black may turn as a symbol of the betterment of humanity. A theatre auditorium and work shop rooms and rooms for all kinds of craft and art exhibitions would provide, perhaps, the best center possible for both adult and child education. And if a block property could be obtained, entrance on one street might be to the community rooms, educational features of the scheme you plan; and the other street entrance more directly to the outer rooms, with a definite economy in certain common features like a little theatre, which would be used by both projects.

Alain Locke, letter to Shelton Bishop, 23 Dec. 1929, box 164-14, folder 9, ALP MSRC.

110. On the position of *Vanity Fair* within the field of American modernist magazines, see Rainey, *Institutions of Modernism* 94-99.

111. I am grateful to Bill Maxwell for first bringing Johnson's poem to my attention.

112. Locke, "Exhibition of African Sculpture."

113. Charlotte Osgood Mason, letter to Alain Locke, 6 July 1927, box 164-68, folder 17, ALP MSRC. The role of Mason in the Harlem Museum project, as well as in Locke's subsequent career, is of great significance and merits extensive consideration in a longer study of the museum. The passage quoted here is indicative of Mason's notoriously unreconstructed primitivism, which would also affect her later patronage of Hughes and Hurston (relationships that were brokered by Locke). Harris and Molesworth provide a helpful overview of Locke's relationship with Mason (237-50).

114. There are minor variations between the *Vanity Fair* version of the poem and the one published in *Caroling Dusk*. I am quoting from the latter. H. Johnson 221-23.

115. Lynes 518, 520-22.

116. David Levering Lewis famously uses the refrain as the title of the first chapter of *When Harlem Was in Vogue* (3-24).

117. Julien; Gaines. On the figure of the black dandy in the 1920s, see Winkiel 187-88; M. Miller 176-218.

118. See Sinnette 134-40.

119. Lynes 520. Here we may also briefly observe the disassociation of vernacular culture from official culture, categories whose unification had been promoted in Johnson's preface to *The Book of American Negro Poetry*.

120. "In their collection they owned some Covarrubias originals. . . . They owned all the Robeson records and all the Bessie Smith. And they had a manuscript of Countee Cullen's. . . . And then the most marvellous ebony boy walked into their life, a boy as black as all the Negroes they'd ever known put together." Hughes, "Slave on the Block" 21, 19-20.

121. Thurman 22, 228.

Chapter 5. Modernism's Archives

1. Cheyney and Trent; Cheyney and Conroy; Graham; Harrison. Graham's anthology, which included the nonrevolutionary modernists Pound, Eliot, and Frost, as well as other figures whose leftist credentials were questionable, such as George Sylvester Viereck and Shaemas O'Sheel, merits further consideration. The earliest critical attention Graham's anthology received was from Cary Nelson, who argued, "It does not matter what intentions these poets may have had for their work. History had taken these poems up and given them new meanings. Graham's collection, to be sure . . . is an extreme instance of rearticulation. But it helps set the stage for what has to be treated in part as a collective, dialogic moment in American poetry: the evolution of the discourse of proletarian revolution in the 1920s and 1930s" (149-50).

2. Quoted in Hugh Ford, Introduction, Cunard xvii.

3. Pound, *Profile* 13.

4. Pound, *Letters of Ezra Pound to Alice Corbin Henderson* 230.

5. Eight poems are reprinted from his anthology *Des Imagistes*, as well as four from *Catholic Anthology*. From the latter, Yeats's "The Scholars," a poem with special connection to Pound, appeared again. Seven poems that had appeared a few years earlier in Pound's journal the *Exile* are in *Profile*, as are T. E. Hulme's "Complete Poetical Works," which had been printed at the end of Pound's *Ripostes* in 1912. Poems from Mina Loy and Marianne Moore, both of whom had received special recognition from Pound in the *Little Review*, are included. And, unsurprisingly, Pound included several poems of his own, beginning with "The Tree" (the first poem in the 1928 *Selected Poems* edited by Eliot), but not extending beyond a section from *Hugh Selwyn Mauberley* (1920), which marks the volume's midway point.

6. Cunard iii.

7. On Lawrence Gellert, see Garabedian 179-206.

8. Pound, *Profile* 136. Introducing the *New Masses* poetry, Pound wrote, "I have been for some time under the impression that almost every number of the New Masses contained at least one good poem, class poetry, the personal authorship of which did not matter. e.g. I never remembered which poem was by which author" (129). Leading into

the "Negro Songs of Protest," Pound continued, "At any rate a good deal of the New Masses poetry is better taken in sympathetic context than separate. (The poems here are by H.J. Kreier, James A. Miller, Bob Brown, Russac, and Horace Gregory.) Along with poems voluntarily anonymous the group has printed actual songs of the negro to which no individual authorship can be assigned" (135-36).

9. Edwards 306.

10. Notable interventionist anthologies from later in the century include Allen; Jones and Neal; and Chin et al.

11. On Gallatin, see Stavitsky 46-63.

12. On the development of MoMA's collection, see Kantor 240-41, 366-71.

13. MoMA's watershed year of 1951, which included the dedication of Philip Johnson's Grace Rainey Rogers Annex, was also the year of Albert Barnes's death; Katherine Dreier would die the following year.

14. Brooks and Warren.

15. Golding 109. My gloss of *Understanding Poetry* condenses a few of the points from Golding's excellent discussion (102-13).

16. On the institutionalized separation of poetry from painting and their consequent rivalry, see Levy.

17. Malraux 16. On the intellectual origins of Malraux's project, and his debt to Benjamin in particular, see Andrew and Ungar 369-75.

18. I quote Abbott's letter to Ficke, but this was the form letter he sent to the first fifty poets contacted for the collection. Charles D. Abbott, letter to Arthur Davison Ficke, 23 Nov. 1936, box 494, folder 10, PCMS-0001, Contemporary Manuscripts Collection, ca. 1880-2009, The Poetry Collection of the University Libraries, University at Buffalo, The State University of New York (hereafter cited as CMC PCUB). Van Vechten, *Letters* 179. Van Vechten's letter is dated October 22, 1941.

19. For the definitive account of this divide, see Graff 121-243.

20. "This volume is, so to speak, the laboratory's public dedication, its formal offer of hospitality to those who are willing to approach the problems of twentieth-century poetry seriously." Charles D. Abbott, Introduction, Auden et al. 5; "Exercises Marking the Opening."

21. Founded in 1846, and establishing its College of Arts and Sciences in 1915, the University of Buffalo was incorporated into the State University of New York system in 1960, when it was renamed the State University of New York at Buffalo; it is now called the University at Buffalo. On the Lockwood bequest, see Bolze 414-41.

22. Charles Abbott, Introduction, Auden et al. 6.

23. Abbott specifically named as examples Eliot, Frost, Sitwell, Elinor Wylie, and Yeats. Charles Abbott, Introduction, Auden et al. 7.

24. In Abbott's words, many of these were "compilations of that current poetry which might not, without them, have received publication so early." Charles Abbott, Introduction, Auden et al. 3.

25. Charles Abbott, "Poetry in the Making" 260. The Society of American Archivists defines an "organic collection" as "a body of records that grows as the result of the routine activities of its creator." Pearce-Moses.

26. Charles Abbott, Introduction, Auden et al. 14–15.

27. Ibid. 10–11.

28. Charles Abbott, "Poetry in the Making" 258–59.

29. See, for instance, Crane. I thank Evan Kindley for pointing out the connection to me.

30. Charles Abbott, "Poetry in the Making" 261.

31. Alvarez 155.

32. Ibid. 156.

33. Bontemps 19.

34. Considering the central importance of the James Weldon Johnson Memorial Collection to the last two decades of scholarship, it is striking that Van Vechten's archives have almost entirely escaped critical commentary even as his other collecting activities have inspired an impressive range of scholarly inquiry. Van Vechten's homoerotic scrapbooks, for example, which were made available for study in the early 1990s, have been the subject of studies by Jonathan Weinberg and Scott Herring. Miriam Thaggert, meanwhile, presents a consideration of *Nigger Heaven* as a collection in itself and compares it to Van Vechten's photographic collection of black celebrities. Weinberg 25–49; Herring 144–49; Thaggert 112–44.

35. "I am actuated in making this gift to Yale principally by a casual remark of yours. Your [sic] acknowledged that Yale was deficient in books of this character." Carl Van Vechten, letter to Bernhard Knollenberg, n.d. [1941], Yale University Library, Records of the University Librarian, 1938–1950, box 109, folder 1505.

36. Reprinted in Van Vechten, *"Keep A-Inchin' Along"* 124.

37. Charles S. Johnson, letter to Walter White, 30 Aug. 1941, Yale University Library, Records of the University Librarian, 1938–1950, box 109, folder 1505.

38. Van Vechten, *Letters* 195. On the Yale Library position, see Jones 55.

39. Bontemps 22.

40. Van Vechten, *Letters* 177. The Buffalo Poetry Collection would eventually admit fiction manuscripts, such as the late Joyce materials (including the *Finnegans Wake* notebooks). In determining the parameters of future acquisitions for the Yale collection, Van Vechten proposed (and the Yale librarian Bernhard Knollenberg agreed) "that the James Weldon Johnson Memorial Collection should contain eventually ANY book or manuscript by ANY Negro and, so far as possible, the BEST books dealing with Negroes by whites." The enormous annotated catalog Van Vechten compiled during the course of the collection's accessions reveals a wide range of materials fitting under the latter category. This included not only works such as Gertrude Stein's *Three Lives* and Joseph Conrad's *Nigger of the Narcissus*, but also Evelyn Waugh's *Black Mischief* and Vachel Lindsay's notorious *The Congo and Other*

Poems, as well as a second printing of Lothrop Stoddard's *The Rising Tide of Color*. Carl Van Vechten, letter to Bernhard Knollenberg, 15 July 1941, Yale University Library, Records of the University Librarian, 1938–1950, box 109, folder 1505; *James Weldon Johnson Memorial Collection: Catalogue*, Carl Van Vechten Papers, James Weldon Johnson Memorial Collection, Beinecke Rare Book and Manuscript Library, Range 75, Section 2, Shelf 3, box 21.

41. Carl Van Vechten, letter to Bernhard Knollenberg, n.d. [1941], Yale University Library, Records of the University Librarian, 1938–1950, box 109, folder 1505.

42. Jones.

43. The importance of these materials for the purposes of genetic scholarship was also recognized by the donors and intermediaries. An exemplary instance of this can be found in a 1943 letter to Van Vechten from Alain Locke: "Enclosed are the [Sterling] Brown manuscripts and an installment of mine. . . . Sterling apparently never uses pen—but these pencil manuscripts are really most interesting." Alain Locke, letter to Carl Van Vechten, 3 Apr. 1943, letters from Blacks, Carl Van Vechten Papers, James Weldon Johnson Collection, Beinecke Rare Book and Manuscript Library.

44. The Society of American Archivists defines "associational value" as "the usefulness or significance of materials based on its relationship to an individual, family, organization, place, or event," adding that "associational value may be based on ownership, creation, or the subject matter of the material." Pearce-Moses.

45. Van Vechten, *Letters* 179.

46. In this way, the signatures of Van Vechten's correspondents resemble what Jacques Derrida identified as "the *impression* left . . . by the *Freudian signature* on its own archive," an impression made palpable at the moment of, and despite, its institutionalization at Yale. Derrida 5.

47. This letter concerns Van Vechten's frustration that, by the 1950s, (he felt) he was receiving neither the appropriate cooperation nor appreciation from the Negroes in whose name the collection was founded. Quoted in Birnbaum 126.

48. *James Weldon Johnson Memorial Collection: Catalogue*, p. 44, Carl Van Vechten Papers, James Weldon Johnson Memorial Collection, Beinecke Rare Book and Manuscript Library, Range 75, Section 2, Shelf 3, box 21.

49. *James Weldon Johnson Memorial Collection: Catalogue*, p. 99, Carl Van Vechten Papers, James Weldon Johnson Memorial Collection, Beinecke Rare Book and Manuscript Library, Range 75, Section 2, Shelf 3, box 21.

50. Following the collector's own organization, the Beinecke uses different call numbers for Van Vechten's correspondence with African Americans (call number: JWJ Van Vechten Correspondence with Blacks, NAME) and non-African Americans (call number: ZA Van Vechten Correspondence with Whites, NAME).

51. Anne Spencer, letter to Harold Jackman, 21 May 1942. Jackman enclosed Spencer's letter in his letter to Van Vechten, 24 May 1942, letters from Blacks, Carl Van

Vechten Papers, James Weldon Johnson Memorial Collection, Beinecke Rare Book and Manuscript Library.

52. Birnbaum 128, 130.

53. The highly contradictory documents that describe the controversy concerning the failed collaboration of Langston Hughes and Zora Neale Hurston on the play *Mule Bone* are an excellent case in point. These are helpfully compiled as an appendix in George Houston Bass and Henry Louis Gates Jr.'s 1991 Harper edition. Hughes and Hurston. See also Rosenberg 79–105.

54. Ezra Pound, letter to Charles D. Abbott, 29 Nov. [1936], box 741, folder 2, PCMS-0001, CMC PCUB.

55. See Cunard's letter just after the war: "I have written a line to Ezra (from the burned, ruined village of Rimont) and shall certainly write him a long, long letter as I have a great deal to say to him, indeed I have, beginning with Fascism and ending with the fact that it was his own 'Cantos' that I found in lieu of window-glass in one of the rooms of my devastated house in Normandy Ezra's friends put it there, the German ones, or maybe even the French ones." Nancy Cunard, letter to Leslie Daiken, [1946], box 565, folder 5, PCMS-0001, CMC PCUB.

56. Nancy Cunard, letter to Charles D. Abbott, 21 July 1937, box 565, folder 1, PCMS-0001, CMC PCUB.

57. My thinking on this issue has been profoundly shaped by Damien Keane, and in particular by his forthcoming book *Ireland and the Problem of Information*.

Bibliography

Abbott, Charles D. "Poetry in the Making." *Poetry* 55 (Dec. 1939): 258-66.

Abbott, Craig S. "Modern American Poetry: Anthologies, Classrooms, and Canons." *College Literature* 17.2-3 (Jun. 1990): 209-21.

Adorno, Theodor W. "Theses on the Sociology of Art." Trans. Brian Trench. *Working Papers in Cultural Studies* 2 (Spring 1972): 121-28.

———. "Valéry Proust Museum." *Prisms*. Trans. Samuel and Shierry Weber. Cambridge, MA: MIT Press, 1981. 175-85.

Adorno, Theodor W., and Walter Benjamin. *The Complete Correspondence 1928-1940*. Ed. Henri Lonitz. Trans. Nicholas Walker. Cambridge, MA: Harvard University Press, 1999.

Aiken, Conrad. "Esoteric Catholicity." Rev. of *Catholic Anthology 1914-1915*. *Poetry Journal* 5.3 (Apr. 1916): 127-29.

———. "The Place of Imagism." Rev. of *Some Imagist Poets*. *New Republic* 3.29 (22 May 1915): 75-76.

Aldington, Richard. *Richard Aldington: His Life in Letters*. Ed. Norman T. Gates. University Park: Pennsylvania State University Press, 1992.

Allen, Donald, ed. *The New American Poetry, 1945-1960*. New York: Grove Press, 1960.

Allied War Salon. Exhibition Catalog. New York: American Art Galleries, 1918.

Alvarez, A. "A Library of Poetry." *Listener* (31 Jul. 1958): 155-56.

American Poetry 1922: A Miscellany. New York: Harcourt Brace, 1922.

Andersen, Mark, and Mark Jenkins, *Dance of Days: Two Decades of Punk in the Nation's Capital*. New York: Akashic Books, 2001.

Anderson, John. *Art Held Hostage: The Battle over the Barnes Collection*. New York and London: W. W. Norton, 2003.

[Anderson, Margaret]. "A Rebel Anthology." *Little Review* 1.6 (Oct. 1914): 37.

Andrew, Dudley, and Steven Ungar. *Popular Front Paris and the Poetics of Culture*. Cambridge, MA: Harvard University Press, 2005.

Antliff, Allan. *Anarchist Modernism: Art, Politics, and the First American Avant-Garde.* Chicago: University of Chicago Press, 2001.

Argott, Don, dir. *The Art of the Steal.* IFC Films, 2009.

"Argyrol." Argyrol Pharmaceuticals. www.argyrol.com/agprotein.phtml.

Auden, W. H., Karl Shapiro, Rudolf Arnheim, and Donald A. Stauffer. *Poets at Work: Essays Based on the Modern Poetry Collection at the Lockwood Memorial Library, University of Buffalo.* New York: Harcourt Brace, 1948.

Babcock, Robert G. "Verses, Translations, and Reflections from 'The Anthology': H. D., Ezra Pound, and the Greek Anthology." *Sagetrieb* 14.1-2 (1995): 201-16.

Bagnall, Robert W. Rev. of Alain Locke, ed., *The New Negro. Opportunity* 4.38 (Feb. 1926): 74.

Bahr, Megan Granda. "Transferring Values: Albert C. Barnes, Work and the Work of Art." Diss. University of Texas at Austin, 1998.

Baker, Houston A., Jr. *Modernism and the Harlem Renaissance.* Chicago: University of Chicago Press, 1987.

Barnes, Albert C. *The Art in Painting.* New York: Harcourt Brace, 1925.

——. *The Art in Painting.* 3rd rev. ed. New York: Harcourt Brace, 1937.

——. "The Art of the American Negro." *The Barnwell Addresses.* Vol. 2. Philadelphia: Central High School, 1937. 375-86.

——. "The Barnes Foundation." *New Republic* (14 Mar. 1923): 65-67.

——. "How to Judge a Painting." *Arts and Decoration* 5.6 (Apr. 1915): 217-20, 246, 248-50.

——. "Introduction." *Catalogue of an Exhibition of Contemporary European Paintings and Sculpture.* Philadelphia: Pennsylvania Academy of the Fine Arts, 1923. 3-7.

——. "Negro Art, Past and Present." *Opportunity* 4.41 (May 1926): 148-49, 168-69.

"Barnes Foundation FAQs." The Barnes Foundation. www.barnesfoundation.org/barnesfaq.html.

Barr, Alfred H., Jr., ed. *Masters of Modern Art.* New York: Museum of Modern Art, 1954.

——. *Picasso: Fifty Years of His Art.* New York: Museum of Modern Art, 1946.

——. "Plastic Values." Rev. of Albert C. Barnes, *The Art in Painting. Saturday Review of Literature* (24 Jul. 1926): 948.

Baudrillard, Jean. *The System of Objects.* Trans. James Benedict. London: Verso, 1996.

Bell, Clive. *Since Cézanne.* New York: Harcourt Brace, 1922.

Benedict, Barbara M. *Making the Modern Reader: Cultural Mediation in Early Modern Literary Anthologies.* Princeton: Princeton University Press, 1996.

Benjamin, Walter. *The Arcades Project.* Trans. Howard Eiland and Kevin McLaughlin. Cambridge, MA: Belknap/Harvard University Press, 1999.

——. "Eduard Fuchs, Collector and Historian." Trans. Howard Eiland and Michael W. Jennings. *Selected Writings.* Vol. 3. Ed. Eiland and Jennings. Cambridge, MA: Belknap/Harvard University Press, 2002. 260-302.

———. "Paris, the Capital of the Nineteenth Century." Trans. Howard Eiland, *Selected Writings*. Vol. 3, 1935-38. Ed. Howard Eiland and Michael W. Jennings. Cambridge, MA: Belknap/Harvard University Press, 2002. 32-49.

———. "Unpacking My Library: A Talk about Collecting." Trans. Harry Zohn, *Selected Writings*. Vol. 2, 1927-1934. Ed. Michael W. Jennings, Howard Eiland, and Gary Smith. Cambridge, MA: Belknap/Harvard University Press, 1999. 486-93.

———. "The Work of Art in the Age of Its Technological Reproducibility" (second version). Trans. Edmund Jephcott and Harry Zohn. *Selected Writings*. Vol. 3, 1935-38. Ed. Howard Eiland and Michael W. Jennings. Cambridge, MA: Belknap/Harvard University Press, 2002. 101-33.

Berke, Nancy. *Women Poets on the Left: Lola Ridge, Genevieve Taggard, Margaret Walker*. Gainesville: University Press of Florida, 2001.

Berman, Laura. "The Artful Dodger." *Detroit Free Press Magazine* (3 Aug. 1986): 10-15, 17, 20.

Bernstein, Adam. "CIA Officer and art museum chairman Laughlin Phillips, 85, dies." *Washington Post*, 26 Jan. 2010. www.washingtonpost.com/wp-dyn/content/article/2010/01/25/AR2010012503741.html.

Birnbaum, Michele. *Race, Work, and Desire in American Literature, 1860-1930*. Cambridge: Cambridge University Press, 2003.

Blair, Sara. "Home Truths: Gertrude Stein, 27 Rue de Fleurus, and the Place of the Avant-Garde." *American Literary History* 12.3 (2000): 417-37.

Bochner, Jay. *An American Lens: Scenes from Alfred Stieglitz's New York Secession*. Cambridge, MA: MIT Press, 2005.

Bohan, Ruth L. *The Société Anonyme's Brooklyn Exhibition: Katherine Dreier and Modernism in America*. Ann Arbor: UMI Press, 1982.

Bolze, Thomas A. "From Private Passion to Public Virtue: Thomas B. Lockwood and the Making of a Cultural Philanthropist, 1895-1935." *Libraries and the Cultural Record* 45.4 (2010): 414-41.

Bontemps, Arna. "The James Weldon Johnson Memorial Collection of Negro Arts and Letters." *Yale University Library Gazette* 18.2 (Oct. 1943): 19-26.

Bornstein, George. *Material Modernism: The Politics of the Page*. Cambridge: Cambridge University Press, 2001.

Bourdieu, Pierre. *Distinction: A Social Critique of the Judgement of Taste*. Trans. Richard Nice. Cambridge, MA: Harvard University Press, 1984.

———. *The Field of Cultural Production: Essays on Art and Literature*. Ed. Randal Johnson. New York: Columbia University Press, 1993.

———. *The Logic of Practice*. Trans. Richard Nice. Stanford: Stanford University Press, 1990.

———. *The Rules of Art: Genesis and Structure of the Literary Field*. Trans. Susan Emanuel. Stanford: Stanford University Press, 1996.

Bourdieu, Pierre, and Loïc J. D. Wacquant. *An Invitation to Reflexive Sociology*. Chicago: University of Chicago Press, 1992.

Braddock, Jeremy. "Neurotic Cities: Barnes in Philadelphia." *Art Journal* 63.4 (2004): 46–61.

———. "The Poetics of Conjecture: Countee Cullen's Subversive Exemplarity." *Callaloo* 25.4 (2002): 1250–71.

Bradshaw, Melissa. "Outselling the Modernisms of Men: Amy Lowell and the Art of Self-Commodification." *Victorian Poetry* 38.1 (2000): 141–69.

Braithwaite, William Stanley. *Anthology of Magazine Verse for 1916 and Year Book of American Poetry*. New York: Laurence J. Gomme, 1916.

———. "Imagism: Another View." *New Republic* 3.33 (12 Jun. 1915): 154.

———. *The Poetic Year for 1916: A Critical Anthology*. Boston: Small, Maynard, 1916.

———, ed., *Victory! Celebrated by Thirty-Eight American Poets*. Boston: Small, Maynard, 1919.

Breasted, James Henry. *The Conquest of Civilization*. New York: Harper, 1926.

———. *A History of Egypt*. New York: Charles Scribner, 1905.

Brinkman, Bartholomew. "Making Modern *Poetry*: Format, Genre and the Invention of Imagism(e)." *Journal of Modern Literature* 32.2 (2009): 20–40.

Brooks, Cleanth, and Robert Penn Warren. *Understanding Poetry: An Anthology for College Students*. New York: Henry Holt, 1938.

Brown, Sterling A. *Outline for the Study of the Poetry of American Negroes*. New York: Harcourt Brace, 1931.

Bruccoli, Matthew J. *The Fortunes of Mitchell Kennerley, Bookman*. San Diego: Harcourt Brace Jovanovich, 1986.

Bryant, Marsha, and Mary Ann Eaverly. "Egypto-Modernism: James Henry Breasted, H. D., and the New Past." *Modernism/modernity* 14.3 (2007): 435–54.

Buermeyer, Laurence. *The Aesthetic Experience*. 2nd ed. Merion, PA: Barnes Foundation Press, 1929.

———. "An Experiment in Education." *Nation* 120.3119 (15 Apr. 1925): 442–44.

Bürger, Peter. *Theory of the Avant-Garde*. Trans. Michael Shaw. Minneapolis: University of Minnesota Press, 1984.

Burlin, Natalie Curtis. *Negro Folk Songs: The Hampton Series, Vols. 1–4*. New York: G. Schirmer, 1918–19.

Cabanne, Pierre, and Marcel Duchamp. *Dialogues with Marcel Duchamp*. New York: Da Capo, 1987.

Calo, Mary Ann. *Distinction and Denial: Race, Nation, and the Critical Construction of the African American Artist, 1920–40*. Ann Arbor: University of Michigan Press, 2007.

Cantor, Gilbert M. *The Barnes Foundation: Reality vs. Myth*. Philadelphia: Consolidated/Drake Press, 1963.

"The Case of Poetry." *Dial* 53.636 (16 Dec. 1912): 477–79.

Catalogue of the First Exhibition of the Society of Independent Artists. New York: Society of Independent Artists, 1917.

Cendrars, Blaise. *The African Saga.* [*Anthologie Nègre.*] Trans. Margery Williams Bianco. New York: Payson and Clarke, 1927.

Chakkalakal, Tess. "'Making a Collection': James Weldon Johnson and the Mission of African American Literature." *South Atlantic Quarterly* 104.3 (2005): 521-41.

"Chavannes Picture Is Sold for $8,000." *New York Times* (11 Feb. 1927): 44.

Cheney, Sheldon. "An Adventurer among Art Collectors." *New York Times* (3 Jan. 1926): 10, 23.

Cheyney, Ralph, and Jack Conroy, eds. *Unrest: The Rebel Poets' Anthology for 1929.* London: Arthur H. Stockwell, 1929.

Cheyney, Ralph, and Lucia Trent, eds. *America Arraigned!* New York: York, Dean, 1928.

Chin, Frank, Jeffrey Paul Chan, Lawson Fusao Inada, and Shawn Hsu Wong, eds. *Aiiieeeee!: An Anthology of Asian-American Writers.* Washington, DC: Howard University Press, 1974.

Churchill, Suzanne W. *The Little Magazine "Others" and the Renovation of Modern American Poetry.* Aldershot, UK: Ashgate, 2006.

Clarke, Christa J. "Defining African Art: Primitive Negro Sculpture and the Aesthetic Philosophy of Albert Barnes." *African Arts* 36.1 (2003): 40-51.

———. "Defining Taste: Albert Barnes and the Promotion of African Art in the United States during the 1920s." Diss. University of Maryland, College Park, 1998.

Clarke, George Herbert, ed. *A Treasury of War Poetry, 1914-1917.* Boston: Houghton Mifflin, 1917.

Clifford, James. *The Predicament of Culture: Twentieth-Century Ethnography, Literature, and Art.* Cambridge, MA: Harvard University Press, 1988.

Coetzee, J. M. "The Marvels of Walter Benjamin." *New York Review of Books* (11 Jan. 2001): 28-33.

Colum, Padraic, and Edward J. O'Brien, eds. *Poems of the Irish Revolutionary Brotherhood.* Boston: Small, Maynard, 1916.

Conn, Steven. *Museums and American Intellectual Life, 1876-1926.* Chicago: University of Chicago Press, 1998.

Conroy, Jack, and Ralph Cheyney, eds. *Unrest 1931.* New York: Henry Harrison, 1931.

"Contest Awards." *Opportunity* 3.29 (May 1925): 142-43.

Corbett, David Peters, and Andrew Thacker. "Raymond Williams and Cultural Formations: Movements and Magazines." *Prose Studies* 16.2 (1993): 84-106.

Corbey, Raymond. "African Art in Brussels." *Anthropology Today* 15.6 (Dec. 1999): 11-16.

Corn, Wanda M. *The Great American Thing: Modern Art and National Identity, 1915-1935.* Berkeley: University of California Press, 1999.

"Counter Attack in Fight on Modernists." *American Art News* (15 Oct. 1921).

Crane, Mary Thomas. *Shakespeare's Brain: Reading with Cognitive Theory*. Princeton: Princeton University Press, 2000.

Craven, Thomas Jewell. "The Awakening of the Academy." *Dial* (June 1921): 673-78.

Cronyn, George W. ed. *The Path on the Rainbow: An Anthology of Songs and Chants from the Indians of North America*. New York: Boni and Liveright, 1918.

Crunden, Robert M. *American Salons: Encounters with European Modernism 1885-1917*. New York: Oxford University Press, 1993.

Cullen, Countee, ed. *Caroling Dusk: An Anthology of Verse by Negro Poets*. New York: Harper, 1927.

Cunard, Nancy, ed. *Negro: An Anthology*. London: Wishart, 1934.

Damon, S. Foster. *Amy Lowell: A Chronicle, with Extracts from Her Correspondence*. Boston: Houghton Mifflin, 1935.

Davis, James C. *Commerce in Color: Race, Consumer Culture, and American Literature, 1893-1933*. Ann Arbor: University of Michigan Press, 2007.

de Mazia, Violette. *The Barnes Foundation: The Display of Its Art Collection*. Merion Station, PA: Barnes Foundation Press, 1995.

Derrida, Jacques. *Archive Fever: A Freudian Impression*. Trans. Eric Prenowitz. Chicago: University of Chicago Press, 1995.

Dewey, John. *Art as Experience*. 1934. New York: Perigee, 1980.

———. *The Correspondence of John Dewey, 1871-1952*. Ed. Larry Hickman. Charlottesville, VA: Intelex Corporation, 2008.

———. *Human Nature and Conduct*. New York: Henry Holt, 1922.

———. "The New Psychology." *Andover Review* 2 (1884): 278-89.

Dewey, John, Albert C. Barnes, Laurence Buermeyer, Thomas Munro, Paul Guillaume, Mary Mullen, and Violette de Mazia. *Art and Education*. Merion, PA: Barnes Foundation Press, 1929.

de Zayas, Marius. *How, When, and Why Modern Art Came to New York*. Ed. Francis M. Naumann. Cambridge, MA: MIT Press, 1996.

Diepeveen, Leonard. *Changing Voices: The Modern Quoting Poem*. Ann Arbor: University of Michigan Press, 1993.

———. "When Did Modernism Begin? Formulating Boundaries in the Modern Anthology." *English Studies in Canada* 30.1 (2004): 137-56.

DiMaggio, Paul J. "Constructing an Organizational Field as a Professional Project: U.S. Art Museums, 1920-1940." Walter W. Powell and Paul J. DiMaggio, eds., *The New Institutionalism in Organizational Analysis*. Chicago: University of Chicago Press, 1991. 267-92.

Drinnon, Richard. *Facing West: The Metaphysics of Indian-Hating and Empire Building*. Norman: University of Oklahoma Press, 1997.

Du Bois, Guy Pène. "A Modern American Collection." *Arts and Decoration* (Jun. 1914): 304-6, 325-36.

DuPlessis, Rachel Blau. *Genders, Races, and Religious Cultures in Modern American Poetry, 1908-1934*. Cambridge: Cambridge University Press, 2001.

Eagleton, Terry. *The Function of Criticism: From* The Spectator *to Post-Structuralism*. London: Verso, 1984.

Earle, Ferdinand, ed. *The Lyric Year: One Hundred Poems*. New York: Mitchell Kennerley, 1912.

Eburne, Jonathan P. "The Future of Irrevolution: Surrealism and Mediation in the 1950s." *Contemporary French Civilization* 34.2 (2010): 67-90.

Edwards, Brent Hayes. *The Practice of Diaspora: Literature, Translation, and the Rise of Black Internationalism*. Cambridge, MA: Harvard University Press, 2003.

Eliot, T. S. *The Letters of T. S. Eliot*. Vol. 1. Ed. Valerie Eliot. San Diego: Harcourt Brace Jovanovich, 1988.

———. "Reflections on Contemporary Poetry." *Egoist* 4.8 (Sept. 1917): 118-19.

———. "Tradition and the Individual Talent." *Selected Essays*. London: Faber and Faber, 1934. 13-22.

Elliott, Bridget. "Art Deco Worlds in a Tomb: Reanimating Egypt in Modern(ist) Visual Culture." *South Central Review* 25.1 (2008): 114-35.

"Exercises Marking the Opening of the James Weldon Johnson Memorial Collection of Negro Arts and Letters Founded by Carl Van Vechten." Program of Events. New Haven, 7 Jan. 1950.

"'The Failure of Modern Art.'" *Art News* (26 Feb. 1927): 8.

Ferry, Anne. *Tradition and the Individual Poem: An Inquiry into Anthologies*. Stanford: Stanford University Press, 2001.

Field, Hamilton Easter. "Dr. Barnes Says Modern Artists Are Not Insane." *Brooklyn Daily Eagle* (22 May 1921): 22.

Fields, Jim, and Michael Gramaglia, dirs. *End of the Century: The Story of the Ramones*. Magnolia Pictures, 2003.

Firkins, O. W. "The Irrepressible Anthology." Rev. essay. *Nation* 105.2735 (29 Nov. 1917): 596.

Fishbein, Leslie. *Rebels in Bohemia: The Radicals of "The Masses," 1911-1917*. Chapel Hill: University of North Carolina Press, 1982.

FitzGerald, Michael C. *Making Modernism: Picasso and the Creation of the Market for Twentieth-Century Art*. New York: Farrar, Straus and Giroux, 1995.

Flint, F. S. "Imagisme." *Poetry* 1.6 (Mar. 1913): 198-200.

Foley, Barbara. *Spectres of 1919: Class and Nation in the Making of the New Negro*. Urbana: University of Illinois Press, 2003.

Fore, Devin, ed. "Soviet Factography." Special issue of *October* 118 (2006).

Freud, Sigmund. *The Interpretation of Dreams*. Trans. and ed. James Strachey. London: Penguin-Pelican, 1976.

Fried, Debra. "Andromeda Unbound: Gender and Genre in Millay's Sonnets." *Twentieth Century Literature* 32.1 (1986): 1-22.

Fry, Roger. *Vision and Design*. New York: Brentano's, 1924.

Furth, Leslie. *Augustus Vincent Tack: Landscape of the Spirit*. Washington, DC: Phillips Collection, 1993.

Gaines, Reg E. *Bring in 'da Noise, Bring in 'da Funk*. Dir. George C. Wolfe. Chor. Savion Glover. New York Shakespeare Festival/Public Theatre, 1995; New York Ambassador Theatre, 1996-99.

Garabedian, Steven. "Reds, Whites, and the Blues: Lawrence Gellert, 'Negro Songs of Protest,' and the Left-Wing Folk-Song Revival of the 1930s and 1940s." *American Quarterly* 57.1 (2005): 179-206.

Gates, Henry Louis, Jr. "The Trope of a New Negro and the Reconstruction of the Image of the Black." *Representations* 24 (1988): 129-55.

Geist, Sidney. *Interpreting Cézanne*. Cambridge, MA: Harvard University Press, 1988.

Gikandi, Simon. "Africa and the Epiphany of Modernism." *Geomodernisms: Race, Modernism, Modernity*. Ed. Laura Doyle and Laura Winkiel. Bloomington: Indiana University Press, 2005. 31-50.

Goeser, Carolyn. *Picturing the New Negro: Harlem Renaissance Print Culture and Modern Black Identity*. Lawrence: University of Kansas Press, 2007.

Golding, Alan. *From Outlaw to Classic: Canons in American Poetry*. Madison: University of Wisconsin Press, 1995.

Goodyear, A. Conger. "A Half Century of Art." *Albright Art Gallery: Gallery Notes* 21.2 (1958): 2-4.

Graff, Gerald. *Professing Literature: An Institutional History*. Chicago: University of Chicago Press, 1987.

Graham, Marcus, ed. *Anthology of Revolutionary Poetry*. New York: Active Press, 1929.

Great French Paintings from the Barnes Foundation: Impressionist, Post-Impressionst, and Early Modern. New York: Alfred A. Knopf in association with Lincoln University Press, 1995.

Greenfeld, Howard. *The Devil and Dr. Barnes: Portrait of an American Art Collector*. New York: Penguin, 1987.

Gregg, Frederick James. "Europe Raids the John Quinn Collection." *Independent* 116 (27 Feb. 1926): 240-41.

Gross, Jennifer R., ed. *The Société Anonyme: Modernism for America*. New Haven: Yale University Press in association with the Yale University Art Gallery, 2006.

Guillaume, Paul, and Thomas Munro. *Primitive Negro Sculpture*. New York: Hacker Art Books, 1968.

Guillory, John. *Cultural Capital: The Problem of Literary Canon Formation*. Chicago: University of Chicago Press, 1993.

———. "Genesis of the Media Concept." *Critical Inquiry* 36 (2010): 321-62.

Habermas, Jürgen. *The Structural Transformation of the Public Sphere: An Inquiry into a Category of Bourgeois Society*. Trans. Thomas Burger with Frederic Lawrence. Cambridge, MA: MIT Press, 1991.

Handy, W. C., and Abbe Niles, eds. *Blues—An Anthology.* New York: Albert and Charles Boni, 1926.

Harris, Leonard, and Charles Molesworth. *Alain L. Locke: Biography of a Philosopher.* Chicago: University of Chicago Press, 2008.

Harrison, Henry, ed. *The Sacco-Vanzetti Anthology of Verse.* New York: Henry Harrison, 1927.

Hassall, Christopher. *Edward Marsh: Patron of the Arts.* London: Longmans, 1959.

jh [Heap, Jane]. "Light Occupations of the Editor While There Is Nothing to Edit." *Little Review* 3.6 (Sept. 1916): 14-15.

A. C. H. [Henderson, Alice Corbin]. "A New School of Poetry." Rev. of *Others: An Anthology of the New Verse. Poetry* 8.2 (May 1916): 103-5.

Herring, Scott. *Queering the Underworld: Slumming, Literature, and the Undoing of Lesbian and Gay History.* Chicago: University of Chicago Press, 2007.

Herskovits, Melville J. "African Art from an Ivory Tower." Rev. of Paul Guillaume and Thomas Munro, *Primitive Negro Sculpture. Arts* 10.4 (Oct. 1926): 241-43.

———. "The Art of the Congo." *Opportunity* 5.5 (May 1927): 135-36.

Higonnet, Anne. "Whither the Barnes?" *Art in America* 82.3 (1994): 62-69.

Hoffman, Frederick J., Charles Allen, and Carolyn F. Ulrich. *The Little Magazine: A History and a Bibliography.* Princeton: Princeton University Press, 1946.

Hohendahl, Peter Uwe. *Prismatic Thought: Theodor W. Adorno.* Lincoln: University of Nebraska Press, 1995.

Holdengräber, Paul. "Between the Profane and the Redemptive: The Collector as Possessor in Walter Benjamin's *Passagen-Werk.*" *Internationale Zeitschrift für Philosophie* (1993): 113-35.

Hormats, Bess. "Duncan Phillips, Collector as Critic: The 1920s." *The Phillips Collection in the Making, 1920-1930.* Ed. Ruth Spiegel. Washington, DC: Smithsonian Institution and Phillips Collection, 1979. 18-27.

Hughes, Langston. *The Big Sea.* New York: Hill and Wang, 1993.

———. "The Negro Artist and the Racial Mountain." *Nation* 122.3181 (23 Jun. 1926): 692-94.

———. "Slave on the Block." *The Ways of White Folks.* New York: Vintage, 1990. 19-31.

Hughes, Langston, and Zora Neale Hurston. *Mule Bone: A Comedy of Negro Life.* Ed. George Houston Bass and Henry Louis Gates, Jr. New York: Harper Perennial, 1991.

Hutchinson, George. *The Harlem Renaissance in Black and White.* Cambridge, MA: Belknap/Harvard University Press, 1995.

Jaffe, Aaron. *Modernism and the Culture of Celebrity.* Cambridge: Cambridge University Press, 2005.

Jameson, Fredric. *The Political Unconscious: Narrative as a Socially Symbolic Act.* Ithaca: Cornell University Press, 1981.

Jarzombek, Mark. *The Psychologizing of Modernity: Art, Architecture, and History*. Cambridge: Cambridge University Press, 2000.

Jefferson, Thomas. "Notes on the State of Virginia." *Selected Writings*. Ed. Wayne Franklin. New York: W. W. Norton, 2010. 24-177.

Jensen, Robert. *Marketing Modernism in Fin-de-Siècle Europe*. Princeton: Princeton University Press, 1994.

Johns, Margaret. "Free Footed Verse Is Danced in Ridgefield, New Jersey: Get What Meaning You Can Out of the Futurist Verse—Efficiency Is Its Byword and Base—It's as Esoteric as Gertrude Stein Herself or a Loyd Puzzle—'Others' Is the Name of the Field Through Which You Must Wander to Grasp It." *New York Tribune* (25 Jul. 1915): sec. 3, p. 2.

Johns, Orrick. "Olives." *Others* 1.1 (Jul. 1915): 12.

——. *Time of Our Lives: The Story of My Father and Myself*. New York: Stackpole, 1937.

Johnson, Charles S., ed. *Ebony and Topaz: A Collectanea*. Freeport, NY: Books for Libraries Press, 1971.

——. "More on African Art." *Opportunity* 5.5 (May 1927): 126.

——. "Negro Art." *Opportunity* 4.41 (May 1926): 142.

Johnson, Helene. "Bottled." *Vanity Fair* (May 1927): 76.

Johnson, James Weldon, ed. *The Book of American Negro Poetry*. New York: Harcourt Brace, 1922.

——, ed. *The Book of American Negro Spirituals*. New York: Viking, 1925.

Jones, Jacqueline C. "The Unknown Patron: Harold Jackman and the Harlem Renaissance Archives." *Langston Hughes Review* 19 (2005): 55-66.

Jones, LeRoi [Amiri Baraka], and Larry Neal, eds. *Black Fire: An Anthology of Afro-American Writing*. New York: Morrow, 1968.

Joyce, James. *Ulysses*. New York: Random House, 1986.

Julien, Isaac, dir. *Looking for Langston*. Sankofa Film and Video, 1988.

K. "Book Discussion: A Watteauesque Enthusiast." Rev. of Duncan Phillips, *The Enchantment of Art*. *Little Review* 1.9 (Dec. 1914): 65.

Kantor, Sybil Gordon. *Alfred H. Barr, Jr. and the Intellectual Origins of the Museum of Modern Art*. Cambridge, MA: MIT Press, 2002.

Kenner, Hugh. *The Pound Era*. Berkeley: University of California Press, 1971.

Kerlin, Robert T. *Negro Poets and Their Poems*. Washington, DC: Associated Publishers, 1923.

Kilmer, Joyce. "Free Verse Hampers Poets and Is Undemocratic: Josephine Preston Peabody Says That, Nevertheless, the War Is Making Poetry Less Exclusive and the Imagiste Cult Will Be Swept Away." *New York Times* (23 Jan. 1916): SM14.

Kirby, David K. "Countee Cullen's 'Heritage': A Black 'Waste Land.'" *South Atlantic Bulletin* 36.4 (1971): 14-20.

Kirschke, Amy Helene. *Aaron Douglas: Art, Race, and the Harlem Renaissance*. Jackson: University Press of Mississippi, 1995.

[Kling, Joseph, ed.]. *A Pagan Anthology: Composed of Poems by Contributors to the PAGAN Magazine*. New York: Pagan, 1918.

Knight, Christopher. "The Barnes Foundation's Alarming Architectural Plans." *Los Angeles Times*, 21 Oct. 2010. http://latimesblogs.latimes.com/culturemonster/2010/10/barnes-foundation-tod-williams-billie-tsien-architecture.html.

Knish, Anne, and Emanuel Morgan [Arthur Davison Ficke and Witter Bynner]. *Spectra: A Book of Poetic Experiments*. New York: Mitchell Kennerley, 1916.

———. "The Spectric School of Poetry." *Forum* (June 1916): 675–78.

Krauss, Rosalind. *The Originality of the Avant-Garde and Other Modernist Myths*. Cambridge, MA: MIT Press, 1985.

Kreymborg, Alfred. *Mushrooms: A Book of Free Forms*. New York: John Marshall, 1916.

———. "Others." *Poetry Journal* 6.4 (Feb. 1917): 141.

———, ed. *Others: An Anthology of the New Verse*. New York: Alfred A. Knopf, 1916.

———, ed. *Others: An Anthology of the New Verse (1917)*. New York: Alfred A. Knopf, 1917.

———, ed. *Others for 1919: An Anthology of the New Verse*. New York: Nicholas L. Brown, 1920.

———. *Our Singing Strength: An Outline of American Poetry (1620–1930)*. New York: Coward-McCann, 1929.

———. Preface. *Others* 5.1 (Jan. 1918): 1.

———. *Troubadour: An Autobiography*. New York: Boni and Liveright, 1925.

Lane, George [pseud. Amy Lowell and John Gould Fletcher]. "Some Imagist Poets." *Little Review* 2.3 (May 1915): 27–35.

Lee, Corinna King. "Recovered from the Thirties." Diss. Cornell University, 2011.

Lemke, Sieglinde. *Primitivist Modernism: Black Culture and the Origins of Transatlantic Modernism*. Oxford: Oxford University Press, 1998.

Lentricchia, Frank. *Modernist Quartet*. Cambridge: Cambridge University Press, 1994.

Le Prade, Ruth, ed. *Debs and the Poets*. Pasadena: Upton Sinclair, 1920.

Levenson, Michael. *A Genealogy of Modernism: A Study of English Literary Doctrine 1908–1922*. Cambridge: Cambridge University Press, 1984.

Levy, Ellen. "Borrowing Paints from a Girl: Greenberg, Eliot, Moore and the Struggle between the Arts." *Modernism/modernity* 17.1 (2010): 1–20.

Lewis, D. B. Wyndham, ed. *The Stuffed Owl: An Anthology of Bad Verse*. London: J. M. Dent and Sons, 1930.

Lewis, David Levering. *When Harlem Was in Vogue*. New York: Oxford University Press, 1979.

Lewis, Stephen E. "The Modern Gallery and American Commodity Culture." *Modernism/modernity* 4.3 (1997): 67–91.

Lindsay, Vachel. *The Congo and Other Poems*. New York: Macmillan, 1914.

Locke, Alain. "African Art in America." *Nation* 124 (16 Mar. 1927): 290.

——. *American Philosophy Today and Tomorrow*. Ed. Horace Kallen and Sidney Hook. New York: L. Furman, 1935.

——. "The Blondiau-Theatre Arts Collection." Exhibition Catalog. Blondiau-Theatre Arts Collection of Primitive African Art. New Art Circle. New York (Feb. 7–Mar. 5, 1927).

——. *The Critical Temper of Alain Locke*. Ed. Jeffrey Stewart. New York: Garland, 1983.

——. "An Exhibition of African Sculpture and Handicraft from the Travelling Collection of Harlem Museum of African Art of New York City." Exhibition Catalog. Carnegie Library of Howard University (3–8 June 1928).

——, ed. *Four Negro Poets*. New York: Simon and Schuster, 1927.

——. "Impressions of Luxor." *Howard Alumnus* 2.4 (May 1924): 74–78.

——, ed. *The New Negro: An Interpretation*. New York: Albert and Charles Boni, 1925.

Locke, Alain, and Montgomery Gregory, eds. *Plays of Negro Life: A Source-Book of Native American Drama*. New York: Harper, 1927.

Longenbach, James. *Stone Cottage: Pound, Yeats, and Modernism*. New York: Oxford University Press, 1988.

Lowell, Amy. "Miss Lowell Not the Editor." *Poetry* 6.1 (Apr. 1915): 52.

——. *Sword Blades and Poppy Seed*. New York: Macmillan, 1914.

——. *Tendencies in Modern American Poetry*. New York: Macmillan, 1917.

Loy, Mina. "Love Songs." *Others* 1.1 (Jul. 1915): 6.

Lukács, Georg. "Realism in the Balance." Trans. Rodney Livingstone. In *Walter Benjamin, Ernst Bloch, Bertolt Brecht, and Georg Lukács. Aesthetics and Politics*. London: Verso, 1980. 28–59.

Lynes, Katherine R. "'A real honest-to-cripe jungle': Contested Authenticities in Helene Johnson's 'Bottled.'" *Modernism/modernity* 14.3 (2007): 517–25.

Lyon, Janet. *Manifestoes: Provocations of the Modern*. Ithaca: Cornell University Press, 1999.

——. "Sociability in the Metropole: Modernism's Bohemian Salons." *ELH* 76 (2009): 687–711.

Maleuvre, Didier. *Museum Memories: History, Technology, Art*. Stanford: Stanford University Press, 1999.

Malraux, André. *The Voices of Silence*. Trans. Stuart Gilbert. Garden City, NY: Doubleday, 1953.

Marek, Jayne E. "Amy Lowell, *Some Imagist Poets*, and the Context of the New Poetry." *Amy Lowell, American Modern*, ed. Adrienne Munich and Melissa Bradshaw. New Brunswick: Rutgers University Press, 2004. 154–66.

Mariani, Paul. *William Carlos Williams: A New World Naked*. New York: McGraw-Hill, 1981.

Marinetti, Filippo Tomasso. "The Founding and Manifesto of Futurism." *Selected Writings*. Ed. R. W. Flint. Trans. R. W. Flint and Arthur A. Coppotelli. New York: Farrar, Straus and Giroux, 1972. 39–44.

[Marsh, Edward], ed. *Georgian Poetry 1911–1912*. London: Poetry Bookshop, 1913.

———, ed. *Georgian Poetry 1920–1922*. London: Poetry Bookshop, 1922.

———. *A Number of People: A Book of Reminiscences*. New York: Harper and Brothers, 1939.

Mason, Theodore O., Jr. "The African-American Anthology: Mapping the Territory, Taking the National Census, Building the Museum." *American Literary History* 10.1 (1998): 185–98.

Masters, Edgar Lee. "The Genesis of Spoon River." *Spoon River Anthology*. New York: Limited Editions Club, 1942. ix–xxx.

Materer, Timothy. "From Henry James to Ezra Pound: John Quinn and the Art of Patronage." *Paideuma* 17.2–3 (1988): 47–68.

Maxwell, William J. *New Negro/Old Left: African-American Writing and Communism between the Wars*. New York: Columbia University Press, 1999.

Maxwell, William J., and Joseph Valente. "Rebirth of the New: Five Easy Theses on Modernism and the Celtic and Harlem Renaissances." Penn Modernist Reading Group, Philadelphia (6 Mar. 2000).

McBride, Henry. "Modern Art." *Dial* 80.2 (Feb. 1926): 170–72.

McGuire, William. *Poetry's Catbird Seat: The Consultantship in Poetry in the English Language at the Library of Congress, 1937–1987*. Washington, DC: Library of Congress, 1988.

McHenry, Elizabeth. *Forgotten Readers: Recovering the Lost History of African American Literary Societies*. Durham: Duke University Press, 2002.

McKible, Adam. *The Space and Place of Modernism: The Russian Revolution, Little Magazines, and New York*. New York: Routledge, 2002.

Mellow, James R. *Charmed Circle: Gertrude Stein and Company*. New York: Praeger, 1974.

"Merion to House Art of 'Radicals.'" *Evening Bulletin* (13 Jan. 1923): n.p.

Meyerowitz, Lisa. "The *Negro in Art Week*: Defining the 'New Negro' through Art Exhibition." *African American Review* 31.1 (1997): 75–89.

Meyers, Mary Ann. *Art, Education, and African-American Culture: Albert Barnes and the Science of Philanthropy*. New Brunswick: Transaction, 2004.

Michaels, Walter Benn. *Our America: Nativism, Modernism, and Pluralism*. Durham: Duke University Press, 1995.

Michelson, Max. "The Independents." Rev. of *Catholic Anthology 1914–1915*, ed. Ezra Pound. *Poetry* 8.2 (May 1916): 94–96.

——. "The Radicals." Rev. of *Others: An Anthology of the New Verse*. *Poetry* 8.3 (Jun. 1916): 151–55.

Miller, Cristanne. "Tongues 'loosened in the melting pot': The Poets of *Others* and the Lower East Side." *Modernism/modernity* 14.3 (2007): 455–76.

Miller, Monica L. *Slaves to Fashion: Black Dandyism and the Styling of Black Diasporic Identity*. Durham: Duke University Press, 2009.

Monaghan, Peter. "Collected Wisdom: A New Wave of Scholarship Examines the Centuries-Old 'Mental Landscape' of Collectors." *Chronicle of Higher Education* (28 Jun. 2002): A17.

Monro, Harold. "The Death of the Poet Laureate." *Poetry and Drama* 1.1 (1913): 136.

H. M. [Monroe, Harriet]. Rev. of Ferdinand Earle, ed., *The Lyric Year*. *Poetry* 1.4 (Jan. 1913): 128–31.

Monroe, Harriet, and Alice Corbin Henderson, eds. *The New Poetry: An Anthology*. New York: Macmillan, 1917.

Montserrat, Dominic. *Akhenaten: History, Fantasy, and Ancient Egypt*. New York: Routledge, 2000.

Moore, Marianne. *Becoming Marianne Moore: The Early Poems, 1907–1924*. Ed. Robin G. Schulze. Berkeley: University of California Press, 2002.

Morrisson, Mark S. *The Public Face of Modernism: Little Magazines, Audiences and Reception, 1905–1920*. Madison: University of Wisconsin Press, 2001.

Mullen, Mary. "An Experiment in Adult Negro Education." *Opportunity* 4.41 (May 1926): 160–61.

Munich, Adrienne, and Melissa Bradshaw, eds. *Amy Lowell, American Modern*. New Brunswick: Rutgers University Press, 2004.

Munro, Thomas. "Good and Bad Negro Art." *Nation* 124 (2 Mar. 1927): 242–43.

Nadell, Martha Jane. *Enter the New Negroes: Images of Race in American Culture*. Cambridge, MA: Harvard University Press, 2004.

Naumann, Francis. "Walter Conrad Arensberg: Poet, Patron, and Participant in the New York Avant-Garde, 1915-1920." *Philadelphia Museum of Art Bulletin* 76.328 (1980): 3–32.

Nelson, Cary. *Repression and Recovery: Modern American Poetry and the Politics of Cultural Memory, 1910–1945*. Madison: University of Wisconsin Press, 1989.

Nelson, James G. *Elkin Mathews: Publisher to Yeats, Joyce, Pound*. Madison: University of Wisconsin Press, 1989.

Newhouse, Victoria. *Art and the Power of Placement*. New York: Monacelli Press, 2005.

North, Michael. *The Dialect of Modernism: Race, Language and Twentieth-Century Literature*. New York: Oxford University Press, 1994.

——. *Reading 1922: A Return to the Scene of the Modern*. New York: Oxford University Press, 1999.

Oberndorf, Clarence P. *A History of Psychoanalysis in America*. New York: Harper Torchbooks, 1953.

O'Brien, Edward J., ed. *The Masque of Poets: A Collection of New Poems by Contemporary American Poets*. New York: Dodd, Mead, 1918.

Outka, Elizabeth. *Consuming Traditions: Modernity, Modernism, and the Commodified Authentic*. Oxford: Oxford University Press, 2009.

Pach, Walter. *American Artists, Authors, and Collectors: The Walter Pach Letters, 1906-1958*. Ed. Bernard B. Perlman. Albany: State University of New York Press, 2002.

Parham, Marisa. "Hughes, Cullen, and the In-Sites of Loss." *ELH* 74 (2007): 429-47.

Parisi, Joseph, and Stephen Young, eds. *Dear Editor: A History of Poetry in Letters: The First Fifty Years, 1912-1962*. New York: W. W. Norton, 2002. 73-84.

Passantino, Erika D., ed. *The Eye of Duncan Phillips: A Collection in the Making*. Washington, DC: Phillips Collection and Yale University Press, 1999.

Passantino, Erika, and Sarah Martin. "Chronology." *Duncan Phillips: Centennial Exhibition*. Washington, DC: Phillips Collection, 1986. 26-46.

A Passion for Art: Renoir, Cézanne, Matisse, and Dr. Barnes. CD-ROM. Belleview, WA: Corbis and Barnes Foundation, 2003.

Paudrat, Jean-Louis. "From Africa." *"Primitivism" in 20th Century Art: Affinity of the Tribal and the Modern*. Vol. 1. Ed. William Rubin. New York: Museum of Modern Art, 1984. 125-75.

Pearce-Moses, Richard. "A Glossary of Archival and Records Terminology." Society of American Archivists. www.archivists.org/glossary/.

Pensky, Max. *Melancholy Dialectics: Walter Benjamin and the Play of Mourning*. Amherst: University of Massachusetts Press, 1993.

Perloff, Marjorie. *The Futurist Moment: Avant-Garde, Avant Guerre, and the Language of Rupture*. Chicago: University of Chicago Press, 2003.

Phillips, Duncan. "The Allied War Salon." *American Magazine of Art* 10.4 (Feb. 1919): 115-23.

———. "Art and Understanding." *Art and Understanding* 1.1. (Nov. 1929): 7-16.

———. "Art and War." *Bulletin of the College Art Association of America* 1.4 (Sept. 1918): 24-37.

———. *The Artist Sees Differently: Essays Based upon the Philosophy of "A Collection in the Making."* New York: E. Weyhe and Phillips Memorial Gallery, 1931.

———. *A Collection in the Making: A Survey of the Problems Involved in Collecting Pictures together with Brief Estimates of the Painters in the Phillips Memorial Gallery*. New York: E. Weyhe and Phillips Memorial Gallery, 1926.

———. "Egyptian Stone Head, 18th Dynasty: The Voice of Many Waters by Augustus Vincent Tack." *Forerunner of the General Convention, A.D. 1928* 2 (Easter 1928) 24.

———. *The Enchantment of Art as Part of the Enchantment of Experience: Fifteen Years Later*. Washington, DC: Phillips Memorial Gallery, 1927.

——. "Fallacies of the New Dogmatism in Art," pt. 1. *American Magazine of Art* 9.2 (Dec. 1917): 43-48.

——. "Fallacies of the New Dogmatism in Art," pt. 2. *American Magazine of Art* 9.3 (Jan. 1918): 101-6.

——. *Honoré Daumier: Appreciations of His Life and Works*. New York: E. P. Dutton, 1922.

——. "Inter-Creating Intelligence, a Symposium." *Art and Understanding* 1.1 (1929): 21-37.

——. "Julian Alden Weir." *Julian Alden Weir: An Appreciation of His Life and Works*. New York: E. P. Dutton, 1922. 3-47.

——. "The Need of Art at Yale." *Yale Literary Magazine* 72 (June 1907): 355-61.

——. "The Phillips Memorial Art Gallery." *Art Bulletin* 3.4 (June 1921): 147-52.

——. "Principles and Practice in American Art." *Yale Review* 14.1 (Oct. 1924): 165-71.

——. "Revolutions and Reactions in Painting." *International Studio* 51.202 (Dec. 1913): cxxiii-cxxix.

——. "Sensibility and Simplification in Ancient Sculpture and Contemporary Painting." *Bulletin of the Phillips Collection* (1927): 7-13.

Phillips, Duncan, and Charles Law Watkins. "Terms We Use in Art Criticism." *Art and Understanding* 1.2 (Mar. 1930): 160-74.

Phillips, Laughlin. Interview by Donita M. Moorhus. Dec. 2003-Jan. 2004. Phillips Collection Oral History Program. Phillips Collection Archives, Washington, DC.

Phillips, Marjorie. *Duncan Phillips and His Collection*. Boston: Little, Brown, 1970.

Phillips Collection. *Master Paintings: The Phillips Collection*. Washington DC: Counterpoint and Phillips Collection, 1998.

——. *The Phillips Collection: A Museum of Modern Art and Its Sources. Catalogue*. New York: Thames and Hudson, 1952.

Phillips Memorial Art Gallery. *Honoré Daumier: Appreciations of His Life and Works*. New York: E. P. Dutton, 1922.

Pound, Ezra. "Albert C. Barnes." *Ezra Pound and the Visual Arts*. Ed. Harriet Zinnes. New York: New Directions, 1980. 309-10.

——, ed. *Catholic Anthology 1914-1915*. London: Elkin Mathews, 1915.

——, ed. *Des Imagistes: An Anthology*. New York: Albert and Charles Boni, 1914.

——. "A Few Don'ts by an *Imagiste*." *Poetry* 1.6 (Mar. 1913): 200-206.

——. "How to Read." *Literary Essays*. Ed. T. S. Eliot. New York: New Directions, 1935. 15-40.

——. *The Letters of Ezra Pound, 1907-1941*. Ed. D. D. Paige. New York: Harcourt, Brace, 1950.

——. *The Letters of Ezra Pound to Alice Corbin Henderson*. Ed. Ira B. Nadel. Austin: University of Texas Press, 1993.

——. *Pound/Joyce: The Letters of Ezra Pound to James Joyce, with Pound's Essays on Joyce*. Ed. Forrest Read. New York: New Directions, 1967.

———, ed. *Profile: An Anthology Collected in MCMXXXI.* Milan: Giovanni Scheiwiller, 1932.

———. *Selected Prose, 1909-1965.* Ed. William Cookson. New York: New Directions, 1973.

———. "Status Rerum." *Poetry* 1.4 (Jan. 1913): 123-27.

Pound, Ezra, and Louis Zukofsky, *Pound/Zukofsky: Selected Letters of Ezra Pound and Louis Zukofsky.* Ed. Barry Ahearn. New York: New Directions, 1987.

Price, Leah. *The Anthology and the Rise of the Novel: From Richardson to George Eliot.* Cambridge: Cambridge University Press, 2000.

Qian, Zhaoming. *Orientalism and Modernism: The Legacy of China in Pound and Williams.* Durham: Duke University Press, 1995.

Rabaté, Jean-Michel. *The Ghosts of Modernity.* Gainesville: University of Florida Press, 1996.

Rainey, Lawrence. *Institutions of Modernism: Literary Elites and Public Culture.* New Haven: Yale University Press, 1998.

———. "The Price of Modernism: Reconsidering the Publication of *The Waste Land.*" *Yale Review* 78.2 (1989): 279-300.

Rampersad, Arnold. *The Life of Langston Hughes.* 2 Vols. New York: Oxford University Press, 1986, 1988.

Rathbone, Eliza E. *Duncan Phillips: Centennial Exhibition.* Washington DC: Phillips Collection, 1986.

Reed, Christopher. *Bloomsbury Rooms: Modernism, Subculture, and Domesticity.* New Haven: Yale University Press, 2004.

Reed, Ishmael. *Mumbo Jumbo.* New York: Scribner, 1972.

Reid, B. L. *The Man from New York: John Quinn and His Friends.* New York: Oxford University Press, 1968.

Reif, Rita. "Spring Series of Art Auctions May Top $1 Billion in Sales." *New York Times* (8 May 1990): C18.

Reimonenq, Alden. "Countee Cullen's Uranian 'Soul Windows.'" *Critical Essays: Gay and Lesbian Writers of Color.* Ed. Emmanuel S. Nelson. Spec. issue of *Journal of Homosexuality* 26.2-3 (1993): 143-65.

Rewald, John. *Cézanne and America: Dealers, Collectors, Artists and Critics 1891-1921.* Princeton: Princeton University Press, 1989.

Riding, Laura, and Robert Graves. *A Survey of Modernist Poetry and a Pamphlet against Anthologies.* Manchester: Carcanet, 2002.

Roberts, Mary Fanton. "The Touchstone." *Arts* 1.7 (Aug.-Sept. 1921): 25-26.

Robins, Gay. *The Art of Ancient Egypt.* Cambridge, MA: Harvard University Press, 1997.

Rodgers, Timothy Robert. "Alfred Stieglitz, Duncan Phillips and the '$6000 Marin.'" *Oxford Art Journal* 15.1 (1992): 54-66.

Rogers, Timothy, ed. *Georgian Poetry, 1911-1922: The Critical Heritage.* London: Routledge & Kegan Paul, 1977.

Rosenberg, Rachel A. "Looking for Zora's *Mule Bone*: The Battle for Artistic Authority in the Hughes-Hurston Collaboration." *Modernism/modernity* 6.2 (1999): 79–105.

Rosenblum, Robert. "Resurrecting August Vincent Tack." *The Abstractions of Augustus Vincent Tack (1870–1949)*. New York: M. Knoedler, 1986. 2–4, 15.

Ross, Alex. *The Rest Is Noise: Listening to the Twentieth Century*. New York: Picador, 2007.

Ross, Robert H. *The Georgian Revolt, 1910–1922: Rise and Fall of a Poetic Ideal*. Carbondale: Southern Illinois University Press, 1965.

Saarinen, Aline B. *The Proud Possessors: The Lives, Times and Tastes of Some Adventurous American Art Collectors*. New York: Random House, 1958.

Saint-Amour, Paul K. *The Copywrights: Intellectual Property and the Literary Imagination*. Ithaca: Cornell University Press, 2003.

Schauffler, Robert Haven, ed. *The Poetry Cure: A Pocket Medicine Chest of Verse*. New York: Dodd, Mead, 1925.

Schomburg, Arthur A. *A Bibliographic Checklist of American Negro Poetry*. New York: Charles F. Heartman, 1916.

[L.S.] Simonson, Lee. "The Land of Sunday Afternoon." *New Republic* 1.3 (21 Nov. 1914): 22–23.

——. "Refugees and Mausoleums." *New Republic* 1.10 (9 Jan. 1915): 24–25.

Simpson, David. "Raymond Williams: Feeling for Structures, Voicing 'History.'" *Social Text* 30 (1992): 9–26.

Sinclair, Upton, ed. *The Cry for Justice: An Anthology of the Literature of Social Protest*. Philadelphia: John C. Winston, 1915.

Sinnette, Elinor. *Arthur Alfonso Schomburg, Black Bibliophile and Collector: A Biography*. New York: New York Public Library and Wayne State University Press, 1989.

Smart, Pamela G. "Possession: Intimate Artifice at the Menil Collection." *Modernism/modernity* 13.1 (Jan. 2006): 765–85.

Smith, William Jay. *The Spectra Hoax*. Middletown, CT: Wessleyan University Press, 1961.

Snead, James A. "Repetition as a Figure of Black Culture." *Black Literature and Literary Theory*. Ed. Henry Louis Gates, Jr. New York: Routledge, 1990. 59–80.

Société Anonyme (The First Museum of Modern Art: 1920–1944): Selected Publications. 3 vols. New York: Arno Press, 1972.

Some Imagist Poets: An Anthology. Boston: Houghton Mifflin, 1915.

Some Imagist Poets 1916: An Annual Anthology. Boston: Houghton Mifflin, 1916.

Songs and Sonnets for England in War Time: Being a Collection of Lyrics by Various Authors Inspired by the Great War. London: John Lane, 1914.

Spiegel, Ruth, ed. *The Phillips Collection in the Making, 1920–1930*. Washington, DC: Smithsonian Institution and Phillips Collection, 1979.

Stansell, Christine. *American Moderns: Bohemian New York and the Creation of a New Century*. New York: Metropolitan, 2000.

Stavitsky, Gail. "A. E. Gallatin's Gallery and Museum of Living Art." *American Art* 7.2 (1993): 46-63.

Stein, Gertrude. *Selected Writings*. Ed. Carl Van Vechten. New York: Vintage, 1990.

Stein, Leo. "The Art in Painting." Rev. of Albert C. Barnes, *The Art in Painting*. *New Republic* (2 Dec. 1925): 56-57.

Steiner, Christopher. "Discovering African Art . . . Again." *African Arts* 29.4 (Autumn 1996): 1-8.

Taggard, Genevieve, ed. *May Days: An Anthology of Verse from Masses-Liberator*. New York: Boni and Liveright, 1925.

Taruskin, Richard. *Stravinsky and the Russian Traditions: A Biography of the Works through* Mavra. Vol. 1. Berkeley: University of California Press, 1996.

Thacker, Andrew. "Amy Lowell and H. D.: The Other Imagists." *Women: A Cultural Review* 14.1 (1993): 49-59.

Thaggert, Miriam. *Images of Black Modernism: Verbal and Visual Strategies of the Harlem Renaissance*. Amherst: University of Massachusetts Press, 2010.

"Three Masks from the Blondiau-Theatre Arts Collection." *Theatre Arts* 11.3 (Mar. 1927): 181-83.

Thurman, Wallace. *Infants of the Spring*. Boston: Northeastern University Press, 1992.

Toobin, Jeffrey. "Onward and Upward with the Arts: Battle for the Barnes." *New Yorker* (21 Jan. 2002): 34-39.

Topia, André. "The Matrix and the Echo: Intertextuality in *Ulysses*." *Post-Structuralist Joyce*. Ed. Derek Attridge and Daniel Ferrer. Cambridge: Cambridge University Press, 1984. 103-25.

Untermeyer, Louis, ed. *Modern American Poetry*. New York: Harcourt, 1919.

Van Vechten, Carl. *"Keep A-Inchin' Along": Selected Writings of Carl Van Vechten about Black Art and Letters*. Ed. Bruce Kellner. Westport, CT: Greenwood Press, 1979.

———. *Letters of Carl Van Vechten*. Ed. Bruce Kellner. New Haven: Yale University Press, 1987.

von Hallberg, Robert. "Libertarian Imagism." *Modernism/modernity* 2.2 (1995): 63-79.

Voyce, Stephen. " 'Make the World Your Salon': Poetry and Community at the Arensberg Apartment." *Modernism/modernity* 15.4 (2008): 627-46.

Wardwell, Allen. *African Sculpture from the University Museum*. Philadelphia: Philadelphia Museum of Art, 1986.

Watson, Forbes. "The Barnes Foundation," pt. 1. *Arts* 3.1 (Jan. 1923): 9-22.

———. "Le Déjeuner des Canotiers." *Arts* 5.4 (Apr. 1924): 203.

Watson, Steven. *Strange Bedfellows: The First American Avant-Garde*. New York: Abbeville Press, 1991.

Wattenmaker, Richard J. *American Paintings and Works on Paper in the Barnes Founda-tion*. Merion, PA: Barnes Foundation in association with Yale University Press, 2010.

Weinberg, Jonathan. "'Boy Crazy': Carl Van Vechten's Queer Collection." *Yale Journal of Criticism* 7.2 (1994): 25-49.

Wheeler, W. Reginald, ed. *A Book of Verse of the Great War*. New Haven: Yale University Press, 1917.

White, Newman Ivey, and Walter Clinton Jackson, eds. *An Anthology of Verse by American Negroes*. Durham: Trinity College Press, 1924.

Wilkinson, Marguerite, ed. *Contemporary Poetry*. New York: Macmillan, 1923.

——. *New Voices: An Introduction to Contemporary Poetry*. New York: Macmillan, 1919.

Williams, Ellen. *Harriet Monroe and the Poetry Renaissance: The First Ten Years of "Po-etry," 1912-22*. Urbana: University of Illinois Press, 1977.

Williams, Raymond. "Crisis in English Studies." *The Raymond Williams Reader*. Ed. John Higgins. Oxford: Blackwell, 2001. 249-65.

——. *Keywords: A Vocabulary of Culture and Society*. Rev. ed. New York: Oxford University Press, 1983.

——. *Marxism and Literature*. Oxford: Oxford University Press, 1977.

——. *The Politics of Modernism: Against the New Conformists*. London: Verso, 1989.

Williams, William Carlos. *The Autobiography of William Carlos Williams*. New York: Random House, 1951.

——. "The Great Opportunity." *Egoist* 4.7 (Aug. 1917): 137.

W.C.W. [Williams, William Carlos]. "On First Opening *The Lyric Year*." *Poetry* 2.3 (Jun. 1913): 114-15.

Winkiel, Laura. *Modernism, Race, and Manifestos*. Cambridge: Cambridge University Press, 2008.

Wood, Clement. "The Charlie Chaplins of Poetry." *Independent* (12 Jan. 1918): 64, 76.

Work, Frederick J. *Folk Songs of the American Negro*. Nashville: Work Bros. & Hart, 1907.

Work, John Wesley. *Folk Song of the American Negro*. Nashville: Press of Fisk University, 1915.

"The World of Art: The Greatest of the Renoirs Acquired for America." *New York Times* (9 Dec. 1923): SM8, 12.

Yates, Frances A. *The Art of Memory*. Chicago: University of Chicago Press, 1966.

Yount, Sylvia. "Rocking the Cradle of Liberty: Philadelphia's Adventures in Modern-ism." *To Be Modern: American Encounters with Cézanne and Company*. Ed. Sylvia Yount and Elizabeth Johns. Philadelphia: Museum of American Art of the Penn-sylvania Academy of the Fine Arts, 1996. 9-25.

Zilczer, Judith. "The Dispersal of the John Quinn Collection." *Archives of the American Art Journal* 19.3 (1979): 15-21.

———. "John Quinn and Modern Art Collectors in America, 1913-1924." *American Art Journal* 14.1 (1982): 56-71.

———. *"The Noble Buyer": John Quinn, Patron of the Avant-Garde.* Washington, DC: Hirshhorn Museum and Sculpture Garden and Smithsonian Institution Press, 1978.

Zukofsky, Louis, ed. *An "Objectivists" Anthology.* Var, France: Le Beaussett, 1932.

Index

Abbott, Charles D., 215, 218. *See also* Poetry Collection

Academy of Natural Sciences (Philadelphia), 137, 262n102

Acrobat and Young Harlequin (Picasso), 260n78

Adorno, Theodor, 251n56

African American anthologies, 23-25; *Anthology of Verse by American Negroes,* 166-67, 169, 180; *Book of American Negro Poetry,* 166, 169-73, 180-82, 274n119; *Negro Poets and Their Poems,* 166, 167-69, 180, 191. See also *The New Negro*

African American art: and Barnes, 124; and Barnes Foundation, 260n82; and Egyptian art, 251-52n65; and Phillips Memorial Gallery, 260n82

African art, 251-52n65; and "Bottled," 201-2, 205; contemporary, 124, 259n53; and *Ebony and Topaz,* 195; Harlem Museum of African Art, 159, 179, 196-201, 202, 272-73n107, 273n109, 273n113; and "Heritage," 189-90; and Locke, 157, 197-99; and Charlotte Osgood Mason, 202, 273n113; modernist appropriation of, 178-80; and *The New Negro,* 180, 181, 182; and Quinn sales, 260n84; racist portrayals of, 94-95, 123-24, 258-59n50. *See also* Barnes Foundation and African art

Aiken, Conrad, 37, 43, 69, 238n34, 239n44, 240n61, 241n83, 246n150

Akhenaten, 97-102, 101, 252n68, 252n82, 253n83, 253n92

Albright Gallery (Buffalo), 201

Aldington, Richard, 34, 39, 43, 45, 237n16, 239n38

Alexander, Lewis, 271n69

Allied War Salon, 74, 75

Alvarez, A., 218

America Arraigned! (Cheyney & Trent), 209

American Anthology (Stedman), 229n8

American Art News, 129

American Artists (Cortissoz), 247-48n22

American Federation of the Arts, 47-48, 90

American Indian literature, 160-62, 266n14

American Poetry, 36-38, 69-70, 163, 246n150

anarchism, 48, 50, 51, 75-76

Anderson, John, 106-7

Anderson, Margaret, 64, 267n18

Anthologie Nègre (Cendrars), 179, 189, 193, 195, 271n73

anthology form: and *American Poetry,* 36-38, 69-70, 246n150; and archives, 4, 216, 275n24; and art collections, 4, 36-37, 158; Brooke on, 234n62; cemetery metaphor for, 32-33; and collective identity, 20-21, 159-60, 179; and collector's role, 22, 38; and cultural authority, 19, 21; and little magazines, 16, 40-41, 238n33; and Lowell, 16, 20, 35-36, 44-45; Lukács on, 25-26; and *The Lyric Year,* 29-33, 34, 36, 37, 236n7; and *The Masque of Poets,* 68-69, 160; and patriotism, 22, 235n81; and Phillips, 102-3; and politics, 162-66, 209, 211, 267n18, 267n24, 267-68n30, 274n1, 274-75n8; and Pound, 20, 234n65; as provisional institution, 16, 242n81; and race, 23-25; Riding and Graves on, 21-24, 26, 38, 68, 210, 211, 235n77; and social engagement, 16, 33, 233n56, 237n13, 242n84, 275n10; and Spectra hoax, 20-21,

anthology form (*cont.*)
24, 64-68, 234n62; and *Spoon River
Anthology,* 38-39, 237-38n24. *See also*
Pound-Lowell competition; *specific
anthologies*
Anthology of Jewish Poetry (Friedlander), 64
Anthology of Revolutionary Poetry (Graham),
209, 274n1
Anthology of Verse by American Negroes
(White & Jackson), 166-67, 169, 180
anthropology, 1, 133-34, 261-62n102
Antliff, Allan, 75-76
Apollinaire, Guillaume, 130, 179
Arcades Project (Benjamin), 1, 26-27, 229n3,
235n90
archives, 2, 214-28, 229n2; and anthology
form, 4, 216, 275n24; and author self-
documentation, 224-28, 278n53; Poetry
Collection, 214, 215-18, 226-28,
275nn20-21, 275nn23-24, 276n40,
278n55. *See also* James Weldon Johnson
Memorial Collection
Arensberg, Louise, 52, 242n87
Arensberg, Walter Conrad: and African art,
94; collection of, 52, 233n51, 242n87;
and Grantwood colony, 55; and *Others,*
52-54, 62; and Quinn sales, 10
Argott, Don, 106-7
Armory Show (1913): and anthology form,
37; and Ashcan School, 126; and Barnes
Foundation, 128; and market influences,
10; and *Nude Descending a Staircase,* 30,
230n21; and Phillips, 73, 74, 75; and poli-
tics, 76, 247n20; and Quinn, 8, 128
Arnheim, Rudolf, 218
Arp, Jean, 82
arrangement. *See* collection arrangement
Art and Education (Barnes Foundation), 102-3
Art and Understanding, 86, 103, 250-51n52
Art as Experience (Dewey), 112, 113, 117-18,
119-20, 199
art collections: and anthology form, 4,
36-37, 158; museum acquisition of, 15,
232-33n51. *See also* Barnes Foundation;
Phillips Memorial Gallery; Quinn sales
Art Held Hostage (Anderson), 106-7
The Art in Painting (Barnes), 112-17, 119, 121,
132, 139, 141, 255n13, 256n26, 256-57n28,
258n38. *See also* Barnes' aesthetic theory

Art Institute of Chicago, 201, 233n51
Art News, 231n32
The Art of the Steal (Argott), 106-7
Artists League, 102, 103
Arts, 129, 131, 198
Ashcan School, 126
Ask Your Mama (Hughes), 271n80
association value, 221, 223-24, 277n44
"Astigmatism" (Lowell), 44-45, 157
Austin, Alfred, 18, 19
Austin, Mary, 161, 162, 172, 266n14
author self-documentation, 224-28, 278n53
authored nature of collections, 6, 39, 111,
220. *See also* collector's role
avant-garde: and *Catholic Anthology,* 49; and
Celtic Revival, 269n48; and collective
identity, 51; and *Georgian Poetry,* 17; and
imagism, 49, 237n15; and Marinetti, 34;
and *The New Negro,* 176, 177, 178; and
Others, 51, 57, 58, 63; and Phillips Memo-
rial Gallery, 7, 45, 86, 91, 99, 104, 250n44;
and politics, 75, 76; and Quinn sales, 9
Avery, Milton, 72

Bagnall, Robert W., 195
Baker, Houston A., Jr., 266n4
Baltimore Museum of Art, 233n51
Barnes, Albert: *The Art in Painting,* 112-17, 119,
121, 139, 141, 255n13, 256n26, 256-57n28,
258n38; class background of, 107, 109,
247n6, 254nn2-3; and De Mazia, 152,
265n126; and Exhibition of Paintings and
Drawings Showing the Later Tendencies
in Art, 129-30; "How to Judge a Paint-
ing," 128-29; and Locke, 108, 156, 178;
"Negro Art and America," 156; and Phil-
lips, 73; and Quinn sales, 250n47. *See
also* Barnes' aesthetic theory; Barnes
Foundation
Barnes' aesthetic theory, 112-21; and Bour-
dieu, 118-19, 120, 257n32, 257n37; and
collection arrangement, 139, 141, 142-43,
263n112; and collector's role, 128-29; and
Contemporary European Paintings and
Sculpture Exhibition, 132; and education,
116-17; and form, 95, 120-22, 257-58n38,
258nn39-40, 258n42; and Freudian psy-
chology, 110-11, 124-25, 139, 143, 144-46,
255n19, 262n109; and labor, 113-15,

256n27; Pound on, 114, 256n26; and pragmatism, 110-11, 112-13, 117-21, 123, 128, 139, 256n21, 256n27, 257n33; and social engagement, 115; Stein on, 256-57n28

Barnes Foundation, 106-55; and African American art, 260n82; artists exhibited, 107, 126-27, 128, 254nn4-5; Center City move plans, 107-8, 154, 155, 254n6, 264n118; collection development, 126-29, 130-31, 260n78; collector's role, 14, 111, 138-39, 145-46, 148, 149-54, 265n123, 267n127; controversies about, 106-7; and cultural authority, 108, 115, 130, 156; and education, 109-10, 116-17, 128, 134, 135, 137-38, 256n26, 257n30; inauguration of, 135; and New Negro movement, 108, 124-25, 133, 156, 259n57; and Phillips Memorial Gallery, 87, 108-9, 130; as provisional institution, 6, 7, 13-14, 125, 129, 159; and social engagement, 6, 7, 13-14, 115, 125, 129, 131, 132-33, 159, 260n82; University of Pennsylvania negotiations, 134-37, 261n90. See also Barnes, Albert

Barnes Foundation and African art: and Barnes' aesthetic theory, 115; and collection arrangement, 125-26, 127, 146, 148-49, 150, 180, 265n122; and collector's role, 152, 153; and Gikandi, 261n87; and Guillaume, 131, 258n48; and Locke, 197, 198, 199-200, 272-73n107; pragmatist primitivism, 122-25, 148; and racist portrayals, 94-95, 123-24, 258-59n50; and social engagement, 132-33, 260n82; and University of Pennsylvania negotiations, 136-37

Barnes Foundation collection arrangement, 137-54, 264n115; and African art, 125-26, 127, 146, 148-49, 150, 180, 265n122; and Barnes' aesthetic theory, 139, 141, 142-43, 263n112; and Center City move plans, 107-8, 154, 254n6, 264n118; and collector's role, 138-39, 145-46, 148, 149-54, 265n123, 265n127; and education, 137-38; European antecedents of, 139, 262n110; and Freudian psychology, 139, 144-46, 264n117, 264-65n121; and heterogeneity, 107, 254n5; and Joy of Life, 140, 262-63n111; and The New Negro, 180, 183

Barr, Alfred H., Jr., 71, 117, 246n1, 250n44
Bartlett, Helen Birch, 233n51
Bartók, Béla, 229n5
Bather and Maid (Renoir), 140
Bathers (Renoir), 263n115
Baudrillard, Jean, 2, 14
Beal, Gifford, 74
Bell, Clive, 258-59n50
Bellows, George, 74
Benedict, Barbara, 14
Benjamin, Walter: Arcades Project, 1, 26-27, 229n3, 235n90; on museums, 15, 233n52; and quotations, 1; "The Work of Art in the Age of Its Technological Reproducibility," 214
Bennett, Gwendolyn, 108, 156, 270n61
Berenson, Bernard, 117
Bernheim-Jeune gallery, 126
Bibliographic Checklist of American Negro Poetry (Schomberg), 166, 182
The Big Sea (Hughes), 266n7
Birnbaum, Michele, 222, 225
Black Mischief (Waugh), 276n40
Blake, William, 191, 192
Bliss, Lillie P., 213, 232-33n51
Blondiau-Theatre Arts Collection of Primitive African Art, 197-200, 201, 205
Bloomsbury Rooms (Reed), 80
Blue Nude (Matisse), 8, 230n21
Blue Still Life (Matisse), 260n78
Boas, Franz, 1, 124, 160, 204
Bodenheim, Maxwell, 41, 42, 63, 68, 69, 164
Boeckel, Florence Brewer, 102
bohemian salon formation, 51, 55-57, 80-81, 243n100, 243n104
"The Bomb Thrower" (Sexton), 168, 268n41
Le bonheur de vivre (Matisse). See The Joy of Life
Boni, Albert, 20, 29, 241n77, 270n58
Boni, Charles, 20, 29, 241n77
Boni and Liveright, 160, 162
Bonnard, Pierre, 72, 90, 91, 93, 94, 150-51
Bontemps, Arna, 218-19, 220, 221
Book of American Negro Poetry (J. W. Johnson), 166, 169-73, 180-82, 274n119
Book of American Negro Spirituals (J. W. Johnson), 268n32
Bookman, 68
Bornstein, George, 180

"The Boston Evening Transcript" (Eliot), 238n35
"Bottled" (H. Johnson), 157, 196, 201-8
Bourdieu, Pierre, 5, 52, 110, 118-19, 120, 257n32, 257n37
Boy in a Red Vest (Cézanne), 263-64n115
Boy with Skull (Cézanne), 140
Bradshaw, Melissa, 48-49, 240n55
Braithwaite, William Stanley, 30, 42, 45, 51-52, 56, 69, 211, 240n61
Brâncuşi, Constantin, 10
Braque, Georges, 72, 90, 91, 92, 251n55
Breasted, James Henry, 97, 98-101, 133, 252n79, 252n81, 253n83
Bridges, Robert, 19, 64
Bring in 'da Noise, Bring in 'da Funk, 206
Brinkman, Bartholomew, 181
Brooke, Rupert, 16, 17, 234n62
Brooks, Cleanth, 213
Brooks, Van Wyck, 6, 184
Brown, Bob, 51, 61, 275n8
Brown, Sterling, 1, 166, 225-26, 277n43
Bruce, Edward, 93
Brummer, Joseph, 11, 94, 231n37
Bryant, Marsha, 100
Buermeyer, Laurence, 112, 115, 117, 128, 134, 137
Buffalo Collection. *See* Poetry Collection
Bürger, Peter, 86
Burlin, Natalie Curtis, 1, 160, 268n32
Buzzi, Paolo, 17, 29
Bynner, Witter, 20, 65, 66, 69, 246n145. *See also* Spectra hoax

Calo, Mary Ann, 198
Camp, Kimberly, 265n126
Cannéll, Kathleen, 55
Cannéll, Skipwith, 34, 55
canonical anthologies. *See* historical anthologies
Cantos (Pound), 1, 229n3
Capitein, Jacobus Eliza, 183, 184
The Card Players (Cézanne), 107
Carnegie International exhibition, 36, 37
Caroling Dusk (Cullen), 196, 201, 207
Carpenter, Edward, 271n69
Casement, Roger, 246n149
Cather, Willa, 161
Catholic Anthology (Pound): arrangement of, 41-42, 238-39n36; contributors, 39,

40-41, 238nn34-35, 239n38; cover of, 49, 66; and *The New Poetry,* 159; and Pound-Lowell competition, 39, 40, 45, 238n29; and *Profile,* 274n5; reception of, 20, 42, 238n34; and World War I, 238n29
Celtic revival, 171-72, 174, 175, 269n48
cemetery metaphor for collecting, 12-13, 32-33
Cendrars, Blaise, 179, 189, 193, 195, 271n73
Century Association, 74
Cézanne, Paul: and Barnes Foundation, 107, 108, 126, 127, 128, 130, 140, 259n62, 263-64n115; and market influences, 250n47; and Phillips Memorial Gallery, 88, 89, 93, 94
Cézanne, Paul, works: *Boy in a Red Vest,* 263-64n115; *Boy with Skull,* 140; *The Card Players,* 107; *Gardener,* 263-64n115; *Girl with a Basket of Fish,* 263-64n115; *Girl with a Basket of Oranges,* 263-64n115; *Madame Cézanne,* 127; *Mont Saint-Victoire* paintings, 89, 126, 140-41, 142-43; *Reclining Nude,* 263n115; *Red Earth,* 263n115; *Road at Marines,* 140; *Still Life with a Skull,* 140-41; *Still Life with Bottle, Tablecloth, and Fruits,* 259n62; *Woman in a Green Hat,* 128, 263-64n115
Chardin, Jean-Baptiste-Siméon, 91
Cheney, Sheldon, 232n44
Chesterton, G. K., 233n58
Cheyney, Ralph, 209, 246n145
Churchill, Suzanne, 52, 55, 62, 64, 65, 66, 245n124
The Circus (Seurat), 10
Civilization in the United States (Stearns), 170
Clarke, Christa J., 198
class: and Barnes Foundation, 109-10; in "Bottled," 206; and collector backgrounds, 48-49, 73-74, 107, 109, 247n6, 254nn2-3; and public, 7, 14, 109-10
Clauson, J. Earl, 64
Clay, Frederick, 233n51
Clifford, James, 27
Clown in Top Hat (Rouault), 152
Coetzee, J. M., 1, 229n3
Coicou, Massilon, 172
Cold War, 105
collage, 1
collecting as theme, 2, 26, 229n6, 235n88

collection arrangement: *Book of American Negro Poetry,* 180-82; *Catholic Anthology,* 41-42, 238-39n36; and collection as provisional institution, 6; *Des Imagistes,* 34-35, 182, 237n16; James Weldon Johnson Memorial Collection, 218, 222-24, 277n50; *May Days,* 267-68n30; Metropolitan Museum of Art, 79; Museum of Modern Art, 78-79, 81; *Negro Poets and Their Poems,* 168, 180; *The New Negro,* 159, 180-85, 270nn57-58; Phillips Memorial Gallery, 78-82, 91-93, 138, 248-49n33, 251n56; Société Anonyme, 72, 78, 82, 248-49n33; *Some Imagist Poets,* 41. *See also* Barnes Foundation collection arrangement

collection as intervention. *See* social engagement

collection as provisional institution, 3, 7-8, 27-28; and anthology form, 16, 242n84; and archives, 227-28; and Barnes Foundation, 6, 7, 13-14, 125, 129, 159; and collective identity, 243-44n107; and museums, 12, 13, 232n43; and *The New Negro,* 7, 159, 174; and *Others,* 57, 62-64, 242n84; and Phillips Memorial Gallery, 88, 249n42; and Quinn, 12, 13, 232n44; and race, 6. *See also* social engagement

A Collection in the Making (Phillips), 87, 88, 89, 92, 93, 103

collective identity, 243n96; and anthology form, 20-21, 159-60, 179; and bohemian salon formations, 51, 55-57; and *Des Imagistes,* 35-36; formations, 51, 57-58, 61, 243n100, 243-44n107, 244n108; and "Heritage," 190-91; and imagism, 34, 44, 237n15; and *The New Negro,* 157-59, 176-79, 270n54; and *Others,* 50-51, 55, 57-58, 60, 61, 243n100; and Société Anonyme, 57-58, 244n108; and Spectra hoax, 20-21, 65, 178

collectivity. *See* collective identity

collector's role, 2-3; and Akhenaten, 101, 252n82; and anthology form, 22, 38; and Barnes' aesthetic theory, 128-29; Barnes Foundation, 14, 111, 138-39, 145-46, 148, 149-54, 265n123, 265n127; Benjamin on, 27, 235n90; *Des Imagistes,* 5, 34, 35, 38, 39, 45, 237n19; influence on production,

5, 86, 185-87, 216, 249n41; James Weldon Johnson Memorial Collection, 218-19, 220-22, 225, 277nn46-47; and mediation, 6, 230n15; *The New Negro,* 5, 185-87, 195; *Others,* 56-57, 58-59, 61-62, 63-64; Phillips Memorial Gallery, 5, 86, 92, 249n41; Poetry Collection, 216; *Profile,* 210; and Quinn sales, 11-12, 231n36; Riding and Graves on, 22; Société Anonyme, 63-64; *Some Imagist Poets,* 43, 44, 239-40n51

Color (Cullen), 186, 246n145

Colum, Padraic, 64, 69, 246n149

company schools, 257n30

Composition: The Peasants (Picasso), 132

Cone, Claribel, 233n51

Cone, Etta, 233n51

"The Congo" (Lindsay), 192, 193, 271n78, 271n80

The Congo and Other Poems (Lindsay), 276-77n40

Conjugal Life (La Fresnaye), 149-50, 151

The Conquest of Civilization (Breasted), 98-99

Conrad, Joseph, 9, 26, 235n88, 276n40

Conroy, Jack, *Unrest,* 209, 246n145

Contemporary Verse, 40

contributors: Barnes Foundation, 107, 126-27, 128, 254nn4-5; *Book of American Negro Poetry,* 172; *Catholic Anthology,* 39, 40-41, 238nn34-35, 239n38; *Georgian Poetry,* 233n58; James Weldon Johnson Memorial Collection, 221; *The Masque of Poets,* 69; *The New Negro,* 173; *Others,* 51-52, 53, 57, 61, 245n121; Phillips Memorial Gallery, 74, 87-93, 250n51, 250-51n52, 251n55, 251n60; Poetry Collection, 215-16, 275n23, 276n40; *Some Imagist Poets,* 43, 239n45

Conversation Piece: Masqueraders (Longhi), 152-53

"Cool Tombs" (Sandburg), 22

Corbett, David Peters, 244n107

Corot, Jean-Baptiste-Camille, 126

Cortissoz, Royal, 247-48n22

cosmopolitanism. *See* internationalism

coteries. *See* collective identity

The "Country Life" Anthology (Graham), 64

Courbet, Gustave, 144, 147

Cowboy Songs (Lomax), 64

Cowley, Malcolm, 245n141

Crane, Hart, 68, 161
Crapsey, Adelaide, 61
"The Creation" (J. W. Johnson), 169, 177, 269n44
Cret, Paul, 134
Crisis, 192, 219
Cronyn, George W., 160-62, 171-72, 268n32
The Cry for Justice (Sinclair), 267n18
Cullen, Charles, 195
Cullen, Countee: and Bynner, 246n145; Caroling Dusk, 196, 201, 207; and collective identity, 178, 270n54; Color, 186, 246n145; and homosexuality, 186, 271n69; and Poetry Collection, 216; Riding and Graves on, 23; and "Saturday Nighters," 56; "The Shroud of Color," 185. See also "Heritage"
cultural authority, 4; and African art, 200; and anthology form, 19, 21; and Barnes Foundation, 108, 115, 130, 156; and definitions of modernism, 15-16, 233n55; Dewey on, 117-18, 257n33; and Georgian Poetry, 18-19, 234n69, 234-35n70; and institutional fluidity, 2, 229-30n8; and The Lyric Year, 31, 32, 33; and Museum of Modern Art, 212-13; and New Negro movement, 156, 158; and Phillips Memorial Gallery, 71; and Poet Laureate, 18-19, 234n69; and Quinn sales, 9; and Spectra hoax, 66; and Understanding Poetry, 213
cultural nationalism: and The New Negro, 157, 175-76, 242n95; and Others, 242n95
Cummings, E. E., 24, 164
Cunard, Nancy, 7, 173, 210-12, 226-27, 228, 251n65, 278n55
Cunliffe, J. W., 64

Dada, 52
Daumier, Honoré, 91, 127, 250n51
Davies, Arthur B., 126
Davies, Mary Carolyn, 55, 68
De Chirico, Giorgio, 143-44, 148, 149, 150, 152, 153, 154
de la Mare, Walter, 18
de Mazia, Violette, 138, 139, 152, 154, 262n103, 265n126
de Zayas, Marius, 95, 123-24, 131, 258-59n50
Debs, Eugene, 267n18
Debs and the Poets, 246n145, 267n18
Degas, Edgar, 126

Le Déjeuners des Canotiers (Renoir), 73, 88-89, 108, 247n7
Delacroix, Eugène, 91
Dell, Floyd, 51, 162
Democracy and Education (Dewey), 110, 112
Demuth, Charles, 57, 90, 93, 126
Derain, André, 90
Dercum, Francis X., 111, 129-30
Derrida, Jacques, 277n46
Des Imagistes (Pound), 33-36; arrangement of, 34-35, 182, 237n16; and art collections, 37; and Catholic Anthology, 42; and collective identity, 35-36; collector's role, 5, 34, 35, 38, 39, 45, 237n19; and The Lyric Year, 29; and male dominance, 234n65; and The New Poetry, 159; and Others, 53; and Profile, 274n5; reception of, 29; and social engagement, 33; and sources, 34, 47, 237n16; as successor to Georgian Poetry, 20, 29; successors to, 65; and Williams, 33, 34-35
Dewey, John, 114; Art as Experience, 112, 113, 117-18, 119-20, 199; and Barnes Foundation inauguration, 135; and Barnes' seminars, 112-13; and Buermeyer, 128; on cultural code, 119-20; Democracy and Education, 110, 112; departure from Barnes Foundation, 137; and Freudian psychology, 111; on habit, 118, 257n33; on labor, 115, 256n27; and Locke, 199, 269n52; on museums, 117-18; and University of Pennsylvania negotiations, 135
Dial, 32
dialect poetry, 167, 170-71, 272n85
Diepeveen, Leonard, 233n56
dilettantism, 109, 254-55n10, 255n13
DiMaggio, Paul J., 249n39
Distel, Anne, 131, 262n110, 264n116
Dogon Couple, 152, 153
Dog's Book of Verse (Clauson), 64
Dogs Chasing a Cat on a Man on a Donkey (Goya), 152
domesticity, 78-82, 248-49n33, 251n56
Doolittle, Hilda. See H. D.
Douglas, Aaron, 108, 156, 195, 260n82
Dove, Arthur, 72, 90, 91
Dreier, Katherine, 7, 10, 63-64, 247n6. See also Société Anonyme

Du Bois, W. E. B., 177, 205
Duchamp, Marcel, 30, 55, 57; *Fountain*, 237n23; *Large Glass*, 71-72, 246n2; *Nude Descending a Staircase*, 8, 10, 163, 230-31n21; and Quinn sales, 8, 10, 230n21
Dufy, Raoul, 90
Dunbar, Paul Laurence, 170, 195, 269n44
Durand-Ruel, Georges, 126, 259-60n62
Durand-Ruel, Joseph, 126, 247n7, 259-60n62
Durand-Ruel, Paul, 73

Eagleton, Terry, 254-55n10
Earle, Ferdinand, 29-33, 34, 36, 37, 236n7
Early Spring (Bonnard), 90
Eastman, Max, 162
"Eatonville Anthology" (Hurston), 39
Eaverly, Mary Ann, 100
Ebony and Topaz (C. S. Johnson), 195-96
Eddy, Arthur Jerome, 233n51
"Eduard Fuchs: Collector and Historian" (Benjamin), 26
education: and Barnes Foundation, 109-10, 116-17, 128, 134, 135, 137-38, 256n26, 257n30; and Phillips Memorial Gallery, 84-87, 249n39, 249n41. *See also* social engagement
Edwards, Brent Hayes, 23, 24, 172-73, 211
Egyptian art, 133, 251-52n65, 252n82. *See also* Egyptian Stone Head
Egyptian Stone Head, 94-95, 96, 97-102, 133, 251n62, 252n74
The Eight, 126
Eliot, T. S.: and *Anthology of Revolutionary Poetry*, 274n1; and archive, 2; and *Catholic Anthology*, 41, 42, 238n35; on Lowell, 39-40; and *Others*, 243n100, 245n121; on patriotism, 235n81; on sources, 47
Eliot, T. S., works: "The Boston Evening Transcript," 238n35; "Hysteria," 238n35; "The Love Song of J. Alfred Prufrock," 41, 42, 238n35; "Miss Helen Slingsby," 238n35; "Portrait of a Lady," 41, 238n35, 245n121; *The Waste Land*, 1, 158, 186, 194
The Enchantment of Art (Phillips), 74, 241n73, 247n10, 250n43
Exhibition of Contemporary European Paintings and Sculpture (Pennsylvania Academy of Fine Arts) (1923), 132, 260n80
Exhibition of Independent Artists (1910), 126

Exhibition of Paintings and Drawings Showing the Later Tendencies in Art (Pennsylvania Academy of Fine Arts) (1921), 111-12, 129-30
exhibition units. *See* collection arrangement
Exile, 274n5
experiment stations. *See* collection arrangement

factography, 1
"Fantastic Art, Dada, Surrealism" exhibition (MoMA) (1936-1937), 81
fascism, 210
Fauset, Jessie Redmun, 56, 266n7
Ferrer Center, 51
"A Few Don'ts by an Imagiste" (Pound), 46
Ficke, Arthur Davison, 20, 65, 67, 69. *See also* Spectra hoax
Fine Clothes to the Jew (Hughes), 1
Fire!!, 56
FitzGerald, Michael, 9, 10
Flaubert, Gustave, 2, 229n2
Fletcher, John Gould, 37, 45, 69, 239n49, 244n113
Flint, F. S., 34, 39, 43, 46, 47
Foley, Barbara, 157, 165, 170, 269n51
folk culture, 1; and *Book of American Negro Poetry*, 171-73, 274n119; and music, 229n5; and *The New Negro*, 174-75, 268n32
form: Barnes on, 95, 120-22, 257-58n38, 258nn39-40, 258n42; and *Book of American Negro Poetry*, 170-71; and collection as provisional institution, 7; and "Heritage," 191-92; and Lowell, 49, 50, 54, 241n73; and *The Lyric Year*, 31; and *The Masque of Poets*, 69; and mediation, 5-6; and Millay, 236n5; and *Negro Poets and Their Poems*, 168, 191; and *The New Negro*, 169, 174-75, 269n44; and oral tradition, 168, 169; and *Others*, 4, 53, 54; and politics, 163-64; and *Spoon River Anthology*, 38, 237-38n24; and *Understanding Poetry*, 213
formations, 51, 243-44n107; *Others* as, 57-58, 61, 243n100; Société Anonyme as, 57-58, 244n108. *See also* collective identity
Forum, 65
Foucault, Michel, 229n2
Fountain (Duchamp), 237n23
Four Negro Poets (Locke), 194-95
Frazer, James George, 1

free verse: and "Heritage," 191–92; and
Lowell, 49, 54; and *The Masque of Poets*,
69; and oral tradition, 168, 169; and poli-
tics, 163–64; and Spectra hoax, 66; and
Spoon River Anthology, 38. *See also* form
"Freedom" (Lott), 164–65
Freud, Sigmund, 110, 111, 144–45, 252n68. *See
also* Freudian psychology
Freudian psychology, 110–11, 124–25, 139, 143,
144–46, 255n19, 262n109
Fried, Debra, 236n5
Friedlander, Joseph, 64
Frobenius, Leo, 1, 197
Frost, Robert, 243n100, 246n150, 274n1
Fry, Roger, 128, 259n50
"Futurist Manifesto" (Marinetti), 12

Gaines, Reg E., 206
Gallatin, A. E., 13, 74, 233n51
Gardener (Cézanne), 263–64n115
Gates, Henry Louis, Jr., 168, 266n4
Gaudier-Brzeska, Henri, 102
Gauguin, Paul, 89
Geiger, Laura, 259n57
Geist, Sidney, 140, 143
Gellert, Lawrence, 211
gender, 45, 66–67, 68, 234n65, 236n5, 240n55
Georgian Poetry (Marsh), 16–19; contributors,
233n58; and cultural authority, 18–19,
234n60, 234–35n70; and *Des Imagistes*,
20, 29; and male dominance, 234n65; and
Marinetti, 17; and patriotism, 22; sales,
17–18, 234n64; and social engagement,
237n13; successors to, 65
Gikandi, Simon, 259n53, 261n87
Giovanniti, Arturo, 51
Girl with a Basket of Fish (Cézanne), 263–64n115
Girl with a Basket of Oranges (Cézanne),
263–64n115
Girl with a Goat (Picasso), 143–44, 146
Girl with Glove (Renoir), 264n115
Glackens, William, 126
Glebe, 20, 29, 51, 52, 241n77, 242n89
Glover, Savion, 206
Goeser, Caroline, 252n65
The Golden Treasury of English Songs and Lyrics
(Palgrave), 17, 169, 191, 238n31
Golding, Alan, 213, 233n56
Goldman, Emma, 51

Goldring, Douglas, 41
Goodyear, A. Conger, 10, 11, 231n35
Gosse, Edmund, 17, 18
Goya, Francisco, 152
Graham, John D., 72, 91
Graham, Marcus, 209, 274n1
Graham, P. Anderson, 64
Grantwood colony, 51, 52, 55
Graves, Robert, 21–24, 38, 218; *A Pamphlet
against Anthologies*, 21–22, 24, 68, 210,
211; *Survey of Modernist Poetry*, 21, 22–23,
24, 235n77
El Greco, 91, 140, 142, 250n51
Greek Anthology, 33, 34, 38, 47, 238n24
Green, Paul, 196
Greenberg, Clement, 257–58n38
Greenfeld, Howard, 130
Greenslet, Ferris, 44, 45
Gregg, Frederick James, 11, 231n36
Gregory, Horace, 275n8
Gregory, Montgomery, 195, 196
Grimké, Angelina Weld, 56
Guillaume, Paul, 123, 130–31, 133, 178–79, 197,
199, 258n48. See also *Primitive Negro
Sculpture*
Guillory, John, 230n15

H. D., 34, 37, 39, 43, 162, 246n150
Habermas, Jürgen, 84, 249n38
Halpert, Samuel, 51, 57, 93
Hamilton, George Heard, 90
Hapgood, Hutchins, 247n20
Harcourt Brace, 170
Harlem Museum of African Art, 159, 179, 196–
201, 202, 272–73n107, 273n109, 273n113
Harlem Renaissance. *See* New Negro movement
Harmonium (Stevens), 64
Harrison, Henry, 22, 209, 211
Hartley, Marsden, 57, 90
"A Harvest Stiff Comes Back to Town"
(Wallis), 267–68n30
Hassam, Childe, 74, 93
Hay, Elijah. *See* Spectra hoax
Haywood, Big Bill, 267n18
Head of a Man (Picasso), 151–52
Head of a Woman (Picasso), 151–52
Healing of Lazarus, 152
Heap, Jane, 52
Hegel, G. W. F., 15, 233n55

Henderson, Alice Corbin, 16, 41, 60-61, 159-61, 238-39n36, 271n78
Henri, Robert, 126
"Heritage" (Cullen), 157, 185-94; and African art, 189-90; and "Bottled," 196, 201; and collective identity, 190-91; and collector's role, 185-87; and form, 191-92; and historicization, 193-94; and homosexuality, 186, 187, 271n69; and *The New Negro* arrangement, 182
Herskovits, Melville, 123, 187
Hieratic Head of Ezra Pound (Gaudier-Brzeska), 102
Himes, Chester, 221
historical anthologies, 3, 16, 17, 18, 160, 168, 172, 233n56, 269n46
Holdengräber, Paul, 27
Holley, Horace, 55
homosexuality, 186, 187, 271n69
Horter, Earl, 72, 94, 233n51
Houghton Mifflin, 44, 45
Hours Press, 212
"How to Judge a Painting" (Barnes), 128-29
Hoyt, Helen, 56, 61, 63, 164
Hueffer, Ford Madox, 42, 237n16, 239n45
Hughes, Langston: and collective identity, 176, 178, 270n54; and Cullen, 192; on cultural authority, 2; and homosexuality, 271n69; and James Weldon Johnson Memorial Collection, 221; and Lindsay, 192-93, 271n80; and Poetry Collection, 216; and "Saturday Nighters," 56; self-documentation, 224
Hughes, Langston, works: *Ask Your Mama*, 271n80; *The Big Sea*, 266n7; *Fine Clothes to the Jew*, 1; "Jazzonia," 182, 183, 189, 193; *Mule Bone*, 278n53; "The Negro," 168; "The Negro Artist and the Racial Mountain," 192; "The Negro Speaks of Rivers," 193-94; "Nude Young Dancer," 182; "Slave on the Block," 207-8, 274n120
Hulme, T. E., 274n5
Humphries, Rolfe, 268n30
Hurston, Zora Neale, 1, 39, 56, 204, 278n53
Hutchinson, George, 157, 168
"Hysteria" (Eliot), 238n35

Idyll of Tahiti (Gauguin), 89
"If We Must Die" (McKay), 168

imagism, 21, 30; and American Indian literature, 161-62; and anthology form, 34; and avant-garde, 49, 237n15; and collective identity, 34, 44, 237n15; and form, 54; founding documents of, 46-47, 240n61; and Lowell, 39-40, 45, 54-55, 240n57; Pound on, 34; Riding and Graves on, 21; and sources, 35. See also *Des Imagistes*; Pound-Lowell competition; *Some Imagist Poets*
"Imagisme" (Flint), 46, 47
immigration, 67-68, 252n79, 257n30
imperialism, 35, 101, 253n85
"In the Little Old Market-Place" (Hueffer), 42
individualism, 24; and collector's role, 56-57; and *Others*, 60, 61, 63; and Phillips Memorial Gallery, 93, 98, 104, 105
Infants of the Spring (Thurman), 2, 208
Institutions of Modernism (Rainey), 2-3
"Inter-Creating Intelligence" (Phillips), 103
Interior with Seated Figure (Matisse), 151
internationalism: and *Book of American Negro Poetry*, 172, 173; and *Des Imagistes*, 35; and *The New Negro*, 176; and Phillips Memorial Gallery, 93-94, 100, 101, 251n60, 253n85
The Interpretation of Dreams (Freud), 144-45
intervention. See social engagement
Intimate Gallery, 90
Iolāus: An Anthology of Friendship (Carpenter), 271n69
Irish Renaissance. See Celtic revival
Irradiations (Fletcher), 239n49
Isaacs, Edith J. R., 197, 199, 200

Jackman, Harold, 219, 221
Jackson, Walter Clinton, 166-67, 169, 180
Jaffe, Aaron, 18, 234n65, 237n19
James, William, 110, 112, 128, 256n21
James Weldon Johnson Memorial Collection of Negro Arts and Letters (Yale University), 214, 218-26; arrangement of, 218, 222-24, 277n50; and author self-documentation, 224-26, 278n53; collector's role, 218-19, 220-22, 225, 277nn46-47; contributors, 221, 276-77n40, 277n43; critical neglect of, 276n34; dedication of, 215; and social engagement, 219-20, 276n35
Jameson, Fredric, 5, 6, 26, 235n88

Janácek, Leoš, 229n5
Jarzombek, Mark, 120, 257-58n38
"Jazzonia" (Hughes), 182, 183, 189, 193
Jefferson, Thomas, 125
Johns, Orrick: and Catholic Anthology, 41; and form, 236n5; and Grantwood, 51; and Others, 58, 63, 241-42n83, 242n91; "Second Avenue," 30, 31, 236n7
Johns, Peggy, 51, 55
Johnson, Charles S., 56, 108, 156, 195-96, 219, 266n7
Johnson, Fenton, 169, 243n100
Johnson, Georgia Douglas, 56
Johnson, Grace Nail, 221
Johnson, Helene, 157, 196, 201-8, 270n61
Johnson, James Weldon: and Barnes Foundation, 156; and James Weldon Johnson Memorial Collection, 220-21; and "Saturday Nighters," 56
Johnson, James Weldon, works: Book of American Negro Poetry, 166, 169-73, 180-82, 274n119; Book of American Negro Spirituals, 268n32; "The Creation," 169, 177, 269n44; "On the Negro's Creative Genius," 170-72
Jolas, Eugene, 245n141
Jones, Jacqueline C., 221
Joseph-Etienne Roulin (Van Gogh), 126, 140
Journal of the Barnes Foundation, 135, 137
The Joy of Life (Matisse), 107, 131, 132, 140, 262-63n111
Joyce, James, 2, 9, 218, 229n6
Julien, Isaac, 206

"Kammersymphonie" (Schoenberg), 132
Kann, Alphonse, 94
Karfiol, Bernard, 93
Kauffman, Reginald Wright, 163
Kellogg, Paul U., 270n58
Kenner, Hugh, 39
Kennerley, Mitchell, 30, 65, 231n36, 236n1
Kerfoot, J. B., 53
Kerlin, Robert, 166, 167-69, 180, 191
Kilmer, Joyce, 50, 75
Klee, Paul, 72, 91
Kling, Joseph, 67
Knaths, Karl, 72, 91, 93, 249n41
Knight, Christopher, 262-63n111
Knish, Anne. See Spectra hoax

Knollenberg, Bernhard, 219, 276n40
Knopf, Alfred A., 59, 62, 65
Komoroff, Manuel, 51
Kora in Hell (Williams), 110
Krauss, Rosalind, 139
Kreier, H. J., 275n8
Kreymborg, Alfred: and American Poetry, 37, 246n150; and anarchism, 51; and anthology form, 35-36; and Catholic Anthology, 41; and collector's role, 58-59; and Glebe, 20, 29, 51, 52, 241n77, 242n89; and The Masque of Poets, 69; Our Singing Strength, 55; and Society of Independent Artists, 57. See also Others

La Fresnaye, Roger de, 149-50, 151
Laib, Monnie, 67
Laird, Warren, 136
Large Glass (Duchamp), 71-72, 246n2
Larsen, Nella, 190
Later Tendencies Exhibition (Pennsylvania Academy of Fine Arts) (1921), 111-12, 129-30
Lawrence, D. H., 42, 43
Lawrence, Jacob, 72, 260n82
Lawson, Ernest, 93, 126
Leaving the Conservatory (Renoir), 137, 143-44, 145, 264n116
"The Legacy of the Ancestral Arts" (Locke), 178-79, 182, 186, 188, 190
Léger, Fernand, 7
Lemke, Sieglinde, 180
Level, André, 9
Lewis, David Levering, 273n116
Lewis, John F., 136
Lewis, Wyndham, 218
Liberator, 40-41, 162-66, 268n30
Liberty, Sebastien, 51, 52
Lindsay, Vachel, 69, 192-93, 246n150, 271n78, 271n80, 276-77n40
Lippmann, Walter, 101
Lissitzky, El, 82
little magazines: and anthology form, 16, 40-41, 238n33; and politics, 163. See also specific magazines
Little Review, 16, 21, 66, 74, 247n10
Living Gallery, 13
Locke, Alain: and African art, 157, 197-99; and Barnes, 108, 156, 178; and bohemian

salon formations, 56; and collection as provisional institution, 6, 7; on Egyptian art, 251-52n65; *Four Negro Poets,* 194-95; and Harlem Museum of African Art, 179, 196-201, 202, 272-73n107, 273n109; "The Legacy of the Ancestral Arts," 178-79, 182, 186, 188, 190; and Charlotte Osgood Mason, 273n113; as midwife, 158, 266n7; "Negro Youth Speaks," 176-77; *The New Negro* preface, 171; *Plays of Negro Life,* 195, 196; and pragmatism, 269n52. See also *The New Negro*

Lockwood, Thomas B., 215

Lomax, John A., 64

Longenbach, James, 40

Longhi, Pietro, 152-53

Looking for Langston (Julien), 206

Lord Jim (Conrad), 26, 235n88

Lott, Eve, 164-65

"The Love Song of J. Alfred Prufrock" (Eliot), 41, 42, 238n35

"Love Songs" (Loy), 241-42n83, 245n121

Lowell, Amy: and American Indian literature, 266n14; and *American Poetry,* 37, 246n150; and anthology form, 16, 20, 35-36, 44-45; class background of, 48-49; and *Des Imagistes,* 34, 35-36; and form, 49, 50, 54, 241n73; and imagism, 39-40, 45, 54-55, 240n57; and *The Masque of Poets,* 69; and *May Days,* 164; and *Others,* 51, 52, 244n113; and Phillips, 20, 47-49, 241n73; and politics, 48, 50; and Spectra hoax, 20, 65

Lowell, Amy, works: "Astigmatism," 44-45, 157; *Sword Blades and Poppy Seed,* 44-45; *Tendencies in Modern American Poetry,* 45, 240n57. See also Pound-Lowell competition; *Some Imagist Poets*

Loy, Mina: "Love Songs," 241-42n83, 245n121; *Lunar Baedeker,* 64; and *Others,* 53, 55, 56, 66, 241-42n83, 243n58, 245n121; and *Profile,* 274n5; and Society of Independent Artists, 57

Lukács, György, 25-26

Luks, George, 74, 93, 126

Lunar Baedeker (Loy), 64

Lustgarten, Samuel, 10

"The Lynching" (McKay), 168

Lynes, Katherine R., 204-5, 207

Lyon, Janet, 46, 81, 243n104

The Lyric Year (Earle), 29-33, 34, 36, 37, 236n7

Macdonagh, Thomas, 246n149

Mad for Modernism exhibition (1999), 72

Madame Cézanne (Cézanne), 127

Making Modernism (FitzGerald), 9

Malbin, Lydia Kahn Winston, 15

male dominance. See gender

Maleuvre, Didier, 232n38

Malraux, André, 214

Man Ray. See Ray, Man

Marek, Jayne, 239-40n51

Margetson, George Reginald, 172

Marin, John, 72, 90, 91, 93, 94

Marinetti, Filippo Tommaso, 33, 34, 234n61; "Futurist Manifesto," 12; *I poeti futuristi,* 17, 29; and Pound, 20, 33, 237n15

market influences, 19; and African art, 123; and Barnes Foundation, 127, 259-60n62; Bourdieu on, 119; and Lowell's influence on imagism, 40; and *Others,* 59, 244-45n115; and Phillips Memorial Gallery, 90, 250n47; and Quinn sales, 8-11

Marquet, Albert, 93

Marsh, Edward, 19, 234n61. See also *Georgian Poetry*

Marshall, John, 62

Mason, Charlotte Osgood, 202, 273n113

Mason, Theodore O., Jr., 170, 269n46

The Masque of Poets (O'Brien), 68-69, 160

Masses, 40, 162-66, 238n33, 268n30

Masters, Edgar Lee, 38-39, 41, 42, 237-38n24

Mather, Frank Jewett, 74, 117

Mathews, Elkin, 39, 42

Matisse, Henri: and Barnes Foundation, 126, 127, 260n78; and Peau de l'Ours collection sale, 9; and Phillips Memorial Gallery, 88, 90, 93; and Quinn sales, 8, 230n21

Matisse, Henri, works: *Blue Nude,* 8, 230n21; *Blue Still Life,* 260n78; *Interior with Seated Figure,* 151; *Joy of Life,* 107, 131, 132, 140, 262-63n111; *Red Madras Headdress,* 260n78; *Seated Riffian,* 260n78; *Woman Reading at Dressing Table,* 151

Maurer, Alfred, 126

Maxwell, William J., 172, 173-74, 269n48

May Days (Taggard), 160, 162-66, 178, 209, 238n33, 267n24, 267n27, 267-68n30

McBride, Henry, 231n36
McKay, Claude: and *Book of American Negro Poetry,* 172; and collective identity, 178, 270n54; and homosexuality, 271n69; and James Weldon Johnson Memorial Collection, 221; and *The New Negro,* 195
McKay, Claude, works: "If We Must Die," 168; "The Lynching," 168; "Negro Dancers," 182; "Negro Spiritual," 268n30
McKenna, Edmond, 51
mediation, 4-7, 22, 227-28, 230n15. *See also* social engagement
Mellow, James, 81
Metropolitan Museum of Art, 12-13, 15, 33, 79
Meyers, Mary Ann, 134, 135, 136, 255n19, 257n30
Michaels, Walter Benn, 161, 187-88, 189, 190, 191, 266n14
Michelson, Max, 42, 49, 61
Migration Series (Lawrence), 72, 260n82
"Milk for the Cat" (Monro), 42
Millay, Edna St. Vincent, 30-32, 33, 37, 185, 236n5, 236n7, 246n150
Miller, Cristanne, 65, 66-67
Miller, James A., 275n8
Millet, Jean-François, 126
misogyny. *See* gender
"Miss Helen Slingsby" (Eliot), 238n35
Models (Seurat), 107
Modern American Poetry (Untermeyer), 16, 170, 271n78
Modern Library, 160
modernism: Bourdieu on, 118-19; critiques of, 24-25, 129-30; as indeterminate, 15-16, 233n55; Jameson on, 26; Lukács on, 25-26; Phillips' conversion to, 88, 90-91, 100, 250n43, 250n50; Riding and Graves on, 21, 26, 235n77
Modigliani, Amedeo, 132, 149, 151, 261n87
Monet, Claude, 91
Monro, Harold, 17, 19, 20, 29, 41, 42, 239n38
Monroe, Harriet: and anthology form, 21; and *Catholic Anthology,* 41, 239n38; and *The Lyric Year,* 32, 34, 36; *The New Poetry,* 16, 159-60, 271n78; and *Others,* 52, 54. See also *Poetry*
Mont Saint-Victoire paintings (Cézanne), 89, 126, 140-41, 142-43

Montserrat, Dominic, 97, 100, 104, 252n68, 253n83
Moore, Marianne, 55, 64, 66, 243n58, 245n121, 274n5
Moore, T. Sturge, 233n58
Morgan, Emanuel. *See* Spectra hoax
Morgan, J. P., 12
Morrisson, Mark, 164, 268n30
"Mother" in Verse and Prose (Rice & Schauffler), 64
Mule Bone (Hughes & Hurston), 278n53
Mumbo Jumbo (Reed), 23
Munro, Thomas, 131, 135, 137, 199-200. See also *Primitive Negro Sculpture*
Murry, John Middleton, 18, 19
Le Musée imaginaire (Malraux), 214
Museum of Modern Art (MoMA): acquisition of modernist collections, 232nn51-52; arrangement of, 78-79, 81; and cultural authority, 212-13; "Fantastic Art, Dada, Surrealism" exhibition (1936-1937), 81; and Goodyear, 231n35; and Phillips, 50-51; and Phillips Memorial Gallery, 88, 104-5, 250n44, 254n95; and Société Anonyme, 71, 246n1
museums: acquisition of modernist collections, 15, 232-33n51; Benjamin on, 15, 233n52; Bourdieu on, 118-19; and collection as provisional institution, 12, 13, 232n43; criticisms of, 12-13, 33, 232n38; Dewey on, 117-18; and Quinn sales, 10-11, 14-15, 231n36. *See also specific museums*
music: African American spirituals, 180; and collective identity, 55, 243n96; and folk culture, 229n5; and *The New Negro,* 182, 270n61
Myers, Jerome, 93
Mysterious Bathers (De Chirico), 149, 150

Nadell, Martha Jane, 183, 270n57
Nadir, Moishe, 67
Nation, 115, 156, 163, 199
National Gallery of Art (Washington, DC), 90, 250n49
"The Need of Art at Yale" (Phillips), 108-9
"The Negro" (Hughes), 168
Negro: An Anthology (Cunard), 173, 210-12, 251n65

"Negro Art and America" (Barnes), 156
"The Negro Artist and the Racial Mountain" (Hughes), 192
"The Negro Church" (Razafkeriefo), 168
"Negro Dancers" (McKay), 182
"The Negro Digs Up His Past" (Schomberg), 183, 191
Negro Poets and Their Poems (Kerlin), 166, 167–69, 180, 191
"The Negro Speaks of Rivers" (Hughes), 193–94
"Negro Spiritual" (McKay), 268n30
Nelson, Cary, 266n4, 274n1
New Criticism, 21, 213, 214
New Masses, 211, 212, 267n18, 274n8
The New Negro (Locke): *Anthology of Verse by American Negroes* as precursor of, 166–67, 169, 180; arrangement of, 159, 180–85, 270nn57-58; and art collections, 158–59; and Barnes, 125; and Barnes Foundation, 108; *Book of American Negro Poetry* as precursor to, 166, 169–73, 180–82; *Caroling Dusk* as successor to, 196; and collective identity, 157–59, 176–79, 270n54; and collector's role, 5, 185–87, 195; contributors, 173, 178; criticisms of, 195; and cultural nationalism, 157, 175–76, 242n95; *Ebony and Topaz* as successor to, 195–96; and folk culture, 174–75, 268n32; and form, 169, 174–75, 269n44; and homosexuality, 271n69; importance of, 157, 266n4; and James Weldon Johnson Memorial Collection, 222–23; *May Days* as precursor to, 162–66, 178; and modernist appropriation of African art, 178–80; and music, 182, 270n61; *Negro Poets and Their Poems* as precursor to, 166, 167–69, 180; *The Path on the Rainbow* as precursor to, 160–62, 171–72, 268n32; and politics, 7, 173–74, 178, 269n51; preface of, 171; as provisional institution, 7, 159, 174; publishers of, 20, 29; and social engagement, 173, 174, 176, 209; and Spectra hoax, 68; successors to, 158, 194. *See also* "Heritage"
"The New Negro" (Watkins), 168
New Negro movement, 2; and avant-garde, 177; and Barnes Foundation, 108, 124–25, 133, 156, 259n57; and bohemian salon

formation, 56; and cultural authority, 156, 158; and James Weldon Johnson Memorial Collection, 221; Locke as midwife of, 158, 266n7
The New Poetry (Monroe & Henderson), 16, 159–60, 271n78
New Republic, 12, 33, 43, 128, 163, 240n61
New Woman, 68, 236n5
New York Public Library, 206–7
Nigger Heaven (Van Vechten), 219, 221, 276n34
Nigger of the Narcissus (Conrad), 276n40
North, Michael, 169, 246n144, 269n44, 272n85
Nude Descending a Staircase (Duchamp), 8, 10, 163, 230–31n21
"Nude Young Dancer" (Hughes), 182
Nugent, Richard Bruce, 56, 195, 271n69

An *"Objectivists" Anthology* (Zukofsky), 159
O'Brien, Edward J., 64, 68–69, 160, 246n149
Observations (Moore), 64
O'Keeffe, Georgia, 90
"On First Opening *The Lyric Year*" (Williams), 32–33, 157
"On Heaven" (Hueffer), 239n45
"On the Negro's Creative Genius" (J. W. Johnson), 170–72
O'Neill, Eugene, 196
Oppenheim, James, 164, 246n150
Opportunity, 108, 122, 124, 185, 186, 195
oral tradition, 168, 169
"Oread" (H. D.), 162
organic collections, 216, 218, 276n25
organization. *See* collection arrangement
O'Sheel, Shaemas, 274n1
Others, 50–64; and anthology form, 40; and Arensberg, 52–54, 62; and bohemian salon formation, 55–57, 243n100; and *Catholic Anthology*, 41; and collective identity, 50–51, 55, 57–58, 60, 61, 243n100; collector's role, 56–57, 58–59, 61–62, 63–64; contributors, 51–52, 53, 57, 61, 245n121; cover of, 53; and cultural nationalism, 242n95; and form, 4, 53, 54; and Lowell, 51, 52, 244n113; and market influences, 59, 244–45n115; motto of, 53, 242n91; and *The New Poetry*, 160; and politics, 51–52, 75–76, 242n84, 242n86; as

Others (*cont.*)
 provisional institution, 57, 62-64, 242n84;
 reception of, 52, 60-61, 241-42n83; and
 Société Anonyme, 57-58; and sources,
 54-55, 242n95; and Spectra hoax, 21, 63,
 65, 66; successors to, 65. *See also* Spectra
 hoax
"Others" (Reyher), 245n123
"Others" (Sandburg), 61-62, 157, 245nn123-24
Our Singing Strength (Kreymborg), 55
Outka, Elizabeth, 248-49n33
Oxford Book of Victorian Verse (Quiller-
 Couch), 17

Pach, Walter, 231n36
pacifism, 102
Pagan, 40, 67-68, 245n141
Palgrave, Francis Turner, 17, 169, 191, 238n31
A Pamphlet against Anthologies (Riding &
 Graves), 21-22, 24, 68, 210, 211
Pareyn, Henri, 197
Parham, Marisa, 190, 193-94
The Path on the Rainbow (Cronyn), 160-62,
 171-72, 268n32
"Patria Mia" (Pound), 35
patrilineage, 76, 77-78, 154, 248n26
patriotism, 22, 74-75, 235n81
Paudrat, Jean-Louis, 123
Pearse, Patrick, 246n149
Peau de l'Ours collection sale (1914), 9, 11, 19
Pène Du Bois, Guy, 128
Penniman, Josiah, 134, 136-37
Pensky, Max, 235n90
Perloff, Marjorie, 1
"Peter Quince at the Clavier" (Stevens),
 245n121
Peterson, Dorothy, 221
Philadelphia Museum of Art, 137, 233n51,
 262n102
Phillips, Duncan: class background of, 48-49,
 73-74, 247n6; conversion to modernism,
 88, 90-91, 100, 250n43, 250n50; and Low-
 ell, 20, 47-49, 241n73; and Museum of
 Modern Art, 50-51; and politics, 7, 74-77,
 247-48n22; and Quinn sales, 11, 73-74,
 90, 250n47; and race, 6
Phillips, Duncan, works: *A Collection in the
 Making,* 87, 88, 89, 92, 93, 103; *The
 Enchantment of Art,* 74, 241n73, 247n10,

250n43; "Inter-Creating Intelligence,"
 103; "The Need of Art at Yale," 108-9.
 See also Phillips Memorial Gallery
Phillips, Laughlin, 108, 154, 248n26
Phillips, Marjorie, 83, 93, 249n41
Phillips Collection. *See* Phillips Memorial
 Gallery
Phillips Memorial Gallery, 71-105; and Afri-
 can American art, 260n82; arrangement
 of, 78-82, 91-93, 138, 248-49n33, 251n56;
 artists exhibited, 74, 87-93, 250n51, 250-
 51n52, 251n55, 251n60; and Barnes Foun-
 dation, 87, 108-9, 130; collector's role,
 5, 86, 92, 249n41; Egyptian Stone Head,
 94-95, 96, 97-102, 133, 251n62, 252n74;
 establishment of, 77-78, 248n26; and
 internationalism, 93-94, 100, 101, 251n60,
 253n85; and Museum of Modern Art, 88,
 104-5, 250n44, 254n95; names of, 247n4;
 and patrilineage, 77-78, 248n26; and pub-
 lic, 82-86, 103-4, 249nn38-39; Sensibility
 and Simplification exhibit, 93-94, 95-96,
 101-2, 132-33; and social engagement,
 84-87, 88, 249n39, 249nn41-42; and
 Société Anonyme, 71-72, 87, 246n2
Picasso, Pablo: and Barnes Foundation, 126,
 149, 151-52, 260n78; and El Greco, 250n51;
 and Peau de l'Ours collection sale, 9; and
 Phillips Memorial Gallery, 88, 90, 92; and
 politics, 163; and Quinn sales, 8, 10,
 230n20
Picasso, Pablo, works: *Acrobat and Young
 Harlequin,* 260n78; *Composition: The Peas-
 ants,* 132; *Girl with a Goat,* 143-44, 146;
 Head of a Man, 151-52; *Head of a Woman,*
 151-52; *La Toilette,* 11; *Woman with a
 Cigarette,* 126
Pippin, Horace, 72, 108, 260n82
Pissarro, Camille, 127, 250n51
"The Place of Imagism" (Aiken), 43
Plácido, 172
plastic form, 95, 120, 121, 258n40, 258n42.
 See also Barnes' aesthetic theory
Plays of Negro Life (Locke & Gregory), 195, 196
Plukett, Joseph Mary, 246n149
Poems of the Great War (Cunliffe), 64
Poems of the Irish Revolutionary Brotherhood
 (Colum & O'Brien), 64, 69, 246n149
Poems on Various Subjects (Wheatley), 220

Poet Laureate, 2, 18-19, 64, 229-30n8
I poeti futuristi (Marinetti & Buzzi), 17, 29
poetic institutions, 2, 229-30n8, 234n69. *See also* anthology form
Poetry: arrangement of, 181; and *Catholic Anthology*, 40, 41; and form, 53, 54; and founding documents of imagism, 46; and *The Lyric Year*, 32; and Pound, 34; and Spectra hoax, 21
Poetry and Drama, 19
Poetry Collection (University of Buffalo), 214, 215-18, 226-28, 275nn20-21, 275n24, 278n55; contributors, 215-16, 275n23, 276n40
Poetry Society, 241n83
Poets at Work (Abbott), 215, 218
The Political Unconscious (Jameson), 26, 235n88
politics: and anthology form, 162-66, 209, 211, 267n18, 267n24, 267-68n30, 274n1, 274-75n8; and Armory Show, 76, 247n20; and collection as provisional institution, 7-8; and Lowell, 48, 50; and *May Days*, 162-66, 267n24, 268n30; and *Negro Poets and Their Poems*, 168; and *The New Negro*, 7, 173-74, 178, 269n51; and *Others*, 51-52, 75-76, 242n84, 242n86; and Phillips, 7, 74-77, 247-48n22; and Spectra hoax, 246n145; and World War I, 75-76, 247n19. *See also* collection as provisional institution; social engagement
"Portrait of a Lady" (Eliot), 41, 238n35, 245n121
"Postlude" (Williams), 33, 34-35
Pound, Ezra: and anthology form, 20, 234n65; and *Anthology of Revolutionary Poetry*, 274n1; and archive, 2, 226-27; on Barnes, 114, 256n26; and collection as provisional institution, 7; and collective identity, 65; on cultural authority, 2; and *Georgian Poetry*, 233n58; on Lowell, 39; and Marinetti, 20, 33, 237n15; as midwife, 158; and *Others*, 61; on Palgrave, 238n31; and Poetry Collection, 226, 227-28; and Spectra hoax, 65, 66; and *The Waste Land*, 158, 186; world poetry anthology project, 160, 266n9
Pound, Ezra, works: *Cantos*, 1, 229n3; "A Few Don'ts by an Imagiste," 46; "Patria Mia,"

35; *Profile*, 210-12, 274n5, 274-75n8; "Status Rerum," 34; "The Tree," 274n5. *See also Catholic Anthology*; *Des Imagistes*; Pound-Lowell competition
Pound-Lowell competition, 43-50; and *Catholic Anthology*, 39, 40, 45, 238n29; narratives of, 39-40; and *Some Imagist Poets*, 44-47, 240n55; and sources, 47; and *Tendencies in Modern American Poetry*, 45, 240n57
Powell, John Wesley, 133
pragmatism, 110-11, 112, 112-13, 120, 123, 128, 139, 256n21, 256n27, 269n52
pragmatist primitivism, 122-25, 148
A Preface to Morals (Lippmann), 101
Prendergast, Maurice, 93, 94, 126
Primitive Negro Sculpture (Guillaume & Munro), 122, 123, 131, 136, 149, 198, 199
Principles of Psychology (James), 110
"Prison Weeds" (Wolff), 242n86
prize anthologies, 30. *See also The Lyric Year*
Profile (Pound), 210-12, 274n5, 274-75n8
Proust, Marcel, 251n56
provisional institutions. *See* collection as provisional institution; social engagement
Przerwa-Tetmajer, Kazimierz, 35
public: and Barnes Foundation, 14; and class, 7, 14, 109-10; and Phillips Memorial Gallery, 82-86, 103-4, 249nn38-39; and *Some Imagist Poets*, 47, 242n83. *See also* education; social engagement

Quiller-Couch, Arthur, 17
Quinn, John: and African art, 94; and anthology form, 22; and Armory Show, 8, 128; and Barnes, 107; class background of, 247n6; and museums, 13; and social engagement, 12, 13, 232n44; and subjective nature of collecting, 3. *See also* Quinn sales
Quinn sales, 8-12; and African art, 260n84; and anthology form, 70; and Brummer, 231n37; and collector's role, 11-12, 231n36; and Duchamp, 8, 10, 230n21; media responses to, 10, 231nn31-32; and museums, 10-11, 14-15, 231n36; and Phillips, 11, 73-74, 90, 250n47; and Picasso, 8, 10, 230n20
Quintilian, 262n109

Rabaté, Jean-Michel, 15
race: and anthology form, 23-25; and
 collection as provisional institution, 6;
 and Egyptian art, 95, 133, 251-52n65;
 and *May Days,* 268n30; and public, 7;
 and Spectra hoax, 6, 24, 67, 68, 178,
 246nn143-44
Rainey, Lawrence, 2-3, 13, 20, 237n15,
 242n84, 244n115
Raisin, Ovro'om, 68
Rampersad, Arnold, 271n80
Rathbone, Eliza E., 254n94
Ray, Man, 20, 29, 51, 57, 242n89
Razafkeriefo, Andrea, 168, 169
reader. *See* public
"Realism in the Balance" (Lukács), 25-26
Reclining Nude (Cézanne), 263n115
Reconstruction in Philosophy (Dewey), 255n19
Red Earth (Cézanne), 263n115
Red Madras Headdress (Matisse), 260n78
Reed, Christopher, 80
Reed, Ishmael, 23
Reed, John, 162
reform. *See* social engagement
Reid, B. L., 10
Reimonenq, Alden, 271n69
Reiss, Winold, 180, 181, 183
"Renascence" (Millay), 30-32, 33, 185, 236n7
Renoir, Pierre-Auguste: and Barnes Founda-
 tion, 126, 127, 128, 130, 143, 254n4,
 264n115; and Phillips Memorial Gallery,
 72, 91, 108
Renoir, Pierre-Auguste, works: *Bather and
 Maid,* 140; *Bathers,* 263n115; *Le Déjeuners
 des Canotiers,* 73, 88-89, 108, 247n7; *Girl
 with Glove,* 264n115; *Leaving the Conserva-
 tory,* 137, 143-44, 145, 264n116
reprisal anthologies, 38
"Returning Soldiers" (Du Bois), 205
Rewald, John, 259-60n62
Reyher, Ferdinand, 245n123
Rice, Susan Tracy, 64
Ridge, Lola, 51, 66
Riding, Laura, 21-24, 26, 38; *A Pamphlet
 against Anthologies,* 21-22, 24, 68, 210,
 211; *Survey of Modernist Poetry,* 21, 22-23,
 24, 235n77
The Rising Tide of Color (Stoddard), 277n40
"The Road" (H. Johnson), 270n61

Road at Marines (Cézanne), 140
Robeson, Paul, 200
Robins, Gay, 97
Robinson, Edward Arlington, 69
Rodgers, Timothy Robert, 249n41
"The Rose" (Przerwa-Tetmajer), 35
Rosenberg, Paul, 8, 230n20
Rosenblum, Robert, 253n93
Rothko, Mark, 72
Rouault, Georges, 72, 152
Rousseau, Henri (le Douanier), 10, 90, 143-44
Ryder, Albert Pinkham, 74

Saarinen, Aline, 10
Sacco-Vanzetti Anthology of Verse (Harrison),
 22, 209, 211
Sackville-West, Vita, 233n58
*Saint Francis and Brother Leo Meditating on
 Death* (El Greco), 140, 142
Sandburg, Carl: and American Indian literature,
 266n14; and *American Poetry,* 246n150; and
 Catholic Anthology, 41; and *The Masque of
 Poets,* 69; and *May Days,* 164
Sandburg, Carl, works: "Cool Tombs," 22;
 "Others," 61-62, 157, 245nn123-24
Santayana, George, 112, 128, 256n21
Saphier, William, 56
"Saturday Nighters," 56
"Scented Leaves from a Chinese Jar"
 (Upward), 35
Schauffler, Robert Haven, 64
Schoenberg, Arnold, 132
"The Scholars" (Yeats), 40, 41, 274n5
Schomberg, Arthur, 166, 182, 183, 184, 185,
 190, 191, 206-7
Schulze, Robin, 64
Schwitters, Kurt, 82
Seated Couple (Dogon), 152, 153
Seated Riffian (Matisse), 260n78
"Second Avenue" (Johns), 30, 31, 236n7
Segoznac, André Dunoyer de, 90, 93
Seiffert, Marjorie Allen, 65
Selfridges department store, 248-49n33
Sensibility and Simplification in Ancient
 Sculpture and Contemporary Painting
 (Phillips Memorial Gallery), 93-94, 95-96,
 101-2, 132-33
Servitute, Libertati, Christianae Non Contraria
 (Capitein), 183, 184

Seurat, Georges, 10, 90, 93, 94, 107
Seven Arts, 48
Sexton, Will, 168, 268n41
Shakespear, Dorothy, 49
Shchukin, Sergei, 94, 263n111
Sheeler, Charles, 90
Shove, Fredegond, 233n58
"The Shroud of Color" (Cullen), 185
Silver, Kenneth E., 92, 248n26
Simonides, 262n109
Simonson, Lee, 12-13, 33
Simpson, David, 7
Sinclair, Upton, 267n18
Singer, Edgar A., Jr., 135
Sitwell, Edith, 64-65, 234n65
"Slave on the Block" (Hughes), 207-8,
 274n120
Sleeping Gypsy (Rousseau), 10
Sloan, John, 126
Smart, Pamela, 14
Smith, William Jay, 65
social engagement, 2, 3, 6, 7-8, 27-28; and
 American Poetry, 37-38; and anthology
 form, 16, 33, 233n56, 237n13, 242n84,
 275n10; and archives, 219, 227-28; and
 Barnes Foundation, 6, 7, 13-14, 115, 125,
 129, 131, 132-33, 159, 260n82; and Book of
 American Negro Poetry, 170-72; and col-
 lective identity, 243-44n107; and James
 Weldon Johnson Memorial Collection,
 219-20, 276n35; and Lowell, 50; and The
 Lyric Year, 33; and The Masque of Poets,
 69; and mediation, 4-7, 22, 227-28,
 230n15; and museums, 12, 13, 232n43;
 and Negro: An Anthology, 211, 212; and
 The New Negro, 173, 174, 176, 209; and
 Others, 57, 62-64, 242n84; and The Path
 on the Rainbow, 160-62, 171-72; and Phil-
 lips Memorial Gallery, 84-87, 88, 249n39,
 249nn41-42; and Quinn, 12, 13, 232n44;
 and Spoon River Anthology, 38-39
Société Anonyme: arrangement of, 72, 78,
 82, 248-49n33; and collective identity,
 57-58, 244n108; collector's role, 63-64;
 and museum acquisition, 232-33n51; and
 Museum of Modern Art, 71, 246n1; and
 Others, 57-58; and Phillips Memorial Gal-
 lery, 71-72, 87, 246n2; and social engage-
 ment, 13, 85, 232n43

Society of Independent Artists, 237n23; and
 American Poetry, 37, 70; and Arensberg,
 52; and Others, 57; and Phillips, 73; and
 politics, 163; and World War I, 75
Some Imagist Poets (Lowell), 45-50; arrange-
 ment of, 41; and Catholic Anthology, 40,
 42, 238n29; collector's role, 43, 44,
 239-40n51; contributors, 43, 239n45;
 cover of, 48, 49; and The New Poetry, 159;
 and Pound-Lowell competition, 44-47,
 240n55; preface of, 45-47; publishers of,
 43-44; reception of, 43, 239n44, 240n61,
 241-42n83; serial publication of, 16; suc-
 cessors to, 65
"Song" (Bennett), 270n61
sources: and Celtic revival, 269n48; and
 Des Imagistes, 34, 47, 237n16; and folk
 culture, 1; and Others, 54-55, 242n95;
 and Phillips Memorial Gallery, 94; and
 Pound-Lowell competition, 47; and
 Spoon River Anthology, 238n24
Southern Road (Brown), 1
Soutine, Chaim, 131, 132
Spectra hoax, 63, 64-68; and Brooke, 234n62;
 and collective identity, 20-21, 65, 178;
 and politics, 246n145; and race, 6, 24,
 67, 68, 178, 246nn143-44
Spencer, Anne, 224
Spingarn, Arthur, 195, 197
The Spirit of Man (Bridges), 64
Spoon River Anthology (Masters), 38-39,
 237-38n24
Spring and All (Williams), 64
Stansell, Christine, 49, 247n19
"Status Rerum" (Pound), 34
Stearns, Harold, 170
Stedman, Edmund Clarence, 229n8
Stein, Gertrude, 24, 80, 94, 219, 254n3,
 276n40
Stein, Leo, 80, 94, 126, 230n21, 256-57n28
Sterling, George, 69
Sterne, Maurice, 90, 93
Stevens, Wallace, 51, 53, 64, 245n121
Stieglitz, Alfred, 52, 90, 94, 124, 231n36,
 237n23
Still Life with a Skull (Cézanne), 140-41
Still Life with Bottle, Tablecloth, and Fruits
 (Cézanne), 259n62
Stoddard, Lothrop, 277n40

Stokowski, Leopold, 135
Storrs, John, 64
Stransky, Josef, 250n47
Stravinsky, Igor, 229n5
subjective nature of collecting. *See* collector's role
Survey Graphic, 182, 185, 197, 199, 270n58
Survey of Modernist Poetry (Riding & Graves), 21, 22-23, 24, 235n77
Swan (De Chirico), 143-44
Sword Blades and Poppy Seed (Lowell), 44-45
Synge, J. M., 171, 174, 175

Tack, Augustus Vincent, 74, 93, 94, 96, 102, 104, 253n93, 254n94
Taggard, Genevieve, 160, 162-66, 178, 209, 216-17, 238n33, 267n24, 267n27, 267-68n30
Talented Tenth, 177
Teasdale, Sara, 246n150
The Ten, 248n28
Tendencies in Modern American Poetry (Lowell), 45, 240n57
Tennyson, Alfred Lord, 18-19, 234n69
Thacker, Andrew, 45, 240n55, 244n107
Theatre Arts, 197, 198
Three Lives (Stein), 276n40
Thurman, Wallace, 2, 56, 208
"To an Unhappy Negro" (Humphries), 268n30
"To Statecraft Embalmed" (Moore), 245n121
La Toilette (Picasso), 11
Toklas, Alice B., 80
Toomer, Jean, 1, 56, 178, 268n30, 270n54
Topia, André, 1, 229n2
Torrence, Ridgely, 196
Torrey, Frederic C., 230n21
"The Tree" (Pound), 274n5
Trent, Lucia, 209
"A Tribute," 164, 267n27
Trotsky, Leon, 76
Tutankhamun, 251n65
Twachtman, John Henry, 74, 93, 94

Ulysses (Joyce), 2, 9, 229n6
Understanding Poetry (Brooks & Warren), 213
university archives. *See* archives
University Museum (University of Pennsylvania), 132, 133-34, 137, 260n84, 261n87, 261-62n102

University of Pennsylvania: Barnes Foundation negotiations, 134-37, 261n90; University Museum, 132, 133-34, 137, 260n84, 261n87, 261-62n102
"Unpacking My Library" (Benjamin), 26
Unpleasant Surprise (Rousseau), 143
Unrest (Conroy & Cheyney), 209, 246n145
Untermeyer, Jean Starr, 246n150
Untermeyer, Louis, 16, 170, 246n150, 271n78
Upward, Allen, 35, 41
Utrillo, Maurice, 93

Valente, Joseph, 172, 269n48
Valéry, Paul, 251n56
Van Gogh, Vincent, 90, 126, 140
Van Vechten, Carl, 185, 219, 221, 276n34. *See also* James Weldon Johnson Memorial Collection
Vanity Fair, 201, 205, 206
"Verses, Translations, and Reflections from 'The Anthology'" (H. D.), 34
Victory! Celebrated by Thirty-eight American Poets (Braithwaite), 211
Viereck, George Sylvester, 274n1
viewer. *See* public
Vlaminck, Maurice de, 128
The Voice of Many Waters (Tack), 94, 96, 102, 104
The Voice of the Negro (Kerlin), 168
Vollard, Ambroise, 126, 127, 259n62
Vuillard, Jean-Édouard, 90, 93

Wacquant, Loïc, 118
wall ensembles. *See* Barnes Foundation collection arrangement
Wallis, Keene, 267-68n30
Walrond, Eric, 271n69
Warren, Robert Penn, 213
The Waste Land (Eliot), 1, 158, 186, 194
Watkins, Lucian B., 168, 169
Watson, Forbes, 88, 131
Wattenmaker, Richard J., 134, 136, 137, 149, 254n5, 256n21, 260n78, 263-64n115
Waugh, Evelyn, 276n40
Weir, Julian Alden, 76, 77, 248n28
Weiss, Jeffrey S., 150, 151-52
Weyhe, E., 10
Wheatley, Phillis, 220
Wheeler, Edward J., 30, 236n7

Wheels (Sitwell), 64–65, 234n65
White, Newman Ivey, 166–67, 169, 180
Whitney, John Hay, 104
Williams, Ellen, 40
Williams, Raymond, 5, 6, 7, 26, 57, 76, 165,
 230n15, 243–44n107
Williams, William Carlos: and *Catholic
 Anthology,* 41, 42; and *Des Imagistes,* 33,
 34–35; and Grantwood colony, 55; and
 Others, 56, 61, 62, 63; and Poetry Collec-
 tion, 218; and Society of Independent
 Artists, 57; on sources, 242n95
Williams, William Carlos, works: *Kora in Hell,*
 110; "On First Opening *The Lyric Year,"*
 32–33, 157; "Postlude," 33, 34–35; *Spring
 and All,* 64
Wilson, Woodrow, 75, 247n19
Wolff, Adolph, 51, 57, 242n86
Woman and Dog at Table (Bonnard), 150–51
Woman in a Green Hat (Cézanne), 128, 263–
 64n115
Woman Reading at Dressing Table (Matisse), 151

Woman with a Cigarette (Picasso), 126
Woman with Dog (Bonnard), 90
Woman with White Stockings (Courbet), 144,
 147
Woods, Clement, 60–61
Work, John Wesley, 1
"The Work of Art in the Age of Its Techno-
 logical Reproducibility" (Benjamin), 214
World War I: and African Americans, 205,
 273n116; and *Catholic Anthology,* 238n29;
 and Egyptian art, 252n81; and Phillips,
 50, 74–76, 100; and politics, 75–76, 247n19
Wright, Richard, 221

Yale University, 232–33n51
Yates, Frances, 139, 262n109
Yeats, William Butler, 1, 40, 41, 274n5

Zilczer, Judith, 10, 231n36
Zorach, Marguerite, 57
Zorach, William, 57, 82, 93
Zukofsky, Louis, 159